**Singular Sensations**

# Singular Sensations

••••••••••••••••••••••••••••••••••••••••••

A Cultural History of One-Panel Comics in the United States

MICHELLE ANN ABATE

**Rutgers University Press**
New Brunswick, Camden, and Newark, New Jersey
London and Oxford

Rutgers University Press is a department of Rutgers, The State University of New Jersey, one of the leading public research universities in the nation. By publishing worldwide, it furthers the University's mission of dedication to excellence in teaching, scholarship, research, and clinical care.

Library of Congress Cataloging-in-Publication Data

Names: Abate, Michelle Ann, 1975– author.
Title: Singular sensations : a cultural history of one-panel comics in the United States / Michelle Ann Abate.
Description: New Brunswick : Rutgers University Press, 2024. | Includes bibliographical references and index.
Identifiers: LCCN 2023055478 | ISBN 9781978840683 (paper) | ISBN 9781978840690 (cloth) | ISBN 9781978840713 (pdf) | ISBN 9781978840706 (epub)
Subjects: LCSH: Caricatures and cartoons—United States—History. | American wit and humor, Pictorial—History. | LCGFT: Comics criticism.
Classification: LCC NC1420 .A36 2024 | DDC 741.5/973—dc23/eng/20240511
LC record available at https://lccn.loc.gov/2023055478

A British Cataloging-in-Publication record for this book is available from the British Library.

Copyright © 2024 by Michelle Ann Abate
All rights reserved
No part of this book may be reproduced or utilized in any form or by any means, electronic or mechanical, or by any information storage and retrieval system, without written permission from the publisher. Please contact Rutgers University Press, 106 Somerset Street, New Brunswick, NJ 08901. The only exception to this prohibition is "fair use" as defined by U.S. copyright law.

The author has made all attempts to contact copyright holders for images in this book. If you are a rights holder, please contact the Press and we will include your rights information in future printings.

References to internet websites (URLs) were accurate at the time of writing. Neither the author nor Rutgers University Press is responsible for URLs that may have expired or changed since the manuscript was prepared.

∞ The paper used in this publication meets the requirements of the American National Standard for Information Sciences—Permanence of Paper for Printed Library Materials, ANSI Z39.48-1992.

rutgersuniversitypress.org

# Contents

|   | Preface and Acknowledgments | vii |
|---|---|---|
|   | Introduction: All by Myself: Single-Panel Comics and the Question of Genre | 1 |
| 1 | "Those Damned Pictures": Thomas Nast and the Rise of the Single-Panel Comic as a Political Cartoon | 22 |
| 2 | Freeze Frame: R. F. Outcault's *The Yellow Kid* and the Tableau Vivant | 45 |
| 3 | "*The New Yorker*'s Most Influential Cartoonist": Peter Arno and the Extraordinary Ordinary of Everyday Life | 68 |
| 4 | Not Jokester, but Prankster: *Little Lulu*'s Silent Social Commentary | 85 |
| 5 | Civil/Rights: Jackie Ormes's *Patty-Jo 'n' Ginger*, Black Girlhood, and the Black Bourgeoisie | 106 |
| 6 | Outside the Circle of Influence: *The Family Circus*, Diegetic Space, and Comics Narratology | 137 |
| 7 | Ziggy Was Here: Tom Wilson's Newspaper Series, World War II, and the Role of Graffiti in Comics | 155 |
| 8 | "His People Are Grotesque": *The Far Side* and the Aesthetics of Ugliness | 173 |
|   | Epilogue: Reimagine, Recombine, Recreate: Dan Piraro's *Bizarro*, Mash-Ups, and the Comics of Remix Culture | 195 |
|   | Notes | 215 |
|   | Works Cited | 221 |
|   | Index | 233 |

# Preface and Acknowledgments

Robert Mankoff, the celebrated cartoon editor at *The New Yorker*, offered the following observation about the art form: "Cartoons present a different way to see life's problems. They deliver a kind of mental health service" (qtd. in Goldstein, *Jackie* 205). Few would disagree with this statement. Comics in general and many of the single-panel titles examined here can be regarded as a therapeutic form of entertainment. For decades, installments of *The Far Side*, *The Family Circus*, and *The New Yorker* have provided readers with much-needed humor, a welcome distraction, and often insightful wit. This situation is especially true for me. I worked on these pages during a time of acute turmoil: the global COVID-19 pandemic, the 2020 presidential election, the January 6 insurrection, and national protests against police brutality. Accordingly, the single-panel comics that I discuss in these chapters provided me not only with "a different way to see life's problems"—as Mankoff notes—but a helpful way to cope with them.

Together with being grateful for the wit, humor, and distraction of the comics that I examine in these pages, I am equally grateful for the encouragement, wisdom, and good cheer of the many people who supported me while I wrote about them. First and foremost, I'd like to thank my editor at Rutgers University Press, Nicole Solano. From the beginning, she was an enthusiastic supporter of this project—and of me. I am equally indebted to the outside anonymous reviewers who read drafts of this manuscript and

provided insightful suggestions for revision. Their feedback made these chapters stronger and my arguments more insightful.

I also want to extend my thanks to many colleagues for both their feedback and friendship. First and foremost, I owe a special thanks to Gwen Athene Tarbox. For decades now, she has been a trusted intellectual sounding board, a source of sage professional advice, and a treasured personal pal. I am also indebted to the vibrant community of comics studies scholars. I am particularly grateful for the support of Aaron Kashtan, Joe Sutliff Sanders, Lara Saguisag, Margaret Galvan, Qiana Whitted, Frederick Luis Aldama, Alison Halsall, and Jonathan Warren.

Portions of some chapters have appeared previously. A version of chapter 4 was published in the *Journal of Graphic Novels and Comics*, 2016, volume 7, issue 4, pages 381–402. A modified edition of chapter 7 appeared in the *Journal of Graphic Novels and Comics*, 2022, volume 13, issue 1, pages 52–71. Finally, a segment of chapter 8 appeared in the online journal, *ImageTexT: Interdisciplinary Studies in Comics*, 2020, volume 11, issue 2. I am grateful to the editors of these journals for their permission to reprint.

American politician and professional football player Jack Kemp once remarked, "The power of one [individual] . . . doing the right thing for the right reason, and at the right time, is the greatest influence on society" (qtd. in Canfield et al. 271). While Kemp was referring to the sociocultural arena, his comments can also be applied to comics. The single-panel titles profiled in the chapters that follow have not only appeared at the right time and for the right reason for untold millions of readers; they have also exerted a tremendous influence on sequential art. *Singular Sensations* uncovers and unpacks this history. In so doing, it demonstrates that the name of the genre notwithstanding, sequential art has been profoundly shaped by—and continues to be impacted by—comics that consist of a solitary panel.

**Singular Sensations**

# Introduction

## All by Myself

• • • • • • • • • • • • • • • • • • • • •

Single-Panel Comics and the
Question of Genre

Perhaps no other mode of comic art is simultaneously more beloved and more belittled than the single panel. For generations in the United States, comics ranging from silly gag panels to serious political cartoons have appeared in this form. The diversity of subject matter addressed in single-panel comics is matched only by the length of its history. Some of the earliest examples of cartoon art in the United States took the form of a single-panel drawing. The first original comic published in the American colonies, Benjamin Franklin's political cartoon "Join, or Die" in 1754, was a solitary image. A century later, when lithography made printing images cheaper, faster, and easier, periodicals like *Puck* and *Judge* routinely included comedic drawings; many of them were individual images. Then, in 1895, a newspaper series that is commonly seen as the origins of commercial comics in the United States made its debut: R. F. Outcault's *Hogan's Alley*. His installments featuring The Yellow Kid routinely appeared as one large panel.

Single-panel comics were a fixture in American print and popular culture throughout the twentieth century. In 1925, Harold Ross founded *The*

*New Yorker* magazine. The publication became known for its eclectic mix of news, poetry, and fiction—as well as for peppering its pages with witty single-panel comics. A decade later, *The Saturday Evening Post* became the venue for another hugely popular single-panel series: Marjorie Henderson Buell's *Little Lulu*. Each installment followed the same formula. It was comprised of a solitary image that included no dialogue and featured the title character engaging in some type of amusing mischief.

The 1940s and 1950s were the heyday of Black newspapers in the United States, and they featured an array of popular and important single-panel comics. In *The Pittsburgh Courier*, Ollie Harrington's *Dark Laughter* series along with Jackie Ormes's *Patty-Jo 'n' Ginger* addressed issues ranging from Jim Crow segregation and the burgeoning civil rights movement to postwar consumerism and the rise of the Black middle class.

The transformations to American family life in the decades following the Second World War formed the basis for another hugely popular single-panel series, Bil Keane's *The Family Circus*. Making its debut on February 29, 1960, the comic presented a slice-of-life portrayal of the experiences of a white, middle-class, suburban, heterosexual couple as they raised their four young children. At the height of its popularity, *The Family Circus* enjoyed a daily readership of more than fifty million people (Astor 112). Moreover, installments have been reprinted in no fewer than eighty-nine paperback books, which have collectively sold more than fifteen million copies (Schudel).

The final decades of the twentieth century served as the backdrop to one of the most celebrated single-panel series of all time: Gary Larson's *The Far Side*. Appearing on January 1, 1980, the comic featured an ever-changing array of both humans and anthropomorphized animals to offer quirky observations about both daily life and cosmic existence. By the time the series ended on January 1, 1995—when Larson retired from cartooning to pursue other interests—*The Far Side* was running in more than nineteen hundred newspapers. Additionally, it had been reprinted in nearly two dozen books and translated into seventeen languages (Markstein, "Far Side").

Single-panel comics remain an important platform for cartoon art in the twenty-first century. From Dan Piraro's *Bizarro*, Mark Parisi's *Off the Mark*, and Scott Hilburn's *The Argyle Sweater* to Josh Alves's *Tastes like Chicken*, Ged Backland's *Aunty Acid*, and Scott Metzger's cat cartoons, the format has not simply persisted; it has flourished. Many of these single-panel titles enjoy large fan bases. *Aunty Acid*, which features sassy one-liners uttered by an older white female character, for example, had amassed more than eleven million followers on Facebook by 2022 (Aunty Acid). Single-panel

comics were also the recipient of impressive critical accolades: Parisi's *Off the Mark* was named Best Newspaper Comic Panel by the National Cartoonists Society in 2008, 2011, and 2017.

As even this brief overview demonstrates, single-panel comics form a key facet of cartoon art in the United States. From the eighteenth century through the new millennium, titles of this nature have been not merely a fixture in the medium; they have occupied its forefront. Given both the number and the notoriety of these titles, the odds are good that, for most fans of the medium, at least one of their favorite strips over the years has been a single-panel series. Many of the most commercially successful as well as critically acclaimed comics have been single-panel.

In spite of both the long historical presence and strong cultural significance of single-panel comics in the United States, they are not widely discussed. To date, no scholarly books are dedicated to this form. Unlike other modes of cartoon art—graphic narratives, comic books, newspaper strips—single-panel comics remain on the margins of the field. This observation is true even for the most successful single-panel series. The tremendous growth of comics studies during the past few decades has not changed this situation. Well-known titles like *The Family Circus* (1960–present) have yet to be the focus of sustained scholarly attention.

*Singular Sensations* offers a corrective to this situation. This book is the first full-length critical study of single-panel comics in the United States. In so doing, it ends the long-standing scholarly neglect of this culturally popular and creatively important mode of cartoon art. This opening introduction begins by exploring the cultural, aesthetic, and narratological reasons for the neglect of the single-panel format; it concludes by presenting an argument for seeing single-panel comics as an integral part of the genre. Then, in each of the eight chapters that follow, I examine some of the most important, influential, and innovative single-panel titles released in the United States. From political cartoons in the Gilded Age and gag panels in the Depression era to the character-based work of the postwar period and digital comics in the twenty-first century, I engage with a wide array of historical time periods, sociopolitical subject matter, and aesthetic styles. During this process, my discussion demonstrates that titles belonging to this category have played an important role in the origins, history, and evolution of the genre in the United States. In many respects, comics as we know them—and especially as we love them—would not be the same without the single-panel form. Accordingly, *Singular Sensations* moves this mode of cartoon art out of the margins and into the foreground.

In 1975, American musician Eric Carmen released a new song, "All by Myself." The ballad was a meditation on heartbreak, regret, and the passage of time. In what became a well-known refrain, the chorus of the hit song asserted "All by myself / Don't wanna be / All by myself / Anymore." In Carmen's ballad, being alone did not evoke positive feelings of independence, empowerment, and autonomy. Instead, it was associated with negative experiences, feelings of loneliness, rejection, and isolation.

A single-panel comic shares the experience of being "All by Myself." Unlike Eric Carmen's ballad, however, this condition is not lamentable. As *Singular Sensations* demonstrates, one-panel comics have played both a consistent and a significant role in the history of cartoon art in the United States. Moreover, these titles often represent the medium at its most artistically creative as well as culturally powerful.

## Singled Out: One-Panel Comics in U.S. Comics History—and Outside of Comics Studies

The factors fueling the success of single-panel comics are, ironically, the same ones that have fueled their critical neglect. First and foremost, these titles, because they comprise only one panel, can generally be read quickly and understood easily. Whether appearing in a daily newspaper, weekly magazine, or internet site, single-panel comics do not have a complex grid of panels to examine, and they also generally don't have a complex plot to decode. Broadly speaking, in titles ranging from *The Family Circus* and *Heathcliff* to *Ziggy* and *Marmaduke*, both the text and the image are simple and straightforward. For this reason, they typically do not require a major investment of time or interpretive skills. Anyone—from a highly skilled adult reader to a young person on the margins of literacy—can understand and enjoy them.

The accessibility of single-panel comics has allowed them to amass a wide readership, but it has also caused them to be seen as simplistic and even facile. Because these titles do not contain multiple installments of visual-verbal components, they are not seen as aesthetically or thematically complex. Single-panel comics might be entertaining and fun, the argument seems to run, but they do not merit or even support critical analysis. Their meaning is regarded as so straightforward that there is little (if anything) to analyze. Certain titles might be noteworthy as a phenomenon in popular culture but not in the realm of cartoon art. Single-panel titles are regarded as the "empty

calories" of comic reading—they are culturally delicious but not intellectually nutritious.

Exacerbating this viewpoint is the comedic mode to which many single-panel comics belong. More than simply being humorous, many single-panel titles are gag panels. They rely on amusing misunderstandings, wordplay, practical jokes, puns, and slapstick—forms of comedy that are commonly regarded as lacking in sophistication and, thus, the need for analysis. Indeed, drawings of the big, clumsy Marmaduke tackling someone with a hug or one of the kids in *The Family Circus* uttering an adorable malapropism ("Pasgetti and meat bulbs!") are self-evident. They require little or even no explanation.

Finally, but far from insignificantly, another factor fueling the neglect of single-panel comics is their publication platform. Generally speaking, these titles have appeared in newspapers and magazines. As Jared Gardner and Ian Gordon have discussed, comics that have appeared in print periodicals remain an understudied area in the field (4–7). Although such strips form some of the most popular, enduring, and influential works of cartoon art, they have not received a level of attention that is commensurate with their creative and cultural status. Instead, they remain overshadowed by work that has appeared in comic books and graphic narratives.

All that said, the historical neglect of single-panel comics goes beyond simply the traits that these titles possess; it also encompasses a feature that they lack. For many in the field of comics studies, single-panel comics are not regarded as comics. Titles like *Hazel*, *The Family Circus*, and *Ziggy* are outside the realm of scholarly attention because they are regarded as being outside of the genre. Despite the long history and strong presence of single-panel comics in the United States, they have routinely been excluded from discussions of the medium.

Will Eisner, in his groundbreaking 1985 book about comics, coined a now-famous term to describe it: "sequential art." In its most elemental form, he explained, comics are a series of images placed in a particular order to create a specific literary, artistic, or narratological effect. "The task is to arrange the sequence of events [or pictures] so as to bridge the gaps in action," Eisner wrote (46). In so doing, "the reader may fill in the intervening events" and thereby help generate meaning (Eisner 46).

In the decades since Eisner released *Comics and Sequential Art*, his viewpoint has been critiqued and refined, but the core concept has remained the same. Scott McCloud, in the opening pages of *Understanding Comics* (1993), for example, offers the following definition of the medium: "Juxtaposed

pictorial and other images in deliberate sequence" (9). Over the course of the chapters that follow, McCloud examines what he sees as the essential components of comics, many of which are directly predicated on, or strongly connected to, this basic understanding. From the centrality of the gutter to the various relationships that can exist between panels, the Eisnerian view that comics are sequential art forms the underlying premise of his analysis.

The work of both Will Eisner and Scott McCloud has been tremendously influential. While their ideas have faced pushback over the years, few would dispute that *Comics and Sequential Art* and *Understanding Comics* are foundational texts, essential reading for anyone interested in the field. Indeed, Charles Hatfield, himself an influential comics scholar, has called McCloud's book "seminal," "indispensable," and filled with passages that "will be cited over and over again" ("Thoughts" 89). The work of both McCloud and Eisner presents core concepts, describes key components, and provides necessary vocabulary. For this reason, they are frequently cited by critics and—especially *Understanding Comics*—commonly used in classrooms.

That said, the basic definition initially proposed by Eisner and then reaffirmed and popularized by McCloud is not without its problems. As Jean-Paul Gabilliet pointed out, "If one concentrates on sequentiality—the visual juxtaposition of pictures—one excludes all comics that rely on single panels or images" (xiii). Generally speaking, this practice has been the norm in the field. Titles that comprise a single image have routinely been regarded as outside of the genre. As McCloud has said on the subject, "Single panels might be classified as '*comic art*' in the sense that they derive part of their **visual vocabulary** from comics" (20; emphasis in original). However, he—along with many others—does not consider them comics because they lack what is regarded as an essential component: multiple panels. In the words of McCloud once again, "I say they're no more **comics** than [a] still [frame] of *Humphrey Bogart is film!*" (21; emphasis in original). Instead, McCloud uses a different term to classify or characterize single-panel drawings. "They are **cartoons**," he asserts, "and there is a *long-standing relationship* between comics and cartoons—**but they are not the same thing**" (21; emphasis in original). To further underscore this point, McCloud includes an image of himself as a character from *The Family Circus* (see Fig. I.1). Below the drawing is a line of Keane-esque dialogue: "Mommy, why ain't I juxtaposed?" (McCloud 20). Meanwhile, an exposition box above this illustration offers the following commentary: "Single panels like this one are often lumped in with comics, yet there's no such thing as a sequence of one" (McCloud 20). For McCloud—like for Will Eisner before him and an array of critics

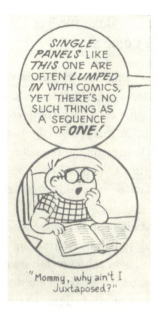

FIG. I.1 Panel from Scott McCloud's *Understanding Comics*, p. 20.

since—the most basic feature of comics is that they are *sequential* art; they comprise multiple panels.

In the decades since the appearance of McCloud and Eisner's work, a multitude of discussions have reiterated that multi-image sequences are a core element of comics.[1] Such observations are so pervasive that they are too numerous to survey here. For the most part, any attempt to define comics includes some reference to sequentiality. Indeed, the fact that the origin of comics is often traced to the work of Rodolphe Töpffer—who wrote multi-image narratives that he called "picture stories" (Kunzle, *Rodolphe* 3)— demonstrates how central this feature is to conceptions of the medium.[2]

As even this brief overview demonstrates, while there has been much disagreement among comics scholars over the decades regarding when, where, and how the genre began, there has been relative agreement over one trait: the medium comprises multiple images arranged in a deliberate order. From a grammatical standpoint, the noun "comics" is plural. Perhaps not coincidentally, from the standpoint of genre, there is a similar expectation that the panels that constitute comics are as well.

## Single and Fabulous: The Case for Seeing One-Panel Comics as Comics

Whether individuals adore single-panel comics or avoid such titles, they have been an undeniable force over the decades. Cartoon art in the United States would not be the same creatively, commercially, or culturally without the single-panel form. For this reason, the time has come to challenge and even overturn the long-standing omission of single-panel comics from discussions of the genre. One-panel comics are not only comics; they are examples of the form at its most condensed, compact, and efficient in many ways.

Because single-panel comics can usually be read quickly and easily, they are seen as lacking in visual, verbal, and narratological sophistication. Creating a successful single-panel comic, however, is exceedingly difficult. Unlike their multipanel counterparts, single-panel comics must work quickly and concisely. After all, they have only one frame in which to accomplish everything that they seek to accomplish. Whether it's telling a story, making an observation, or presenting a joke, these works need to perform all of their aesthetic, literary, and narratological tasks within the confines of a single frame. As a result, every facet of the panel must serve this purpose. From the artistic style of the drawing and the composition of the image to the specific visual details and the use of written text (if any), no feature can be overlooked, squandered, or held in reserve. In so doing, single-panel comics put tremendous pressure both on the individual cartoonist and on the medium of comics as a whole. They give the artist one opportunity (and only one opportunity) to achieve their goal. In this way, single-panel comics are exceedingly demanding and brutally unforgiving. There is little, if any, room for error—or even simple oversight. On the contrary, each feature must be first marshaled, then actualized.

A *Little Lulu* gag panel that was originally published on December 4, 1943, embodies a poignant case in point (see Fig. I.2). Every facet of the comic is employed to construct the scenario—and convey the joke. From the overall layout of the composition to the specific details included in the drawing, no feature is superfluous, no element is squandered, and no aspect is unnecessary. The night table that holds a stopped bottle and tall glass with a spoon sitting in it reveals that the title character is not simply sleeping but ill in bed. Likewise, the voluminous loops of barbed wire blocking the entrance to her room and the toy artillery pieces that she has lined up behind them demonstrate the fortifications that the young girl has constructed.

All by Myself • 9

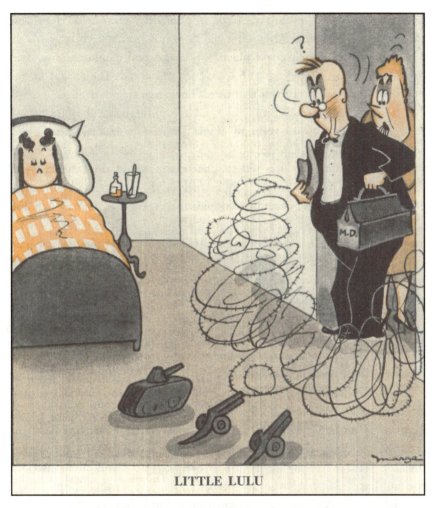

FIG. I.2 *Little Lulu* by Marjorie Henderson Buell, *The Saturday Evening Post*, December 4, 1943.

Finally, the two adult figures—a balding older man in a dark suit who is carrying a valise marked with the letters "M. D." accompanied by a white middle-aged woman—show both what the young girl is defending herself against and how readers are intended to react to these actions. There is no image, feature, or even line in this comic that is not needed—and not necessary. On the contrary, every single facet is used in the service of the comic's message. In so doing, the gag panel is not simply effective but exceedingly efficient. Indeed, while many of Buell's *Little Lulu* comics contain text and even dialogue, this one is wordless. Other than the initials "M. D." on the man's case to convey that he is a doctor, this panel is devoid of writing. In

one respect, the wordlessness of this panel puts added pressure on the image to convey the meaning. After all, Buell does not have speech balloons or exposition boxes to help make her point. However, I would contend that this panel is wordless because no words are warranted. The images in the panel are employed so adroitly that textual elements are not needed.

Although single-panel comics are rigid and unforgiving, they are also—for this exact reason—exceedingly efficient. These items make visible the semiotic workings, visual mechanics, and aesthetic operations that are at play in every comic panel, whether sequential or stand-alone. Since these items are comprised of just one panel, however, they do so in a highly concentrated manner. Of course, the content of single-panel comics may not always be the most lofty or sophisticated. Many titles of this nature present a simple gag (*Little Lulu*), offer an eccentric observation (*The Far Side*), or depict a familiar slice-of-life (*The Family Circus*). Even though the subject matter of single-panel comics may not be the most complex or well wrought, the method for presenting this material needs to be.

The way in which single-panel comics represent the medium at its most compact, elemental, and efficient is not limited to Buell's *Little Lulu*. This phenomenon can be found throughout many other single-panel comics, including those that are not held in the same esteem as Buell's work. Take *Ziggy*, for instance. Tom Wilson's series about the foibles, failures, and follies of his title character is not considered groundbreaking from the standpoint of its aesthetic style or its subject matter. On the contrary, the comic is seen as quotidian at best and a mere vehicle for licensing and merchandising at worst (Markstein, "Ziggy"). However, *Ziggy* routinely demonstrates the multifaceted operations of single-panel comics. The panel that appeared on March 26, 1987, offers an illuminating example (see Fig. I.3). Akin to *Little Lulu*, every feature of the image is used in service of the gag. From the half-opened window shade showing the sun rising, which conveys that it is morning, to the smiles on the slippers, which reveal their delight about the events that have transpired overnight, each element works toward the same common purpose. No aspect is extraneous; no feature is fallow. Analogous close readings can be conducted using examples from a multitude of single-panel comics, ranging from Gary Larson's quirky *The Far Side* to Bil Keane's more conventional *The Family Circus*.

Tracing the mechanics and unpacking the operations of single-panel comics not only changes our perception of the aesthetic, visual, and semiotic processes at work in these materials; it also invites us to rethink the notion of sequentiality in the medium. As discussed above, this concept is arguably

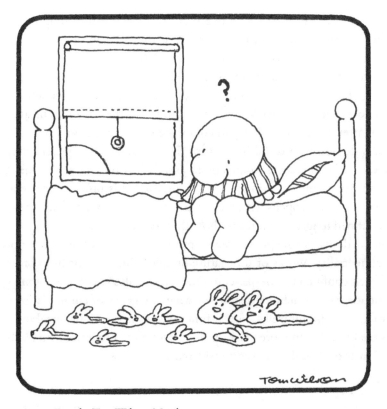

FIG. I.3  *Ziggy* by Tom Wilson, March 26, 1987.

the most important to the field: it is widely regarded as not simply a core trait but a prerequisite quality for the texts we study. That said, views of comics as sequential art have been predicated on understandings of the word "sequence" to denote the presence of multiple panels. Comics that contain only one frame do not appear in a sequence, and the absence of this element has formed the basis for their exclusion from the genre. While single-panel comics do not possess a sequence *between* panels, they can be seen as doing so *within* their panel. These works deliberately and carefully direct the reader's attention around the image. They guide the viewer's eye to what they should examine first, second, and third in order to follow the story, get the joke, or understand the observation. Moreover, this process routinely goes far beyond the dialogic relationship that exists between the text and the image; it also commonly encompasses elements within the image itself.

Both the *Little Lulu* and the *Ziggy* panels that I discussed earlier have clear, conscious, and unmistakable sequentiality. These images do not simply

invite but require readers to move their eyes around the composition to examine various elements, ponder their relationship to one another, and thereby help construct the overall scenario. What details should they view and, even more importantly, in what order? Examining these features in relation to one another, in the context of one another, and in a sequence with one another are necessary for understanding what these features mean, why they matter, and how they help us comprehend the comic as a whole. While readers do not need to fill in the gaps that occur between panels, they do need to make inferences, connections, and deductions about the ones that are present within this single panel. Moreover, this process represents in miniature what happens within every panel of every comic: from ones that are confined to just one frame to those that span book-length.

In so doing, single-panel comics prompt us to reconsider the notion of sequentiality. Works of this nature broaden this concept from one that had been confined to *inter*panel to one that can also encompass *intra*panel. Sequentiality is a defining feature of what the genre of comics is from an aesthetic standpoint well as how it functions from a semiotic one. However, this quality exists in more places and involves more processes than has been previously discussed—or even considered.

In a well-known episode from the popular HBO series *Sex and the City* (1998–2004), protagonist Carrie Bradshaw offers a proud new proclamation about heterosexual women who are not in romantic relationships. She deems these figures "Single and Fabulous!" "Being *single* used to mean that nobody wanted you," Carrie explains in one of her signature voice-overs. "Now it means you're pretty sexy and you're taking your time deciding how you want your life to be and who you want to spend it with." For centuries in the United States, heterosexual women who were not married or did not have a boyfriend had been pitied, both by society and also often by themselves. But in the closing years of the twentieth century, this episode of *Sex and the City* explores how attitudes about these individuals were changing, and they are being seen in far more positive ways.

In the same way that Carrie Bradshaw declares that nonmarried women are "Single and Fabulous!" this exact observation can also be made about one-panel comics. Whereas works of this nature have long been derided and dismissed, the time has come for these views to change. Single-panel comics are not only comics; they are examples of the medium at its most concentrated, compact, and concise. Furthermore, far from existing outside the

realm of sequential art, these materials shed new light on its key concept and core process. To evoke *Sex and the City* once again, by broadening our view of comics to include single-panel titles, what had formerly been seen as a pitiable party of one reveals itself to be the formidable power of one.

## Single and Ready to Mingle: Methodology, Organization, and Chapter Summaries

Single-panel comics are not only comics; they have appeared in every school, style, and platform imaginable. From gag panels and political cartoons to newspaper series and digital work, these titles have permeated the medium. *Singular Sensations* examines a cross section of these items, from both a historical standpoint and a thematic one. In the chapters that follow, I examine single-panel titles that span a wide array of time periods, subject matter, and cultural venues. In so doing, this project breaks with other conventions of the field. For instance, although political cartoons are one of the first, most robust, and historically long-standing forms of cartoon art in the United States, they do not occupy a commensurate place in the field of comics studies. Instead, these items are largely seen as different and, thus, separate from newspaper strips, comic books, and graphic narratives. As their placement on the op-ed page of newspapers suggests and the fact that one of their most important and prolific scholars is Stephen Hess—who has been a fellow at both the Brookings Institute and the John F. Kennedy Institute of Politics at Harvard—political cartoons are more commonly regarded as the purview of historians and political scientists rather than comics scholars.

In the same way that certain types of comics are overlooked, so too are certain venues for them. As discussed above, comics that appeared in newspapers have not gotten the attention that they deserve, and work published in magazines has been even more overlooked. Periodicals like *The Saturday Evening Post* and, of course, *The New Yorker* served as a creative and cultural incubator for the single-panel form. Just as importantly, these publications played a significant role in developing, disseminating, and popularizing comics in the United States. Indeed, even individuals who have never read an issue of *The New Yorker* have likely seen one of its cartoons.

*Singular Sensations* demonstrates not only the benefit but also the necessity of bringing these areas of comics into conversation. Just as single-panel comics need to be seen as comics, so too do political cartoons and work that

appeared in magazines. Comics are a complex, multifaceted, and expansive art form. Discussion of them needs to acknowledge, embrace, and celebrate this reality rather than minimize, obfuscate, or even deny it. *Singular Sensations* reflects this situation. Over the course of eight chapters, I examine work that appeared over a wide array of different time periods in different cultural platforms and addressing different subject matter. From nineteenth-century political cartoons, long-running series from mainstream national newspapers, and cartoons from the *The New Yorker* to gag panels that appeared in magazines during the Depression era, work from postwar Black newspapers, and digital comics posted online in the twenty-first century, *Singular Sensations* moves across a wide array of historical eras, aesthetic tastes, and thematic content. As a result, this book might contain more generic variety than some readers are accustomed to—or feel is appropriate for a unified monograph. While it is not common for these disparate areas of cartoon art to appear alongside one another, there is a tremendous benefit to doing so. Bringing political cartoons, gag panels, digital comics, and cartoons from *The New Yorker* into conversation reveals not only overlooked areas of creative and cultural continuity but also new critical insights. In the same way that *Singular Sensations* demonstrates the value of seeing single-panel comics as part of comics, it does the same for other schools, styles, and subject matter.

Chapter 1 examines the ascendency of the single-panel comic in the United States during the nineteenth century by examining the work of a political cartoonist who was one of its most effective promoters as well as skilled practitioners: Thomas Nast. In the 1870s, Nast's drawings in *Harper's Weekly* became national sensations when they helped topple one of the most corrupt political leaders in the history of New York City if not the United States—William "Boss" Tweed. The success of Nast's political cartoons has commonly been attributed to his talents as a caricaturist. While Nast's ability to satirically exaggerate the physical attributes of his subjects exerted an undeniable impact on the power of his cartoons, my discussion explores another equally important but neglected aspect of his work: his use of backgrounds. Instead of front-loading his compositions so that they could be read quickly and understood easily, Nast often created a broader depth of field that asked viewers to look, linger, and ponder. In so doing, he changed the relationship that both his work and single-panel political cartoons as a whole have to internal space as well as external time. At the same time, seeing the way that Nast utilizes depth of field in his panels creates a link

to a mode of drawing in which he began his career and would continue to work throughout his life: illustration. Ultimately, Thomas Nast's blending of cartoon, caricature, and illustration complicates contemporary discussions about the generic construction of comics.

Chapter 2 examines the work of another groundbreaking figure in the history of comics: R. F. Outcault. While his series featuring The Yellow Kid is commonly touted for the role that it played in what would become known as *sequential* art, my discussion examines its significance as a *single*-panel comic. Both when Outcault's work appeared in *The New York World* and when it moved to *The New York Journal*, it commonly appeared as one large drawing. My discussion identifies a possible overlooked source of influence on these compositions: the tableau vivant. A performance mode in which an individual or a group poses motionless in imitation of a well-known painting, sculpture, classical myth, literary work, or historical event, the tableau vivant was one of the most popular forms of entertainment in the United States for much of the nineteenth century. Outcault's single-panel drawings possess an array of connections to this phenomenon. These elements include their interest in both spectacle and spectatorship, their carefully choreographed compositions, and their engagement with questions of class and culture. When taken collectively, these features liken the cartoonist's comic frames to tableaux-like "freeze frames" in many ways. Exploring the possible presence of the tableau vivant in Outcault's series about The Yellow Kid adds a new source of influence on a foundational series in the history of U.S. cartooning, while it also adds a new facet to the sociopolitical critique operating in and through it. Finally, and just as importantly, viewing Outcault's The Yellow Kid panels through the lens of the tableau vivant calls added attention to the role that theater in general and performance art in particular played in the construction of this series and, given its historical significance, the emergence of commercial comics in the United States as a whole.

Chapter 3 examines the work of the figure who has been dubbed "*The New Yorker*'s Greatest Cartoonist," Peter Arno. Arno revolutionized the mechanics of the single-panel comic through his interplay of word and image. He also revolutionized the source of its content. Arno depicted a diverse array of individuals over the course of his career, from the flappers, dowagers, and plutocrats of the 1920s and 1930s to the secretaries, suburbanites, and men in gray flannel suits of the 1950s and 1960s. Whether Arno's drawings featured a chorus girl at a Prohibition speakeasy or an executive

at a postwar conference table, one element united them: they portrayed ordinary moments from daily life. Even when his cartoons took place in exciting settings—a crowded cabaret, an elegant dinner party, a picturesque beach—they routinely spotlighted something quotidian. In so doing, Arno's drawings demonstrated how seemingly empty and unimportant moments were actually exquisite and remarkable—primarily because they were resplendent with humor. For more than four decades at *The New Yorker*, Peter Arno's work captured what might be called the extraordinary ordinary of daily life. Accordingly, my discussion explores the role of everyday life in the work of Peter Arno. This feature alters our perception of this iconic cartoonist, adding a new facet to his repertoire of topics, themes, and subject matter. At the same time, Arno's engagement with the extraordinary ordinary alters our perception of comics, single-panel or otherwise. Much attention has been paid to the growing presence of the quotidian in sequential art during the new millennium. Peter Arno's *New Yorker* cartoons upend the origins of this phenomenon. As his prolific and popular corpus of single-panel comics reveals, everyday life has been a key feature of sequential art in the United States for at least a century.

Chapter 4 reconsiders one of the most popular magazine comics of all time, Marjorie Henderson Buell's *Little Lulu*. While the single-panel series certainly featured a plethora of amusing gags, a variety of installments presented the title character engaging in a markedly different activity: pulling a prank. Far from an inconsequential linguistic distinction, pranks serve a different comedic as well as cultural function. Whereas gags seek to amuse, delight, and entertain, pranks seek to question, challenge, and even provoke. Recognizing Little Lulu as a prankster in addition to a jokester changes the way we view, engage with, and understand her character, as well as the comic as a whole. The character's antics certainly make readers laugh, but they also invite them to think: about gender norms, social conventions, and established authority. This unexplored facet of *Little Lulu* links the comic series to the long, storied history of pranking in the United States, while it simultaneously calls attention to the important but understudied role that comics have played in this tradition.

Chapter 5 examines the single-panel comic by African American cartoonist Jackie Ormes that was both her longest-running title and arguably her most famous: *Patty-Jo 'n' Ginger*. Making its debut on September 1, 1945, in *The Pittsburgh Courier*, the weekly series was a gag panel starring two sisters: Patty-Jo, who is approximately six years old, and her older sibling, Ginger,

who is in her late teens or early twenties. The specific scenario for each installment varied widely, but the setup was the same: the two young Black girls would be engaged in some activity and, in the caption at the bottom of the image, young Patty-Jo would make a frank comment or offer a blunt observation about this issue or event. Ginger would be so dumbfounded by her sister's words that she was rendered speechless. For this reason, *Patty-Jo 'n' Ginger* has long been seen as participating in the "kids say the darnedest things" tradition of humor (Jackson 72). The age, race, class, and gender of its main characters, however, reveal that it is engaging in a far different, and far more political, cultural project. Instead of simply repeating a well-known trope about American childhood, the single-panel series explores new models of middle-class Black girlhood. After generations of encouraging respectability as a pathway to sociopolitical power, *Patty-Jo 'n' Ginger* offers a vivid demonstration of the benefits of being iconoclastic. Jackie Ormes's single-panel series appeared in one of the nation's leading Black newspapers in the years directly preceding the civil rights movement. Her popular female characters demonstrate the role that middle-class young people could—and soon would—play in it. This new way of viewing Ormes's series invites us to reconsider the connection that *Patty-Jo 'n' Ginger* has to its historical era and, with it, the comics and cartoonists from it. More specifically, this perspective changes the relationship that Ormes's single-panel series has to the comic that appeared beside it in *The Pittsburgh Courier* and with which it is most often contrasted: Ollie Harrington's *Dark Laughter*.

Chapter 6 challenges long-standing attitudes about Bil Keane's wildly popular newspaper series, *The Family Circus*. The single-panel comic, which debuted on February 19, 1960, is known for its slice-of-life portrayal of the trials and tribulations of raising children. Whatever the specific scenario being depicted, *The Family Circus* offered what Keane himself deemed "good, wholesome family entertainment" (qtd. in Eschner). My chapter argues that *The Family Circus* may not ask much of its audience when it comes to its subject matter, but it does so with regard to its layout. In features that have become iconic, the series appears as a single image enclosed by a black circular frame; the text that forms the gag—and which is usually uttered by a figure depicted in the image—is printed underneath as a caption. This seemingly simple, straightforward arrangement of word and image in *The Family Circus* is actually quite complicated from a narratological standpoint. By routinely placing intradiegetic material in extradiegetic space, *The Family Circus* explores the spatial and structural mechanics of

sequential art. Ultimately, recognizing and examining the way in which *The Family Circus* uses diegetic space complicates our understanding of both Keane's work and, just as importantly, comics narratology.

Chapter 7 offers a new perspective on the creative origins, aesthetic qualities, and sociocultural significance of Tom Wilson's newspaper comic, *Ziggy*. More specifically, I point out the ways in which Tom Wilson's well-known character from the 1970s contains elements of visual, thematic, and cultural overlap with an equally well-known figure from the 1940s: Kilroy. A simple line drawing of a bald fellow whose nose and fingers peek over a wall as a caption reads "Kilroy Was Here," the persona was a popular form of graffiti that began during the Second World War. Placing Ziggy in dialogue with Kilroy brings together two iconic figures from the history of American cartooning, inviting us to reconsider them both. While much has been written about the important role that the Second World War played in U.S. comics, these discussions have largely focused on the influence of comic books. The suggestive echoes between Ziggy and Kilroy call attention to the role that individual characters who circulated outside of the floppies played in the rise of sequential art during this era. More specifically, given that the figure of Kilroy was scrawled on walls, tanks, and barracks by U.S. service members, it highlights the important but long-overlooked role of modern graffiti in contemporary comics.

Chapter 8 examines the newspaper series that is arguably the most beloved and acclaimed single-panel comic of all time: Gary Larson's *The Far Side*. While much previous criticism has focused on the content of Larson's strip—his nerdy subject matter, witty humor, and off-beat point of view—my discussion explores another equally central aspect of the single-panel series: its aesthetic style. Whether man or woman, old or young, Neanderthal or contemporary human, Larson depicts his characters in a crude, unflattering, and even unattractive manner. Ugliness is more than simply an iconic feature of this equally iconic strip; it is both critically and culturally significant. The use of ugliness in *The Far Side* enriches the meaning, enhances the impact, and augments the resonance of these strips. An examination of ugliness in the work of Gary Larson has implications that extend beyond simply this cartoonist and his creation. It also calls attention to a long-neglected aspect in discussions about the aesthetics of comics: namely, the role that ugliness plays in the genre. Much attention has been given over the decades to the gorgeous artistry of comics. Various books, essays, and articles have discussed the exquisite line work, finely crafted compositions, and magnificent drawings that permeate comics and demonstrate

that it is a serious form of art. Gary Larson's single-panel comics add a new and contradictory facet to this ongoing conversation. *The Far Side* offers an instructive case study of the beauty of ugliness. In so doing, it reveals an unexpected but compelling kinship between Larson's series and some of the most successful digital comics released during the opening decades of the new millennium.

Finally, the epilogue considers the state and status of single-panel comics in the United States during the twenty-first century by reevaluating Dan Piraro's exceedingly popular *Bizarro* series. More specifically, I make a case that although *Bizarro* owes an undeniable debt to *The Far Side*, it is not a mere copycat. While the series does traffic in Larson's off-beat style of humor, *The Far Side* is not its sole or even primary creative touchstone. Instead, *Bizarro* can more productively be seen as participating in a larger cultural phenomenon: the mash-up. As the name implies, mash-ups take two or more existing elements and combine—or mash—them together. Drawing on previous practices like sampling, pastiche, and parody, mash-ups have become a defining feature of not simply music but literature, visual art, and film over the past few decades. Mash-ups also form a core creative component of *Bizarro*. Piraro draws on a wide array of elements from print, visual, and popular culture in his panels. From well-known books, movies, and television shows to current events, public figures, and historical happenings, the series is far more of a collage than a homage. Locating Piraro's work within remix culture not only offers a more accurate view of its logic of production; it also invites us to consider the important but overlooked role that mash-ups play in comics as a whole. For decades, this mode of production has embodied a defining aesthetic of music, literature, film, and visual art. *Bizarro* calls attention to the way that the mash-up has also been a driving force in comics, both single-panel and otherwise, past and present.

As this summary demonstrates, single-panel comics are a rich area of inquiry. They have played an important role in the aesthetic, thematic, narratological, commercial, and cultural operations of cartoon art in the past, and they continue to exert a powerful influence on the genre in the present day. Examining single-panel titles not only reveals compelling insights about some of the most popular, beloved, and successful titles over the decades; it also enriches our understanding of comics as a whole.

A few more remarks about methodology. While this book examines a wide array of single-panel titles in the United States, it is not exhaustive or all-inclusive. My goal is to spotlight some of the most culturally resonant single-panel series, not to present an encyclopedic catalog of them. *Singular*

*Sensations* seeks to demonstrate that single-panel comics are a valid and vibrant genre of cartoon art; it does not seek to document every example. There are a number of well-known and long-running single-panel series that I do not discuss but merit scholarly attention. In the realm of U.S. newspapers alone, examples include Ted Key's *Hazel* (1943–2018), Brad Anderson's *Marmaduke* (1945–present), Hank Ketcham's *Dennis the Menace* (1951–present), Jerry Marcus's *Trudy* (1963–2005), Virgil Partch's *Big George* (1960–1990), George Gately's *Heathcliff* (1973–present), and Jim Unger's *Herman* (1975–1992).

The single-panel form has been equally endemic in the work of nonwhite cartoonists. Ollie Harrington's *Dark Laughter* series (debuted 1935) as well as Tom Floyd's collection *Integration Is a . . . Bitch!* (1969) and his *Black Man Comics* (1972) from *Jet* magazine embody excellent examples. So, too, is the poignant series *Without Reservations* (2006–present) by Indigenous cartoonist Ricardo Caté (Kewa Pueblo). Meanwhile, Latinx cartoonists Eric J. García, Alberto Ledesma, and Lalo Alcaraz have been using the form of the one-panel comic to engage with contemporary topics ranging from immigration, citizenship, and migration at the U.S.-Mexico border to the COVID-19 pandemic and global lockdown.[3] Finally, but just as significantly, Asian American cartoonist Amy Hwang has been one of the most popular, prolific, and critically acclaimed cartoonists at *The New Yorker* since joining the magazine's staff in 2010. In 2019, Hwang received the Reuben Award for best gag cartoonist from the National Cartoonists Society.

While single-panel comics have permeated every historical era, the opening decades of the twentieth century were an especially rich period. The Gilded Age, Jazz era, and Depression years gave rise to the careers of figures like John T. McCutcheon (1870–1949), Claire A. Briggs (1875–1930), Tad Dorgan (1877–1929), Harold T. Webster (1885–1950), Ethel Hays (1892–1989), Gene Ahern (1895–1960), J. R. Williams (1888–1957), and John Held Jr. (1889–1958)—all of whom worked in the single-panel form and whose oeuvres are all ripe for in-depth evaluation. Furthermore, an array of long-running and successful comic series began as single-panel comics, ranging from Hank Ketcham's *Dennis the Menace* (1951–present) to Alison Bechdel's *Dykes to Watch Out For* (1983–present). Moreover, other series, including Bill Watterson's *Calvin and Hobbes* (1985–1995) have often employed the single-panel form.

Of course, political cartoons embody another fertile site of the single-panel form. In examples ranging from the work of Clifford Berryman (1869–1949), Nelson Harding (1879–1944), and Edmund Duffy (1899–1962)

to that of Herbert Block (1909–2001), Bill Mauldin (1921–2003), and Tom Toles (1951–present), many of the most memorable and celebrated political cartoons appear as a single image. In fact, between 1922 and 1967, when the Pulitzer Prize for Editorial Cartooning was awarded for individual drawings rather than for that year's body of work, only two of the comics were multipanel.[4] In the decades since, the single-panel form continues to be a common vehicle for political cartoons. Examples permeate the work of many of the most acclaimed editorial cartoonists, including Mike Peters, Ann Telnaes, and Adam Zyglis. It is my hope that *Singular Sensations* will inspire additional work on titles, cartoonists, and the form as a whole.

One final comment on the subject of methodology. The chapters that follow are arranged chronologically, but this organization ought not to imply a type of aesthetic progression. My goal is to simply chart different examples of the single-panel form across time, not suggest aesthetic or thematic evolution over the decades. For this same reason, the chapters can be read both individually and out of order. While I have tried to identify through-lines that link my discussions together, each chapter can also stand on its own as a self-contained analysis.

The word "single" has a complex history in the English language. As the *Oxford English Dictionary* relays—together with contemporary understandings as "solo," "alone," and "unaccompanied"—the adjective has been used to indicate being "undivided," "unbroken," and even "uncompromised" ("single, adj."). Single-panel comics embody all of these meanings and usages. Such titles are created by a solitary image. Additionally, they convey their message in a way that is not divided over multiple panels. What you see is what you get with a single-panel comic. There is no ambiguity about what might (or might not) have transpired in the gutter. There is no uncertainty about the time that may (or may not) have elapsed between frames. Moreover, there is no puzzling over the relationship that one image has (or doesn't have) to another. Single-panel comics are truly singular sensations. From a cultural, narratological, and aesthetic standpoint, there is nothing else like them. The time is long overdue for the field of comic studies to recognize their ingenuity, their indispensability, and their importance.

# 1

## "Those Damned Pictures"

### Thomas Nast and the Rise of the Single-Panel Comic as a Political Cartoon

The first original comic published in the American colonies was a single-panel one: Benjamin Franklin's political cartoon "Join, or Die," from 1754 (see Fig. 1.1).[1] The now-iconic image depicts a snake whose body is sliced into segments. Each piece is labeled to represent a different colony. The message of "Join, or Die" is clear: the colonies cannot survive as independent entities; if they wish to endure, they must unite to form a single governmental organism.

Franklin's political cartoon was powerful, but it was also a rarity. Mass-producing images in the eighteenth century was both costly and time-consuming. By the time the drawing was carved onto a wood block, printed onto sheets of paper, and distributed to the public, the issue that it was addressing had often been resolved—or another one had arisen in its place. At the very least, the cartoon was no longer topical. As Stephen Hess and Milton Kaplan have written, "For political cartoons to have mass appeal required two developments: a process that could cut the cost of production

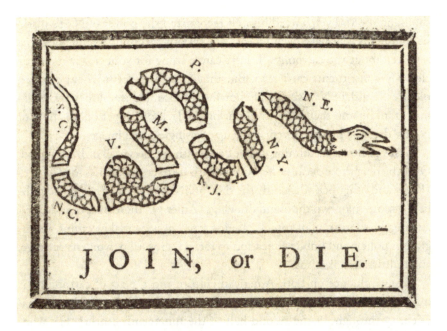

FIG. 1.1 "Join, or Die" by Benjamin Franklin. Originally published in *The Philadelphia Gazette* on May 9, 1754.

and a subject colorful enough to inspire broad interest and controversy. The election of 1828 produced both—lithography and Andrew Jackson" (67). Whether these cartoons supported the famous military leader in his bid for the White House or ridiculed him, they overwhelmingly took the form of a single image.

The election of Andrew Jackson may have marked the moment when political cartoons became a fixture in American print culture, but—as Victor S. Navasky has discussed—"the American cartoon didn't really come into its own until 1871" (32). That year, Thomas Nast, a staff artist for *Harper's Weekly*, used his drawings to help topple one of the most corrupt political leaders in the history of New York City if not the United States: William "Boss" Tweed. Working in tandem with reporters at *The New York Times*, Nast's cartoons exposed the vast financial graft and egregious voter fraud that supported Tweed and his cronies at Tammany Hall, the headquarters of the Democratic Party's political operations in Manhattan. Nast's drawings were printed on the front page of *Harper's Weekly*. His cartoons were not only tremendously effective; they were exceedingly popular. As Lynda Pflueger has noted, "During the crusade against the ring, *Harper's* circulation tripled from one hundred thousand readers to three hundred

thousand" (68). Even Tweed himself recognized the power of Nast's work. In comments that have been repeated in various forms, he complained to a reporter about the cartoons: "I don't care a straw for your newspaper articles. My constituents can't read. But they can't help seeing them damned pictures!" (qtd. in Navasky 79). Following the example established by Benjamin Franklin and then reinforced during the Jacksonian period, the bulk of Nast's "damned pictures" were made up of a single-panel image.

Nast's political cartooning did not end with the downfall of Boss Tweed. Over the next three decades, he would continue to create comics for *Harper's Weekly* and other periodicals. By the time of his death in 1902, Nast had published more than two thousand drawings (Adler v). These images addressed an equally wide array of topics, ranging from presidential elections, immigration policy, and public education to racial segregation, women's suffrage, and industrial capitalism.

Nast's influence on both American culture and the art of cartooning is difficult to overstate. He was not merely a household name but a national celebrity throughout the second half of the nineteenth century. His work shaped public opinion, and it also earned him fame and fortune. In 1873 alone, for example, when the average annual income was less than $500, *Harper's Weekly* paid him a "yearly retainer of five thousand dollars whether or not he submitted any drawings to them. Also, for each picture submitted, he . . . receive[d] an additional one hundred fifty dollars" (Pflueger 74). That same year, Nast embarked on a national speaking tour; the dates spanned "seven months and earned [him] forty thousand dollars" (Pflueger 75). Although the cartoonist's financial fortunes would rise and fall over the years—amid national economic crashes, poor investment decisions, and a failed attempt to start his own magazine—the esteem in which he was held did not. As one recent exhibit of his work observed, "Nast's persuasive, and sometimes scathing, cartoons proved crucial in influencing the nation's vote and affecting the outcomes of six presidential elections between 1864 and 1884" ("Presidents, Politics, and the Pen"). Together with impacting national politics, Nast's work also made lasting contributions to its visual lexicon. The cartoonist was the first person to use the elephant as a symbol of the Republican party. Additionally, he popularized the image of the Democratic donkey (Halloran 289). Given these accomplishments, Nast has been dubbed "The Father of the American Political Cartoon" (Pflueger). Although he did not invent this form, he demonstrated the power that it possessed.

This chapter marks the ascendency of the single-panel comic in the United States through the work of this political cartoonist who was one of

its most effective promoters as well as skilled practitioners. Thomas Nast is remembered not only for the content of his drawings—boldly tackling some of the most controversial topics of his day—but also for their aesthetic appearance. As Hess and Northrop have noted, "Where earlier cartoons rarely ventured beyond recognizable portraits, Nast used caricature to drive home his points" (55). By satirically exaggerating the physical attributes of his subjects, he enhanced his sociopolitical critique of them. Nast's caricatures were so skillful, in fact, that when William Tweed escaped from prison and fled to Spain, one of his cartoons was used to identify and apprehend him (Adler 255–257). Even before this event, the cartoonist was known as the "Prince of Caricaturists" (Dewey 10; Pflueger 74). To this day, he is lauded "as a political caricaturist *par excellence*" (Justice 173).

While Thomas Nast's talents as a caricaturist exerted an undeniable impact on the power of his cartoons, the discussion that follows examines another equally important but neglected aspect of his work: his use of backgrounds. Both in the realm of American political cartooning and in the larger Western tradition of caricature, the backdrop to compositions is routinely sparse. These drawings focus primarily if not exclusively on the figure(s) in the foreground. Artists do not wish to distract the audience's attention from the main subject matter with elements in the distance. Consequently, at most, they offer a few details to convey the setting. In many cases, the background space is blank; it comprises negative or empty space.

Thomas Nast's political cartoons both participate in this tradition and challenge it. While many of his well-known depictions of public figures appear against a sparse or even blank backdrop, others break from this convention. These drawings include not only a developed and detailed background but one that is integral to the panel. In some instances, viewers need to consider elements featured in the distance to understand the message. Meanwhile, in other cartoons, details in this space augment or amplify the satire presented in the foreground. Either way, Nast's use of background space is unexpected, iconoclastic, and above all, noteworthy.

Examining the way that background space operates in Thomas Nast's political cartoons adds a new facet to the ingenuity and complexity of his work. Instead of front-loading his compositions so that they can be read quickly and understood easily, Nast often creates a broader depth of field that asks viewers to look, linger, and ponder. In so doing, his work changes the relationship that his comics have to both internal space and external time. Thomas Nast has long been praised for the caricatures that appear in the foreground of his drawings. In a long-overlooked facet of his aesthetic

techniques, many of his political cartoons were just as remarkable for their utilization of background space. Seeing the way that Nast engaged with the depth of field in his panels creates a link to a mode of drawing in which he began his career and would continue to work throughout his life: illustration. Ultimately, Nast's blending of cartoon, caricature, and illustration complicates contemporary discussions about the construction of comics.

## "Less Is More": Political Cartoons and the Minimalist Aesthetic

Historian Roger Fischer described the task of political cartoonist in the following way: "In less than ten seconds, the skilled cartoonist must establish audience recognition of his or her visual symbol, make a political statement, and sell newspapers or magazines" (qtd. in Hess and Northrop 12). This statement is far from an exaggeration. Editorial cartoons are asked to accomplish a great deal—creatively, commercially, and cognitively—in an exceedingly short amount of time. Whereas readers expect to linger over newspaper articles, they don't expect to do so with political cartoons. The meaning or message of the drawing should be clear and even obvious. If the cartoon is too complicated or confusing, many readers will simply move on rather than puzzle over it. Indeed, as Gerald W. Johnston noted, "A cartoon 'shall produce its main effect in the first ten seconds, for ordinarily, it will not be given an eleventh second'" (qtd. in Fischer 14). Affirming the veracity of this observation, the Cartoonists' Guild commented that political cartoons generally lack a sense of "ponderousness" (qtd. in Halloran 86). Although the drawings offer insightful commentary about issues that are routinely complex, they themselves need to be straightforward. For this reason, political cartoonists tend to follow "the maxim that 'less is more'" (qtd. in Halloran 86). Their drawings generally have a minimalist approach, devoid of compositional elements that are not necessary to convey their point.

This quality dates back to the very first political cartoon, Benjamin Franklin's "Join, or Die" (see Fig. 1.1 once again). Originally published in *The Philadelphia Gazette* on May 9, 1754, the drawing is direct and simple. The composition contains only the features that are necessary to establish its premise and convey its point: namely, the snake that is being used as a metaphor for the American colonies. Additionally, the details in the drawing—the scales along the snake's body along with its eye and tongue—are not mere embellishments. Instead, they clarify that the creature

is a serpent as opposed to a worm, eel, or slug. As Hess and Kaplan remind us, "The cartoon was based on the popular superstition that a snake that had been severed would come back to life if the pieces were put together before sunset" (52). Consequently, these features are essential details, not extraneous decoration. Franklin's image contains no background elements. There is no sky or clouds above the snake, no grass or dirt beneath it, and no hills or houses in the distance—there isn't even a groundline. The segmented reptile floats against a blank backdrop of negative space. Rather than making the image more confusing because it lacks context, the absence of background detail makes it more intelligible: there is nothing to distract from the snake and, thus, detract from the point that Franklin is making about it. The simplicity of the drawing facilitates the clarity of its message.

The minimalist appearance of "Join, or Die" was more than simply a personal aesthetic preference; it was also a deliberate sociopolitical strategy. As Patrick J. Kiger has written, literacy rates were relatively low in the eighteenth century, "so the drawing and its message provided a way to reach colonists who might not have been able to read his editorial" (Kiger). The sparsity of words along with the simplicity of imagery maximized its potential audience. Franklin's cartoon required no "ponderousness."

Political cartoons appeared only sporadically throughout the colonial and Federalist periods. Whereas such images today are known for being a daily phenomenon, they were only published around once a year during this era (Hess and Northrop 38). These panels were created by a variety of individuals and addressed an equally diverse array of sociopolitical issues, from the fragility of a newly formed nation to the outbreak of the War of 1812. That said, the drawings were routinely united by a common feature: many adopted a minimalistic approach, especially when it came to rendering backgrounds. In examples such as Benjamin Russell's "The Federal Superstructure" (1788), Gilbert Stuart's "The Gerry-mander" (1812), and Amos Doolittle's "Brother Jonathan Administering a Salutory Cordial to John Bull" (1813), early American political cartoons did not fill the space behind the focal objects with detail. Instead, they showcased the main image in the center foreground. Akin to Franklin's "Join, or Die," the background space either was left blank or contained only those elements necessary to set the scene and convey the context.

The advent of lithography and the contentious presidential election of 1828 marked the moment when political cartoons became a common feature in American culture. Although such images may have been more numerous, the same overall aesthetic continued to typify them. Akin to Franklin's

"Join, or Die" political cartoons from the Jacksonian era routinely featured backgrounds that were sparse or even blank. Once again, this trait can be seen as a pragmatic decision as much as an aesthetic one; it allowed viewers to see the figures as well as read any speech balloons more easily.

In the decades to come, political cartoons would remain an important feature of American print culture—and political debate. Whether these panels addressed presidential elections, slavery, or immigration, many of them adopted the "less is more" approach when it came to background space. The area behind the central image is routinely left as white space. While this format was not the only one, it was a recurring and even common one.

This overall appearance continues to typify the work of many of the most commercially successful and critically acclaimed practitioners of the genre in the United States. From the drawings of Bill Mauldin, Herbert Block, Paul Conrad, and Mike Peters to panels by Tom Toles, Ann Telnaes, Michael Ramirez, and Darrin Bell, many political cartoons possess a strikingly similar aesthetic. Whether they were published during the second half of the twentieth century or the opening decades of the new millennium—and regardless of whether they addressed an issue from a liberal or conservative standpoint—these drawings largely present a foreground image that is surrounded by ample amounts of white space.

Although much has changed in the realm of American political cartooning over the past 250 years—print technology, public taste, policy issues—one element has persisted: the frequent use of a minimalist background. This feature is not a defining trait or universal aspect of the genre, but it has permeated political cartooning in the United States from its origins through the present day.

## Necessary Background Information: Thomas Nast's Political Cartooning in Three Dimensions

Rollin Kirby, who received the first Pulitzer Prize for Editorial Cartooning in 1922, once commented that a successful "cartoon consists of *75% idea* and *25% drawing*. 'A good idea has carried many indifferent drawings to glory, but never has a good drawing rescued a bad idea from oblivion'" (qtd. in Minix 76; italics in original). Thomas Nast did each of these components equally well. Not only did he have strong ideas for his panels, but he drew them skillfully. Nast had a particularly keen eye for creating an effective composition. Many of his political cartoons reflected the long-standing aesthetic

convention of the genre by presenting his subject matter against a sparse or even blank backdrop (see Fig. 1.2). This decision not only allowed his work to be understood quickly; it also heightened their effect. Because the area behind the central image was either completely empty or rendered with minimal detail, it called further attention to Nast's subject. The empty space framed the material in the foreground and concentrated the reader's attention wholly on it. After all, there was nothing else for the viewer to look at.

Not all of Nast's panels adopted this approach, however. Whereas many of his political cartoons used a blank backdrop to great effect, other installments broke from this trend. These drawings made use not simply of the composition's foreground but also its middle ground and background. Panels rendered in this way contained details in these areas that contributed to the message of Nast's work. In some instances, an examination of the middle ground and background was necessary to understand the main point of the cartoon. Moreover, far from isolated and esoteric examples from Nast's massive corpus, such cartoons embody some of his most important, impactful, and enduring work.

Moving Nast's treatment of the background to the forefront of our consideration reveals a new facet to the compositional geography and spatial mechanics operating in many of his panels. Nast demonstrated that a topical political cartoon could—and even should—be examined, pondered, and scrutinized in the same way and to the same extent as any other work of art. The more time viewers spent looking at his panel, the more meaning they discovered in it. In many of his most famous drawings, the Father of the American Political Cartoon asked his audience to read deeper into his work, not just figuratively but literally.

Thomas Nast was at the height of his creative powers in 1871—the year that he toppled the Tweed Ring. So it is no surprise that this is also the time when his work contains multiple instances of using background space in complex, iconoclastic, and interesting ways. One of the first examples of this phenomenon is also one of his most well-known cartoons: "Under the Thumb" (see Fig. 1.3). Appearing in *Harper's Weekly* on June 10, 1871, the drawing made a powerful statement about the oppressive control that Tammany Hall held over New York City. As the title of the cartoon suggests, Nast's panel depicts the island of Manhattan being squashed by a giant thumb. The enormous hand is not merely a symbolic representation of the Democratic political machine as a whole; rather, it represents the power wielded by a specific

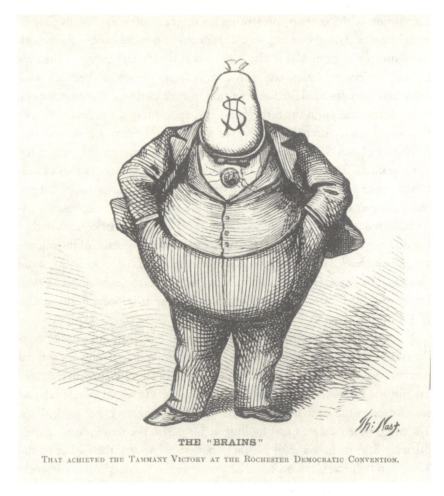

FIG. 1.2 "The Brains" by Thomas Nast. Originally published in *Harper's Weekly* on October 21, 1871.

individual. The cuff link on the sleeve of the Gulliver-esque arm is engraved with the name "William M. Tweed."

The message of Nast's "Under the Thumb" is straightforward. However, the layout of his drawing is not. In a break from the conventions of both caricature and political cartooning, the main image of the composition appears in the background of the drawing. Tweed's giant thumb occupies a large swath of space in the upper half of the image, but this space is not the foreground. On the contrary, the area of the drawing that is closest to the viewer is a picturesque town across the river from New York. Clearly labeled "New Jersey" in all caps, the settlement is drawn in detail and presented as utopian:

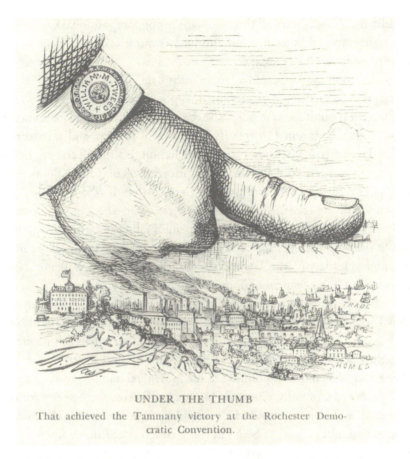

UNDER THE THUMB
That achieved the Tammany victory at the Rochester Democratic Convention.

FIG. 1.3 "Under the Thumb" by Thomas Nast. Originally published in *Harper's Weekly* on June 10, 1871.

it has a large public school, bustling factories, a beautiful church, and charming houses. This little New Jersey town, however, is not the focal point of Nast's comic. Rather, the settlement serves as a counterpoint. Because the riverside community is not being held down by corrupt politicians, it has been able to thrive. Nast's cartoon could make the same point about New York City being "under the thumb" of Boss Tweed without this feature. The entire foreground of the drawing could be removed, and the sociopolitical message of the panel would remain the same. By positioning the giant thumb in the background of the drawing, though, Nast gets his readers to pause, look, and ponder. They need to consider not only the relationship of text and image but also the relationship between elements placed in the distance of the drawing and those that appear in closer proximity. In so doing, Nast's

"Under the Thumb" uses all three dimensions of compositional space—left and right, top and bottom, front and back—and it asks readers to do the same to understand its message.

In a cartoon that appeared a few months later, "Who Stole the People's Money?" Nast made even greater use of depth of field to convey a powerful sociopolitical point (see Fig. 1.4). The drawing was an immediate sensation upon its publication in *Harper's Weekly* on April 19, 1871, and it remains a widely known panel—if not Nast's most famous political cartoon. Echoing the interplay of word and image that forms the basis for much of comic art, Nast's drawing offers an answer to the question of who has defrauded the public in the construction of the new city hall. This query, of course, is being posed to the members of Tammany Hall. The center foreground of the drawing presents caricatures of the four central—as well as most infamous—leaders of the Democratic political machine: William "Boss" Tweed, the Grand Sachem of Tammany Hall; Peter B. Sweeny, who served as the City Chamberlain and Park Commissioner; Richard B. Connolly, the New York State Controller; and A. Oakley Hall, who was the mayor of New York City. When asked the question, "Who Stole the People's Money?" though, none of these figures take responsibility. Instead, they shift the blame onto someone else, pointing to the individual standing to their right: Hall points to Connolly, Connolly implicates Sweeny, and Sweeny accuses Tweed. Boss Tweed, however, does not admit any culpability. The middle ground and background of Nast's drawing contains additional figures onto whom blame is placed: Tweed signals a man whose hatband reads "Chairs," the item that he procured for the new city hall. Meanwhile, that man points to a figure to his right whose jacket lapel reads "Plaster." This figure, in turn, holds out his arm to indict the man who was contracted for the carpets. This process continues from person to person and building item to building item—carpentry, gas pipes, awnings, and so on—until Mayor Hall is the one being blamed again. The question has literally come full circle, and no one has been held accountable. Given the circular nature of the inquiry, no one will take responsibility. Instead, the second attempt to procure an answer to the question "Who Stole the People's Money?" will play out in the same way as the first attempt: each figure will blame the one to his right until the circle loops around again.

The message of Nast's "Who Stole the People's Money?" is powerful and effective; moreover, it is only possible because it utilizes not just the foreground of the drawing but the middle ground and background as well. A ring operates in three dimensions; thus, the cartoonist's rendering must

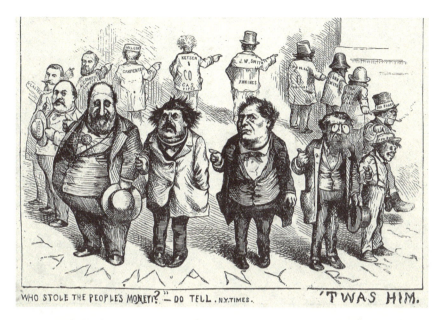

FIG. 1.4 "Who Stole the People's Money?" by Thomas Nast. Originally published in *Harper's Weekly* on April 19, 1871.

reflect this quality. Nast's audience cannot simply look at the caricatures of the four primary players—Tweed, Hall, Sweeny, and Connolly—in the center and front of the composition. The individuals located in the middle ground and background of the drawing are just as important. Moreover, all three of these compositional areas need to be viewed as elements that are working in tandem to make the satiric point about the lack of accountability within Tammany Hall.

Of all of the cartoons by Thomas Nast that use background space in rich and complex ways, "The American River Ganges" is arguably the most sophisticated (see Fig. 1.5). First appearing in *Harper's Weekly* on September 30, 1871, the image has been called "the most powerful graphic image Nast ever drew" (Fischer 15). The composition combines the cartoonist's two main sources of antipathy: Tammany Hall and the Catholic Church. The foreground of the image depicts a large pack of crocodiles—who are dressed in Bishop's garments and whose jaws are formed by the miter hat—crawling out of the water and toward a group of terrified young children huddled on the river's edge. An adult man attempts to shield them from the menacing onslaught. However, both the number of crocodiles and their large size make it clear that such efforts will be futile. The title that Nast selected for his drawing adds to this critique. As John Adler has written, "The cartoonist

FIG. 1.5 "The American River Ganges" by Thomas Nast. Originally published in *Harper's Weekly* on September 30, 1871.

realized that most of his American audience would associate the Ganges with religious superstition, which was one of the messages about the Catholic Church he wished to convey" (Adler 30). Not only were the "Romanists" and their chicanery a rapidly growing threat to the United States; they had their sights on the nation's children.

"The American River Ganges" requires little analysis. Even readers who are just glancing at the panel can understand its meaning and decipher its message. Unlike Nast's "Under the Thumb" or "Who Stole the People's Money?," the cartoon does not require readers to pause, peer, and ponder to understand its point. All of the information that audiences need to know is contained in the foreground of the drawing. Moreover, this vignette is so striking in many ways that it militates against looking at the background. Readers are so struck by the army of Catholic crocodiles emerging from the water—with their miter-hat jaws, sharp little teeth, and drooling mouths as they approach the terrified children who are huddled on the shore—that it is difficult to focus on anything else. The eye of the viewer is drawn to this scene, and rightly so. It is a tour de force.

Although "The American River Ganges" does not require its viewers to scrutinize the image to understand it, it rewards those who do. The background of Nast's drawing is just as semiotically rich as its foreground. In the

distance on the left side of the composition stands St. Peter's Basilica of Vatican City. That said, this iconic structure does far more than merely establish the religious identity of the crocodiles. It also connects the Catholics in Rome with the corrupt Democrats in New York City. Engraved on the pediment of the structure is the name "TAMMANY HALL." Forming a clear commentary about the solidarity between the seat of the Catholic Church in Italy and its Irish followers in the United States, the Papal flag flies from one spire atop St. Peter's, while the flag of Ireland adorns the other. Tammany Hall is populated by Irish Catholics, this detail in the distance suggests, whose loyalty is to the Pope in Rome, not the president of the United States.

The background to the right side of Nast's "The American River Ganges" is just as poignant. A multistory building labeled "U.S. Public School" stands at the edge of the bluff. The structure is in poor condition—its walls are crumbling, its roof is missing, and the American flag has been turned upside down in a signal of distress. Indeed, the public school looks as if it has not simply fallen into disrepair from benign neglect but has been brutally attacked and violently destroyed. The implication, of course, is that Catholics wish to do away with public education and instead institute religious-based institutions.

The school building might be nearly in ruins, but it is not vacant. A plethora of individuals surround it. Far from a stock crowd scene of unidentified members of the general public, a closer inspection reveals that many of these figures are recognizable. Moreover, their actions are equally significant. Just in front of the schoolhouse, an older man holds a young boy by the back of his shirt over the edge of the bluff. Although it is conceivable that he could be hoisting the child onto the cliff and, thus, to safety, both his body language and that of the boy suggest otherwise. The man's left hand is pointing to the crocodiles below, as if they are the boy's destination. Meanwhile, the child has covered his eyes, as if he knows his fate and cannot face it. Far from an unidentified man performing this terrible action, a closer inspection of the figure's face reveals that it is A. Oakley Hall, the corrupt mayor of New York City. Meanwhile, leaning on the cliff beside him and idly watching his horrific actions is another even more recognizable figure: William Tweed. Finally, observing this scene behind Oakley is a third member of the Tammany Ring: Peter B. Sweeny. Once again, these details give new meaning and added urgency to the message of Nast's cartoon. The Catholic Church is threatening the nation's schoolchildren, and the city's current elected officials are helping sacrifice them to this vicious predator.

Members of the Tammany Ring are not the only significant individuals featured in this area of the background to "The American River Ganges." Just above Hall, Sweeny, and Tweed is another cluster of figures. Akin to the nearby scene, this scenario does not look amicable. Two men are leading a young woman away. One man is holding what looks like a baton in his right hand, which he has raised in anticipation of striking the woman or, at the least, threatening to do so. Additionally, the woman's arms are behind her back, as if she has been handcuffed. Finally, and most ominously of all, they are walking the young woman, not in the direction of a jail, but toward the gallows: a wooden scaffold stands in the distance, with an empty noose dangling from the crossbar and two exuberant executioners on each side of the rope. To contemporary audiences, the young woman being escorted to the gallows is just a beautiful maiden. However, to Nast's original audience, she would have been immediately recognizable as Columbia or Lady Liberty, a common allegorical symbol for the United States. Once again, these background details to "The American River Ganges" make the panel more visually powerful and politically poignant. Although they are not necessary to understand the main message of the cartoon, they greatly add to its meaning.

Nast's drawings that addressed Boss Tweed and Tammany Hall were not his only political cartoons that explored the semiotic potential of background space. Many panels over the course of his career that engaged with different sociopolitical issues did so as well. Akin to examples like "The American River Ganges" and "Who Stole the People's Money?," some of these images rank among his most groundbreaking and enduring. The panel "Stranger Things Have Happened," which appeared in *Harper's Weekly* on December 27, 1879, embodies an excellent case in point (see Fig. 1.6). The drawing is identified as the first time that the donkey, which had long symbolized the Democratic Party, and the elephant, which Nast created as a metonym for the Republican one a few years earlier, appeared together in the same cartoon (Halloran 289). In a detail that is significant, these two animals are not shown side by side. Instead, one is presented in the foreground, and the other is depicted in the background. At the forefront of "Stranger Things Have Happened," Senator Thomas Bayard desperately holds the donkey—which has the words "Democratic Party" written on his side—by the tail in an attempt to keep it from plunging into a chasm labeled "Financial Chaos." By contrast, behind him in the distance, the Republican elephant slumbers calmly and securely on the ground under the watchful eye of U.S. Treasury Secretary John Sherman. In some respects, placing

FIG. 1.6 "Stranger Things Have Happened" by Thomas Nast. Originally published in *Harper's Weekly* on December 27, 1879.

these two images next to each other would call greater attention to the differing fiscal approaches of each party. After all, this arrangement creates a direct side-by-side comparison that commends the Republican approach as much as it disparages that of the Democrats. Instead of placing the donkey and elephant on the same dimensional plane, though, Nast situates them at different spatial coordinates. This decision alters the internal geography of the panel. The presence of these different spatial planes also creates different literal and figurative levels of reading. For members of Nast's audience whose gaze stops at the foreground, they see his criticism of the Democratic Party—the cartoonist's primary message. Meanwhile, for individuals who take more time to look into the background, they see his endorsement of

the Republican approach. Either reading, of course, is a productive one. However, the deeper they peer into the cartoon spatially, the deeper the sociopolitical commentary of the cartoon becomes as well.

When Nast's oeuvre is viewed from the perspective of its use of background space, an array of additional examples come to light. For instance, perceptive readers will notice that on the wall behind the main figures in "We Propose (When Things Blow Over)" (1871) is a small framed picture of George Washington weeping (see Fig. 1.7). Along those same lines, viewers who gaze beyond the brutal gladiatorial battle showcased in the foreground of Nast's famous "The Tammany Tiger on the Loose" (1871) will see William Tweed and his cronies sitting in the stands of the Colosseum (see Fig. 1.8). Finally, but just as compellingly, readers who linger for a moment over "Too Heavy to Carry" (1884) will see a chair aloft in the background (see Fig. 1.9). The item alludes both to the leadership position that Blaine had long held in his political party—as chair of the Maine Republican State Committee for more than two decades (Crapol 17)—and given its inscription with the year 1885, to the lofty one that he aspired to attain but that was, akin to the kite, far above his stature: to occupy the chair of the president of the United States.

Nick Sousanis, in his groundbreaking book *Unflattening* (2015), lamented the limited way that comics have been critically discussed. "Like a great weight descending," he opines in the opening statement, "flatness permeates the landscape" (Sousanis 5). Although Sousanis clarifies on the following page that "This flatness is not literal" (6). Rather, it is "a flatness of sight, a contraction of possibilities . . . where inhabitants conform to what Marcuse called 'a pattern of one-dimensional thought and behavior'" (Sousanis 6). Accordingly, *Unflattening* makes a case for resisting the "single chorus" of monolithic thinking and instead remembering as well as reconnecting with "the wonder of what might be" (Sousanis 7).

Thomas Nast's political cartoons were an important platform not only for popularizing the single-panel form in the United States but also—to borrow Sousanis's term—for "unflattening" them. His work demonstrated that these drawings need not operate in merely two-dimensions; they could and even should utilize all three. Rather than seeing background space as a potential distraction from the cartoon's sociopolitical message, it could be used to poignantly convey or powerfully enhance it. In many of his panels, in fact, the backgrounds ironically occupy the forefront. Far from being superfluous, they are substantive. Rather than being blank, they are highly developed. Instead of embodying empty space, they are filled with meaning.

FIG. 1.7 Detail from "We Propose (When Things Blow Over)" by Thomas Nast. Originally published in *Harper's Weekly* on August 26, 1871.

## Cartoon, Caricature, Illustration: Thomas Nast and the Merging of Artistic Modes

Thomas Nast began working for *Harper's Weekly* in 1862. However, he was hired not as a political cartoonist but as an illustrator. More specifically, Nast was brought to the magazine to create drawings of the Civil War. While photographers like Mathew Brady were documenting the conflict, printing technology hadn't yet developed to publish these images in newspapers or magazines. So the nation's periodicals still relied on illustrations. Nast had experience sketching battlefield scenes. Two years earlier, in 1860, the future political cartoonist had traveled to Italy for *The Illustrated London News* to cover Garibaldi's military campaign (Pflueger 24–26). Nast's drawings and articles about the charismatic leader's fight to unify Italy were tremendously popular with readers, and they helped establish Nast's reputation. They also gave him a professional niche. *Harper's Weekly* was looking to compete with rival publications like *Frank Leslie's Illustrated Newspaper*, whose pages were filled with drawings depicting wartime events. Public

FIG. 1.8 "The Tammany Tiger on the Loose" by Thomas Nast. Originally published in *Harper's Weekly* on November 11, 1871.

interest in not simply written articles about the war but visual imagery of what was happening on the front lines was enormous, and the circulation of *Frank Leslie's* skyrocketed (Brown, *Beyond* 40–57). *Harper's Weekly* was still a new publication—founded just four years prior to the firing on Fort Sumter—and it was still struggling to secure an audience. Thomas Nast's illustrations of the Civil War did just that (see Fig. 1.10, Fig. 1.11, and Fig. 1.12). From 1862 through 1865, his drawings of both factual scenes that he had observed on the battlefield and fictive vignettes about slavery, national sacrifice, and wartime separation launched both the artist and *Harper's Weekly* into the national spotlight. Nast's illustrations were so popular as well as so powerful that Abraham Lincoln referred to him as "the best recruiting sergeant" for the Union Army (Pflueger 40).

Nast would continue to work in illustration throughout his life. Even after becoming a renowned political cartoonist, he routinely created drawings for books ranging from novels by Charles Dickens to editions of the Bible. Additionally, and even more famously, Nast made illustrations about his favorite holiday: Christmas (Pflueger 98). In *Harper's Weekly* alone, Nast published more than thirty illustrations that had a yuletide theme (Boissoneault). Moreover, his rendering of Santa Claus was unique. Forming a

FIG. 1.9 "Too Heavy to Carry" by Thomas Nast. Originally published in *Harper's Weekly* on June 14, 1884.

departure from previous depictions, Nast portrayed him with a thick white beard, plump belly, and jolly demeanor. This version quickly became iconic. As Ryan Hyman along with other critics and biographers have commented, Nast "created the modern image of Santa Claus" (qtd. in Boissoneault). His likeness continues to serve as the model for the "American representation of St. Nick more than 100 years after his death" (Halloran 210).

Nast's political cartoons are widely seen as separate from his work in illustration. In many respects, these two facets of his career are regarded as having little in common creatively, compositionally, and culturally. Although many of Nast's illustrations addressed subject matter that was inherently political, they were also—unlike his later cartoon panels—highly sentimental. Whether depicting a factual scene of a battle during the Civil War or a fictional one about Christmas, the drawing was designed to tug at the viewer's heartstrings, not spark their sense of outrage. Nast's illustrations and his political cartoons differed in other ways. His illustrations are large-scale, multi-image compositions that strive to tell a broad story. By contrast, the bulk of his political cartoons are single-panel drawings that offer satiric commentary about a specific event or select individual. Finally, but just

FIG. 1.10 "After the Battle—Rebels in Possession of a Field" by Thomas Nast. Originally published in *Harper's Weekly* on October 25, 1862.

FIG. 1.11 "Emancipation" by Thomas Nast. Originally published in *Harper's Weekly* on January 24, 1863.

FIG. 1.12 "Christmas Eve" by Thomas Nast. Originally published in *Harper's Weekly* on January 3, 1863.

as importantly, these two modes use a very different artistic style. Whereas Nast would become famous for the use of caricature in his political cartoons, his Civil War illustrations employ realism. These drawings are densely packed compositions. While it is possible to quickly glance at illustrations like "Emancipation" or "Christmas Eve," the multiple vignettes and intricate details encourage and even require a prolonged gaze.

Given these differences, Nast's work in illustration is often framed as a prologue to his later and "true" artistic vocation: political cartooning. Illustration served as a training ground, a stepping stone, and a launching pad. The success that Nast had as an illustrator provided him with the platform for the far more significant, original, and enduring work that he would do later as a political cartoonist. In fact, critics often identify Nast's "mature style" as the panels in which he fully abandoned the realism that typified his illustrations and rendered his subjects in caricatures with thick black outlines (Vinson 5; Bryant and Coleman 405). His political cartoons, unlike his illustrations, contain a "directness" by "concentrat[ing] on a single strong image" (Bryant and Coleman 405).

Nast's use of background space in panels like "Under the Thumb" and "The American River Ganges" calls into question the formerly firm divide between his work in illustration and that in political cartooning. Far from seeing these artistic modes as two distinct phases of his career, they possess more areas of overlap than previously believed. Nast did not wholly abandon illustration when he created his political cartoons; instead, he recognized the potential that this drawing style had to augment this work. From the utilization of depth of field and his inclusion of detailed backgrounds

rich with meaning, he created political cartoons that incorporated key aspects of illustration. Far from hampering the effectiveness of his panels, these elements enhanced them. Both during the time of Thomas Nast and in the decades since his death, political cartoons have commonly operated according to the maxim "less is more." In panels like "The American River Ganges," Nast demonstrated that more can be more.

A central preoccupation of comics studies over the past few decades has been with formalist questions concerning genre: What is a comic? How do we define it? What distinguishes it from other modes of art? Can single-panel images be regarded as comics? What is the relationship between caricature and cartooning? Is caricature a form of comics, or is it a tool or technique for cartoonists? When does a caricature become a comic?

Throughout the second half of the nineteenth century, Thomas Nast's panels changed how Americans viewed politics. In the same way, a reexamination of his political cartoons changes the way that we view comics. Through images that not only appeared in single-panel form but also made frequent use of caricature and illustration, Nast's oeuvre makes a powerful case for a more fluid and expansive view of the genre. His political cartoons reveal that comics are enhanced by incorporating other artistic modes, not diluted by them. Instead of defining comics in largely exclusionary terms—as separate from illustration, distinct from caricature, and so on—Nast's panels reveal the benefits of seeing them in more inclusionary ways: as a form that makes productive use of various artistic schools, creative styles, and aesthetic modes. Thomas Nast brought the single-panel comic to the forefront of American popular culture with his political cartoons. Just as importantly, his work demonstrates the benefits of seeing the boundaries of this genre in more permeable rather than restrictive ways.

The following chapter charts the next major landmark in the history of single-panel comics in the United States by examining the work of another nineteenth-century cartoonist who is not commonly connected with Thomas Nast but follows in his footsteps in many ways: R. F. Outcault. In 1895, Outcault's *Hogan's Alley* made its debut in the new Sunday comics section of *The New York World* newspaper. Echoing his predecessor a generation earlier at *Harper's Weekly*, Outcault's series routinely engaged with content that was highly political, and it did so in drawings that were also highly detailed.

## 2

## Freeze Frame

●●●●●●●●●●●●●●●●●●●●

R. F. Outcault's The Yellow Kid
and the Tableau Vivant

The significance of Richard Felton Outcault to the development of comics in the United States is undisputed. Born in Lancaster, Ohio, in 1863, R. F. Outcault, as he was known professionally, would become one of the most successful and influential newspaper cartoonists, not merely of his generation, but arguably of all time. In what has become an oft-repeated biographical detail, in 1895, Outcault was hired as a contributor to a new full-color Sunday comics supplement that was being published in Joseph Pulitzer's newspaper, *The New York World*. Outcault's first panel appeared on May 1, 1895, and immediately resonated with readers. Called "Hogan's Alley," the series chronicled the antics of a group of raucous immigrant children on New York's Lower East Side. The kids were led by a scrappy young boy whose given name was Mickey Dugan but who quickly became known by the nickname "The Yellow Kid" after the mustard-colored nightshirt that he wore.

The specific subject matter for *Hogan's Alley* varied each week, but its format was almost always the same: Outcault's work typically appeared as a large single-panel image. Most installments, in fact, occupied the top half

of a newspaper page. In the years to come, Outcault would experiment with comics comprised of multiple drawings arranged in a sequence—an innovation that would cause him to play a central role in the emergence of the commercial comic strip in the United States (Saguisag 3; Blackbeard 68). However, Outcault's work most frequently took the form of a large single-panel comic. Far from a pragmatic decision dictated by the newspaper, this mode was one that Outcault both deliberately selected and, in many ways, professionally preferred. As Bill Blackbeard has written, while the cartoonist certainly had fun exploring the creative possibilities afforded by multi-image comics, "His real passion remained invested in the full page drawings" (72). The cartoonist took extra time and care with these images, giving them a level of detail that demonstrated his enthusiasm for the form. Outcault's single-panel work was beloved by his readers. In the words of Blackbeard, the large solitary "panels were the cornerstone of his success" (72). These drawings were the ones that originally captured the public's attention, and they remain the ones with which his work remains powerfully associated.

*Hogan's Alley* in general and The Yellow Kid in particular attained a level of success that was unprecedented in U.S. popular culture. Within a few months, the comic "was read avidly by nearly a million readers" (Bolton 16). Outcault's series in general and focal figure in particular quickly grew so popular that *The New York World* couldn't contain them. The Yellow Kid became "the first merchandized comic strip character, appearing on cracker tins, cigarette packs, ladies' fans, buttons, and a host of other artifacts" (Harvey, "Outcault"). Additionally, the puckish protagonist was an inspiration for songs, the basis of comedy routines, and the subject of stage plays in genres ranging from musical and farce to burlesque and pantomime (Meyer 30–33, 56). Given the numerous material platforms in which Outcault's character appeared in the 1890s, he has been identified "as a precursor to the rise of transmedia franchise in the twentieth century" (Meyer 53).

The tremendous popularity of *Hogan's Alley* prompted William Randolph Hearst, who owned a rival newspaper, to lure Outcault away with a lucrative contract. The first installment of The Yellow Kid in Hearst's *New York Journal* ran on October 18, 1896. That said, Pulitzer's publication held the rights to the name "Hogan's Alley," so Outcault's cartoons appeared under a new title: "McFadden's Row of Flats." Complicating matters, *The New York World* continued to publish weekly installments of *Hogan's Alley*, assigning the series to a staff cartoonist, George B. Luks. Over the next few years, comics starring The Yellow Kid appeared in both newspapers simultaneously. Far from causing oversaturation, the existence of both *Hogan's Alley*

(by Luks in *The New York World*) and *McFadden's Row of Flats* (by Outcault in *The New York Journal*) delighted audiences who now had two weekly installments featuring their favorite character.

By the time that R. F. Outcault retired The Yellow Kid in early 1898 to pursue other professional endeavors, "his work made him a fortune and turned him into a national celebrity" (Saguisag 1). While the cartoonist would attain great success with his new *Buster Brown* series, he would secure a place in history for the groundbreaking features that he introduced in The Yellow Kid comics. From his revival and repurposing of the speech balloon to his experiments with multipanel sequences, "Outcault utilized elements that are now considered standard in the modern newspaper comic strip" (Saguisag 3). Both during his lifetime and into the present day, he is regarded "as an innovative, astute artist who helped lay the foundations of the American comic strip" (Saguisag 1). For many, he is simply "The Father of the American Sunday Comics" (Olson).

This chapter takes another look at R. F. Outcault's groundbreaking work featuring The Yellow Kid, not for the role that it played in what would become known as sequential art, but for its significance as a single-panel comic. In sentiments that have been echoed by many other critics, Lisa Yaszek wrote, "While Outcault's sequential strips were wildly successful, his true genius shone through in the single panel cartoon" (33). From their densely packed compositions and fine detail to their clever humor and memorable characters, his drawings amazed audiences in the 1890s, and they continue to impress viewers today. For this reason, Outcault's single-panel images featuring The Yellow Kid are not only an important starting point for the development of commercial comics in the United States; they remain a high point in many ways. Over the years, numerous critics have deemed Outcault's work nothing less than genius (see Harvey "Outcault"; Blackbeard; and Olson).

Outcault's comics, both when they appeared as *Hogan's Alley* and when they were published under the moniker *McFadden's Row of Flats*, were profoundly influenced by the events taking place during their era. The closing decade of the nineteenth century was one of the most dynamic and tumultuous periods in American history. From massive immigration, rapid industrialization, and widespread urbanization to technological innovations such as the advent of the phonograph, the appearance of the new electric streetcar, and the rise of motion pictures, these events would forever change American society. Outcault's comics featuring The Yellow Kid frequently engaged with these events.

The discussion that follows remembers and recoups another cultural phenomenon that was taking place during the time of Outcault's work on The Yellow Kid, and that can be regarded as playing an important, and heretofore overlooked, role in his cartooning: the tableau vivant. A performance mode in which an individual or a group poses motionless in imitation of a well-known painting, sculpture, classical myth, literary work, or historical event, the tableau vivant was one of the most popular forms of entertainment in the United States for much of the nineteenth century. These performances initially began as wholesome family fare that was seen as educational and even edifying, but they soon devolved into flimsy excuses for audiences of men to stare at women's often scantily clad bodies. Regardless of whether a tableau vivant was respectable or ribald, such performances permeated both the public sphere and private realm throughout the fin de siècle.

Among the myriad sociocultural events that influenced comics featuring The Yellow Kid, the tableau vivant needs to be added. Outcault's single-panel drawings possess an array of connections to this popular performance mode, ranging from their re-creation of familiar events and their interest in spectatorship to their carefully choreographed compositions and their engagement with questions of class and culture. When taken collectively, these features liken the cartoonist's comic frames to tableaux-like "freeze frames" in many ways.

Exploring the possible presence of the tableau vivant in comics featuring The Yellow Kid adds a new source of influence on a foundational series in the history of U.S. cartooning, while it also adds a new facet to the sociopolitical critique operating in and through it. Especially by the final decade of the nineteenth century when Outcault's work appeared in newspapers, the tableau vivant was known for challenging the boundaries between highbrow and lowbrow, edification and titillation, timeless art and tasteless ephemera. Outcault's The Yellow Kid had a similar interest in questioning and even upending the status quo. More than simply embodying another element from the era's popular culture that can be identified in the cartoonist's work, the tableau vivant offers an additional means to explore issues of class, taste, and culture. Ultimately, viewing Outcault's The Yellow Kid panels through the lens of the tableau vivant adds a new facet to the role that theater in general and performance art in particular played in the construction of this series and, given its historical significance, the emergence of commercial comics in the United States as a whole.

## Setting the Stage: A Brief History of the Tableau Vivant

As historian Jack McCullough noted, "Viewed from the present, the entertainment known as tableaux vivants, or living pictures, seems a quaint curiosity, a precious exercise from the past, lacking modern significance" (1). Such views notwithstanding, this performance mode has a long, rich, and complex history in the United States. Beginning in the antebellum era and extending through the postbellum period, the tableau vivant had a profound impact on mass entertainment in general and theatrical performance in particular. Moreover, the tableau vivant enjoys a legacy that remains influential today.

The tableau vivant would become a sensation in the United States in the opening decades of the nineteenth century, but this performance mode was neither an American invention nor one that originated in the 1800s. As historians Shannon Murphy, D. H. Eichberger, and Jack McCullough have all discussed, the practice of individuals donning costumes, holding props, and posing in carefully choreographed scenes extends back to at least the medieval era in Europe. Generally reserved for special occasions—such as religious celebrations, political pageants, community festivals, and so on—these "presentations were often highly fanciful and extremely elaborate" (McCullough 1).

During the eighteenth century, the tableau vivant moved from being a public spectacle to a private entertainment. More specifically, in the words of Barry Faulk, it found new life "as an aristocratic diversion" (Faulk 147). Tableaux staged in the homes of wealthy families sometimes marked an important civic event or celebrated religious holiday. However, they more commonly presented a different subject matter in this different setting: these spectacles recreated famous paintings, sculptures, historical events, or mythological scenarios. As Lori Merish, Peter M. McIsaac, and Mary Chapman have all written, this new form of tableau vivant embodied both a fun pastime and a challenging game for everyone involved. For the performers, it was a test to see if they could faithfully recreate the event through costumes, props, and of course, the placement of their bodies. Meanwhile, for their audience, the tableau was a test of their cultural refinement to see if they could correctly identify the iconic painting, mythological scene, or historical event (Chapman 24; McIsaac 156).

The tableau vivant moved out of the drawing rooms of the upper class and into the parlors of the middle class in the opening years of the nineteenth century. This shift can largely be credited to German author Johann Wolfgang von Goethe who featured them in his popular novel *Elective*

*Affinities* (1809). Within a decade, parlor tableaux vivants had crossed the Atlantic and become a widespread mode of home entertainment for white middle-class Americans. An array of guidebooks offered ideas for various tableaux that could be staged at home as well as instructions about the poses and information about the costumes, backdrops, and props needed to make them successful (Chapman 27–28).

In the 1830s, the tableau vivant would experience yet another cultural shift. This time, they entered the public venue of professional theaters, first as "an attraction on a multiple bill" and then as stand-alone programs (McCullough 143). In many ways, this development was purely pragmatic: the form had become so popular that theaters realized they could make money by staging such scenes themselves. Additionally, creating tableaux vivants at home was arduous and time-consuming. From constructing the costumes and making the backdrops to locating the necessary props and practicing the poses, a single tableau often involved weeks of preparation. It was far more convenient to attend an evening of these scenes at the theater, initially as a means to supplement one's appetite for them and then—as the stage shows grew more elaborate—to replace the home versions altogether. As Jack W. McCullough has discussed, "by the mid-1840s, tableaux vivants had become a familiar and popular entertainment form in the New York theatre" (McCullough 16). Such performances had "found their way into the most respected theatres as well as the lowliest concert saloons and music halls" (McCullough 143). Moreover, nearly every stage play—be it a drama, comedy, farce, or musical—incorporated them. As one theater critic grumbled, "dramas will soon have no scenes, only 'tableaux'" (qtd. in McCullough 64).

The national craze for the tableau vivant waned by the era of Reconstruction, when the form largely became associated as an excuse to display women clad only in sheer body stockings to an audience of leering men. However, the art form experienced a resurgence in the final decade of the nineteenth century. By this point, the performance mode had been out of the public realm long enough for it to be considered nostalgic to older generations and a "new novelty" to the younger ones (McCullough 101). In the words of Jack McCullough: "the late 1890's saw a blaze of tableau glory such had not occurred before was not to be seen again" (113). New York City, as a hub of American theater as well as a crucible for the nation's popular culture, was the epicenter of this phenomenon in many ways.

All that said, the tableau vivant would not remain at the forefront of either the American theater or the nation's popular entertainment. New

leisure-time pursuits—especially motion pictures—would lure audiences away. By the 1920s, the tableau vivant as a stand-alone performance was over. That said, the legacy of tableaux can be seen in a variety of contemporary cultural sites and modern entertainment sources. First and foremost, the tableau vivant profoundly shaped—and continues to shape—photographic images. As Kristine Somerville has discussed, "When photography was invented in 1839, the familiar practice of role-playing and staging scenes for tableaux became a natural subject for the new medium" (Somerville, "Living" 38). This phenomenon has persisted over the decades. In examples ranging from the meticulously staged scenarios captured by Gregory Crewdson to the provocative portraits taken by Annie Lebovitz, many modern photographers can be likened to "directors, posing 'actors,' choosing the sets, props, and costumes, and determining the lighting and placement of implied narratives" in ways that resonate with the tableau vivant (Somerville, "Living" 38). Still pictures taken with a camera are not the only modes of cultural expression that possess a kinship with the tableau vivant. Such elements have also been traced in a wide array of other art forms, including theatrical musicals, parade floats, and modern performance art. As these examples attest, the tableau vivant is both antiquated and very much alive in the United States. Mary Chapman remarked how "the *tableau vivant* captivated the imaginations of Americans" (26) throughout the nineteenth century. Moreover, this performance mode continues to exert a tacit, but tangible, influence in the twenty-first century.

## Striking a Pose: Outcault's Comics Tableaux as Tableaux Vivants

R. F. Outcault's comics about The Yellow Kid routinely engaged with events happening in the realm of American theater.[1] As Christina Meyer, David Westbrook, and Bill Blackbeard have all discussed, the cartoonist—akin to many of his peers—borrowed heavily from vaudeville. Additionally, via recurring characters such as the cancan-dancing Ricadonna sisters, Outcault also incorporated facets of burlesque.

Of the many dramatic forms with which Outcault's work can be connected, the tableau vivant should be added. In the same way that elements from vaudeville and burlesque can be found in panels featuring The Yellow Kid, so too can this popular performance mode. Outcault surely knew about tableaux vivants. Especially in New York City where the cartoonist lived and

where his comics series is principally set, this theatrical style was prominent. In 1895, the same year that The Yellow Kid debuted, one Manhattan-based journalist declared that such "artistic tableaux" were nothing short of "a new 'craze' in our crazy town" (qtd. in McCullough 113).

Given the popularity and pervasiveness of tableaux vivants during this era, combined with Outcault's interest in current events, it seems not merely fitting but even expected that he would engage with them in some way. After all, the cartoonist incorporated many of the era's leisure-time entertainments in his work. Although no specific Yellow Kid panel makes a direct reference to the tableau vivant, many can be viewed as drawing on key facets of them. In features ranging from their carefully choreographed scenes and strategically posed figures to their interest in mimicry and juxtaposition of motion and stillness, Outcault's comics scenes resemble tableau scenes in many ways.

Bill Blackbeard, in his book celebrating the centenary of Outcault's The Yellow Kid, refers to the cartoonist's single-panel drawings as "comic tableaux" (36).[2] The pioneering critic, however, does not use this term as a means to establish or explore the kinship that Outcault's work has with this performance mode. Instead, Blackbeard designates the panels of *Hogan's Alley / McFadden's Row of Flats* in this way as a means to indicate their large size and eventful scenes. While the comics critic does mention the theatricality of Outcault's vignettes (72), the connection that his work has to the tableau vivant is not part of his analysis.

Bill Blackbeard's descriptor for Outcault's single-panel comics was far more apt than he realized or even anticipated. The cartoonist's work featuring The Yellow Kid can be regarded as "comics tableaux" not only because they operate on a grand scale but—in a feature that has gone unexplored—because they also contain a variety of elements from tableaux vivants. Together with adding to the examples of popular culture that can be identified in Outcault's comics, the presence of this theatrical form also adds to our understanding of their aesthetics. The tableau vivant forms an important and long-overlooked part of the visual vocabulary of the cartoonist's work. In many respects, the components for staging a successful tableau also embody the components for Outcault's staging of a successful comics panel.

The suggestive echoes of the tableau vivant in Outcault's work featuring The Yellow Kid begin with the very first panel of the series: "At the Circus in Hogan's Alley" (see Fig. 2.1). Appearing in *The New York World* on May 5,

FIG. 2.1 "At the Circus in Hogan's Alley" by R. F. Outcault. Originally published in *The New York World* on May 5, 1895.

1895, the drawing depicts a large group of children in an empty lot behind a tenement. As the title of the panel suggests, the kids have created their own neighborhood circus using items that they have on hand. To that end, one boy is serving as a juggler, tossing a combination of rocks and a tin cup. Another holds a makeshift whip akin to a lion tamer. Directly behind him, a trio of boys are performing gymnastic stunts. Finally, near the center of the image, a child dressed as a clown holds up a paper ring. The object is presumably intended for either the dog or goat—both of whom are running around the empty lot. Forming a comedic element, however, the ring has ensnared one of the kids rather than animals: he is stuck midway through the hoop, his back side facing the viewer.

One of the first features that readers likely notice about Outcault's "At the Circus in Hogan's Alley" is its careful choreography: figures are placed in the foreground, middle ground, and background—as well as on the left side and right side of the image—in ways that make the composition balanced and, just as importantly, the action visible. In marked contrast to the situation if the event were taking place in an actual tenement lot with real, flesh-and-blood children, no individuals (or objects for that matter) obscure any part of the view. On the contrary, the figures scarcely overlap, a detail that gives them the appearance of being strategically positioned and the overall scene,

as Jean Lee Cole has commented about Outcault's cartooning as a whole, of being "meticulously constructed" (52). All of these features, of course, typify the tableau vivant. In language that is strikingly similar to descriptions of Outcault's drawings, Barry Faulk has written how the living pictures were known for their "meticulous efforts to represent pictorial detail" (158).

"At the Circus in Hogan's Alley" was not the only panel to feature this subject matter. Roughly one year later, in a comic that appeared in *The New York World* on April 26, 1896, Outcault revisited this topic, albeit with some significant variation (see Fig. 2.2). Titled "Amateur Circus: The Smallest Show on Earth," the drawing depicted a group of young people—led by The Yellow Kid—once again staging their own carnival-like event. Rather than doing so in an empty lot behind a tenement on the Lower East Side, though, they are now doing so in the living room of an upper-middle-class home. Numerous details around the room convey the socioeconomic status of the family who resides there: a portrait in a gilded frame adorns the wall, a crystal chandelier hangs from the ceiling, and a grand piano completes the space. This setting is far afield from The Yellow Kid's usual environs, but it does echo the original domestic locale for the tableau vivant: the parlors of aristocratic homes. Although the site for this version of Outcault's amateur circus has changed, the aesthetic details remain the same. As before, the scene seems very adroitly staged and painstakingly choreographed. From the foreground to the background of the composition, all of the action and each of the figures are positioned in a way to maximize viewing—as well as complete the scene. Even more so than the cartoonist's previous panel featuring a circus, every area of the composition is so productively used that it undercuts its own alleged veracity or, at least, verisimilitude. Instead of a drawing of an "actual" amateur circus, Outcault's image seems like a staged rendition of one: in short, a tableau.

Outcault's panels about the circus were not the only ones to recall the tableau vivant. A variety of other comics featuring an equally wide array of subject matter likewise contain these elements. The crowded compositions are so methodically arranged, the multitude of figures are so precisely positioned, and the chaotic action is so strikingly frozen in time that the panels seem not simply artistically created but self-consciously posed. The comic that appeared in *The New York Journal* on January 5, 1896, forms an excellent case in point (see Fig. 2.3). Titled "Golf—the Great Society Sport as Played in Hogan's Alley," the drawing operates from the same basic premise as Outcault's debut panel featuring the circus. The image shows The Yellow Kid and the other working-class children from his neighborhood engaging in their own

FIG. 2.2 "Amateur Circus: The Smallest Show on Earth" by R. F. Outcault. Originally published in *The New York World* on April 26, 1896.

rendition of this upper-class sport. Lacking actual golfing equipment, they improvise with the items they have on hand: broken umbrellas and broom handles function as golf clubs, rocks serve as balls, and a tin cup becomes the makeshift hole. Additionally, in lieu of a grass-covered golf course, the kids turn a section of the street, sidewalk, and stoop into their links. Outcault's panel is both densely populated and action packed. More than a dozen children are playing golf in the street; meanwhile, nearly the same number serve as either the intentional or unintentional spectators to their game.

One detail that even casual viewers of "Golf—the Great Society Sport as Played in Hogan's Alley" likely notice is the tremendous amount of action that has been frozen in time and space. As Christina Meyer has said about Outcault's work, "episodes in The Yellow Kid series capture a dynamic moment" (9). This quality is on vivid display in this panel. Such features, of course, also form a hallmark of the tableau vivant. Lynda Nead, in her discussion about both the aesthetic artistry and audience appeal of the tableau vivant, commented that the "performance was the constant and provocative oscillation between stasis and movement" (Nead 72). Audiences marveled at the ability of the performers to hold themselves completely still not only for extended periods of time but also in challenging positions: with their arm raised, leg extended, or torso angled. Given this situation, together with marveling at the gorgeous costumes, impressive sets, and stunning lighting, "Part of the exquisite fascination for audiences must surely have been

FIG. 2.3 "Golf—the Great Society Sport as Played in Hogan's Alley" by R. F. Outcault. Originally published in *The New York Journal* on January 5, 1896.

watching for signs of life and movement throughout the duration of a pose and observing the performers release one pose and settle into another" (Nead 72). Participants in the tableau were acutely aware of this feature. For both scenes staged at home and those mounted at professional theaters, "arrangements were frequently chosen that exaggerated the perception of arrested movement and increased the danger of performers dropping the pose" (Nead 72). One manual that offered suggestions for tableaux that could be performed either at home or on a stage, for example, "recommended a scene with '*the boy just rising to his feet*' and a finale of a '*rough and tumble fight with four boys*'"—because the difficulty involved would impress audiences (Nead 72; italics in original).

Outcault's "Golf—the Great Society Sport as Played in Hogan's Alley" can be viewed in this context. Akin to "At the Circus in Hogan's Alley," everything is carefully arranged and evenly spaced: no figure blocks another; no action obscures a simultaneous event. In so doing, the panel exemplifies the tableau vivant's interest in what Lynda Nead has called the "paradoxes of animation and de-animation" (Nead 75). On one hand, the figures are engaged in vigorous activity. Indeed, the drawing contains some elements that indicate or, at least, emphasize motion: a dotted line marks the pathway that a

ball takes after being struck, an area of kinetic blur relays the vigorous backswing of a club, and action lines show the speed of the rock rolling across the pavement. That said, Outcault's figures are also completely frozen in time and space. When this detail is combined with the careful placement of figures and strategic staging of events, it gives the impression that the characters haven't been surreptitiously captured but are deliberately posing.

While an array of the single-panel comics that R. F. Outcault created can be viewed through the lens of the tableau vivant, perhaps none invite such readings more than "The Studio Party in McFadden's Flats" (see Fig. 2.4). Appearing in *The New York Journal* on January 3, 1897, the drawing focuses on George Du Maurier's bestselling novel, *Trilby*. Akin to Outcault's The Yellow Kid, Du Maurier's book "set off a marketing frenzy during which the heroine's name was bestowed upon a hat, several shoe designs, candy, toothpaste, soap, a brand of sausage, and even a town in Florida" (Pintar and Lynn 1). Even more importantly for the purposes of this discussion, "Trilby clubs were formed and parties were held where guests would perform dramatic readings from the novel, or dress up in *tableaux vivants*, to match the story's illustrations" (Pintar and Lynn 1; italics in original). In this way, the popularity of *Trilby* fed the popularity of the tableau vivant, and vice versa.

Outcault's comic both participates in and perpetuates the *Trilby* craze. In the center of the drawing, a young girl is costumed and posed in a manner that mirrors the depiction of Du Maurier's title character on the cover as well as the frontispiece of many editions of the novel. That said, the panel's homage to *Trilby* is more complex. Not only is the female figure dressed as Du Maurier's protagonist; she is also situated beside a life-sized portrait of her. This canvas was painted by none other than The Yellow Kid himself; he is standing beside the artwork, holding an oversized palette. Additionally, impish captions that are printed on both the canvas and his signature yellow nightshirt comment about his foray into fine art portraiture. In so doing, Outcault's panel is trafficking in the fundamental feature of the tableau vivant: mimicry. Moreover, it is doing so in a multivalent or multidirectional way akin to these scenes: the young girl is mimicking Du Maurier's character, The Yellow Kid's portrait is mimicking her, and she is, in turn, mimicking the painting back.

The connections that "The Studio Party" have to the tableau vivant, however, extend far beyond its participation in the *Trilby* craze. The young girl's impersonation of Du Maurier's character is only one small area of Outcault's overall composition. The rest of the drawing is filled with other

FIG. 2.4 "The Studio Party in McFadden's Flats" by R. F. Outcault. Originally published in *The New York Journal* on January 3, 1897.

characters creating, interacting with, and even imitating works of fine art. Indeed, although Outcault titled this panel "The Studio Party," the setting is more reminiscent of a museum gallery or genteel drawing room than an artist's atelier. In so doing, this setting evokes the two key ingredients of the tableau vivant: their recreation of works of fine art and their domestic origins as entertainment for aristocratic families (Faulk 147; Chapman 24). Indeed, a vignette featured on the right side of Outcault's panel appears to do just that. The image features a young boy stepping through a large, empty gilded frame, as if he is breaking the fourth wall. The scene is highly reminiscent of the 1874 painting *Escape from Criticism* by Spanish artist Pere Borrell Del Caso. The similarities between the two images, in fact, constitute another segment from Outcault's panel that is engaging in not simply comedic parody but aesthetic mimesis akin to the tableau vivant.

Both during Outcault's lifetime and into the present day, the art form that has been regarded as exerting the most direct and powerful influence on his work has been photography. From his panels being likened to snapshots to his work being compared to the groundbreaking images published by photojournalist Jacob Riis in *How the Other Half Lives* (1890), photos taken by a camera have been seen as the cartoonist's primary artistic kinship and even clear aesthetic debt.

Remembering and recouping the popularity of the tableau vivant during Outcault's work on The Yellow Kid adds a new facet to our understanding of their cultural as well as creative touchstones. While photography unquestionably shaped Outcault's panels for *Hogan's Alley* and *McFadden's Row of Flats*, this artistic medium was not the only one whose presence is extant. In the same way that Outcault's cartoons have been linked to the still pictures taken by a camera, they can also be connected with the living pictures of the tableau vivant.

## Moving into the Spotlight: The Tableau Vivant and Outcault's Sociopolitical Commentary

Whether tableaux vivants were performed by amateurs in private homes or professionals on public stages, they were inextricably tied to socioeconomic class. Upper-class families staged these scenes in their drawing rooms as evidence of their cultured interests, refined taste, and appreciation for fine art. Furthermore, they afforded them an opportunity to engage in conspicuous

consumption. Staging an evening of tableaux vivants allowed the wealthy "to display not only a shared knowledge of literature and the fine arts but also such material class indicators as officers' uniforms belonging to prestigious ancestors, tasteful consuming, and heirloom furniture" (Chapman 29). Of course, together with exhibiting the fine clothing, furniture, and decorations that they already owned, the props, sets, and costumes required for these scenes also gave them an excuse to purchase additional items.

Tableaux vivants functioned somewhat differently in the homes of their middle-class counterparts. While they were certainly used to publicize one's socioeconomic status, they were also used as a means to cultivate it. As Mary Chapman has written, "Buyers of *tableau vivant* manuals were often white rural middle-class hostesses aspiring to be more cosmopolitan and more refined" (28). Many of these guidebooks appealed directly to this interest. William Gill, in the introduction to his *Parlor Tableaux and Amateur Theatricals*, for example, asserted, "To *originate* and *produce* fine *tableaux* undoubtedly requires considerable taste, some knowledge of art" (qtd. in Chapman 29; emphasis in original). That said, he went on to assure his readers: "there can be no reason why a person with a manual before him ... cannot, profiting by the experience of another, be equally successful" (qtd. in Chapman 29). Similar sentiments were echoed by many other manuals. Authors stressed how staging home tableaux imparted "cultivation," "refinement," and "elevation" for everyone involved, from the participants posing to the viewers watching (Chapman 28).

When the tableau vivant moved from being performed in private homes to professional theaters, these dynamics shifted once again. Nonetheless, the issue of class remained central. Now instead of members of the middle and upper classes reenacting classical sculptures, famous paintings, or historical events for their friends and relatives, professional actors—who had a tenuous relationship with respectability in the nineteenth century—did so for an audience of strangers. Working in the theater was already considered undignified for white women in the nineteenth century, but engaging in a performance mode where one's body was on display and would be closely scrutinized was unseemly (Chapman 25–30). It was one thing for husbands, fathers, brothers, and male cousins to watch their female relatives perform these poses; it was quite another for a man who was a complete stranger to do so (Chapman 25–30).

Given the central role that the gaze played in the tableau vivant, it didn't take long for theater troupes to recognize this aspect—and exploit it. Both the performers and, perhaps more commonly, their male managers selected

works like Titian's painting *Venus Rising from the Sea* and Hiram Power's sculpture *The Greek Slave* in which female figures were scantily clad or even nude. Promoters knew that the titillation involved in these scenes would attract a larger crowd. Of course, the women reenacting these artworks were never actually naked; they wore body stockings. Nevertheless, the fabric, makeup, and lighting gave the illusion of nudity. By the 1850s, evenings of tableaux vivants at working-class music halls were regarded as little more than peep shows. Instead of offering the audience an edifying opportunity to see masterworks of art brought to life, it provided the men in the audience with a salacious opportunity to gawk at women's bodies. At best, the tableau vivant was seen as straddling the line "between artistry and indecency" (Murphy). At worst, it was regarded as pornography. A variety of private individuals, civic organizations, and public offices launched campaigns against tableau performances. Before long, police began raiding theaters, arresting performers, and closing down or, at least, fining managers for violating statutes regarding decency (McCullough 71–80). By the 1870s, the association of the tableau vivant with a tawdry skin show greatly contributed to its decline (McCullough 71–80).

In keeping with the mercurial nature of the tableau vivant, these socioeconomic coordinates would not form its final location within American culture. When the performance mode was revived in the mid-1890s, it became highbrow once again. Several factors contributed to this shift. First and foremost, by this point, "Memories of the most objectionable tableaux had begun to fade and more respectable productions, both professional and amateur, had diluted the social stigma attached to such exhibitions" (McCullough 101). Additionally, and even more importantly, Edward Kilyani—a Hungarian-born actor whose performances, first in London and then in New York City, inaugurated the revival—staged an artistically as well as technically sophisticated form of this theatrical mode. Together with being an incredible mimic who left audiences spellbound by his stunning recreations, Kilyani patented a new rotating stage that allowed for faster transitions between each scene as well as for greater control over the special effects that they incorporated. Kilyani's tableaux employed not just exquisite costumes, sets, and props but stunning lighting, makeup, smoke, fog, wind, and even aromas. These elements firmly located his performances in the realm of sophisticated art. Indeed, Kilyani's opening night in New York was reviewed by esteemed theater critics in the most respected newspapers (McCullough 103–104). Additionally, throughout its run, his show was a society event: a place to see and be seen.

In the same way that the tableau vivant can be seen as influencing the aesthetics of R. F. Outcault's comics featuring The Yellow Kid, it can also be seen as playing a role in its sociopolitical critique. The setting of the series in the tenements of New York's Lower East Side and the fact that its protagonist is a working immigrant were not inconsequential details. On the contrary, these features facilitated Outcault's commentary about an array of social, political, cultural, and especially economic issues. From openly confronting topics like economic inequality and political corruption to engaging with subjects like Americanization and the American Dream, the cartoonist's single-panel drawings may have existed at the forefront of what would come to be known as "the funny pages" in U.S. newspapers, but they were also political cartoons in many ways.

Viewing Outcault's comics through the lens of the tableau vivant amplifies these features. By the closing decades of the nineteenth century when The Yellow Kid appeared, this performance mode was connected with a strong and specific set of sociopolitical associations: namely, socioeconomic class, cultural taste, and social refinement. Outcault's panels that embed and evoke the tableau vivant become infused with these details. Far from competing with the commentary that the cartoonist was offering in his work, they augment it, moving such issues further into the spotlight. In so doing, the tableau vivant can be seen not only as an overlooked facet of the visual vocabulary of Outcault's work; it can also be regarded as a neglected mechanism for its sociopolitical commentary.

Among the many cultural coordinates that R. F. Outcault's comics featuring The Yellow Kid have in common with the tableau vivant, perhaps the most prominent is their shared interest in class-based notions of taste. Both when Outcault's panels appeared as *Hogan's Alley* and then when they were published under the title *McFadden's Row of Flats*, they probed the distinctions between highbrow/lowbrow, upper class / lower class, and cultured/uncouth. Such elements, in fact, permeate the cartoonist's initial comic, "At the Circus in Hogan's Alley" (see Fig. 2.1). While it is possible that the tenement kids had so much fun attending the professional circus that they decided to recreate it in the empty lot, it seems more likely that they are too poor to purchase a ticket to the actual event and thus are making one of their own. Details throughout the panel affirm this view. The young characters in Outcault's drawing don clothing that is ragged, torn, and ill-fitting. Additionally, few of the kids are wearing shoes, presumably

because they don't possess any. Finally, the empty lot where they stage their events is strewn with garbage. The Yellow Kid himself is not immune from these conditions. His nightshirt—which is pale blue in this drawing—is marred with dirty handprints. The area around his neck is also filthy, seemingly stained by food. Moreover, the youngster's head is shaved, likely not as a self-conscious hair style, but rather because doing so was the fastest, easiest, and cheapest way to treat head lice—as individuals in the 1890s would immediately recognize (Harvey, "Outcault"). Given these details, Outcault's work offered working-class readers an opportunity to see themselves and their lives represented. "At the Circus in Hogan's Alley" depicts the economic hardships, poor living conditions, and limited leisure-time pursuits that many individuals—including children—faced in major American cities like New York. Of course, this sentiment was exactly what the cartoonist and especially his publisher intended. As Lisa Yaszek reminds us, "The comic strip originally appeared in the sensation papers to boost circulation, especially amongst the lower-middle and working classes" (24). Many immigrants bought English-language newspapers for the first time because they wanted to see the full-color drawings in the new comics supplement (Yaszek 20–26).

That said, echoing the tableau vivant, the class dynamics in Outcault's comics were neither this simplistic nor one-sided. While his panels gave voice and visibility to "how the other half lived" in New York, they were not mere exposés of economic inequality and indictments of urban squalor akin to the work of documentary photographer Jacob Riis. In the same way that the cartoonist depicted the wretched conditions of the working classes, he also commonly lampooned these individuals. Outcault's work mixes a sympathetic portrayal of the impoverished immigrant children with a comedic one. His panels invite both working-class readers and their middle-class counterparts to be amused by the coarse manners, rowdy behavior, and overall uncouth nature of The Yellow Kid and his friends. Outcault's comic "Golf—the Great Society Sport as Played in Hogan's Alley" makes such operations particularly vivid (see Fig. 2.3). While viewers can certainly lament the fact that the child characters are compelled to use broken broom handles for clubs and rocks for balls, the overarching message of the drawing is not one of despair or even pity. On the contrary, it is bemusement. While golf is a calm, quiet, and orderly game when played at an upper-class country club, it is a raucous free-for-all when it is enjoyed on the streets of the Lower East Side. Rather than one player at a time taking their turn, everyone swings their clubs simultaneously. Additionally, instead of directing a shot to the

next hole on the course, Outcault's characters fire balls in seemingly every direction with no clear cup flags in sight. Finally, but far from insignificantly, their game is not simply chaotic but violent. While players on an official golf course take great care not to strike anyone with clubs or balls, the ones on Outcault's makeshift links do so frequently and seemingly without concern. When viewed collectively, these details do not serve to bemoan the poverty that prevents the youngsters from enjoying golf. Rather, they poke fun at the attempt of these working-class kids to engage in this upper-class sport. Middle-class readers will be entertained by the way in which Outcault's kids have bowdlerized the game. This situation, of course, forms another corollary to the tableau vivant. In the same way that the performance mode was often criticized for taking what should be edifying and uplifting works of art and using them for purposes that were indecorous and even illicit, Outcault's characters take what should be an orderly and even edifying sport and turn it into an unruly and undignified activity. Outcault's characters have debased the aristocratic game of golf in a manner that mirrors how tableaux performers debased masterworks of art like Titian's *Venus Rising from the Sea* and Hiram Power's *The Greek Slave*. Of course, Outcault's cartoon does not offer a peep show. However, it does depict something that was arguably just as widely feared and harshly judged when it came to working-class immigrant children: urban mayhem. Critics of the tableau vivant warned that "the display of nude bodies in front of diverse audiences could only result in an unruly spectacle" (Faulk 149). Nativists made a similar argument about the impact of open immigration on the nation's cities, culture, and mores—a position that Outcault's panel seems to affirm.

All that said, the class commentary in "Golf—the Great Society Sport as Played in Hogan's Alley" operates on more than one register. As Christina Meyer has commented about Outcault's work, "The Yellow Kid episodes are filled with class parodies, and mockery diverges into different directions" (118). In the same way that the panel invites middle-class audiences to laugh at the crude attempts of Outcault's working-class characters to engage in the aristocratic game of golf, it also allows working-class readers to delight in the way that The Yellow Kid and his pals reimagine and reinvigorate this stuffy sport of the elites. Rather than bowdlerizing the game, the residents of Hogan's Alley can be viewed as democratizing it: they take a dull, uptight activity and make it fun. No one has to wait their turn, follow any rigid rules, or even engage in self-restraint. In so doing, as many readers likely agreed, The Yellow Kid and his friends put the element of "play" back into the act of playing golf. Rather than laughing *at* Outcault's characters, they are laughing

*with* them. For this audience, the butt of the joke in this panel is the stodgy upper crust, not the rowdy street urchins.

When Outcault moved to *The New York Journal*, the class dynamics of his comics shifted. Although his new series *McFadden's Row of Flats* still featured the impish The Yellow Kid and his tenement pals, the drawings—akin to the newspaper in which they appeared—were more middle class in both tone and content. As Jonathan Bolton has discussed, the clothing of all the characters was cleaner and less tattered (20). Additionally, beyond The Yellow Kid's shaved head, "There are no obvious signs of disease" or even malnourishment among any of the characters (Bolton 20). Finally, the outdoor scenes, while still crowded with people, contained less filth, squalor, or dilapidated conditions than had been depicted in Outcault's *Hogan's Alley* and, of course, would have been realistic for life on the Lower East Side (Bolton 20). As Bolton reminds us, "backyard privies, rotting garbage, and dead animals" (20) were common sights of tenement life but are wholly absent from *McFadden's Row of Flats*.

Arguably the most powerful index of the shifting class dynamics of Outcault's work occurred on January 17, 1897, when The Yellow Kid and company set sail for an around-the-world adventure. Making stops in major European cities like London, Paris, Madrid, and Venice, the sequence mirrored "The Grand Tour" commonly taken by young men and women of the upper classes. As Christina Meyer has written, international travel had become more financially affordable and more logistically accessible in the closing years of the nineteenth century (154–158). Consequently, more young people from the middle classes were embarking on European tours as a means to "finish" their education before getting married as well as, of course, to showcase their class status (Meyer 154–161). Outcault's *Around the World with the Yellow Kid* series operates on a number of sociocultural planes. Akin to "Golf—the Great Society Sport as Played in Hogan's Alley," the panels mock the attempts by working-class characters to mingle with the upper crust; at the same time, they mock the upper crust themselves. Whether it is The Yellow Kid and his pals turning Kensington Palace topsy-turvy while visiting the Queen of England (January 31, 1897) or running amok in the Louvre Museum during their stint in Paris (February 28, 1897), Outcault's panels ridicule the characters' attempts to be cultured, refined, and sophisticated while they also ridicule those who are cultured, refined, and sophisticated. In the same way that The Yellow Kid and his friends are too uncouth and raucous, the upper classes are too uptight and stuffy. No one escapes being mimicked or mocked.

Viewing Outcault's work through the lens of the tableau vivant amplifies both these class dynamics and the sociopolitical commentary that they offer. In the same way that tableau vivant troupes used lowbrow performers to replicate highbrow scenes for heterogenous audiences with equally mixed messages, Outcault engages in an analogous phenomenon in his work. Akin to the performance mode, his comics are both serious and sacrosanct, cultured and uncouth, highbrow and lowbrow. The visual traces of this performance mode in the cartoonist's drawings further encourage viewers to identify as well as interrogate these divisions: how they are made, how they are maintained, and how they are arbitrary. In so doing, the tableau vivant embodies a powerful aesthetic metaphor for presenting his scenes, and it also serves as an effective thematic megaphone for amplifying their messages.

## Taking Center Stage: The Role of Performance Art in Comic Art

Of the myriad cultural phenomena that influenced newspaper comics in the United States, theater has long been counted among them. In elements ranging from the comedic stylings of vaudeville to the racist caricatures of blackface minstrelsy, popular stage performance has long been acknowledged as playing an important role in both the visual appearance and thematic content of U.S. comics.

R. F. Outcault's work featuring The Yellow Kid calls attention to the presence of another theatrical form—the tableau vivant—in both the emergence and the success of the genre. Moreover, given the historical significance of Outcault's series, seeing his comics tableaux as tableaux vivants invites us to consider the way in which this element may have also influenced subsequent cartoonists and comics series. A number of installments of Winsor McCay's *Little Nemo in Slumberland* (1905–1927), for instance, resemble tableaux. The elaborate settings, colorful attire, and dramatic events taking place depict the nighttime reveries of McCay's young protagonist, but these scenarios also routinely evoke theatrical productions.

Elements of this performance mode can also be identified in a variety of more recent comics. Bill Watterson's *Calvin and Hobbes* (1985–1995) constitutes an excellent example. The series routinely presents large-scale scenes: the two title characters go exploring in a beautiful forest or have an imaginative adventure on another planet. That said, episodes where Calvin constructs snow-people especially lend themselves to being viewed as a tableau.

Not only are the figures strategically staged, but the entire scene is carefully choreographed. Akin to performers in a tableau vivant, Calvin's snow-people are routinely engaging in some lively action: screaming, running, protesting, swimming, fleeing, and even vomiting. Moreover, the pose that Calvin has chosen for each snow-person accentuates and even exaggerates their activity. From their raised arms to their splayed bodies, the contrast between the high kinetic energy of the overall scene and the completely static nature of the figures, combined with the fact that the participants are all made from snow, invite these scenes to be seen as both figurative and literal freeze frames.

*Calvin and Hobbes* and *Little Nemo in Slumberland* embody just two examples. A myriad of other past and present comics can be viewed in the context of the tableau vivant. From the theatrically exaggerated body language of characters in Chester Gould's *Dick Tracy* (1931–present) to the mimesis of literary and historical scenes in Hal Foster's *Prince Valiant* (1937–present), elements of this performance mode can be identified in a variety of past and present strips. An awareness of the tableau vivant changes our perception not only of overall comic titles but of individual panels. Seeing each frame of a multipanel sequence as a strategically staged scene in addition to a carefully drawn composition calls attention to the overlooked role that performance art plays in comic art.

As M. Thomas Inge once remarked, newspaper comics "tend to play off a lot of unstated suppositions that are very much of the moment" (qtd. in McEnroe). Whether it is the political references that permeate Garry Trudeau's *Doonesbury* (1970–present) or the musical ones that populate Aaron McGruder's *The Boondocks* (1996–2006), cartoonists tend to create for their immediate, contemporaneous audience. For this reason, reading a series even a few years after its initial publication can be not simply unsatisfying but thoroughly puzzling. Without the original social, political, or cultural context, much of the original message is lost. For this reason, Colin McEnroe has offered the following cautionary advice to present-day readers of past newspaper strips: "You'll need footnotes" (McEnroe).

When it comes to the presence of the tableau vivant in American newspaper comics, individuals need to look not merely at the footnotes but at the footlights. This theatrical mode possesses a tacit but traceable presence in groundbreaking comic series from the nineteenth century through the twenty-first century. The time is long overdue for the tableau vivant to be included in the dramatis personae of comics and, even more importantly, for it to receive the round of applause that it deserves.

# 3

## "*The New Yorker*'s Most Influential Cartoonist"

● ● ● ● ● ● ● ● ● ● ● ● ● ● ● ● ● ● ● ● ● ●

Peter Arno and the
Extraordinary Ordinary of
Everyday Life

No examination of the single-panel comic in the United States would be complete without a discussion of *The New Yorker*. Founded in 1925 by Harold Ross, the weekly magazine contains reviews, commentary, fiction, poetry, criticism, essays, humor, satire, and—perhaps above all—cartoons. As Jonathan Daniel Greenberg noted, "The signature genre of *The New Yorker* has always been the cartoon" (402). In what has become an oft-repeated observation, they are routinely the first element that readers peruse upon picking up the publication (Travis). Moreover, for many individuals, they are the only facet of the magazine that they actually read (Maslin xiii).

Over the decades, *The New Yorker* has featured the work of a multitude of now-iconic cartoonists. From past figures like James Thurber, William Steig, and Charles Addams to more recent artists like Saul Steinberg, Roz Chast, and Bob Mankoff, their work has served as an anchor both in the

pages of the magazine and within the nation's popular culture. Even individuals who have never subscribed to *The New Yorker* have seen its cartoons. The drawings have been clipped and posted on innumerable office doors, kitchen refrigerators, and breakroom corkboards. Additionally, they have been reprinted in a variety of yearly albums, anniversary editions, and themed volumes. Finally, they have appeared on coffee mugs, calendars, and greeting cards.

Although the comics that appear in *The New Yorker* are not always single-panel, many of them, both past and present, have used this format. Indeed, the broad designation "*New Yorker* cartoon" brings to mind a single-panel drawing. For this reason, the magazine has long been—and continues to be—an important venue for the development as well as dissemination of this mode of sequential art.

Of all the cartoonists whose single-frame comics appeared in *The New Yorker* over its history, one stands out: Peter Arno. His drawings, illustrations, and trademark full-page cartoons began appearing in the magazine during its inaugural year. His work was an instant sensation and became a fixture in *The New Yorker* for the next four decades. By the time of the cartoonist's death in 1968, the magazine had published hundreds of his single-panel comics. Given the frequency with which his work appeared in the publication, biographer Michael Maslin asserted, "For forty-three years, from 1925 through 1968, Arno's art was as essential to *The New Yorker* as the Empire State Building is to the Manhattan skyline" (xiii). Far from hyperbole, the cartoonist remains the magazine's most prolific artist (Lee 157).

Peter Arno's work did more than simply appear in large quantities in the pages of *The New Yorker*; it was also of exceptionally high quality. The artist is commonly credited with revolutionizing the single-panel genre. As Ben Schwartz has written, "Before Arno, single-panel cartoons were merely illustrations accompanying written jokes" (Schwartz). Most commonly, the text contained comments uttered by two different speakers, one male and one female, in what was known as the "He/She format" (Maslin 17). The illustration that appeared above the dialogue merely depicted the speakers or portrayed the setting. These drawings were decorative, not integral. In the words of Schwartz once again, "Arno ended that. His image led you to the dialogue caption, a visual setup with a verbal punch line, a combination that remains a *New Yorker* standard to this day" (Schwartz). In many respects, what we think of as a "*New Yorker* cartoon" would not exist without Peter Arno; one might even say that this phenomenon exists *because* of him. For these reasons, in 1956, *The Saturday Review of Literature* called

Arno "Mister *New Yorker* Cartoonist himself" (qtd. in Maslin 182). In the decades since his death, he has been deemed "the ultimate *New Yorker* cartoonist" (Jamieson), "*The New Yorker*'s Greatest Cartoonist" (Maslin), and "*The New Yorker*'s Most Influential Cartoonist" (Schwartz).

This chapter revisits the iconic work of the legendary Peter Arno. In the pages that follow, I call attention to a central, but formerly overlooked, element that made his cartoons so distinctive, so appealing, and—above all—so groundbreaking. In the same way that Arno revolutionized the mechanics of the single-panel comic through his interplay of word and image, he also revolutionized the source of its content. The cartoonist depicted a diverse array of individuals over the course of his career, from the flappers, dowagers, and plutocrats of the 1920s and 1930s to the secretaries, suburbanites, and men in gray flannel suits of the 1950s and 1960s. Whether Arno's drawings featured a chorus girl at a Prohibition speakeasy or an executive at a postwar conference table, one element united them: they portrayed ordinary moments from daily life. Even when his cartoons took place in exciting settings—a crowded cabaret, an elegant dinner party, an exclusive resort—they routinely spotlighted something quotidian. In so doing, Arno's drawings demonstrated how seemingly empty and unimportant moments were actually exquisite and remarkable—primarily because they were resplendent with humor. For more than four decades at *The New Yorker*, Peter Arno's work captured what might be called the extraordinary ordinary of daily life.

Paying attention to the role of everyday life in the work of Peter Arno alters our perception of this iconic cartoonist, adding a new facet to his repertoire of topics, themes, and subject matter. At the same time, Arno's engagement with the extraordinary ordinary alters our perception of comics, single-panel or otherwise. Much attention has been paid in the past few decades to the growing presence of the quotidian in sequential art. As Charles Hatfield, Greice Schneider, and others have discussed, beginning in the 1960s with the advent of alternative comics and then accelerating rapidly in the 1990s with the rise of graphic narratives, cartoonists increasingly created works about regular people leading their daily lives. Whether these texts were fictional or autobiographical, they eschewed the dramatic for the day-to-day. Peter Arno's *New Yorker* cartoons upend the origins of this phenomenon. As his prolific and popular corpus of single-panel comics reveals, everyday life has been a key feature of sequential art in the United States from the opening decades of the twentieth century.

## Drawing on Daily Life: From the Ordinariness of Extraordinary People to the Extraordinariness of Ordinary Moments

From both a personal and a professional standpoint, Peter Arno's life was anything but ordinary. From the time of his birth, the future cartoonist was associated with the exceptional. Born Curtis Arnoux Peters Jr. in 1904 to an upper-class Manhattan family, Arno belonged to the well-educated, well-to-do demographic to which *The New Yorker* catered—and for whom it was created. When founding editor Harold Ross was seeking investors for his new publication, he said it would be "aimed at the young, sophisticated post-World War I generation on vivid display in F. Scott Fitzgerald's 1920 novel, *This Side of Paradise*" (Maslin 27). Far from embodying an abstract ideal, this vision was *The New Yorker*'s operating ethos. The cover of the inaugural issue depicted a dandy figure, "Eustace Tilley," who served as the magazine's mascot—and also set its tone. As Leslie Newton has written, *The New Yorker* represented "a new breed of cultural medium" (67). Whether taking the form of an essay, article, poem, short story, or cartoon, the publication quickly distinguished itself for its "attitude of smartness" and "modern sophistication" (Newton 66).

Peter Arno was the son of a prominent Manhattan lawyer who was later appointed to the New York State Supreme Court. As a result, Arno's youth was one of privilege. The future cartoonist attended the elite boarding school Hotchkiss, then Yale. Of course, enhancing the opportunities that already arose from his socioeconomic class, Arno was also a white heterosexual man during an era when this segment of the populace wielded tremendous hegemonic power. When these elements are viewed collectively, the cartoonist belonged to the exclusive, the elite, or what we might now call the 1 percent.

Although Peter Arno ultimately dropped out of Yale and cut ties with his family—even changing his first and last names—he did not cut ties with this stratum of society. When the cartoonist began working for *The New Yorker*, he presented this world of privilege, wealth, and glamor. As Ian Topliss has written, Arno's comics throughout the 1920s and 1930s typically depicted the American aristocracy: "Clubmen and chorines, dowagers and doormen, lushes and lechers ... in the cabaret world of hotel lobbies, gentlemen's clubs, theaters and speakeasies of a New York City" (21). Arno did not romanticize this arena, however; he ridiculed it. In the words of Schwartz, the cartoonist "drew America's ruling class as unpleasant, unlikable, sometimes awful people, reducing them to pompous, often sexually avaricious, arrogant boobs" (Schwartz). One of the reasons why Arno's *New Yorker* panels were

regarded as so resonant is because they were regarded as rooted in reality. The cartoonist was not simply imaginatively depicting this segment of society; he belonged to it, lived in it, and thus, knew it.

Arno used both the monetary and cultural capital that he obtained from his cartooning to further immerse himself in the exclusive world of the elite. Drawing for *The New Yorker* made Peter Arno both rich and famous. His cartoons were reprinted in nearly a dozen books. The first volume, *Parade* (1929), "made publishing history, selling 4,436 copies the week before Christmas.... 12,124 copies sold in 6 weeks—a recent record in illustrated books" (Maslin 62). Each subsequent volume was a noteworthy event, reviewed in major national publications and enjoying strong sales. The proceeds from Arno's cartooning made him one of the highest-paid artists in the United States. Arno earned more for a single comic than most Americans did in a month. In 1942, for example, when the average annual salary in the United States was roughly $2,500, his payments from *The New Yorker* exceeded $51,000 (Topliss 42).

Arno was as good at spending money as he was at earning it. For much of his life, he lived more like a movie star than a magazine cartoonist: Arno resided in penthouses, drove sports cars, and dated debutantes. A notorious playboy, he partied with stars like Desi Arnaz at the most exclusive clubs in Manhattan (Schwartz). Stories and photographs about his exploits—along with romantic liaisons—were staples of the tabloid newspapers. Arno did not simply embrace the attention; he cultivated it. As biographer Michael Maslin has documented, from the mid-1920s until 1951 when he moved out of Manhattan to upstate New York, the cartoonist "bathed in the limelight: flashbulbs popped in his face and newsreel cameras swiveled in his direction" (Maslin xii). Arno's success as a cartoonist opened up other professional opportunities: lucrative freelance work in advertising, glamorous invitations to create sets for Hollywood movies, the thrilling ability to write, compose, and produce a Broadway musical, and—in the late 1930s—a once-in-a-lifetime contract to design an automobile. As even this brief overview suggests, for much of his lifetime, Peter Arno was one of the most famous and successful figures in the United States. Both in public and in private, he lived a life about which most can only fantasize.

Although Peter Arno has long been linked with the exclusive, elite, and exceptional, his comic art more typically traffics in the mundane, the common, and the ordinary. Even when his panels showcase a powerful plutocrat or wealthy heiress, he rarely presents them as having some significant experience at some momentous occasion. Instead, the figures who populate his

cartoons are more often captured in the midst of a far more banal moment. These commonplace occurrences, however, become a source of uncommonly revealing humor: the embarrassing blunder, the clever remark, the telling chagrin. In so doing, Peter Arno's panels demonstrate that seemingly inconsequential moments are exceedingly interesting and even insightful, if only we are paying attention.

Peter Arno's penchant for depicting moments from everyday life appears in the first drawing that he published in *The New Yorker*. As biographer Michael Maslin has written, the cartoonist's inaugural "contribution was neither a cartoon, nor an illustration, but what *The New Yorker* referred to as a 'spot'" (Maslin 29; see Fig. 3.1). Spots were small drawings, generally of common objects—"flowerpots, bicycles, steam shovels, saltshakers, frogs, or tennis racquets" (Maslin 31)—that served as a type of visual filler. Many spots had little thematic connection to the article that they accompanied. Instead, they were used to round out a page or break up large chunks of prose (Maslin 31).

Peter Arno's debut drawing was considered a spot, but it functioned in a markedly different way. Rather than presenting a common object, the cartoonist's image presented a common event: a man and woman crossing a city street at night. In many respects, the scene is so banal that it hardly seems worth noticing. Akin to the function of a spot, it is meant to fill the empty space at the bottom of the page. In a feature that would typify all of Arno's later work, though, this seemingly simple scenario is anything but that. For those who pause over the image to examine it, the drawing contains an abundance of details that create a rich narrative. First, and perhaps most noticeably, the man is wearing a top hat and carrying a walking stick, suggesting that the couple is well-to-do or, at least, that tonight was a special occasion. Perhaps they are returning from dinner at an elegant restaurant, are on their way to a chic gala, or taking a stroll after a night at the theater, symphony, or opera. Regardless, the body language of both figures suggests joviality: the man is chatting happily with the woman, who is leaning on his arm in an interested if not loving manner. In so doing, Arno's spot depicts an experience in which many urban-dwellers have engaged and especially the largely upper-class readership of the early *New Yorker*.

Arno's seemingly simple drawing, however, tells a more complicated story. The lower right corner of the frame reveals that the couple is not alone: two male figures are leaning against a lamppost in the foreground on the lower right of the composition. Unlike the couple, the two men are dressed in a

FIG. 3.1 Peter Arno's debut spot from *The New Yorker*, published in the June 20, 1925, issue, p. 6.

more working-class manner: one is wearing a dented fedora while the other dons a crumpled newsboy cap. Moreover, the body posture of the two men gives an entirely different impression about their state of mind. The figure in the newsboy cap is slouching, while the one in the fedora looks back at the couple over his shoulder, a grimace on his face. What is about to happen next—if anything at all—is anyone's guess. Perhaps the two men are going to rob the couple, or maybe they are merely glaring at the well-to-do figures, resentful of their obvious opulence. Arno's spot gives no indication, but it also doesn't need to do so. The image's open-ended indeterminacy is arguably far more compelling than any narrative closure. Arno's spot presents a moment from everyday life that most people would not notice let alone contemplate. His drawing, however, invites us to ponder this scene and then rewards us for doing so. As a result, Arno's spot reveals the mysteries that can be found within the mundane—for those who pause to look.

In many respects, the ethos operating in Peter Arno's debut drawing for *The New Yorker* would be the one that guided the many hundreds of cartoons that he created over the decades that followed. Whether generating ideas on his own or working with one of the magazine's gag writers (as was common for cartoonists from this era), Arno gravitated toward and even specialized in scenes taken from daily life. Akin to his oft-mentioned interplay of word and image, this feature set the cartoonist's work apart from that of his peers. Especially in the mid-1920s when *The New Yorker* first debuted, many of the magazine's cartoons embodied what Judith Yaross Lee has called "idea drawings" (166). The humor of these panels arose from comedic situations that were wholly contrived and purely speculative. Alfred Frueh's series from 1926 about ways to solve the traffic and parking problems in Manhattan comes to mind. In panels that are still highly amusing today, Frueh's drawings depict streetlamps outfitted with pulley systems to hoist parked cars off the

street, automobiles that rise up on stilts to allow other drivers to pass beneath them, and apartment buildings with cranes mounted atop them to lift cars onto the terraces of various floors. Peter Arno's cartoons did not participate in *The New Yorker*'s burgeoning tradition of "idea drawings." Instead of presenting scenes that were wholly fictive, he drew scenes that could easily be factual. Their verisimilitude, in fact, forms a key facet of their humor.

A panel that appeared on June 9, 1928, embodies an excellent case in point (see Fig. 3.2). The drawing depicts a common figure from the cartoonist's cast of characters during this era: a flapper. Instead of dancing the Charleston at an exciting speakeasy, however, the young white woman is doing something thoroughly commonplace: looking at herself in a large, full-length

FIG. 3.2  Cartoon by Peter Arno. Originally appeared in *The New Yorker* on June 9, 1928.

mirror. Already fully dressed and with hair and makeup likewise completed, the woman is not using the mirror to prepare to go out. Instead, Arno's cartoon records a far different as well as far more charming interaction. In a moment of playful spontaneity, the woman leans into the mirror from the side. Upon seeing her reflection, she giddily exclaims: "Boo! You pretty creature!" Arno's cartoon captures this delightful act. Of all the experiences this young woman is likely going to have that evening—dancing, drinking, socializing—this moment is likely the least memorable. This spontaneous act will likely never be recounted in stories or even recollections about the evening. On the contrary, the playful interaction with the mirror is a throwaway moment, done quickly and forgotten almost as fast. As Arno's drawing records, however, it is charming and even remarkable in its own right. The glitz and glamor associated with them notwithstanding, flappers are just like everyone else—goofy, impish, and silly, especially when no one is watching.

While it might be tempting to say that domestic settings lend themselves to the commonplace, quotidian moments are also the focal point for comics, which take place in venues that are more lively and presumably eventful, such as bars, nightclubs, and restaurants. Arno's cartoon from January 23, 1954, for example, shows a young white man and woman seated at the table of an elegant boîte (see Fig. 3.3). Rather than documenting any of the rarefied moments from this evening—the gourmet food, the exquisite decor, the elite clientele—Arno's cartoon spotlights an exceedingly mundane occurrence: looking at the menu and placing the order. As the waiter in a tuxedo listens attentively, the man makes the selections, presumably for himself and his female companion. Rather than confidently and commandingly choosing dishes, however, he meekly points at items while telling the waiter—as the caption at the bottom relays—"Cette . . . and cette . . . and cette." The meaning of this remark is clear: the restaurant is French, the menu is in French, and the man knows only this one French word. Indeed, the young diner does even use the French conjunction "et" but the English one "and." The look on the man's face is one of meek embarrassment; he is acutely aware of his linguistic and cultural shortcomings. The demeanor of the waiter is even more telling: from his posture to his facial expression, he exudes an air of knowing superiority. That said, whether the young man is fooling his female companion or not is less certain. Seated beside him, she is looking at the waiter while he orders with an expression that is neither incredulous nor adoring. If anything, in fact, her smile is somewhat vapid. Regardless, a seemingly ordinary moment—ordering food at a restaurant—becomes extraordinarily revealing: about the man, about the couple, and about this entire mise-en-scene.

"*Cette . . . and cette . . . and cette . . . and cette.*"

FIG. 3.3  Cartoon by Peter Arno. Originally appeared in *The New Yorker* on January 23, 1954.

This same ethos applied when Arno was depicting cities outside of New York, including those outside of the United States. Rather than showcasing a thrilling experience from a vibrant foreign metropolis, Arno's cartoons more commonly showcase moments that are thoroughly mundane. A panel that appeared on July 21, 1928—and became an instant classic—forms an illuminating case study (see Fig. 3.4). The image is a scene from the streets of Paris. A well-to-do gentleman—wearing a tailored overcoat, stylish hat, and carrying a walking stick—has just left a restaurant. An awning that bears the

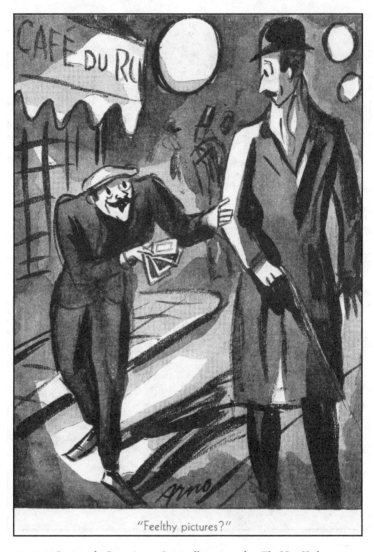

FIG. 3.4 Cartoon by Peter Arno. Originally appeared in *The New Yorker* on July 21, 1928.

name "Café du Rue" can be seen in the background. It is after dark, and the man is crossing the street, presumably on his way home. Arno's finely dressed gentleman is being approached from behind by a short, stooped man. The man is wearing a pinched-waist suit, and his eyes are opened wide, giving them a look not merely of urgency but exhilaration. The hunched figure has grabbed the arm of the well-dressed gentleman to get his attention. In his right hand, the stranger is holding out a series of small rectangular

pieces of paper and offering these objects to him while uttering some comment. The content of these items is unclear until one reads the caption at the bottom of the image: "Feelthy pictures?" it says. Of all the experiences that individuals have along the streets of Paris—breathtaking architecture, exquisite fashion, cultured conversation—Arno's comic documents this one. For most individuals, an encounter of this nature would not be worth relaying let alone recording. The vulgar moment would be edited out of stories and perhaps even omitted from memory. What makes Arno's cartoon successful is that it is real, it is recognizable, and it reverberates. This uncouth interaction resonates far more than any cultured one. Being asked if you would like to see some "feelthy pictures" on the streets of Paris is more memorable and, truth be told, likely more appealing for many individuals than seeing works of art in the Louvre.

Peter Arno's most famous *New Yorker* cartoon—"The Man in the Shower"—likewise explores the tension between the extraordinary and the ordinary. However, it does this in the opposite way (see Fig. 3.5). Whereas the bulk of Arno's panels feature elite members of society in exceedingly common and even uncouth moments, this cartoon—which appeared in the August 28, 1943, issue—presents an ordinary person in the midst of an extraordinary experience. The silent drawing depicts precisely what the title suggests: a man inside a stand-up shower in what is presumably his home. As viewers can see, however, what should be a thoroughly unremarkable event has taken a remarkable turn: the shower stall has filled nearly to the top with water, and—for some unknown reason—the man is unable to open the glass door. The figure is floating practically upside down inside the stall, holding his nose, and urgently pointing at the handle to a woman, presumably his wife, who is standing at the sink in a sheer robe. Few would disagree that such a routine act—taking a shower—could become a more astounding experience. In so doing, Arno broadens and deepens his examination of daily life. In the same way that extraordinary scenes, settings, and individuals contained revealing moments of ordinariness, so too can ordinary moments be punctuated by extraordinariness.

Just a few years after Peter Arno's "The Man in the Shower" appeared in *The New Yorker*, a new book by French Marxist philosopher Henri Lefebvre was published in Europe. Titled *Critique de la vie quotidienne* (1947), the volume is commonly seen as inaugurating a groundbreaking area of philosophical study and sociological consideration: what would come to be known as everyday life theory. For centuries, scholars had concerned themselves with events that were significant and even landmark. From national

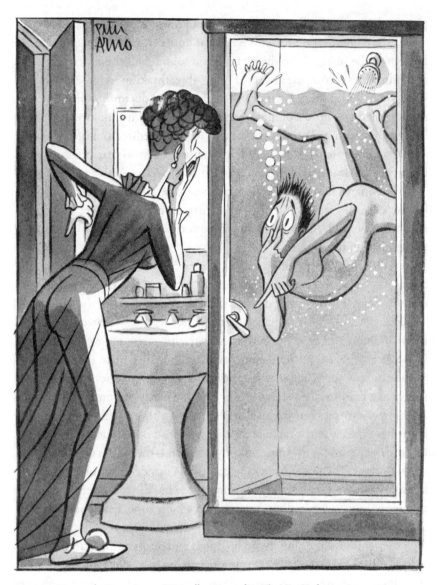

FIG. 3.5  Cartoon by Peter Arno. Originally appeared in *The New Yorker* on August 28, 1943.

triumphs to major tragedies, prevailing wisdom assumed that the best way to understand a country, culture, or community was to examine its historic happenings, not its humdrum occurrences. Lefebvre challenged this viewpoint. As he pointed out, mundane activities—watching television, sitting in meetings, running errands—comprise the bulk of most people's lives. While occurrences like natural disasters, the passage of landmark pieces of legislation, or the outbreak of war were undeniably important, they were

also relatively rare. These events occur only a few times over the course of an individual's life span. Meanwhile, everyday experiences occur every single day. The actions that we take and the decisions that we make on a daily basis—about how we spend our money, where we spend our time, and so on—are rich sites of cultural information and even sociopolitical resistance. As Ben Highmore has said, Lefebvre's work was unique for "its commitment to the revolutionary transformation of everyday life" (Highmore 77). The French philosopher noted that radical changes in a culture or country typically don't occur suddenly, as if from a vacuum. Rather, they are more commonly the culmination of a plethora of smaller individual acts, incremental personal changes, and discrete daily steps.

For all of these reasons, Lefebvre argued, the quotidian needed to become central. Far from being unworthy of our time or attention, the mundane was a rich source of information and even insight. Everyday activities revealed much about an individual, the world in which they lived, and even human nature itself at least as much as and perhaps even more so than once-in-a-lifetime events. For this reason, daily life was both illuminating and it also held the potential to be iconoclastic.

For more than four decades, Peter Arno's *New Yorker* cartoons offered portraits of routine moments from daily life in comic form. As contemporary theorist Michael Sheringham asserted, "we overlook the everyday at our peril. It is the source of our truth" (22–23). Peter Arno was acutely aware of this fact. Decades before figures like Henri Lefebvre made a case for paying attention to quotidian moments, Arno was depicting them in his single-panel comics for *The New Yorker*. Whether he was presenting the partying plutocrats of the Roaring Twenties or the showering suburbanites of the postwar period, he demonstrated how the familiar was filled with the fantastic, if only we pay attention.

## Daily Installments: Rethinking the Relationship of Comics to the Quotidian

Comics have long been associated with everyday life in the United States. The genre first rose to public prominence through a medium that was inextricably connected to the quotidian: daily newspapers. Not only did installments appear on newsstands every day; they also formed a basic aspect of an individual's routine: untold millions started their day by reading the newspaper, including, of course, the comics section.

Although comics have long formed part of everyday life, they have not commonly engaged with this subject themselves. Instead, titles tended to showcase significant happenings in the lives of their characters. As discussed in the previous chapter, far from presenting mundane images of daily life for The Yellow Kid and his neighbors, R. F. Outcault showcased ones that were far more memorable: times when the neighborhood kids staged a circus, played in a makeshift golf tournament, or toured Europe.

Although the subject matter for newspaper comics varied widely, this trait remained true in titles over the following decades. In examples ranging from George Herriman's *Krazy Kat* (1913–1944) to Milton Caniff's *Terry and the Pirates* (1934–1973), strips featured characters, settings, and plotlines that were interesting, amusing, and—above all—exciting. These features were, after all, the reason why individuals read comics in the first place. Newspaper strips offered a respite from the tedium, problems, and routine of one's everyday existence. There was no expectation—nor was there any desire—for them to be a faithful reflection of life. This quality even applied to titles like Rudolph Dirks's *The Katzenjammer Kids* (1897–present), Frank King's *Gasoline Alley* (1918–present), and Chic Young's *Blondie* (1930–present) that took place in domestic settings and focused on marriage and parenthood. The lives of the fathers, mothers, and children who populated these strips were far more eventful than those of the men, women, and young people who read them—which is precisely why they did so.

This quality became even more prominent with the advent of comic books in the 1930s. Whether belonging to the category of superhero, horror, or romance, titles "tended to distance themselves from reality, investing rather in escapist, marvelous fictional worlds filled with non-stop stream of action and adventure" (Schneider 48). In marked contrast to the predictable routine and dull monotony of their lives, the stories in comics books were thrilling, exciting, and—perhaps most importantly—novel.

Throughout the history of sequential art, only one specific form has consistently engaged with the everyday: political cartoons. Offering commentary about recent social, political, or cultural happenings, these panels are rooted in a particular moment in time. Precisely because political cartoons focus on a topical event, they quickly become obsolete or, at least, less appealing. Unlike issues of *Superman* or episodes of *Little Nemo in Slumberland*, contemporary readers perusing past political cartoons may not understand them. The events that they are discussing and references that they are making were connected to that year, month, or even day. As a result, the entire point let alone the humor of the cartoon may now be lost. For this reason,

many cartoonists consciously avoid engaging with current events. As Pulitzer Prize–winning cartoonist Art Spiegelman commented, "nothing has a shorter shelf-life than angry caricatures of politicians" ("Sky").

In the same way that everyday life became a new area of philosophical study and sociological consideration in the years directly following the Second World War, it did so in the realm of comics. As Greice Schneider has written, this shift arguably began with Charles M. Schulz's *Peanuts*. Debuting on October 2, 1950, the series was groundbreaking not only for its spare aesthetic style but also for its unconventional and even iconoclastic subject matter. Whereas other comics were comprised of exciting plotlines, Schulz's new newspaper strip was intentionally uneventful. Many installments, in fact, simply featured characters leaning on a brick wall—or earlier in the series, sitting on a curb—talking to one another. Moreover, when events did take place in *Peanuts*, they were not rare and remarkable moments of achievement, adventure, or excitement. Rather, they were routine and unremarkable instances of frustration, worry, and even misery. From Charlie Brown bemoaning having to write a book report to Snoopy demanding food in his supper dish, the plotlines were exceedingly quotidian. In many instances, Schulz spotlights events that are not merely ordinary but ones that most people would prefer to forget: losing a baseball game, getting a poor grade at school, embarrassing yourself in front of a girl on whom you have a crush.

*Peanuts* was unusual among mainstream newspaper strips for its focus on events that were mundane and unremarkable. However, such subject matter was far more common in alternative and underground comics in the 1960s and 1970s. As Charles Hatfield has documented, creators like R. Crumb and Harvey Pekar rebelled against the mainstream cartooning of their era. Whereas the most popular comics of the day featured exciting exploits and admirable figures, their work documented the boring lives of losers, misfits, and outcasts who were thinly fictionalized versions of themselves. As Harvey Pekar once said, "Hardly anything actually happens [in my comics] . . . mostly just people talking, or [my avatar] Harvey by himself, panel after panel, haranguing the hapless reader" (qtd. in Schneider 50). His *American Splendor* series (1976–2008) was groundbreaking precisely because it focused on such ordinariness. Instead of documenting anything exceptional or spectacular, Pekar's installments featured common events: frustrations with colleagues at work, tensions in the relationship with his wife, and worries about money.

Beginning in the 1990s and then accelerating rapidly in the opening decades of the twenty-first century, this phenomenon moved from the realm

of alternative comics into the mainstream. Graphic narratives exploded on the cultural landscape during this era, and many of the most popular and acclaimed titles were known for "the uneventfulness of [their] stories" (Schneider 20). As Greice Schneider has written, in examples such as Daniel Clowes's *Ghost World* (1997), Chris Ware's *Jimmy Corrigan* (2001), and Adrian Tomine's *Shortcomings* (2007), "depictions of ordinary life [became] almost cliché" (17). The pacing of these narratives is slow, and the plot developments are minimal. A sequence encompassing more than two-dozen panels in Chris Ware's *Acme Novelty Library #18*, for example, simply details a woman getting up, taking a shower, and getting dressed. Likewise, a wordless sequence in Adrian Tomine's *Shortcomings* documents a man taking a taxi to the airport, going through security, and getting on an airplane (108). These situations invite readers to consider—in the words of Greice Schneider—"what happens when nothing happens."

Remembering, revisiting, and reexamining the cartooning of Peter Arno changes this history. Decades before mundane daily events became widespread subject matter for comics, Arno engaged with these issues in his work. Whether showcasing the extraordinary ordinary in cartoons like "The Man in the Shower" or capturing delightful moments that are usually overlooked like a flapper's playful interaction with a mirror before heading out for the evening, his work was an extended study in, and exploration of, the quotidian. Arno's work exerted a tremendous influence over not simply the cartoons that appeared in *The New Yorker* but on the genre of comics as a whole. Arno drew single-panel cartoons for a single publication—and his influence has, perhaps appropriately, also been singular.

Ben Highmore, in his discussion about the origins and evolution of everyday life theory, observed, "'[E]veryday life' signifies ambivalently. On the one hand it points (without judging) to those most repeated actions, those most travelled journeys, those most inhabited space that make up, literally, the day to day" (Highmore 1). At the same time, however, the quotidian also registers in a different way. Together with embodying acts that are so familiar that they are cliché, it can take the form of "the unnoticed, the inconspicuous, the unobtrusive" (Highmore 1). In short, daily life contains both the prosaic and the poetic.

Decades before either the advent of everyday life theory or the emergence of the quotidian as a recurring subject in sequential art, Peter Arno knew the mystery and the magic of this realm. For over forty years, his single-panel comics appeared almost every week in *The New Yorker*. However, his work's true temporal kinship was with the everyday.

# 4

## Not Jokester, but Prankster

••••••••••••••••••••

*Little Lulu*'s Silent Social
Commentary

*Little Lulu* is a milestone both in the history of single-panel comics in the United States and in the history of American popular culture as a whole. Created and drawn by Marjorie Henderson Buell, the series debuted on February 23, 1935, in *The Saturday Evening Post*. The premise for the inaugural panel was simple: it featured the title character, Lulu Moppet, walking down the aisle as a flower girl at a wedding. Instead of sprinkling rose petals, though, she is scattering banana peels. Quite predictably behind her, the bridesmaids can be seen slipping and falling (see Fig. 4.1).

The scenario depicted in the debut comic set the stage for the series. Each installment followed the same pattern from the standpoint of both its form and its content: it comprised a solitary panel that included no dialogue and featured the title character engaging in some type of amusing mischief. Far from finding this formula repetitive and predictable, audiences adored it. Little Lulu's antics charmed readers old and young, urban and rural, male and female. As a result, the series quickly became a beloved feature of *The Saturday Evening Post*, appearing in each weekly issue over the next decade.

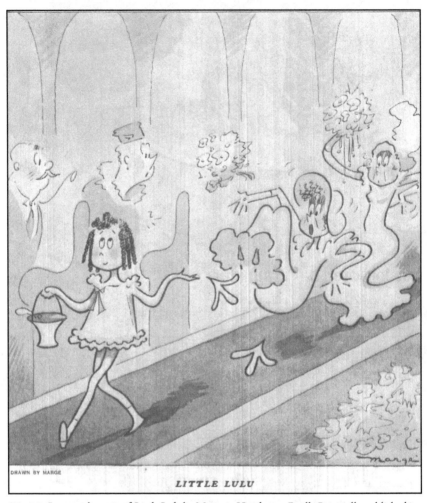

FIG. 4.1 Inaugural comic of *Little Lulu* by Marjorie Henderson Buell. Originally published in *The Saturday Evening Post* on February 23, 1935. Available here: https://en.wikipedia.org/wiki/Little_Lulu#/media/File:Firstlittlelulu022335.jpg.

For many subscribers, in fact, Buell's comic was the first feature that they read, flipping through the pages of the magazine until they spotted her impish protagonist with the corkscrew curls.

Within a few years, *Little Lulu* had grown so popular that Buell's panels were collected and reprinted in gift-style books. The first volume—titled simply *Little Lulu*—was released in 1937. New volumes appeared roughly each year, generally in time for the holiday shopping season. Titles included *Little Lulu and Her Pals* (1939), *Little Lulu on Parade* (1941), *Laughs with Little Lulu* (1942), and *Oh, Little Lulu!* (1943).

The final *Little Lulu* panel appeared in *The Saturday Evening Post* on December 30, 1944. By this point, Buell's creation had outgrown the confines of the magazine. In 1943, Buell signed the first in what would become a long list of lucrative commercial deals for her work. As Tom Heintjes notes, the cartoonist "was one of the first . . . to retain copyright to and licensing control of her characters" ("Marge," par. 2). As a result, in the decades to come, Buell's eponymous character would adorn a variety of commercial brands and also appear in a myriad of media platforms. From the 1940s through the 1960s, for example, Little Lulu appeared in both print and television advertisements for Kleenex facial tissues, embodying what Don Markstein dubbed their official "spokestoon" ("Little Lulu"). In addition, during this same period, Buell's character starred in dozens of animated television shows, movie shorts, and feature-length films. By 1947, in fact, Paramount had produced more than two-dozen cartoons featuring the spunky figure, many of which continued to be broadcast into the 1990s (Schutt 33, 38–39).

Even so, these ventures were dwarfed by the bonanza of *Little Lulu*–themed commercial goods and consumer products. As Craig Schutt commented, "Today's merchandisers have nothing on [Buell's] acumen for licensing her character for supplemental products" (39). Beginning in the 1940s, Little Lulu was featured on toys, dolls, clothes, dishes, stationary, bedding, games, cosmetics, glassware, hosiery, cleaning supplies, furniture, candy, and jewelry (Schutt 39). The ubiquity of these objects remains evident today. In the words of Schutt once again, "it can be difficult to avoid her smiling face while strolling through any toy show (or even flea market) in the country" (32).

*Little Lulu*'s departure from *The Saturday Evening Post* did not signal the title's departure from the realm of print media altogether. Instead, the series moved to the pages of various national newspapers as a syndicated series. When *Little Lulu* left *The Saturday Evening Post*, however, it also left behind one of its signature features: the silent single-panel format. Beginning in 1950 when the comic first appeared in the funny pages until the series ceased in 1969, it was a multipanel strip with speech balloons. While both this new appearance and new publication venue had the potential to repel some of its core fan base, Buell's series continued to be one of the most beloved comics in the United States.

Forming yet another indicator of *Little Lulu*'s popularity during this time, the series expanded into another platform: comic books. The first issue debuted in 1948, and it enjoyed a lengthy run, finally ceasing in 1984. That said, none of these volumes were actually written or drawn by Marjorie

Henderson Buell. By the late 1940s, when the comic book series launched, the cartoonist was already exceedingly busy overseeing the licensing and merchandising side of her cartooning career. At the same time, she was trying to balance the demands of her professional life with those of her personal one as a wife and mother (Heintjes, "Marge" par. 7). For these reasons, Buell approved the creation of a *Little Lulu* comic book series but did not work on it herself. Writer John Stanley and artist Irving Tripp were selected to craft the issues, which bore the title *Marge's Little Lulu* in homage to their creator who was known both personally and professionally by this nickname. Akin to other ventures featuring her comic creation, *Marge's Little Lulu* was hugely successful. Steve Raiteri has called Stanley and Tripp's series "one of the most widely acclaimed and fondly remembered children's comics" of the twentieth century (103).

As even this brief overview suggests, *Little Lulu* has enjoyed a long, rich, and multifaceted life in the United States.[1] Over the span of the twentieth century, Buell's creation appeared in everything from magazines, comic books, and daily newspapers to animated movies, consumer goods, and commercial advertisements. That said, the now-legendary series began as a silent single-panel comic. This format is where the title character had her origins, and it is also the arena in which the comic established its content, themes, and conventions. Furthermore, the silent single-panel configuration is the venue in which Buell's work received its common classification: as a gag comic. Over the years, as *Little Lulu* morphed into other cultural venues and media platforms, this designation remained. In a 2010 review of the collection of *Marge's Little Lulu*, for example, Joe Sutliff Sanders asserted, "There is an elegance to the gags that drives these cartoons, a simplicity that makes them timeless" (69). Lulu's initial appearance spreading banana peels instead of flower petals established the content of, along with the categorization for, the comic series.

This chapter reconsiders this key aspect of *Little Lulu*. While the single-panel comic certainly featured a plethora of amusing gags, a variety of installments presented the title character engaging in a markedly different activity: pulling a prank. Far from an inconsequential linguistic distinction, pranks serve a different comedic as well as cultural function. Whereas gags seek to amuse, delight, and entertain, pranks seek to question, challenge, and even provoke. As Anna Marie Trester has written, pranking involves "the playful defiance of authority" (91). In examples ranging from the satirical writings of Jonathan Swift to the mockumentary personas of Sacha Baron Cohen,

good pranks—in the words of Matthew R. Meier—"move audiences to new perspectives on old situations; good pranks prepare the way for change" (299).

The mischief depicted in many of the silent single-panel *Little Lulu* comics can more accurately be classified as pranks rather than gags. These incidents certainly make readers laugh, but they also invite them to think: about gender norms, social conventions, and authority figures.[2] Recognizing Little Lulu as a prankster as well as a jokester changes the way we view, engage with, and understand her character, as well as the comic as a whole. Additionally, and just as importantly, this unexplored facet of *Little Lulu* links the comic series to the long, storied history of pranking in the United States, while it simultaneously calls attention to the important but understudied role that comics have played in this tradition.

## The Joke's on You: The History, Uses, and Importance of Pranking

While jokes, tricks, and gags help form the rich landscape of humor in the West in general and the United States in particular, pranks occupy a special place. The jovial jabs perpetrated by pranksters over the decades have influenced public opinion, changed cultural norms, and even impacted sociopolitical policy. Consequently, pranks constitute an important comedic tradition—as well as a force for societal change.

While pranking forms its own distinct mode, it is connected to other types of humor. A good prank, for example, likely elicits humor like a joke. It may also incorporate a prop like a gag. Finally, it might involve deception like a trick. That said, a prank differentiates itself from other forms of joviality in one key way: a prank "is a staged provocation meant to enlighten and stir up debate" (McLeod 16). Whether the act is carried out by an individual or conducted by a group, "its trickery is a means to an end: prompting discussion, upending the naturalized rituals of everyday life, enraging and educating" (McLeod 18). The goal of a prank is not merely to elicit humor—be it the sardonic smile, the controlled chuckle, or the gleeful belly laugh. Rather, a prankster uses humor to invite reflection, spark discussion, and even precipitate change.

Human beings have been pulling pranks on one another from the origins of collective living. That said, as Kembrew McLeod has documented, the dawn of the Age of Reason was also the dawn of the age of pranking

(25). Fueled by the faith in rational thinking as well as the proliferation of the printing press, numerous individuals engaged in clever mischief to ridicule problems in society and, in so doing, tried to reform them. Jonathan Swift's pamphlet *A Modest Proposal* (1729) is arguably the most famous example. The treatise offered an inventive solution for how impoverished families in Ireland could stave off starvation: by eating their children. As Swift matter-of-factly pointed out, "A young healthy child well nursed, is, at a year old, a most delicious nourishing and wholesome food, whether stewed, roasted, baked, or boiled; and I make no doubt that it will equally serve in a fricassee, or a ragout" (228). As George Wottkowsky has written, Swift's argument is offered in "a spirit of bitter mockery" (98) that calls attention to its own absurdity. That said, when *A Modest Proposal* first appeared, many fell for the prank: they began reading the treatise in earnest, thinking that it offered a sincere solution to a pressing social problem before realizing that the content was satirical. Swift's pamphlet continues to be read, studied, and written about as a tour de force of irony. *A Modest Proposal* is also an exceedingly clever and effective prank.

Meanwhile, on the other side of the Atlantic, contemporary Benjamin Franklin was engaging in his own print-based pranks under various pseudonyms. Publishing these pieces under monikers like "Silence Dogood," "Anthony Afterwit," and "Ephraim Censorious," he took jovial jabs at everything from organized religion and social mores to civic leaders and the era's growing fears about witchcraft (McLeod 43–53). Franklin's witty articles not only generated laughter; they also prompted individuals to reexamine their beliefs. On April 15, 1747, for example, the future statesman published a speech purportedly given by Polly Baker. This fictional female persona was facing fines and possible imprisonment for having children out of wedlock. During her address to the judge, she calls attention to various flaws in the law. "Can it be a Crime (in the Nature of Things I mean)," she wonders, "to add to the Number of the King's Subjects, in a new Country that really wants People?" (Franklin, "Speech" 18). In case the judge is not persuaded by this civic-minded argument, Baker adds a Biblical one. It is not "the Duty of the first and great Command of Nature, and of Nature's God," she reminds the magistrate, for individuals to "*Encrease* [sic] *and Multiply*" (Franklin, "Speech" 18). Baker concludes her plea to the court by pointing out the hypocrisy of rebuking women like her for having children out of wedlock but not the men who fathered them. When Polly Baker's speech was initially printed, readers did not know that she was a fictional figure and that the remarks were all a fabrication. The speech generated enormous

sympathy and, by extension, media attention. "The Speech of Polly Baker" was reprinted in multiple periodicals in London as well as the American colonies (McLeod 47–49). By the time readers on either side of the Atlantic realized the ruse, the prank had served its purpose: it had compelled people to reconsider their views on unwed mothers.

That the eighteenth century gave rise to gifted, prolific, and influential pranksters like Benjamin Franklin and Jonathan Swift was no coincidence. Times of national strife, cultural conflict, and political upheaval are also times when pranksters become more pervasive—and more important. Making jokes and pulling pranks are effective ways for individuals to blow off steam as well as to offer commentary about current conditions. Not surprisingly, other tumultuous moments in American history have also been moments when pranksters have entered the national spotlight.

During the 1960s, activist Abbie Hoffman routinely employed pranks to get the public's attention and spark conversation about issues ranging from the ills of capitalism to the atrocities of the war in Vietnam. On August 24, 1967, for instance, Hoffman and a group of friends snuck into the New York Stock Exchange. After arriving in the visitor's gallery, they threw hundreds of dollars down onto the trading floor. Trading stopped for nearly ten minutes as brokers "leapt into the air to grab the dollar bills floating down" (Wiener). Not surprisingly, news coverage of the stunt as well as of its impact "was massive" (Wiener). The scene of Wall Street traders grabbing at money fluttering down from the gallery and also crawling around the floor scavenging for bills was far from flattering—and proved the point that Hoffman and his fellow Yippies were trying to make about the greed and avarice that occupies the heart of capitalism (McLeod 136–137).

Of course, not all pranks are carried out by individuals; organizations and groups have also commonly engaged in the practice. In 1993, the feminist collective known as the Barbie Liberation Organization (BLO) made headlines around the United States for a prank that involved two of the most popular childhood toys: Barbie dolls and G.I. Joe action figures. The group swapped the voice recordings embedded in the items, causing G.I. Joe to gush, "I like to go shopping with you!" while Barbie grunted, "Dead men tell no lies" (Hale-Stern). The stark incongruity between the personalities of the toys and their recordings was humorous, but the prank, of course, also called attention to the ways in which Barbie and G.I. Joe reinforce rigid and outmoded gender roles (Hale-Stern).

In the opening decades of the twenty-first century, British comedian Sacha Baron Cohen brought the tradition of pranking back into the spotlight.

Under the guise of various fictional personas—most famously hip-hop journalist "Ali G" and Kazakh media correspondent "Borat Sagdiyev"—Baron Cohen carried out some of the most infamous pranks of his generation. Regardless of the precise personality that Baron Cohen is embodying, his approach is the same: he interacts with individuals who are not aware that his identity is a ruse and sees how they respond to his over-the-top behavior along with absurd, ill-informed, and even appalling comments. A now-famous scene from Baron Cohen's mockumentary *Borat: Cultural Learnings of America for Make Benefit Glorious Nation of Kazakhstan* (2006) provides a representative example. While playing guitar and singing at a country Western bar in Arizona, Borat performs a song with the chorus "Throw the Jew Down the Well." Although the patrons are initially unsettled by the anti-Semitic lyric, it doesn't take long for them to begin enthusiastically singing along. This oft-discussed moment exemplifies Baron Cohen's overall comedic ethos. As he has said, by having his alter egos engage in some type of offensive behavior—anti-Semitism, racism, sexism, homophobia, and so on—"he lets people lower their guard and expose their own prejudice" (qtd. in Straus). Baron Cohen's goal, however, is not merely to embarrass, ridicule, or shame the individuals whom he pranks; instead, he seeks to make visible the ignorance and bigotry that lurks just below the surface of polite society. *Borat* was both critically acclaimed and commercially successful. The film earned more than $260 million worldwide. Additionally, it was nominated for an Academy Award for Best Adapted Screenplay. Baron Cohen has been touted as "the king shock comedy" (Leigh); an equally accurate descriptor would be prankster.

While elements like military battles, social movements, and pieces of legislation form the official history of a country, pranks occupy an equally important facet of its hidden history. From the printed pieces during the eighteenth century to the performance-based antics of the twenty-first century, actions of this nature have a long, rich history in the West. In the same way that elected officials have impacted public opinion, so too have sly pranksters.

## "A Girl Could Get Away with More Fresh Stunts": Little Lulu as a Big Prankster

Marjorie Henderson Buell's Little Lulu is commonly remembered for her adorable corkscrew curls and equally darling dress with the Peter Pan collar.

Indeed, the character's cuteness is one of the reasons why she became so popular—and so marketable.

While Little Lulu is certainly known for being precious, she is just as powerfully associated with being mischievous. As Buell remarked about the star of her new single-panel series, "I wanted a girl because a girl could get away with more fresh stunts that in a small boy would seem boorish" (qtd. in Jacob). And engage in "fresh stunts" is exactly what Little Lulu did. Beginning with the debut panel where she distributed banana peels instead of flower petals, Buell's title character was known for her irreverent antics. That said, many of Little Lulu's capers were not simply comedic; they can also be viewed as coded social commentary. The humor presented in such panels arises from the young girl lampooning conventional manners and mores, making a mockery of traditional gender roles and poking fun at adult authority figures. In so doing, the comics question, challenge, and even defy the status quo—and invite readers to do the same. *Little Lulu* is commonly remembered as a gag comic, but many installments can more accurately be classified as prankster panels.

Little Lulu's penchant for pulling pranks appears in the very first panel of the very first collection of Buell's comics (see Fig. 4.2). The image features the title character sitting in the lap of a statue in the park. The monument depicts a stately-looking gentleman seated in a throne-like chair. He is gazing at a document that he is holding in front of him. Lest any doubt remains about the gravitas of this figure, the statue is featured on a meticulously maintained patch of grass. Furthermore, it is cordoned off by a wrought iron fence. These features make it clear from the outset that Lulu's actions are mischievous. In order for her to sit in the lap of this figure, she not only had to climb up the monument; she had to climb over a fence that was obviously intended to keep visitors away from it.

Lulu is doing much more than simply using the statue as a makeshift bench—it is a place to rest during her stroll through the park. In details that move the scenario out of the realm of a mere gag and firmly into the category of a prank, the young girl is also contently licking a large lollipop whilst gazing at the document that the figure is holding, making it appear as if he is reading her a story. At the base of the statue is an engraving that identifies this figure: "BULWER-LYTTON," it reads. Far from a fictional persona, the inscription refers to Edward George Earle Bulwer-Lytton, who was a famous nineteenth-century British writer and politician. Over the course of his long and prolific career, he was named secretary of state for the colonies, served as a member of Parliament, and crafted pieces of legislation.

FIG. 4.2 *Little Lulu* panel by Marjorie Henderson Buell. Reprinted in *Little Lulu* by Marge (Rand McNally & Company, 1936). The collection is not paginated.

Additionally, he wrote poems and published novels in a variety of genres: science fiction, romance, mystery, and historical fiction. Bulwer-Lytton was highly respected in his own time—as this stately monument erected in a public park suggests. Today, Bulwer-Lytton is remembered—if he is remembered at all—as the man who penned the sentence "It was a dark and stormy night."

Little Lulu sitting in the lap of a statue dedicated to Edward Bulwer-Lytton pokes fun at how young children commonly misbehave in public—scaling fences, climbing monuments, and so on—and it also pokes fun at this revered figure. By looking as if the famed British writer is reading her a story, Buell's character can be seen as making a tacit commentary on his legacy.

Far from penning complex tomes that will surely become timeless classics, he has penned a work that entertains a young child. Moreover, if the document that Bulwer-Lytton is holding is one of his pieces of legislation, the critique becomes even more pointed. In many ways, Lulu's antics foreshadow performance art from later in the twentieth century. One can imagine a group like the Guerrilla Girls trespassing on a monument of a Victorian patriarch like Bulwer-Lytton and offering a commentary of this nature.

A panel that appears a few pages later in the debut collection of *Little Lulu* continues the title character's lampooning of adults in general and men in particular (see Fig. 4.3). The comic shows figures waiting in line at a ticket counter. That the individuals are men is unmistakable: not only are they big and tall, but they are all also wearing items that are readily identifiable as men's clothing: ties, coats, and hats. Moreover, on the wall directly behind the group and positioned just above their heads is a large sign that reads in all-caps, "MEN ONLY."

Enter Little Lulu. On the lower right side of the panel, Buell's title character can be seen surreptitiously standing in line. Sandwiched between two of the large men, she is also dwarfed by them. Lulu is half their height and a fraction of their heft. Whereas the men are robust and even rotund, Little Lulu is lanky and skinny. She is also dressed very differently. The men standing both in front and behind her are wearing long jackets, dark trousers, and a necktie or bow tie. Meanwhile, Little Lulu's coat is markedly dissimilar—it has fur trim on the collar as well as around the cuffs of the sleeves. Even more importantly, the garment is exceedingly short—it just reaches her thighs, revealing what appears to be her bare legs. Furthermore, while Little Lulu is also wearing a hat, it is a small beanie, not a brimmed bowler or fedora, akin to her neighbors. Finally, but far from insignificantly, is Lulu's hair: her corkscrew curls protrude from the beanie. By contrast, the men around her are either bald or, at the very least, have closely clipped hair.

All that said, Little Lulu has strategically selected an accessory to help her blend into this crowd: she is wearing a mustache. The young girl is the only figure in line with facial hair; the two men in front of her and the one standing behind her are all clean-shaven. The look on Little Lulu's face and especially the upward expression of her eyes suggest her uncertainty that the disguise is convincing. The man behind her, in fact, is glancing down at the short figure in a manner that suggests skepticism if not incredulity.

Little Lulu entering the "MEN ONLY" line does more than simply form another example of the character's cheekiness; her actions also call attention to the flaws, cracks, and weaknesses in some foundational facets of society.

FIG. 4.3 *Little Lulu* panel by Marjorie Henderson Buell. Reprinted in *Little Lulu* by Marge (Rand McNally & Company, 1936). The collection is not paginated.

That a young girl can pass—even if only momentarily—as an adult man simply by donning a fake mustache pokes fun at both gender roles and the divide between childhood and adulthood. Indeed, Little Lulu looks nothing like an adult woman let alone a grown man. From her height and hairstyle to her clothing and accessories, she resembles a little girl. That the adults around her can be so easily fooled reveals both the gullibility of grown-ups and the artifice of masculinity. Indeed, Lulu's antics foreshadow Judith Butler's now famous argument about the performativity of gender. Appearing more than fifty years before Butler's landmark book *Gender Trouble* (1991), Buell's protagonist calls attention to how masculinity and femininity are not innate and immutable; rather, they are created and constructed. Individuals make direct and deliberate choices to "look" masculine and feminine: how they style their hair, the clothes they select, and the way that they move and carry their bodies. Moreover, clothing as well as conduct that is considered "masculine" or "feminine" varies greatly by culture, region, and historical time period. For this reason, in the words of Butler, "*gender is a kind of imitation*

*for which there is no original*; in fact, it is a kind of imitation that produces the very notion of the original as an *effect* and consequence of the imitation itself" (21; emphasis in original).

Little Lulu's prank lampoons the seemingly stable categories of both gender and age. In the same way that the young child can trespass into the realm of adults, she can trespass into the arena of masculinity. Moreover, doing so is not complicated or difficult: a simple fake mustache is sufficient to accomplish both of these goals. The hilarity of Little Lulu's actions reveals how cultural categories and social divisions that are commonly seen as clear and fixed are actually flimsy and mutable.

This early panel would not be the only time that Little Lulu would challenge the separation between adults and children. As I have written elsewhere, this issue formed a recurring theme of Buell's single-panel series.[3] A comic from the collection *Oh, Little Lulu!* (1943), for example, shows the title character dressed in dark overalls and a red work shirt walking through a fence gate (see Fig. 4.4). A woman dressed in a similar fashion is following behind her. While Lulu is readily identifiable with her signature corkscrew curls and white-collared dress, she has also altered her appearance in one significant and obvious way: she is considerably taller. The legs of the young girl's overalls are disproportionately long: they are roughly twice the length of her torso. How the young girl has achieved this effect—by wearing stilts, by sitting on the shoulders of another child, and so on—is unclear, since the overalls are covering her body. Regardless, one fact is undeniable: Little Lulu is little no more.

Although readers may not understand exactly how Lulu has been able to become so tall, they are soon able to deduce why she has done so. Details from the foreground and elements in the background of the image offer more information about this scenario. First, and perhaps most importantly, is the issue of where Lulu and her companion are going: the opening in the fence reveals that the pair is heading into some type of factory. The background of the comic features a large two-story building. Indicating that the structure is an industrial plant and not merely a large house, it has two stout chimneys on the left side of its roof and smoke puffing out from a smaller one on the right end of the building. At this point, readers might think that Lulu is personally inspired—or financially compelled—to earn some money. However, a placard on the fence just beside the entrance reveals the likely motivation. The sign reads "Candy Packers Wanted—High Wages." That a young child like Lulu would want to work in a candy factory is wholly unsurprising. However, the fact that she could gain entrance into this realm

FIG. 4.4 *Little Lulu* panel by Marjorie Henderson Buell. Reprinted in *Oh, Little Lulu!* (David McKay Company, 1943). The collection is not paginated.

by simply making herself taller is more shocking. The expression on the face of the adult woman walking behind Lulu suggests that she is skeptical of her coworker: her eyes appear opened wide as if in amazement, and emanata lines around her head suggest that she is startled. However skeptical this woman may be about Little Lulu's appearance, she does not stop her—and neither does anyone else. Instead, the panel suggests that the young girl's ruse is successful. Buell's protagonist is able to stroll into the candy factory for labor that is not only lucrative but undoubtedly delicious.

    A variety of Lulu's other antics also function as a type of wish fulfillment, not only for her but likely for countless other little girls. A panel that appears

later in the collection *Oh, Little Lulu!* depicts a common childhood scene: a small boy is walking down a sidewalk with a toy airplane (see Fig. 4.5). Trailing just a few feet behind him is Little Lulu. She, too, has a toy. The young girl is pulling a miniature artillery gun, presumably to shoot down the boy's plane. Akin to other panels, the humor of this scene goes beyond merely Little Lulu's derring-do. On the contrary, her actions also resonate for other, and more subversive, sociocultural reasons. Boys flying their toy airplanes have disrupted quiet afternoons in the park for untold numbers of individuals, young and old alike. From the noise of the propeller, the calamity of an unexpected dive bomb, and of course, the chaos of the inevitable crash, many of Buell's readers had likely privately contemplated, but never actually carried out, doing exactly what Little Lulu is planning: shooting these annoying toys out of the sky. That said, the character's actions reverberate with another, more specific, audience for an even more specific reason. Over the years, many little girls likely wanted one of these toys—or at least, wanted a turn playing with one of them—but were told that they could not because toy airplanes were "for boys." After being barred from enjoying this item, many girls undoubtedly wished that they had an artillery gun to obliterate the toy—and with it, the gender restrictions surrounding it. In this way, Little Lulu's antics embody more than merely the mischief of one little girl; they call attention to larger sociocultural conditions.

Panels of this nature are not anomalies. Many other subsequent *Little Lulu* comics feature antics that can more accurately be described as pranks rather than gags. The subject matter of this nature embodied such a common feature of the series that it became one of Little Lulu's signature qualities. When John Stanley and Irving Tripp were tasked with creating the comic book version of the series, they wanted to remain true to Buell's vision. Accordingly, as Janet Horowitz Murray has written, they made sure that the title character retained what they felt were her most beloved personality traits: "Nonconformity, proto-feminism ... and blithe courage" (13). As this list reveals, Buell's character is remembered, not simply for being silly, amusing, and funny, but for being bold, daring, and iconoclastic. These traits, of course, are most powerfully on display when Little Lulu is being a prankster.

Patrick A. Reed, in a retrospective essay about Marjorie Henderson Buell, characterized her famed protagonist as a "mute agent of childish chaos" (Reed). More than simply causing unruliness, though, Little Lulu also causes readers to question societal norms. As Kembrew McLeod has written about pranking, "By staging these semiserious, semihumorous spectacles, pranksters try to spark important debates and, in some instances, provoke

FIG. 4.5  *Little Lulu* panel by Marjorie Henderson Buell. Reprinted in *Oh, Little Lulu!* (David McKay Company, 1943). The collection is not paginated.

social change" (3). Whether it is sitting in the lap of the statue of Edward George Earle Bulwer-Lytton or following a boy holding a toy airplane with an artillery gun, "Pranks encourage audiences to pause and reflect, even if it is only for a few seconds" (McLeod 6). Pranks might target an individual or poke fun at a specific event, but "they serve a higher purpose by sowing skepticism and speaking truth to power (or at least cracking jokes that expose fissures in power's façade)" (McLeod 3). Pranksters invite individuals to question what is and, even more importantly, to contemplate what could be. Echoing Little Lulu's penchant for creating chaos, pranksters participate in the carnivalesque. Modern-day pranks mirror the inversions of power and the flouting of convention that occurred during medieval festivals. As Mikhail

Bakhtin famously documented, for the few days that encompassed these feasts, the poor could become the rich, women could become men, children could rule over adults, and the subjugated could become sovereigns (80–82). Pranks likewise "turn existing power relations upside down" (McLeod 12). In so doing, while pranksters are commonly classified as humorists, they can perhaps more accurately be viewed as "artful protestors [who] offer us 'new ways of seeing and judging the world'" (McLeod 7).

Little Lulu participates in this same cultural project and sociopolitical phenomenon. Echoing the long tradition of pranksters in the West, the young girl's irreverent antics challenge and even upend the status quo. Her behavior calls into question foundational facets of U.S. society, from the alleged stability of traditional gender roles to the reverence bestowed on public figures. By poking fun at these issues, however, Lulu is also poking holes in them.

Silent comics, like Buell's series, are sometimes called "pantomime," after the form of nonverbal clowning. *Little Lulu* panels that feature pranks can perhaps more accurately be called panto*mines*, given the way that they explode social norms. Marjorie Henderson Buell may have given the protagonist of her single-panel series the diminutive descriptor "Little." Akin to so many other facets of Buell's character, however, readers ought not to be fooled by this detail. Little Lulu was a big prankster.

## Cartooning as Lampooning: The Overlooked Role of Pranking in U.S. Comics

Humor has always played a central role in comics in the United States. The genre gets its name, in fact, because it was "comical." Additionally, for generations, the section of the newspaper that featured syndicated strips was known as "The Funny Pages." Furthermore, many publishers continue to classify—and bookstores continue to stock—collections of strips in the humor section.

In the same way that humor has played a central role in the creation and consumption of comics, it has likewise occupied a prominent place in its scholarly analysis. Over the years, critics have explored the comedic forms deployed in strips along with the place that these elements occupy in them. In the past few years alone, for example, books such as Jean Lee Cole's *How the Other Half Laughs: The Comic Sensibility in American Culture, 1895–1920* (2020) along with articles including Fallianda et al.'s "Analyzing Humor in

Newspaper Comic Strips Using Verbal-Visual Analysis" (2018) have discussed everything from jokes, gags, and ethnic humor to slapstick, wordplay, and gallows comedy.

In spite of all the attention given to humor in comics, the role of pranks has largely been overlooked. To date, no scholarly studies or critical analyses have explored the history, function, and impact of this phenomenon. However, pranks and pranksters have formed a consistent as well as central role in sequential art in the United States from its commercial origins. *The Katzenjammer Kids*, created by Rudolph Dirks in 1897 and drawn by a variety of cartoonists over the decades, for instance, showcased the mischief of its two protagonists, the twins Hans and Fritz. In each installment, the boys make some adult authority figure look foolish or incompetent through "a typical Katzenjammer Kids prank" (Markstein, "Katzenjammer Kids"). Whether the target is their mother, the Inspector at school, or the Captain (who functions as a father figure), the scenario ends in a similar fashion. As Karen Harris has written, *The Katzenjammer Kids* typically "concluded with the twins being punished for their pranks, often by being spanked by their mother." With this simple premise, *The Katzenjammer Kids* became the longest-syndicated comic strip in U.S. history, enjoying a run of over one hundred years ("Katzenjammer Kids").

Pranking was equally endemic to George Herriman's *Krazy Kat* (1913–1944). The interactions between the strip's two protagonists—the feline title character and a mouse named Ignatz—generally fall under the category of slapstick, given Ignatz's penchant for throwing bricks at Krazy Kat and hitting him in the head. However, the duo's encounters with Officer Bull Pupp take a different form. Far from joking with the canine law enforcement agent, Krazy Kat and especially Ignatz often pull a prank on him. The specific nature of the ruse always changes, but the end result remains the same: the prank makes Bull Pupp look gullible, incompetent, and even stupid. Given that the canine character is an officer of the law, Ignatz's pranks can be seen as poking fun not simply at the specific figure of Bull Pupp but at the police as a whole. Of course, Herriman's decision to depict this character as a slobbery bulldog can itself be viewed as a satirical prank.

Pranks continued to be a common feature of newspaper comics throughout the twentieth century. In Jim Davis's *Garfield* (1978–present), for example, the feline main character often pulls them on both his owner Jon and his fellow pet, the dog Odie. From unscrewing the top of Jon's salt shaker in the strip from January 5, 1984, to getting Odie to stand in front of the recliner so he can extend the footrest and fling the pooch across the room

in the installment from October 27, 1985, the pranks are for his own amusement, but they also demonstrate a larger point: the intellectual inferiority of his human and canine housemates.

The pranks in Morrie Turner's groundbreaking strip *Wee Pals* (1965–2014) are even more pointed and poignant. In attire that is clearly meant to provoke, the character Nipper, who is a young Black boy, dons Civil War caps from both the Union and the Confederate armies. He also has a dog named General Lee. Additionally, Nipper routinely sets up a food stand on the sidewalk, selling items to the neighborhood kids. With signs advertising "Gifilte Grits" and "Chitlin Scalopini," Nipper's menu brings together the cuisine of unexpected cultures. Given the number of times that the gullible white character, Oliver, falls for Nipper's facetious and usually fallacious explanation about the origins of what we would now call "fusion food," Nipper's sidewalk stand becomes as much of a politically charged prank as it does an entrepreneurial enterprise.

Ernie Bushmiller's *Nancy*, which debuted in 1938, offered a unique take on the pranking phenomenon. While his title character engages in an occasional spoof, the cartoonist more commonly pranks his readers. In installments that appeared on major holidays—as well as, of course, April Fool's Day—Bushmiller often shirked crafting a traditional strip. In these instances, such as the one that appeared on January 1, 1949, he would avoid cartooning by doing things like drawing panels of solid white, gray, or black. The caption below each image explained that his characters were caught in a snowstorm, dense fog, and the dark, respectively, and thus could not appear in the strip that day. Together with forming a clever way to give the cartoonist a break from the relentless daily deadlines, these installments also lampooned the conventions of the genre.

The closing decades of the twentieth century saw the publication of a newspaper series that has been called "the best comic strip ever" (Martell 5): Bill Watterson's *Calvin and Hobbes* (1985–1995). Perhaps not coincidentally, the series also commonly featured pranks. Watterson's strip follows the adventures of a precocious six-year-old boy, Calvin, and his stuffed toy tiger, Hobbes—who comes to life when the two are alone. Calvin has a vivid imagination as well as a mischievous personality. When the protagonist plays in the snow during winter, he frequently uses this common childhood activity as an opportunity to stage a prank. The target is usually his parents, but school and societal norms are also lampooned. The strip that originally appeared on January 6, 1995, forms an excellent case in point. In it, Calvin builds a giant chicken out of snow. In an unexpected detail, though, the bird

is not happily pecking in the grass. Instead, he is holding an ax and chopping the head off a snowman—the figure's severed head is lying in the snow, a few feet away from the tree stump that is being used as a chopping block. This act can be seen through an absurdist lens: the chicken is turning the tables on the snowman and enacting a terrible revenge. At the same time, of course, Calvin's vignette can also be seen as offering commentary about the poultry industry specifically and the way that animals are treated by humans as a whole.

Marjorie Henderson Buell's *Little Lulu* participates in the long tradition of pranking in U.S. comics. The single-panel series did not inaugurate this phenomenon, but it calls attention to its important history. Some of the most popular, successful, and influential comics showcase pranksters or, at least, feature instances of pranking. Moving pranks and pranksters from the background to the forefront of U.S. comics gives much-needed attention to this pervasive but neglected type of humor. In the same way that flesh-and-blood pranksters like Benjamin Franklin, Abbie Hoffman, and Sacha Baron Cohen tackle serious sociopolitical issues with their antics, so too do their fictional counterparts on the comics page. From *The Katzenjammer Kids*, *Krazy Kat*, and *Nancy* to *Garfield*, *Wee Pals*, and *Calvin and Hobbes*, comics in the United States form a rich site for the representation of pranking.

Together with impacting the nature of comics as a whole, the presence of pranks in these strips also changes our perception of their engagement in cultural commentary. Comics associated with sociopolitical critique are often limited to titles that directly engage with such topics, such as Garry Trudeau's *Doonesbury* (1970–present) or Berkeley Breathed's *Bloom County* (1980–1989). When our consideration of humor in sequential art includes pranks and pranksters, our view of this phenomenon expands to include a wide array of new titles. Although *Krazy Kat*, *Nancy*, and *Little Lulu* are not overtly political in nature, they are not entirely devoid of such elements. The pranks that these characters stage do more than simply serve as the source of humor for that strip; they also routinely serve as a source of social critique. Whether it is lampooning parents and teachers in *The Katzenjammer Kids* or taking jabs at the police in *Krazy Kat*, these pranksters are also iconoclasts.

Winston Churchill, in an oft-quoted remark, once quipped, "A joke is a very serious thing" (qtd. in Paige 184). The legendary British statesman was making the point that although humor is often regarded as trivial and unimportant, it ought to be viewed as more thoughtful and significant. Crafting a good joke and telling it well is an important skill that not everyone possesses. Additionally, as Sigmund Freud famously discussed in *Jokes and Their*

*Relation to the Unconscious* (1905), humor often possesses hidden meaning. Individuals, under the guise that they are "just joking around," can broach a topic or express an opinion that might otherwise be forbidden. In so doing, jokes routinely contain difficult truths or, at least, moments of unvarnished honesty. Consequently, as Churchill asserted, they ought to be viewed with more gravity and even solemnity.

If Winston Churchill was correct in saying that a joke is a serious thing, then a prank is a telling one. This mode of humor engages with weighty social, cultural, and political issues. Kembrew McLeod observed, "The modern era was ushered in by a prank" (27). In a feature that has been overlooked for too long, comics in the United States likewise have their roots in this tradition. For over a century, the section of the newspaper that contains the comics has been deemed "The Funny Pages." Given the number of past and present strips that feature mischievous characters and their impish antics, this section could just as easily be dubbed "The Prankster Pages." This mode of humor has done more than simply make us chuckle over the years; it has also made us question, critique, and even challenge.

# 5

## Civil/Rights

• • • • • • • • • • • • • • • • • • • •

Jackie Ormes's *Patty-Jo 'n' Ginger*, Black Girlhood, and the Black Bourgeoisie

Single-panel comics have long been relegated to the margins of sequential art. Additionally, women artists have had a difficult time breaking into this male-dominated field. Moreover, cartoonists of color have been vastly underrepresented in—or even wholly excluded from—a medium that has historically presented white characters drawn by white cartoonists for white audiences.

Into this scene arrived Jackie Ormes. Born Zelda Mavin Jackson in 1911, Ormes is widely regarded as the first professional Black female cartoonist in the United States. Her work was syndicated in major Black newspapers like *The Chicago Defender* and *The Pittsburgh Courier* from the 1930s through the 1950s. Over the course of her career, she created four comic series: the multipanel strip *Torchy Brown in "Dixie to Harlem"* (1937–1938), which was later revived and revamped as *Torchy in "Heartbeats"* (1950–1954);[1] the single-panel comics *Candy* (1945), about a wise-cracking housemaid; and *Patty-Jo 'n' Ginger* (1945–1957), about an older and younger sister.

Ormes was not merely the first Black woman to work as a professional cartoonist; her comics were among the most popular of their day. Langston Hughes, in his column "Colored and Colorful" for *The Chicago Defender*, discussed his devotion to her work. "If I were marooned on a desert island," Hughes revealed, "I would miss . . . Jackie Ormes's cute drawings" (qtd. in Goldstein, *Jackie* 2). He was not alone in this sentiment. Biographer Nancy Goldstein has documented how, decades later, members of the Black community recounted the fond memories they had of reading Ormes's work (*Jackie* 2). In light of the tremendous impact that Ormes had on cartooning during the 1940s and 1950s, she was inducted into the Will Eisner Comics Arts Hall of Fame in 2018. Additionally, in 2020, Google honored Ormes with a Doodle. The press release for the logo—which was drawn by cartoonist Liz Montague—touted her as a "pioneering artist" (Cascone).

This chapter examines the single-panel comic by Jackie Ormes that was both her longest-running title and arguably most famous: *Patty-Jo 'n' Ginger*. Making its debut on September 1, 1945, in *The Pittsburgh Courier*, the weekly series was a gag panel starring two sisters: Patty-Jo, who is approximately six years old, and her older sibling, Ginger, who is in her late teens or early twenties. The specific scenario for each installment varied, but the setup was the same. The two girls would be engaged in some activity, and in the caption at the bottom of the image, young Patty-Jo would make a frank comment or offer a blunt observation. Ginger would be so dumbfounded by her sister's candid words that she was rendered speechless.

*Patty-Jo 'n' Ginger* appeared during the heyday of the Black press in the United States. Although based in Pittsburgh, the *Courier* was syndicated in more than a dozen cities around the nation. At its peak, these collective editions were read by more than 358,000 people every week (Goldstein, *Jackie* 39). *Patty-Jo 'n' Ginger* was an exceedingly popular comic throughout its run in the paper. In fact, in a survey conducted in 1946—just one year after Ormes's single-panel comic made its debut—readers of *The Pittsburgh Courier* identified it as their top feature (Goldstein, *Jackie* 79). The following year, the popularity of Ormes's work caused it to morph into a new cultural realm as a doll version of Patty-Jo arrived in stores. Although the item was not the first Black doll to be sold commercially in the United States, it was an important one in the growing postwar desire for toys that offered more a positive representation of Black identity (Goldstein, *Jackie* 159–176). Given the impact that *Patty-Jo 'n' Ginger* had on both print and material culture, Ormes is commonly remembered today for her work on this title. The

Google Doodle, for example, appeared on September 1, 2020, to mark the seventy-fifth anniversary of this series.

In spite of both the postwar popularity and the lasting legacy of *Patty-Jo 'n' Ginger*, surprisingly little scholarly attention has been given to it. Because the series featured punch lines uttered by a young girl, it has often been regarded as mere "children's fare" that had "frivolous content" (Teutsch). When critics have discussed *Patty-Jo 'n' Ginger*, they often do so as the inspiration for the doll. Nancy Goldstein, who penned the groundbreaking biography *Jackie Ormes: The First African American Woman Cartoonist* (2008), in fact, first became interested in Ormes not for her role in cartooning but for American doll history.

The pages that follow make the case that the comic of *Patty-Jo 'n' Ginger* is just as culturally rich and historically resonant as the toy version of its main character. Although the series has often been dismissed because it "was a big sister-little sister setup" (Goldstein, *Jackie* 3), these elements embody the comic's strength rather than its weakness. *Patty-Jo 'n' Ginger* offers a complex portrayal of the interplay of race, class, age, and gender in the postwar era. Both from an individual standpoint and from an intersectional one, Ormes's middle-class Black girl protagonists faced tremendous pressure to conduct themselves in ways that would be regarded as "respectable." As Robin Bernstein has discussed, especially in the years following the end of the Civil War, young Black children were urged to be well behaved, quiet, and polite, especially in public, to combat long-standing derogatory beliefs that they were unruly, ill-mannered, and even wild (4–36). Black girls and women faced additional pressures. Nazera Sadiq Wright, Marcia Chatelain, and Aria S. Halliday have all documented how these members of the community were urged to dress in a modest and ladylike way to counteract racist assumptions that Black women were unfeminine and promiscuous. Members of the Black middle and upper classes felt a similar sense of scrutiny—and thus, responsibility. As landmark works by St. Clair Drake and Horace R. Cayton and others have addressed, one effective way to advocate for racial uplift, members of the Black elite believed, was to demonstrate to whites that they were just as dignified, refined, and well mannered.

Jackie Ormes's *Patty-Jo 'n' Ginger* not only engages with these issues; it offers a poignant critical commentary about them. Her two protagonists are Black girls who hail from an upper-class family, but neither fully conforms to the notions of respectability expected of them. Instead, each character strategically questions and even openly challenges such codes of conduct. Although Ginger rarely speaks in the panels, her clothing and especially

her body posture in many images are anything but modest and demure; instead, they are routinely sexy and even salacious. Her younger sister, Patty-Jo, pushes the boundaries of respectability as well but in a far different area and through very different means. As the recurring premise for each one of Ormes's gag panels reveals, the young girl is routinely startling her sister by making comments that are frank, blunt, and unexpected—but always honest. Moreover, Patty-Jo's outspoken nature knows no limits. The young girl is just as likely to comment on an embarrassing breach of etiquette by her sister as she is to make a remark about racial injustice in American society as a whole. Instead of facing opprobrium for her observations, Patty-Jo is a source of amusement and even admiration. The young girl's comments might be unexpected and shocking, but they are always accurate and even insightful.

*Patty-Jo 'n' Ginger* has long been seen as participating in the "kids say the darnedest things" tradition of humor (Jackson 72). The age, race, class, and gender of its main characters, however, reveal that it is engaging in a far different, and far more political, cultural project. Instead of simply repeating a well-known trope about American childhood, the single-panel series explores new models of middle-class Black girlhood. After generations of encouraging respectability as a pathway to sociopolitical power, *Patty-Jo 'n' Ginger* offers a vivid example of the benefits of being iconoclastic. Jackie Ormes's single-panel series appeared in one of the nation's leading Black newspapers in the years directly preceding the civil rights movement. Her popular female characters demonstrate the role that middle-class young people could—and soon would—play in it. This new way of viewing Ormes's series invites us to reconsider the connection that *Patty-Jo 'n' Ginger* has to its historical era and, with it, the comics and cartoonists from it. More specifically, this perspective changes the relationship that Ormes's single-panel series has to the comic that appeared beside it in *The Pittsburgh Courier* and with which it is most often contrasted: Ollie Harrington's *Dark Laughter*.

## Being Both Seen and Heard: Reclaiming Black Girl's Sexuality and Voice in *Patty-Jo 'n' Ginger*

The first half of the twentieth century in the United States was a period of profound change for all Americans but especially for members of its Black community. Events like the First Great Migration, which began in 1910 and extended through 1950, saw more than three million Black men,

women, and children relocate from the South to the North (Gregory). As a result, vibrant Black communities emerged in cities like New York and Chicago. These new geographic configurations precipitated new creative possibilities. The 1920s and 1930s gave rise to a phenomenal cadre of Black writers, musicians, and artists that would collectively be known as the Harlem Renaissance (Huggins 13–51). Finally, but far from insignificantly, the outbreak of the Second World War created an array of new economic opportunities. In June 1941, the passage of Executive Order 8802 mandated desegregation in the nation's defense industry and opened up thousands of jobs to Black workers (Zelizer 32–50). In light of these changes, Black life in the United States by the mid-1940s was so wholly different from how it had been in 1900 that it was almost unrecognizable. While the Black community still faced many forms of both de jure and de facto discrimination, an array of profound transformations had occurred in American society.

In spite of the changes taking place in Black communities during the opening half of the twentieth century, one element remained constant: the commitment to respectability politics. Akin to many other minoritized groups in the United States, this ethos was regarded as an effective means to combat prejudice and gain acceptance into mainstream white American society. By conforming to codes of conduct that were regarded as "proper" and "decent," Black Americans believed that they would no longer be seen as "other" and, over time, would achieve full enfranchisement (Drake and Cayton 520–540). As a result, from the time of Reconstruction, members of the Black community were encouraged to speak, dress, and behave in a "respectable" manner: in short, in ways that conformed to white, middle-class American values (Drake and Cayton 531).

While all members of the Black community were urged to adhere to notions of respectability, such codes of conduct were regarded as especially important for young Black girls. As Nazera Sadiq Wright, Marcia Chatelain, and Robin Bernstein have all discussed, these figures were imperiled by not only their race but also their gender. They faced the simultaneous hurdles of racism and sexism, along with the ways that such disparaging attitudes combined as misogynoir. Whereas young white girls in the United States were widely seen as pure, innocent, and even angelic, their Black counterparts were just as routinely regarded as lacking these traits. As Bernstein has documented, beginning in the nineteenth century, childhood innocence "was raced white" (4). Examples from print, popular, and material culture revealed that "a representation of a [B]lack child could seem adorable but not innocent" (Bernstein 35). Being seen as cute was not the

same as being viewed as guileless. Black children in general and Black girls in particular were regarded as mischievous, unruly, and even incorrigible (Bernstein 33–36). Echoing hegemonic attitudes about both childhood and femininity, young white girls were seen as blissfully unaware, rightfully oblivious, and appropriately ignorant of any "adult" issues. By contrast, their Black counterparts were viewed as "prematurely knowing" (Wright, *Black* 61). The precocity of young Black girls included the issue of sexuality. Echoing the misogynoir stereotype of the promiscuous Jezebel, these figures were regarded as sexually aware, sexually interested, and—above all—sexually available. Consequently, "Hostile whites did not deem Black girls capable of innocence or worthy of protection" (Wright, *Black* 61). Black girls were seen as not simply unfeminine, but oftentimes, they were regarded as not even children. In the words of Bernstein once again, misogynoir located young Black girls "out of innocence and therefore out of childhood itself" (16).

Given this history, young Black girls in the United States faced added pressure to conduct themselves in "respectable" ways. In light of the derogatory stereotypes about their race and their gender—as well as the way in which such attitudes put them in danger of facing both verbal street harassment and even physical violence—it was imperative for them to dress modestly, speak politely, and behave in demure ways. Nazera Sadiq Wright has discussed how messages about appropriate conduct for young girls, along with chastisements for not adhering to these standards, permeated an array of print sources throughout the nineteenth and early twentieth centuries, ranging from advice guides, conduct manuals, and novels to poems, plays, and articles in newspapers and magazines (*Black* 130–155). While the specific mode of delivery varied, the content remained the same: young Black girls were to behave in ways that reflected middle-class white American values and especially gender norms (Wright, *Black* 3). To that end, young Black girls were not to be outspoken or opinionated. Additionally, they were never to be coy or coquettish (Wright, *Black* 3–13). In both their actions and their attire, they were to be reserved, refined, and even retiring. The ability of young Black girls to be seen as respectable was regarded as important for the "serious issues of safety and survival" in their daily lives as well as for the racial uplift of Black Americans as a whole (Wright, *Black* 61).

*Patty-Jo 'n' Ginger* was published in the midst of such concerns, and it engaged with them. Ormes never directly states the age of either one of her title characters. Patty-Jo has been variously described as being five years old (Goldstein, *Jackie* vii), six years old ("Celebrating"), and even eleven years old (Marulli). Along those same lines, Ginger is presented as a college student

in some comics; meanwhile, in panels that appear later in the series, she is shown still attending high school (Goldstein, "Fashion" 100). Regardless of the specific age of either title character, both are young Black girls, not grown adult women. Even in the panels where Ginger is cast as a college student, she is unmarried, lives at home, and spends most of her time with her younger sibling rather than her same-age peers.

Patty-Jo and Ginger are firmly located within the realm of Black girlhood, and they conform to many of its expectations regarding respectability. Whether out in public or at home in private, both girls always look not simply presentable but impeccable. Their hair is neatly styled, and their clothing is clean, pressed, and well fitting. Moreover, even though Patty-Jo is a kindergarten-aged youngster, she is almost never shown as unkempt. Even when she is playing outdoors, her attire is not torn, soiled, or even disheveled. Additionally, her hands and face are free of the dirt, grass, or food stains that are so common among young children. Finally, Patty-Jo's hair is rarely out of place.

Although Patty-Jo and Ginger conform to many of the expectations regarding respectability for young Black girls, they defy others. Readers of Ormes's comic, for example, likely noticed that Ginger's outfits are not always modest; on the contrary, they are routinely revealing. As Pamela A. Parmal has discussed, the length of hemlines went down in the late 1940s. Long, full skirts were a sign of "the profligate use of material after the deprivations of the war" (Parmal). Ginger's dresses, however, are routinely knee length or shorter. Of course, these hemlines allow Ginger to show off her shapely legs. A number of other *Patty-Jo 'n' Ginger* comics take this phenomenon one step further: these panels are set inside Ginger's bedroom as she is getting dressed, and they use this scenario to present the beautiful young woman in a scantily clad way. In these installments, Ginger is often presented in her bra and panties or a chemise as she decides what to wear.

Together with dressing in an alluring manner, Ginger also conducts herself in an analogous way. As Nancy Goldstein has discussed, the older sister often poses like a pinup girl: her arms are raised above her head, her legs are lifted and crossed, and her face has a come-hither look (*Jackie* 98–100). Rather than trying to obfuscate or even downplay Ginger's sexuality, Ormes is showcasing and even celebrating it.

Even in comics where Ginger is fully clothed, she is presented in ways that call attention to her overall aesthetic beauty and especially to her highly attractive body: Ginger's necklines reveal ample cleavage, her focalization is sexually suggestive, and the way she is positioned invites the gaze. In these

images, Ginger goes beyond simply mirroring postwar pinups; she enters the realm of what Nancy Goldstein terms the "unabashed cheesecake" (*Jackie* 99).

In the hands of a white cartoonist—or a Black male one—such depictions would be voyeuristic and even exploitative. They would seem like an obvious ploy to catch the attention of male readers. In the work of Ormes, however, these drawings carry a different connotation. Adolescence in general and the teenage years in particular are a time when many young girls, regardless of their race, explore their sexuality. This period is one in which they develop romantic interests and begin dating. For many, it is also the time when they wish to dress and carry themselves in ways that call attention to themselves and their bodies. Indeed, behaviors like wearing makeup, donning a tight sweater, or going out in a short skirt are so common among teenage girls that they have become clichés. Young white women in the postwar years were free to explore, experience, and enjoy their budding sexuality. In many ways, in fact, doing so was regarded as a coming-of-age rite during high school and college. Jackie Ormes's presentation of Ginger makes a case that young Black girls should possess the same ability. Instead of being held to strict codes of modesty, the protagonist should have the same freedom as her white peers to investigate, experiment with, and celebrate her sexuality.

Patty-Jo likewise defies the era's conventions of respectability for young Black girls but in a far different way. As a prepubescent youngster, Patty-Jo doesn't challenge these precepts with her sexuality; she does so with her speech. The elementary-aged character might look cute, demure, and adorable, but she does not behave in a similar way. During a time when young Black girls were expected to be quiet, reserved, and polite, Patty-Jo was opinionated, outspoken, and often blunt. This trait emerges from the very first installment of *Patty-Jo 'n' Ginger* (see Fig. 5.1). The debut panel, which was published on September 1, 1945, shows the two title characters standing in the hallway of their home. Patty-Jo is clearly unhappy: her hands are on her hips, her face is compressed into a scowl, and she is tapping her left foot. The line of dialogue that appears at the bottom of the panel reveals the reason for the young girl's mood: "Now that the war is over, I guess I'll see what the man shortage had to do with that no-nickel Jody we've been puttin' up with!" (qtd. in Goldstein, *Jackie* 7). Her older sister, Ginger, is startled by her sibling's frank and precocious comment. Ginger's face, which is presented in profile, has a look of surprise and even shock: her eyebrows are raised, and her mouth is open as if in disbelief. Moreover, Patty-Jo's remarks have stopped Ginger in her tracks. The young woman's right arm is angled away

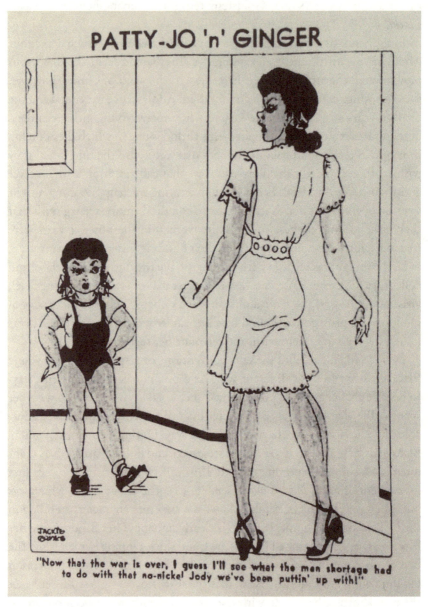

FIG. 5.1 "Now that the war is over," in *Patty-Jo 'n' Ginger* by Jackie Ormes. Originally published in *The Pittsburgh Courier* on September 1, 1945. Republished in Nancy Goldstein's *Jackie Ormes: The First African American Woman Cartoonist* (U of Michigan P, 2008), 87.

from her side, and her wrist and fingers are bent in an awkward manner, as if she is recoiling. Meanwhile, her legs and feet are also in an odd position, giving the impression that Ginger halted midstride.

Patty-Jo's frank, blunt, unfiltered comments are not confined to the private space of the home she shares with her family. In an even bigger breach of the standards of decorum for young Black girls, she also makes such remarks in public. In the comic that appeared on October 18, 1947, for example, the pair goes to the movies. When the usher attempts to show a female patron to an empty seat beside Ginger, the young girl blurts out, "Oh!—But she can't sit here! We're holding this seat for a man . . . Any cute one!" (qtd. in Goldstein, *Jackie* 96). Although truthful, this remark embarrasses her sister. Similarly, when the pair visits a taxidermy shop, Patty-Jo makes another unflattering disclosure, this time about her older sister's culinary skills—or rather, lack thereof. "G'won . . . Ask him somethin'," Patty-Jo tells her sister about the clerk standing behind the display case. "You know what a mess you made of that chicken you stuffed Sunday!" (qtd. in Goldstein, *Jackie* 100). Patty-Jo is the source of chagrin for her older sister once again in the panel that appeared on March 12, 1949. The pair is walking out of a movie theater, and Ginger has apparently just asked Patty-Jo what she liked best about the film. Patty-Jo's answer, however, is not what her sister anticipated. "I 'specially liked the part where the lady in front told you an' Jeannie to shut your mouth!" she says matter-of-factly as the two stroll toward the exit (qtd. in Goldstein, *Jackie* 104). As this overview demonstrates, much of the humor in *Patty-Jo 'n' Ginger* comes from the young protagonist directly and unashamedly saying things that the era's manners and mores—especially for young Black girls—dictate ought to be left unsaid. Moreover, not only does Patty-Jo utter these remarks, but she does so directly, openly, and without embarrassment.

As Ormes's series progressed, so too did Patty-Jo's outspoken nature. Before long, the young girl was not simply making frank comments about quotidian issues like her sister's poor culinary skills, penchant for gossiping, or desire to meet a handsome man; instead, she was making equally blunt observations about major sociopolitical events such as U.S. foreign policy, nuclear proliferation, and the Cold War. In the panel that appeared on July 5, 1947, for example, the young girl and her older sister are standing on the sidewalk outside a local store. Big letters on the shop's front window make the following announcement to potential customers as the July 4 holiday approaches: "Sorry! No Fireworks," it says (qtd. in Goldstein, *Jackie* 93). Having seen this information, young Patty-Jo turns to her sister and

points out a compelling paradox. "Shucks—Let's go price Atom Bombs—" she quips. "They haven't outlawed **them** yet!!!" (qtd. in Goldstein, *Jackie* 93; bold in original). The elementary-aged girl recognizes not simply the irony but the absurdity of fireworks being restricted while nuclear weapons are being stockpiled in the United States and proliferating around the globe.

A few months later, Patty-Jo is even more frank about an issue that is even more sensitive: the national hysteria over communism. The panel, which was published on November 1, 1947, shows the young girl and her older sister wearing matching witch costumes at a Halloween party. In a comment that connects Ginger's desire to become an actress to the film industry's efforts to find and expel communists, Patty-Jo assures Ginger, "You'll be GLAD we came as witches—wait an' see! I understand some Hollywood scouts are simply HUNTING them these days!" (Ormes, qtd. in Goldstein, *Jackie* 97). This comic was not the only time that Patty-Jo engaged with this issue. The panel that appeared on April 23, 1949, addresses it again. The young Black girl is crossing the street with her older sister when she sees an open manhole accompanied by the sign "Men at Work" (qtd. in Goldstein, *Jackie* 106). In comments that are equal parts sharp and scandalous, she points to the construction zone and says, "What'd I tell you? ... underground workers ... jus' wait till the un-American Committee hears about this!" (qtd. in Goldstein, *Jackie* 106). Ginger responds with her signature look of surprise and even shock: her mouth hangs open, and she appears to have stopped in her tracks.

In these and other depictions of Patty-Jo and Ginger, Ormes takes prevailing beliefs about Blackness and innocence and reconfigures them as an asset rather than a liability. For generations, young Black girls had been seen as knowing, precocious, and unruly by white Americans regardless of how respectably they looked, spoke, or acted. Rather than continue the futile effort to refute such viewpoints, Ormes's comic makes a case for embracing them. White Americans were going to see young Black girls as lacking social and sexual innocence, so they might as well showcase and even celebrate their knowledge. Ginger knows that her Black body is beautiful, so why pretend otherwise? Likewise, Patty-Jo is acutely aware of the nation's social ills, so why feign being naive? Instead of confining themselves to strict notions of respectability, Ormes's protagonists embrace the freedom to be who they are. Patty-Jo and Ginger trade being "respectable" and "polite" for being honest and authentic.

For much of the twentieth century, boys and girls in the United States were often told, "Children are to be seen, not heard." This dictum echoed the prevailing societal belief that both public and private spaces rightly

belonged to adults, not young people. Thus, children ought not to be too vocal, visible, or demanding. This sentiment was especially true for young Black girls, who faced the obstacles not simply of gender and age but also of race. Jackie Ormes's *Patty-Jo 'n' Ginger* questions, challenges, and even defines these codes. Ginger, with her alluring attire, boldly makes herself seen; meanwhile, her younger sister, Patty-Jo, with her outspoken comments, bravely makes herself heard.

Nazera Sadiq Wright, in her book *Black Girlhood in the Nineteenth Century*, made the following observation about the autobiography of Harriet Jacobs: "Black women writers reimagined the tight, tortuous spaces of attics, garrets, and storerooms as regenerative. In these spaces, Black girls can think, imagine, and plan" (Wright, *Black* 91). Although these locales were physically confining, they were intellectually, psychologically, and emotionally freeing. In a powerful paradox, such places of detention were also ones where Black women could dream.

The single-panel comic, of course, is a confining space. After all, cartoonists have only one frame in which to both draw their image and relay their text. For this reason, many artists have eschewed creating single-panel comics because the form is too constricting.

Jackie Ormes's *Patty-Jo 'n' Ginger* demonstrates the way in which the limited physical space of the single-panel comic can open up new possibilities. Echoing Wright's observations about the work of nineteenth-century Black writers like Harriet Jacobs, the series demonstrates how the ostensibly confining space of the single-panel format can be an arena where "[B]lack girls can think, imagine, and plan" (*Black* 91). For Patty-Jo and Ginger, it is also a place of reclamation, expression, and celebration. By allowing her protagonists to be fully themselves, the single-panel comic also allows both characters to be something that white America had long denied Black girls: the ability to be fully human.

## Not "Style over Substance" but Substance with Style: *Patty-Jo 'n' Ginger* and the Black Bourgeoisie

At the same time that young Black girls in the mid-twentieth century were being encouraged to behave in ways that were regarded as "respectable," another segment of the community was being criticized for taking this ethos too far: the Black upper classes or, as they were more commonly known then, the Black bourgeoisie.

For generations, as Will Cooley has discussed, successful Black Americans "took on leading roles in the freedom struggle" (Cooley 3). They used their financial resources as well as social and political clout to combat racism and work for social justice. From serving as community leaders and founding charitable organizations to mentoring youth and fighting both de jure and de facto forms of racism, successful Black Americans occupied the vanguard in the fight for civil rights (Cooley 3–20).

By the mid-twentieth century, however, this sense of responsibility had waned. St. Clair Drake and Horace R. Cayton, in their epic study of Black life in Chicago, *Black Metropolis* (1945), said about this new cadre of middle- and upper-class Blacks, "Politically, these persons were conservative" (531). Perhaps because of the hardships faced during the Great Depression, or perhaps in response to witnessing previous generations engage in an arduous fight for civil rights with little demonstrable change, the Black upper classes turned away from causes in social justice and toward activities in high society. In the words of Drake and Cayton again, members of the Black elite "were concerned with 'refinement,' 'culture,' and graceful living as a class-ideal" (Drake and Cayton 531).

Such observations applied to locations outside of Chicago. The postwar era brought unprecedented economic prosperity to the United States. As a result, the Black middle and upper classes expanded in both size and power during this period. That said, the bulk of work for civil rights during the 1950s was being performed by members of the Black working class, not the Black elite. As Bart Landry points out, "The Montgomery bus boycott had been led by a young, middle-class minister, Martin Luther King, Jr., but it was sustained by poor [B]lacks of the city, domestics, garbage collectors, and unskilled laborers as well as [B]lacks of other classes" (*New* 71). Members of the Black upper class did not ride public transportation to or from work; they drove in their automobiles. As a result, they were largely uninvolved with the bus boycott. Given this situation, many lamented how "the [B]lack middle class . . . lost its sense of radical politics and sense of responsibility toward those of the [B]lack community who are poor" (Johnson, "Foreword" xviii).

These viewpoints reached their apex in 1957, with the appearance of E. Franklin Frazier's *Black Bourgeoisie*. Originally published in France in 1955, the volume was an immediate sensation when it appeared in the United States. The book was also immediately controversial. *Black Bourgeoisie* offered nothing short of a "scathing criticism of the values and behavior of the members of the [B]ack middle class" (Landry, "Reinterpretation"

211). Frazier argued that "the [B]lack bourgeoisie do not really wish to be identified with Negroes" (Frazier 215–216). Instead, the group seeks "to gain acceptance by whites" (Frazier 235). As a result, the Black bourgeoisie "failed to play the role of a responsible elite in the Negro community" (Frazier 235). Instead of attending events concerning racial uplift, they attended fashion shows. Rather than going to marches, they went to cotillions. In the place of planning the next challenge to Jim Crow, they planned debutante balls. Of course, as Frazier points out, no matter how much Black elites mimic upper-class whites, they will never be accepted by them. This dual rejection—first, of their own Black identity and then, by white society—causes these men and women to "escape into delusions" (Frazier 229). As Frazier damningly decrees, the lives of the Black bourgeoisie can be characterized as "status without substance" (Frazier 195).

Jackie Ormes was a member of the Black bourgeoisie in Chicago. The cartoonist moved to the South Side in the 1940s when her husband began working as a manager for the historic DuSable Hotel. The property was one of the most prestigious during this era, "hosting a veritable who's who of Black performers, artists, and writers visiting the city" (Williams). Through her husband's position at the DuSable, Ormes "rubbed elbows with leading political figures and entertainers who passed through the city and stayed at the hotel" (Levins). The cartoonist not only met but became good friends with Lena Horne, Sarah Vaughn, and Eartha Kitt (On; Williams). Later, her husband would work for the equally posh Sutherland Hotel. As Nancy Goldstein has noted, the property "featured a jazz club and a dinner-dance ballroom" (*Jackie* 127). Moreover, Ormes and her husband lived on-site at the Sutherland, affording her greater opportunities to socialize with the famous guests who both performed and stayed there.

Jackie Ormes was involved with Black high society beyond her husband's contacts at the DuSable and Sutherland Hotels. As Anthony Letizia has discussed, she "ingratiated herself into the music, fashion and artistic communities of Chicago" (Letizia). A self-described "style maven" who was always impeccably dressed, Ormes organized fashion shows at the famed Marshall Fields Department Store, and she also occasionally "modeled for the company's shoe advertising" (Goldstein, "Fashion" 110). Trained as a journalist, Ormes wrote about these events in a column for *The Chicago Defender*. Called "Social Whirl" and published under her full legal name "Zelda J. Ormes," the series "recounted the comings and goings of fashionable people and promoted community affairs as well" (Goldstein, *Jackie* 25). The column, of course, also earned Ormes entrée into an array of additional

society events, including debutante balls, exclusive parties, and even a reception for Pulitzer Prize–winning playwright Lorraine Hansberry (Goldstein, *Jackie* 25). As this brief overview reveals, "Ormes was celebrated in Chicago's [B]lack social and fashion circles" (Edeh). By any social measure or cultural metric, the cartoonist was "a member of Chicago's [B]lack elite" (Levins).

Ormes's class status is reflected in *Patty-Jo 'n' Ginger*. More than simply dressing her two title characters in a manner that is respectable, the attire of the duo signals that they are members of the upper class. As Nancy Goldstein has documented, many of the skirts, blouses, and gowns that Ginger wears are from the current season of designers like Christian Dior (*Jackie* 86). Moreover, in a variety of panels, Ginger's fashionable clothes take center stage: her silk dress, tailored gown, and alpaca skirt. Nancy Goldstein has even speculated that Ormes's interest in Ginger's fashions may have played a role in the format that she chose for the series. After all, "the larger single panel . . . gave Jackie Ormes sufficient space to feature details of Ginger's fashions, hairstyles, and bodily contours" (Goldstein, *Jackie* 62).[2] The primary focus of each panel, of course, was Patty-Jo's gag, but Ginger's chic outfit also held great import.

Patty-Jo was just as well dressed as her older sister. In the apt words of Goldstein, "No other child in cartoon history had a wardrobe comparable to Patty-Jo's" (*Jackie* 86). Whereas other young female protagonists in newspaper comic strips wore the same signature outfit in every installment—Little Lulu's Peter Pan collared dress, Nancy's black sweater vest, Little Orphan Annie's red dress, and so on—Patty-Jo rarely donned the same garment twice (Goldstein, *Jackie* 86–87). Although readers never see the young child's closet, it was clearly "chock-full of shoes, hats, dresses, pinafores, nightgowns, robes, and skating and cowgirl costumes, as well as all manner of sunsuits and winter and spring coat sets" (Goldstein, *Jackie* 87). Akin to her older sister—and echoing the cartoonist's own interest in fashion—many of Patty-Jo's outfits reflect the latest styles, fabrics, and trends. The character's extensive wardrobe "no doubt [made] her the best-dressed child in all of cartoon history" (Goldstein, "Fashion" 109). At the very least, Patty-Jo was the biggest elementary-aged clothes horse in American comics.

That said, the fashions worn by Patty-Jo and Ginger were not the only elements that connected them with the Black bourgeoisie. So too did the décor in their home. Each room is not simply tastefully furnished but exquisitely appointed. The chairs, tables, rugs, beds, sofas, drapes, knickknacks, and wall hangings are aesthetically elegant, pleasingly placed, and—despite

the fact that a young child lives in the home—in flawless condition. Additionally, as Goldstein has discussed, some pieces of furniture are not imaginative renderings but drawings of actual items by esteemed designers. The comic that appeared on June 21, 1952, for example, features a "glass-top coffee table designed by Isamu Nogushi" (Goldstein, *Jackie* 123). Similarly, the comic that appeared on May 15, 1954, features a chest of drawers "that is by Heywood-Wakefield, furniture that in the era typified style and class" (Goldstein, *Jackie* 127). As Goldstein goes on to note, many other Heywood-Wakefield pieces appear in Ormes's series (*Jackie* 127). Moreover, some of these items were ones that the cartoonist owned herself.

Patty-Jo and Ginger's upper-class taste and lifestyle do not cease when they leave home. The locales that the duo visits and the activities in which they engage are just as indicative of the Black bourgeoisie. In the comics that appeared on September 24, 1949, and December 17, 1956, for example, the girls examine paintings in an art museum (qtd. in Goldstein, *Jackie* 110, 129). Moreover, in the panel that was published on July 12, 1952, Patty-Jo and a young pal visit the elegant Chicago hotel that was hosting the Republican National Convention (qtd. in Goldstein, *Jackie* 124). Finally, in a variety of comics, Ginger is getting ready to attend a posh party, dinner at a fancy restaurant, or an evening at the theater.

Although both Patty-Jo and Ginger are firmly connected with the actions, activities, and accouterments of the Black bourgeoisie from a class standpoint, they do not conform to prevailing beliefs about this demographic's attitudes regarding race. The fact that Ormes's title characters possess a highbrow cultural style does not mean that they lack sociopolitical substance. Ginger largely functions as the silent "straight man" to her younger sister, but her tacit nature ought not to be confused with empty-headedness. On the contrary, the young Black woman is both politically aware and politically active. In the panel that appeared on November 2, 1946, for example, Ginger carries a demonstration sign beside her younger sister on election day. In a commentary about the many men and women who forgo voting when it rains or snows, her placard reads, "X-er-cise your ballot, weather or not!" (qtd. in Goldstein, *Jackie* 91). The letter *X* appears inside a rectangle to look like the mark on a ballot.

This panel is certainly not the only time that Ginger engages in work that can be connected with racial uplift. In the comic that appeared on June 26, 1948, the young woman is wearing a lovely dress and about to leave the house. Ginger is not on her way to a fancy party, elegant dinner, or exciting date. Instead, she is going door-to-door to raise money for Black students.

A booklet that she is holding in her right hand reads "Negro College Fund." Lest any doubt remains about Ginger's plans for the evening, as she pushes the door open with her left hand, she drops a number of cards with the word "PLEDGE" written on them (qtd. in Goldstein, *Jackie* 100).

Patty-Jo takes such endeavors even further. Many of her blunt, frank, and even startling comments call out racism and injustice. Once again, such moments can be traced back to the early days of the series. In the panel that appeared on August 31, 1946, Patty-Jo talks to a young girl around her age (see Fig. 5.2). The playmate is white and is leaning against a playroom constructed with scrap plywood on the back of a roadside billboard. The name of the clubhouse is written in childish scrawl above the doorway: "Little Lilly Club," it says. Given the race of the playmate, the word "Lilly" surely evokes the racially charged phrase "lily-white" and thereby signals conceptions about not only white racial purity but also the redlining of postwar housing developments. The young white girl is dressed quite shabbily: her skirt is patched, her outfit is mismatched, and her hair is mussed. Additionally, empty tin cans litter the ground behind her. By contrast, Patty-Jo's appearance is impeccable: her hair is neatly styled, her pleated skirt is freshly pressed, and her white peacoat is spotless. Patty-Jo is holding a glass jar containing a tiny insect that is labeled "ONE LOUSE!" (qtd. in Goldstein, *Jackie* 90). This detail is important, for the young girl's comments that appear in the caption at the bottom of the image reference this creature. "I told sis about visiting your exclusive neighborhood club-house yesterday," Patty-Jo says, "so she figured I better return this little member that followed me home" (qtd. in Goldstein, *Jackie* 90). In marked contrast to longstanding racist stereotypes that Black families are unclean and their children are dirty, Ormes's protagonist reveals that her unkempt white playmate is the one who has lice. For a young Black girl to openly state this fact—and bring along the visual evidence to prove it—is not simply surprising but shocking. Most would feel that it would be more polite and more pragmatic not to say anything about it—and certainly not to confront the white child directly. Rather, to maintain respectability and also to avoid backlash, it was best to keep this information to themselves.

This comic is not the only time that Patty-Jo engages with racism. A multitude of other panels over the course of Ormes's series address the topic. Although the precise form of injustice being addressed in each panel differs, Patty-Jo's engagement with it contains the same level of unflinching candor. The comic that appeared on April 7, 1951, for example, spotlights segregation (see Fig. 5.3). The drawing shows Patty-Jo and Ginger at a movie theater.

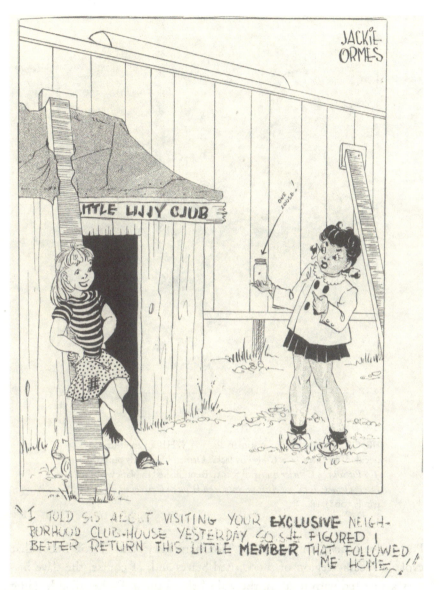

FIG. 5.2 "I told sis about visiting your exclusive neighborhood club-house," in *Patty-Jo 'n' Ginger* by Jackie Ormes. Originally published in *The Pittsburgh Courier* on August 31, 1946. Republished in Nancy Goldstein's *Jackie Ormes: The First African American Woman Cartoonist* (U of Michigan P, 2008), 90.

"It would be interestin' to discover WHICH committee decided it was un-American to be COLORED!"

FIG. 5.3 "It would be interestin' to discover WHICH committee decided," in *Patty-Jo 'n' Ginger* by Jackie Ormes. Originally published in *The Pittsburgh Courier* on April 7, 1951. Republished in Nancy Goldstein's *Jackie Ormes: The First African American Woman Cartoonist* (U of Michigan P, 2008), 118.

Posters for films with names like "Southern Fury" and "Dixie Belle" that evoke a specific region of the United States and, of course, the slave history associated with it adorn the walls behind them. Rather than heading into the main lobby of the theater, Patty-Jo and Ginger are walking down a side hallway. A sign that reads "REAR DOOR" on the right side of the image reveals why: the duo must use a separate entrance to the theater, the one designated for Black patrons. Patty-Jo has an opinion about this situation and—in keeping with her outspoken nature—does not hesitate to vocalize it. "It would be interestin' to discover WHICH committee decided

it was un-American to be COLORED!" she announces to her sister (qtd. in Goldstein, *Jackie* 118; all caps in original). This remark goes beyond being precocious; it is provocative. The young girl is arguing that segregation is not merely inherently unequal; she asserts that the practice is thoroughly un-American. The context for Patty-Jo's remark, of course, is just as shocking as its content. The Black girl utters this observation in public, where other people, including whites, can hear her.

The racial bias that Patty-Jo encounters in public school is another common subject throughout the series. The comic that appeared on October 23, 1948, shows the young girl walking out of the building at the end of the school day. As she approaches her older sister, she relays an experience from class: "Guess what, Sis. Miss Loyalouse says our school is 'WAY behind the times . . . Mostly on account of we're still using old OLD picture lessons showin' ALL races are EQUAL" (qtd. in Goldstein, *Jackie* 102; all caps in original). The young girl's remarks are astute for several reasons. First, they call attention to the fact that schools in Black neighborhoods often have outdated instructional materials. Second, and even more daringly, they assert that the rights and freedoms of Black people in the United States have worsened over time rather than improved. Ginger responds with a look of surprise and even shock. Her mouth is hanging open, and her eyes are opened wide in dismay, likely not because she disagrees with her sister but because her remark was said aloud in public.

This comic, however, is far from Patty-Jo's most controversial as well as radical commentary about race. That distinction belongs to the panel that appeared on October 8, 1955, when the young girl references the murder of Emmett Till in Mississippi (see Fig. 5.4). In what has become an oft-repeated story, earlier that summer, the fourteen-year-old Black boy was kidnaped in the middle of the night by three white men for allegedly whistling at a white woman—the wife of one of the assailants—earlier that day. The trio beat the adolescent who was visiting from Chicago, shot him, and then dumped his body in the Tallahatchie River, weighing it down with a heavy industrial fan. When his remains were discovered a few days later, Till's face had been so brutalized that he was nearly unrecognizable. His body was returned home to Chicago, and his mother made the bold decision to have an open casket at the funeral service; she wanted everyone to see what the perpetrators had done to her son. *Jet* magazine ran a photograph of the young boy's battered, swollen, and disfigured face. The image was reproduced in newspapers across the nation, becoming a symbol of the long history of violence against Blacks in the South. Indeed, Till's death was not simply a murder; it

FIG. 5.4 "I don't want to seem touchy on the subject..." in *Patty-Jo 'n' Ginger* by Jackie Ormes. Originally published in *The Pittsburgh Courier* on October 8, 1955. Republished in Nancy Goldstein's *Jackie Ormes: The First African American Woman Cartoonist* (U of Michigan P, 2008), 128.

was a lynching. In so doing, it served as a powerful catalyst for the era's civil rights movement.³

Jackie Ormes was living in Chicago at the time of Emmett Till's death. Thus, while the event made headlines around the United States, it likely had added poignancy for the cartoonist. Ormes's comic appeared several months after Till's funeral, but the investigation into his murder was still making headlines, especially in the Black press. In a seeming nod to this fact, one of the first details that readers might notice about Ormes's image is that

Ginger is hiding a newspaper behind her back, as if to prevent her young sister from seeing the headline. One can presume that the article is upsetting and perhaps even graphic. Patty-Jo's comments, however, reveal that she is already aware of the details of the case. The young girl walks into the living room and announces to her sister, "I don't want to seem touchy on the subject . . . but, that new little white tea-kettle just whistled at me!" (qtd. in Goldstein, *Jackie* 128). These comments, of course, go far beyond simply satirizing the alleged inciting incident in the Till case. On the contrary, they also reconfigure and even reimagine them in a way that is both gendered and raced. The American South had a long history of lynching Black boys and men like Emmett Till who were accused or even suspected of making sexual advances toward white women. Patty-Jo's comments call attention to the fact that white men—symbolically represented here as the white teakettle—had a long history of making sexual advances toward Black girls and women. Moreover, when these incidents occurred, the white perpetrators were rarely punished. Patty-Jo's comments courageously call attention to the preposterous justification for murdering young Emmett Till while they simultaneously call attention to the long equally long and brutal history of sexual harassment, assault, and even rape of Black girls and women by white men.

In the coming years, as the civil rights movement gained momentum, *Patty-Jo 'n' Ginger* would often engage with it. The panel that appeared on March 31, 1956, for example, referenced one of its most landmark events: the Montgomery bus boycott (see Fig. 5.5). The image shows Ormes's two title characters at home in their living room. Ginger is sitting on an ottoman reading the newspaper. Meanwhile, Patty-Jo crosses the room, dressed in play clothes. Both of the young girl's hands are full, and she has an additional, boxlike item tucked under her right arm. Lest readers can't make out the objects that Patty-Jo is bringing into the house, Ormes has included the words "ROLLER SKATES" with an arrow pointing to the object in her left hand. The caption at the bottom of the image explains why Patty-Jo has brought her skates—and a box—inside: "You guessed it! Bundle for the South . . . Montgomery, Ala., that is!" (qtd. in Goldstein, *Jackie* 130). The boycott of the municipal bus system in the Southern Black city began on December 5, 1955, in response to Rosa Parks's arrest for refusing to give up her seat to a white passenger. In the weeks and months that followed, the Black community organized a myriad means of alternative transportation, from car pools, taxis, and bicycles to private vans, ride shares, and church

FIG. 5.5 "You guessed it! Bundle for the South..." in *Patty-Jo 'n' Ginger* by Jackie Ormes. Originally published in *The Pittsburgh Courier* on March 31, 1956. Republished in Nancy Goldstein's *Jackie Ormes: The First African American Woman Cartoonist* (U of Michigan P, 2008), 130.

shuttles. Now Patty-Jo is offering her roller skates to the cause. Although amusing, it nevertheless shows the young girl's awareness of the events in Montgomery and—even more importantly—her support for them. Far from being disinterested in—or even distancing herself from—the struggles of her race as a member of the Black bourgeoisie, Patty-Jo demonstrates her solidarity with it. More than simply saying that she agrees with the bus boycott, she is willing to send her own material possessions to help the cause.

The message contained in this comic is amplified by the fact that Ormes's series did not appear regularly during this period. As Nancy Goldstein has documented, by the spring of 1956, new installments of *Patty-Jo 'n'*

*Ginger* were being published only sporadically (*Jackie* 130). In some respects, the weekly comic ceased appearing for a purely pragmatic reason; Ormes was simply busy with other professional projects, including her multipanel strip *Torchy in "Heartbeats,"* her oil painting, and her work in journalism. At the same time, though, a personal problem also contributed to these gaps in the series: the cartoonist was experiencing health problems caused by rheumatoid arthritis. Consequently, her hands were often too stiff, sore, and painful for her to work. Within a year, the discomfort would become so severe that Ormes would retire from cartooning altogether. During these final few months of her career, Ormes would create a *Patty-Jo 'n' Ginger* comic only when she felt particularly inspired by an idea or moved by an issue (Goldstein, *Jackie* 130). The message of the panel had to be worth the physical pain that she would experience while producing it.

The final *Patty-Jo 'n' Ginger* comic was published in *The Pittsburgh Courier* on September 22, 1956 (see Fig. 5.6). In a detail that is too significant to be merely coincidental, the topic that the cartoonist chose for this closing installment was civil rights. The two title characters are standing in their living room with its fine furnishings and fancy decor, talking. The young girl is holding a folded newspaper and gesturing toward her older sibling. The caption at the bottom of the image relays Patty-Jo's comment. "So, that's politics!" she exclaims. "Why don't you RUN for a BUS!" Akin to many previous panels, the young girl's remarks contain a double meaning. First and foremost, it evokes the ongoing events in Montgomery, Alabama. The bus boycott was entering its ninth month, and it remained the focus of national attention. That said, Patty-Jo's reference to "running" embeds another meaning: that her sister should consider campaigning for political office. After all, there is a no more effective way to "run" for the busses in Montgomery than to join the ranks of civil leaders who set policies about municipal services. Ginger has turned away from her sister and is facing the reader. In fact, the young woman is looking out from the panel and making direct eye contact with Ormes's audience. Ginger's body posture and eye contact, however, ought not to imply that she is avoiding or ignoring her sister's exultation. On the contrary, Ginger's breaking of the fourth wall draws the reader into the scene—and it implicates them in its subject matter. Her gaze is not a rebuffing stare but an invitation. The young woman's direct eye contact encourages the reader to be more directly engaged with politics and perhaps even to consider running for office themselves.

In this way, Jackie Ormes may bring her comic series to a close, but her final panel reveals the future life trajectory of her two Black female protagonists.

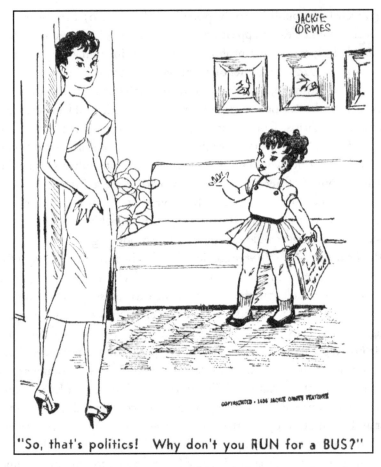

FIG. 5.6 "So, that's politics!" in *Patty-Jo 'n' Ginger* by Jackie Ormes. Originally published in *The Pittsburgh Courier* on September 22, 1956. Republished in Nancy Goldstein's *Jackie Ormes: The First African American Woman Cartoonist* (U of Michigan P, 2008), 130.

Although readers won't receive any more official installments about Ginger and Patty-Jo, the closing comic invites them to imagine the two protagonists productively, happily, and meaningfully occupied with the civil rights movement. Jackie Ormes positions not just Patty-Jo but her sister Ginger as the next generation of political leaders and civil rights participants.

This projected future for Ormes's fictive characters was a lived reality for many factual young Black people. While civil rights efforts during the 1950s were largely organized, conducted, and led by working-class members of the Black community, this situation shifted in the decade that followed. As Bart

Landry has written, "The new wave of protests in the early 1960s was now being led by the sons and daughters of the old middle class and by many who were moving up the class ladder, by students of the traditionally [B]lack colleges of the South, by ministers and other middle-class organizers" (Landry, *New* 71–72). In examples ranging from the Freedom Rides and sit-in demonstrations to voter registration efforts and lunch-counter protests, both the nature of the civil rights efforts and the demographic from which the participants hailed changed dramatically. As James Bracey has commented, by the mid-1960s, "it was the children of the same middle class that Frazier was attacking that led the demonstrations" (qtd. in Young 7).

Jackie Ormes's *Patty-Jo 'n' Ginger* foreshadows these events. Both of her main characters are members of the Black bourgeoisie. However, neither of them adheres to the criticisms levied against this group during the 1940s and 1950s. Instead of being regarded as outliers, however, they can more accurately be viewed as forerunners. Within a few years after the end of Ormes's series, young Black people from the middle and upper classes would be at the center of the civil rights movement.

In the same way that every installment of *Patty-Jo 'n' Ginger* featured a clever verbal gag, it also featured a recurring visual feature: at the bottom of the image, the drawing breaks the border of the frame. Typically, the feature that crosses this boundary is the foot of one of the two title characters. As the eye of the reader moves down to read the caption, they notice that Ginger's high-heeled shoe or both of Patty-Jo's Mary Janes are located outside of the frame. While the cartoonist likely included this detail to give her panels a signature visual appearance, this element also carries a strong symbolic significance. The way that Patty-Jo and Ginger break the physical boundaries of the panel's rectangular frame mirrors the way that they break the behavioral boundaries associated with their race, class, gender, and age.

## From Gag Humor to Dark Laughter: Jackie Ormes and Ollie Harrington

Reconsidering the way in which both Black girlhood and the Black bourgeoisie operate in *Patty-Jo 'n' Ginger* has implications that extend beyond how we view Ormes's popular series; it also invites us to reexamine the relationship that *Patty-Jo 'n' Ginger* has with other comics that appeared during this era. Ormes's work appeared alongside another single-panel series

in *The Pittsburgh Courier*: Ollie Harrington's *Dark Laughter*. Viewing *Patty-Jo 'n' Ginger* as a commentary on Black girlhood and the Black bourgeoisie creates an unexpected kinship with it. Both during the postwar period and into the present day, the work of Ormes and Harrington have been regarded as counterpoints, but they were often in conversation.

Although Jackie Ormes was a popular cartoonist in the Black press during the mid-twentieth century, her colleague Oliver "Ollie" Harrington was the most famous from that era. Langston Hughes, in fact, called him nothing short of "America's greatest African-American cartoonist" (qtd. in Inge xxii). Harrington's career in comics began in the mid-1930s and extended into the 1990s, but his most famous title is the single-panel series, *Dark Laughter*. Making its debut in 1935, the comic chronicled events in the life of a working-class Black male character named "Bootsie," along with his neighbors, family, and friends. As the title "Dark Laughter" suggested, the series did not provide blithe humor. Instead, as Kay Clopton and Jenny E. Robb have written, the installments "attack[ed] racial, economic, and social injustice with razor-sharp wit and insight" (Clopton and Robb). With the protagonist Bootsie functioning as "an observant African-American 'everyman'" (Clopton and Robb), *Dark Laughter* took on subjects like school segregation, voting rights, poverty, redlining, and Jim Crow laws. Moreover, it did so in candid, direct, and unflinching ways. One panel, for example, depicts two young Black children walking on freshly fallen snow. One of the little boys says to the other, "Man, do you realize that if we was in Alabama it would be against the law fer us cullud kids to walk on this stuff" (Harrington 15). Likewise, another installment shows a group of young Black boys in a rowboat in what appears to be Central Park in New York City. As the boys are playing games on the water, one youngster chastises another about his imagined nautical identity: "Well first of all you couldn't be Columbus 'cause white folks wouldn't never let a cullud man discover America!" (Harrington 16). In light of such subject matter, although *Dark Laughter* appeared in the comics section of the newspaper, the series is often seen as a political cartoon that could have easily run on the op-ed page.

Ormes's previous single-panel comic, *Candy* (1945), echoed various facets of *Dark Laughter*. The series appeared on the editorial page of *The Chicago Defender*, and it also featured a central character who was working class. Candy is a domestic maid, and the bulk of panels feature her making cracks at the expense of the wealthy white woman for whom she works. Candy borrows the lady's fine clothing when she goes out on the town, pokes fun at her tacky but expensive decor, and exposes her greediness and hypocrisy

by cheating wartime rationing. In so doing, "Candy establishes her moral superiority over madame" and "invite[s] readers to reflect on the upside-down order of things" (Goldstein, *Jackie* 76)—messages that mirror *Dark Laughter*.

*Candy* was a short-lived series. The comic ran for only four months in the *Defender*, and Ormes was not paid for any of the panels (Goldstein, *Jackie* 33). That said, *Candy* allowed Ormes to sharpen her abilities as a cartoonist, and it also allowed her to experiment with both content and form. Later that year, when Ormes pitched the idea for *Patty-Jo 'n' Ginger* to *The Pittsburgh Courier*, she used Candy as the visual model for Ginger (Goldstein, *Jackie* 76). Of course, her new protagonist rarely spoke. Additionally, she hailed from an upper-class background and did not work. Consequently, while Ginger physically looked like Candy, the similarities ceased there.

Jackie Ormes's new series in *The Pittsburgh Courier* was printed beside the work of Ollie Harrington. *Dark Laughter* and *Patty-Jo 'n' Ginger* embodied powerful contrasts to one another. Although both used the single-panel format, the two series were different in seemingly every other respect: Harrington's core protagonist was a middle-aged man, while Ormes's work featured two title characters who were both young girls. Additionally, Bootsie was working class, whereas Patty-Jo and Ginger were upper class. Finally, and perhaps most significantly of all, *Dark Laughter* directly and consistently offered political commentary; by contrast, *Patty-Jo 'n' Ginger* was primarily seen as a gag panel that "more often focused on topics relating to domestic situations, boyfriends, clothing styles, and human foibles than it did on political topics" (Goldstein, *Jackie* 56). Placing these two seemingly disparate comics next to each other, the *Courier* hoped to appeal to different audiences.

Far from operating independently from Harrington's *Dark Laughter*, Jackie Ormes referenced it in *Patty-Jo 'n' Ginger* on occasion. In the comic that appeared on March 24, 1951, for example, Ormes's young protagonist tells her older sister about an episode that occurred in church that morning: "So, like I said, the Rev. Mr. Holy was leading the congregation in prayer and got us into a wonderful chorus of PEACE MONGERING when Uncle Bootsie yelled 'LAWD an' MR. TRUMAN, TOO!' . . . then a mother jumped straight up an' shouted AMEN . . . that's when the preacher stopped cold an' said: 'This is Easter, Brother Bootsie, let's keep it CLEAN. We don't want no FBI in here!'" (qtd. in Goldstein, *Jackie* 117; all caps in original). The "Mr. Truman" being referenced by Uncle Bootsie, of course, is President Harry S. Truman. Additionally, the desire by Harrington's character for the

commander in chief to engage in "peace mongering" alludes to the current U.S. involvement in the Korean War. That said, while this panel references Uncle Bootsie, the episode functions as a source of humor rather than a moment of solidarity. Patty-Jo doesn't express an esprit de corps with Harrington's protagonist; rather, she recounts this experience to convey comedic unruliness during what ought to have been a solemn church service. Patty-Jo tells this story to highlight how very different Uncle Bootsie is from her, her sister, and the rest of the congregants. Indeed, the behavior of Harrington's character is admonished by the minister himself.

Recognizing and exploring the way in which Ormes's series defies the expectations of Black girlhood and the Black bourgeoisie creates a kinship between her single-panel work and that of Ollie Harrington. Contrary to long-standing perceptions about the different aim, intent, and subject matter of *Patty-Jo 'n' Ginger*, the comic takes up similar topics and engages in similar forms of sociopolitical work. From the panels that address the inequity of public schools to ones that call attention to the injustices of Jim Crow, Ormes's ostensible "gag panels" offer many moments of Harringtonesque "dark laughter."

A few installments of *Patty-Jo 'n' Ginger* resemble *Dark Laughter* more closely. Although Ormes's series generally takes place in the posh settings of the well-to-do, these panels engage with problems facing the Black working class. Patty-Jo has a playmate, Benjie, whose family struggles economically. Comics featuring this young boy—whether he is directly depicted in the panel or merely evoked offstage—call attention to issues like poverty, food insecurity, and the substandard housing conditions experienced by many Black families. The comic that appeared on October 22, 1949 offers a representative example of these installments. The drawing depicts Patty-Jo sitting in the dining room of her well-appointed home: the walls have wood paneling, the floor is parquet, and the tablecloth is impeccably white. Ginger, wearing an apron, has just walked into the dining room from the kitchen to serve her younger sister meat from a large platter. As she approaches, Patty-Jo makes the following disclosure about her previous meal: "Guess what? Over at Benjie's house to day [sic] his mom gave us lunch, an' gosh!—a raisin got up and walked right outa' the bread pudding!" (qtd. in Goldstein, *Jackie* 111). This remark, of course, is meant to be humorous. After all, both Ginger and the panel's readers realize that it was not an invigorated raisin that crawled out of the food but an insect. Ormes's comic, however, does more than simply provide a chuckle from Patty-Jo's misidentification; it also calls attention to bigger and more serious social issues. First and foremost,

the comic calls attention to the fact that not all Black children hail from homes that are clean, well stocked with food, and free from vermin. Indeed, Ormes's young protagonist mistakes the bug in the bread for a raisin, not because she is young and naive, but because she is wealthy and privileged. In so doing, the "joke" in Ormes's panel also serves as an important reminder about the poor conditions in which many Black families and their children reside.

Some installments of *Patty-Jo 'n' Ginger* go even further in this vein. Without referencing either Uncle Bootsie or Benjie, these panels offer Harrington-esque critiques about the plight of the Black working class. The comic that appeared on February 11, 1950, offers a poignant case in point (see Fig. 5.7). The image shows Patty-Jo standing in a dilapidated one-room "kitchenette": the walls are missing large sections of plaster, the glass in the window is broken, and the wood support beams in the ceiling have rotted and are hanging down. The three child occupants of this dilapidated room fare little better: their clothing is ragged and torn; they are exceedingly thin, suggesting malnutrition; and they look emotionally depressed and psychologically downtrodden. Ormes's protagonist, however, has arrived to relay some "good" news. "Now you folks can REALLY stop worryin'," Patty-Jo informs the residents of this wretched kitchenette. "Uncle Sam's blowing our national wad on an H-bomb for your PROTECTION . . . course, that don't spell HOUSING, but you gotta admit it ain't HAY, either!" (qtd. in Goldstein, *Jackie* 112; all caps in original). Of course, mirroring a common source of humor in Harrington's *Dark Laughter*, the young girl's remarks are satirical. Throughout the postwar era, Black leaders often pointed out the folly of the U.S. government spending millions on military weaponry while many of its own citizens lacked basic necessities. For the price of just one fighter jet, ship, or bomb, untold thousands of Americans—including children—could receive adequate food, appropriate shelter, and decent clothing. Ollie Harrington's *Dark Laughter* series called attention to the way that issues of race and class were imbricated. A longtime member of the Communist Party, Harrington recognized that racism was perpetuated not only by a nation's military-industrial complex—as evidenced by the longtime segregation of the U.S. armed forces as well as by barring Black World War II veterans from receiving the full benefits of the G.I. Bill—but also by capitalism. Although such topics were not the main focus of Ormes's *Patty-Jo 'n' Ginger*, her work did engage with them.

Akin to fellow cartoonist Ollie Harrington, Jackie Ormes was acutely aware of the power of humor to engage with serious sociopolitical problems.

FIG. 5.7 "Now you folks can REALLY stop worryin,'" in *Patty-Jo 'n' Ginger* by Jackie Ormes. Originally published in *The Pittsburgh Courier* on February 11, 1950. Republished in Nancy Goldstein's *Jackie Ormes: The First African American Woman Cartoonist* (U of Michigan P, 2008), 112.

The experience of reading both single-panel comics, in fact, mirrors what Mike Lukovich and Mike Peters, two Pulitzer Prize–winning editorial cartoonists, said about their work: "First you look at the cartoon and laugh, and then you look again and get angry" (Lukovich and Peters). Ollie Harrington is widely remembered as an artist who used humor to question, unsettle, and even disrupt. Although Jackie Ormes's *Patty-Jo 'n' Ginger* may have been classified as a "gag panel," it was no joke. When the cartoonist's young Black protagonist uttered her frank, blunt, and astute comments, she was not kidding around.

# 6

## Outside the Circle of Influence

• • • • • • • • • • • • • • • • • • • •

*The Family Circus*, Diegetic Space, and Comics Narratology

Perhaps no other U.S. comic has been as popular or as panned as Bil Keane's *The Family Circus*. Making its debut on February 29, 1960, the single-panel series focuses on the members of a white, middle-class, heterosexual, suburban family: parents Bill and Thelma and their four children—Billy, 7; Dolly, 5; Jeffy, 3; and P.J., 18 months. Although *The Family Circus* did not have a continuous storyline, it did have an overarching theme. Each daily comic presented a slice-of-life portrayal of the trials and tribulations of raising children. Some panels featured heartwarming moments of family togetherness. Meanwhile, others focused on the "cutesy malapropisms" that children often say (Chung). Whatever the specific subject matter, *The Family Circus* offered what Keane himself deemed "good, wholesome family entertainment" (qtd. in Eschner).

*The Family Circus* was an immediate commercial success. Making its debut in a modest nineteen newspapers, the comic would eventually be carried in more than fifteen hundred publications—a figure that rendered

it "the world's most popular single-panel daily cartoon" (Schudel). During this time, *The Family Circus* enjoyed a daily readership of more than fifty million people (Astor 112). Additionally, over the decades, *The Family Circus* was reprinted in no fewer than eighty-nine paperback collections, which collectively sold more than fifteen million copies (Schudel).

The success of *The Family Circus* was not limited to print media. During the 1970s and 1980s when Keane's comic was at the height of its popularity, three prime-time animated specials were released about the series: *A Special Valentine with the "Family Circus"* (1978), *A "Family Circus" Christmas* (1979), *A "Family Circus" Easter* (1982). Furthermore, throughout this period, the characters and comics also adorned a variety of merchandise, from calendars and T-shirts to beach towels and breakfast cereal (Markstein, "Family Circus").

Keane's work was likewise celebrated by his peers. The cartoonist received the National Cartoonists Society's Award for the Best Syndicated Panel four times: 1967, 1971, 1973, and 1974. Then in 1982, he was bestowed the organization's highest accolade, the Reuben Award for Cartoonist of the Year. Additionally, Keane served as president of the National Cartoonists Society from 1981 to 1983. Furthermore, he was the emcee of the organization's annual banquet for sixteen years.

Given the esteem in which the general public as well as his professional peers held him, Bil Keane's death on November 8, 2011, received national attention. Obituaries ran in major newspapers around the country, including *The New York Times*, *The Washington Post*, and *The Los Angeles Times*. In a testament to the sustained popularity of his work, *The Family Circus* did not cease with Keane's passing. New installments continue to be published, written and drawn by his son Jeff.

As often as Bil Keane's work has been lauded, however, it has just as often been derided. By far the most common complaint is that the comic is "treacly" (Miller). As anyone who has seen even a small sample of the series can attest, the strip features "A lot of hugs and cutesy learning moments" (Eschner). For this reason, as one blogger bluntly said about *The Family Circus*, "it's vanilla as hell" (Wagwan).

Given both the single-panel format of *The Family Circus* and its conventional and even conservative content, most critics agree that "Keane's work isn't startlingly innovative" (Markstein, "Family Circus"). The series did not challenge its readers intellectually or artistically. Consisting of a solitary circular image accompanied by one line of text, the comic could be read quickly and understood easily. Similarly, its portrayal of "saccharine images

of familial togetherness" (Eschner) did not stretch either the imaginations or the critical thinking skills of its readers. Consequently, although *The Family Circus* may have been commercially successful, it has long been "dismissed by some as unchallenging" (Rossen).

This chapter contests such common critical assessments. Bil Keane's comic may not have asked much of its audience when it came to its subject matter, but it did so with regard to its layout. In features that have become iconic, *The Family Circus* appears as a single image enclosed by a black circular frame; the text that forms the gag—and which is usually uttered by a figure depicted in the image—is printed underneath as a caption (see Fig. 6.1 and Fig. 6.2). Of course, below-the-frame captions have appeared in an array of other past and present single-panel comics—including the work of Thomas Nast, Peter Arno, Jackie Ormes, and Gary Larson discussed in *Singular Sensations*. However, I'd contend that this feature is especially pronounced in *The Family Circus*, given the comic's signature thick black circle. For this reason, Keane's series forms an excellent case study for exploring it.

This seemingly simple, straightforward arrangement of word and image in *The Family Circus* is actually quite complicated from a narratological standpoint. In marked contrast to the use of a speech balloon, the comments that Keane's characters make are not uttered within the clearly demarcated space of the comic itself. Instead, individuals from *The Family Circus* speak to readers from a region that is outside of the panel. That these captions are typically lines of first-person dialogue—as opposed to third-person narration—only adds to the disjointed nature of this approach. Direct speech is removed from the environment in which it is being spoken and instead is relayed in space that is entirely separate from, and outside of, the well-defined parameters of the comic itself.

The discussion that follows contemplates this well-known feature of *The Family Circus*. Far from an inconsequential detail of Keane's work, I contend that this layout is significant from a cognitive, aesthetic, and experiential standpoint. By routinely placing intradiegetic material in extradiegetic space, *The Family Circus* explores the spatial and structural mechanics of sequential art. Ultimately, recognizing and examining the way in which *The Family Circus* uses diegetic space complicates our understanding of both Keane's work and, just as importantly, comics narratology.

FIG. 6.1 "May I have a cookie, Mommy?" Comic from *The Family Circus* by Bil Keane. Reprinted in *The Family Circus* (Fawcett Gold Medal, 1964). This book is not paginated.

## Bursting the (Speech) Balloon: The Sensory, Cognitive, and Experiential Significance of Captions

Bil Keane was certainly not averse to using speech balloons in his comics. The cartoonist had drawn a variety of newspaper series before *The Family Circus*. In the mid-1950s, for example, Keane published a comic, called *Channel Chuckles*, that offered amusing commentary on the new medium of television. Then a few years later, he created *Silent Set*, a wordless gag panel. That said, one of Keane's most successful comics before *The Family Circus*

FIG. 6.2 "Mommy, are you asleep or just pretendin'?" Comic from *The Family Circus* by Bil Keane. Reprinted in *Where's PJ?* (Fawcett Gold Medal, 1974).

was *Silly Philly*. Set in the cartoonist's hometown of Philadelphia, the strip's protagonist was a young white boy dressed as William Penn. This focus on a child character, however, is where any similarities to *The Family Circus* cease. *Silly Philly* was not only a multipanel strip; it also used speech balloons for dialogue. Far from a short-lived series, *Silly Philly* ran for more than a decade: the comic debuted on April 27, 1947, and ended on September 3, 1961. Accordingly, *Silly Philly* overlapped with *The Family Circus* for more than eighteen months. During this period, Keane was drawing speech balloons for one series and dialogue captions for the other.

In many respects, Keane's use of captions instead of speech balloons for *The Family Circus* can be seen as a pragmatic decision. After all, cartoonists creating a single-panel comic have an exceedingly limited amount of space in

which to work. Consequently, it is understandable that they would not want this already restricted area reduced even further by a speech balloon. By placing any written text—be it lines of dialogue or narrative exposition—below the panel rather than inside of it, they free up much-needed space for drawing.

Giving further credence to this viewpoint, Keane commonly used speech balloons in the Sunday editions of *The Family Circus*, which were often a single image but operated on a much larger scale. Indeed, some of Keane's most beloved and memorable comics appeared on Sundays. These full-color compositions, for example, were home to such now-classic features as a meandering dotted line that traces the pathway taken by one of the child characters around the yard or through the house. The Sunday editions also served as the basis for another recurring subject: Grandma Florence's loving memories of her now-deceased husband, who is depicted—in an area above the events happening on earth—as an angel in heaven. Once again, though, the extra space afforded by the Sunday comics allowed for both these more detailed compositions and the consistent use of speech balloons.

Pragmatic considerations for the placement of text in weekday editions of *The Family Circus* may have also been accompanied by professional influences. As Valerie J. Nelson has written, Keane was "Self-taught as an artist" who "started out imitating the style of *New Yorker* cartoonists in the late 1930s" (Nelson). More specifically, Kene admired and emulated the work of legendary cartoonist Peter Arno. As discussed in chapter 3, Arno did not invent the single-speaker captioned comic, but he played a major role in popularizing it, both in *The New Yorker* and in U.S. print publications more broadly. Robert C. Harvey has noted that this type of comic was Arno's "trademark" ("How Comics" 32). Thus, Keane's use of this layout may have been as much of a professional homage as it was personally handy.

Regardless of the factors fueling it, the placement of the caption below the frame of *The Family Circus* is significant. Even if the decision was largely pragmatic, this layout impacts the process of both reading and understanding Keane's work. More specifically, the placement of words and images has implications from a sensory, cognitive, and experiential standpoint.

First, and perhaps most obviously, relaying dialogue in *The Family Circus* in a caption below the frame removes a key component of sound from the panel. Ian Hague, in *Comics and the Senses: A Multisensory Approach to Comics and Graphic Novels*, challenges the notion that sequential art is exclusively or even primarily a visual medium. On the contrary, as he asserts, comics routinely engage with all the senses: not just sight but also

touch, hearing, taste, and smell. In the realm of the auditory, comics are awash in what Hague calls "visible sounds" (63). Characters utter remarks in speech balloons while onomatopoetic interjections like "Pow!" "Bam!" and "Thwap!" form the soundtrack to their actions. Rendering dialogue as a caption below the frame rather than as a speech balloon within it removes the sound of speech from the comic. In some ways, this tactic renders Keane's cartooning "silent." While some *Family Circus* panels do contain sounds—emanata lines indicate that the television is blaring, the car radio is playing music, or a windup toy is clanging—human voices are not among them. The sound of speech exists outside the space of the panel—or, at least, is visually rendered outside of the panel. In nearly every *Family Circus* comic, a character is saying something. However, the words that they are uttering are "heard" outside of the panel.

The removal of human speech from the interior of the panel does more than simply remove a key component of sound from the image; it also removes the comic's ability to offer an immersive reading experience. Whether a prose-only narrative or one that combines words and images, texts strive to pull readers into their storyworld. Indeed, a commonly identified hallmark of a "good book" is the ability to "lose oneself" in it. An individual gets so engrossed in the story that they forget they are reading, lose track of time, and are even oblivious to events happening around them. The layout of *The Family Circus* eschews this commonly identified goal. The series relies on the interplay of both words and images to relay its point; however, these elements are firmly separated. Going far beyond enclosing lines of dialogue within a speech balloon, *The Family Circus* relegates them to the space outside of the panel frame altogether. As a result, the reader must visually, narratively, and cognitively leave the visual drawing of the comic to access this material. They peer inside the circle of *The Family Circus* to see the action taking place, but then they need to pull themselves back outside of it to read the dialogue that accompanies the image and completes the gag. This phenomenon—of pulling readers in, only to immediately push them back out—is not merely unconventional but iconoclastic. Most creators—whether prose authors or newspaper cartoonists—strive to offer a reader experience that is absorbing, immersive, and seamless. Elements that are jarring, distracting, or disruptive—or that call attention to the constructed nature of the story—are avoided.

The aesthetic, cognitive, and sensory differences between lines of dialogue being relayed as captions below the panel and as speech balloons within it are on vivid display in many of *The Family Circus* paperbacks. The cover

image that appears on a variety of these volumes features a previously published panel which is often (although not always) reprinted in that edition. In most instances, the circular frame of the original newspaper panel has been removed and—even more importantly—so has the caption. The line of dialogue that accompanies the image is now presented as a speech balloon (see Fig. 6.3). Far from an insignificant edit, this shift changes the aesthetic look of the comic, the experience of reading it, and the impact that it has on its audience. Replacing the caption situated outside of the panel frame with a speech balloon that is part of the image makes the reading experience more uniform or, at least, continuous. The words and the image occupy the same physical space and work together more closely. Indeed, readers do not need to visually or cognitively leave the realm of the drawing to access the dialogue. Instead, the comment that the character is making appears inside this same realm.

The significance of this shift is even more pronounced when the iconic circular frame of the panel remains. In 1998, Bil Keane released a new collection of his work, *"The Family Circus" by Request*. Instead of another pocket-sized paperback, this volume was a hardcover coffee-table book. Additionally, all the panels were printed in full color. Finally, as the title implied, rather than simply collecting a segment of newspaper strips that had appeared over the previous few months as earlier paperbacks had done, *"The Family Circus" by Request* represented "fan favorites." As the cartoonist explained in the book's preface, "I have carefully compiled the drawings which have been singled out by readers across the nation as ones that have touched their lives and they have taken to their hearts" (Keane, *Request* 3). Interestingly, a number of the comics that were chosen featured speech balloons rather than bottom captions. As Jeff Keane explained, these panels had previously appeared in wall calendars (Kean, "Re: Follow-up Question").

Given the coffee-table size and landscape layout of *"The Family Circus" by Request*, panels containing speech balloons and those containing captions appear side by side (see Fig. 6.4). The difference between these two formats—both from an aesthetic standpoint and from a cognitive, experiential, and interpretive one—is striking. The presence of the balloons completely changes the reading experience. In the comics containing speech balloons, the verbal feature is visually prominent. Not only do the words occupy a significant portion of the panel, but they are also the element that first captures the reader's attention and attracts their eye. In *Family Circus* comics that contain captions below the frame, readers routinely first look at the image. Then their eye drops below the frame to read the caption and

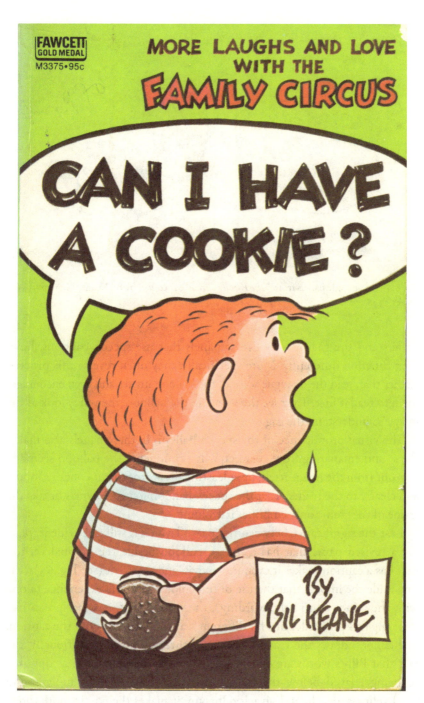

FIG. 6.3  Cover image to *Can I Have a Cookie?* by Bil Keane (Fawcett Gold Medal, 1970).

FIG. 6.4 Side-by-side panels from *"The Family Circus" by Request* by Bil Keane (Guidepost Books, 1998), 106.

understand the gag. *Family Circus* panels that use speech balloons, however, function differently. More specifically, they often reverse this process. Rather than read the dialogue second, the balloon invites and even encourages them to read it first. They see the words in the balloon, then they look at the image to understand the gag.

The visual prominence of the speech balloon in these panels also makes the sound emanating from them equally prominent. The balloon seems to pop out from the image itself, broadcasting the words that it contains loudly and clearly to the reader. That the speech balloon in many panels breaks the frame of the comic only amplifies its volume.

Lest the significance between these two layouts is still not evident, placing a revised panel that has a speech balloon beside the original version that has a caption makes it even more vivid and apparent (see Fig. 6.5). Setting aside the impact that the use of full color has on the experience (along with the minor edit in the wording), the version that uses the speech balloon engages the reader in a far different way than the one with the caption. The balloon draws the reader's eye—and their attention. Additionally, the fact that Billy's words are emanating directly from his mouth, as opposed to being relayed below the frame, gives the drawing not simply sound but liveliness, depth, and vivacity. In sum, it makes the comic more three-dimensional. The fact that the balloon—akin to most of the others that Keane incorporates—breaks the boundary of the panel only adds to its dynamism.

FIG. 6.5 Two versions of the same panel of *The Family Circus* by Bil Keane. The image on the left is from *"The Family Circus" by Request* by Bil Keane (Guidepost Books, 1998), 26. Meanwhile, the one on the right appears in the paperback collection *Where's PJ?* by Bil Keane (Fawcett Gold Medal, 1974).

This detail amplifies the resonance of Billy's words and, with it, the comic's engagement with our senses, our focus, and our imagination.

Charles Hatfield, in his book about alternative comics, discussed the unique experience of reading and understanding a work of sequential art. "Unlike first person narration, which works from the inside out, describing events as experienced by the teller," he wrote, "cartooning ostensibly works *from the outside in*, presenting events from an (imagined) positioned of objectivity, or at least distance" (Hatfield, *Alternative* 115; italics in original). The use of captions as opposed to speech balloons in *The Family Circus* simultaneously affirms and complicates this viewpoint. With the lines of dialogue appearing below the panel frame rather than inside of it, Keane's work engages both processes. The imagery of *The Family Circus* works from the inside out, while the textual elements function from the outside in.

## Speaking in Circles—or Rather, outside of Them: The Storyworld, the Storyspace, and Extrodiegetic Narration

The use of dialogue captions in *The Family Circus* does more than simply alter the experience of reading, understanding, and engaging with the panel; it also alters our understanding of comics narratology. Robyn Warhol has

written about the common modes of narration found in sequential art.[1] She argues, "there are at least three operative layers . . . two of them verbal, the third pictorial" (Warhol 5). As she goes on to explain, the first verbal level is text that appears via exposition boxes, typically at the top or the bottom of a panel. Although these elements do exist inside the frame of the panel, Warhol dubs these features "extradiegetic voice-over narration" (5) because they are at least one degree removed from the people, events, or actions being depicted.[2] Instead of direct dialogue, the text in exposition boxes is detached commentary.[3]

The second verbal level of narration in comics is what Warhol calls "intradiegetic dialogue" (5). Broadly defined as "representations of words spoken inside the narrative world" (Warhol 5), it is commonly represented via speech balloons or thought bubbles. Intradiegetic dialogue is both the most oft-deployed feature of the medium, and it is also one that is seen as most representative of it. Indeed, when individuals think about the signature facets of a comic, the speech balloon is among them.

Finally, but far from insignificantly, sequential art also engages in a pictorial mode of narrative, via "the cartoons themselves" (Warhol 5). In the words of Warhol, the "drawings that sometimes illustrate what the voice-over [or speech balloon] is saying, sometimes contradict it" (5). The image can provide necessary details that enhance or augment the written commentary; alternatively, it can introduce entirely new information that contradicts, challenges, or ignores it (Warhol 5). Regardless, the visuals of a comic constitute their own storytelling thread.

Karin Kukkonen, in her book *Studying Comics and Graphic Novels* (2013), elaborates on these categories. In a chapter devoted to narration, she refines the different kinds of verbal storytelling in sequential art. More than simply relaying events through remarks appearing in printed balloons or as commentary presented in exposition boxes, narration in comics can be further classified as "homodiegetic" or "heterodiegetic." Terms initially coined by Gérard Genette and used with some latitude by Kukkonen,[4] homodiegetic refers to narrators who are part of the storyworld (Kukkonen 39). Whether their words appear in speech balloons or exposition boxes, homodiegetic narrators are involved in the story in some way. By contrast, heterodiegetic narrators exist "outside of the storyworld" (Kukkonen 39). The events that are unfolding in the story do not directly involve them. Instead, they are observers, bystanders, or even total strangers.

*The Family Circus* defies the conventions of comics narration, and in so doing, it demonstrates the need for a new narratological category. The form

of verbal narration utilized in the series—along with other single-panel titles that possess this feature—is neither a voice-over commentary offered in an exposition box, nor is it a direct first-person utterance relayed via a speech balloon. Instead, it is a hybrid of these forms: the captions are intradiegetic dialogue, but they are not being relayed in the diegetic space of the panel. Ironically, in the same way that Keane's iconic black circle clearly and unmistakably demarcates the intradiegetic space from the extradiegetic space of the visual panel, the written text just as quickly contests, challenges, and crosses this boundary.

Complicating this situation further, the captions in *The Family Circus* are also homodiegetic—they are comments being made by an individual who exists inside of the storyworld. Far from being an uninvolved outside observer, the character who is uttering the line of dialogue in the caption is a direct participant in the events that are unfolding. Indeed, this figure is commonly depicted in the image above, often with their mouth open to make it clear that they are the ones speaking.

The use of dialogue captions in *The Family Circus* reveals that the classifications of intradiegetic/extradiegetic and homodiegetic/heterodiegetic are not sufficient. Together with possessing a story*world*, sequential art also possesses what might be called a story*space*: the physical, tangible, and material area in which the narrative is being relayed. The storyworld is the imaginative realm that the characters inhabit and in which the plot unfolds; the storyspace is the physical area on the printed page. The panel frame is a clear, direct, and obvious demarcation of the storyspace for a panel: events that take place inside of that square, circular, or rectangular boundary are part of this diegesis. Meanwhile, elements that exist outside of this frame are also outside the storyspace of that panel.

The lines of dialogue in *The Family Circus* embody an illuminating demonstration of the long-overlooked distinction between the storyworld and the storyspace in comics. These comments are spoken by a character who is visually depicted in the panel and involved in the action; indeed, their remarks are essential to understanding the comic's plot and meaning. That said, even though the captions in *The Family Circus* participate in the story*world*, they do not participate in its story*space*. Instead, the dialogue appears as a caption outside the frame—and thus, the diegesis. Indeed, the caption appears in the negative white space that surrounds the panel.

For this reason, the current narratological terms are insufficient to describe them. The captions in *The Family Circus* are homodiegetic: they are being uttered by a character from the storyworld. However, they are

rendered in an area that is heterodiegetic—that is, outside the clear boundaries of the panel's storyspace. Likewise, these lines of dialogue are neither fully intradiegetic nor entirely extradiegetic—they are both and neither at the same time. The comments are being made by an intradiegetic character, but they appear in an extradiegetic space. Given this situation, a new narratological concept is needed to describe this mode of narration: what I term "extrodiegetic." Whereas the prefix "extra-" means "outside," "extro-" denotes "outward" (*Oxford English Dictionary*). The captions in *The Family Circus*—along with, of course, those in *The Far Side, Patty-Jo 'n' Ginger*, and Peter Arno's cartoons from *The New Yorker*—can best be described in this way. These elements are aspects of the storyworld projected outward from the storyspace.

The editors of the March 2010 issue of *European Comic Art* made the following observation about the medium: "From their earliest days, comics have been an inexhaustible source of narrative invention, as a deceptively simple mechanism—based on discontinuous frames and on interplay between text and image—has been manipulated to dazzling creative effect" (The Editors v). *The Family Circus*—and other single-panel comics that employ captions for dialogue—offers yet another example of the veracity of this claim. Keane's series, which has long been denigrated for being simplistic, contains an exceedingly complex mode of narration. Together with disrupting the immersive reading experience, the layout of the words and the images makes visible the important distinction between storyworlds and storyspaces. Taken collectively, these elements demonstrate another facet of the unique affordances of sequential art. Other storytelling modes combine words and images: picture books, advertising, and so on. However, echoing the comments in *European Comic Art* once again, "comics have been an inexhaustible source of narrative invention" (The Editors v). Moreover, in a detail that upends long-standing views about Bil Keane's series, one of these inventions can be found in *The Family Circus*.

## Not the Gutter but the Alley: Mapping New Semiotic Spaces in Sequential Art

The captions below the panel frame in *The Family Circus* broaden our understanding of the modes of narration in comics. At the same time, they also call attention to an important but heretofore overlooked semiotic space in sequential art.

Since the emergence of comics studies, the field's major focus by far has been formalism. Numerous books, essays, and articles released over the decades have been dedicated to identifying the core components of sequential art. In examples ranging from frames and panels to braiding and gridding, figures like Thierry Groensteen, Pascal Lefèvre, and Scott McCloud have articulated the core elements that comprise a comic as well as how these features work together.

Of all the key components of comics, the gutter is perhaps the most central. Broadly defined as the blank space between two consecutive panels, the gutter is an essential aesthetic, cognitive, and narratological feature of sequential art. Scott McCloud, in fact, devotes an entire chapter to it in his landmark book, *Understanding Comics: The Invisible Art* (1993). As he asserts, "the gutter plays host to much of the magic and mystery that are at the very heart of comics" (McCloud 66). The gutter might be devoid of either words or images, but it is rich in narrative function and semiotic meaning. The empty space between the panels requires readers to bridge the visual gap, forge the cognitive connection, and fill in the storytelling blank. In the words of McCloud, through the gutter, readers go from seeing individual, separate panels to "mentally construct[ing] a continuous, unified reality" (66).[5]

*The Family Circus*, of course, lacks this core feature of comics. Since the series appears as a single panel, it does not have any gutters. That said, the captions below each circular frame create another important—but long-neglected—space in the typography of sequential art: what I propose calling *the alley*. In graphic design, the alley "refers to the spaces that reside on a page between the columns" ("Alley"). In other words, it denotes the negative space that is incorporated into a layout. To that end, the alley can refer to the amount of white space placed between text or the amount of negative space that appears around a logo or an image. Akin to the gutter, the blank space of the alley is anything but inconsequential. On the contrary, it is a key component of graphic design. The presence of the alley shapes the experience of viewing, engaging, and understanding both the words and images. As graphic designers would assert, the use of white space in a layout is just as important—if not more so—than the use of text and image. As anyone who has looked at an advertisement can attest, a composition that is crowded gives a different impression than one that is sparse. More than simply having a different aesthetic look, it conveys a different message and even meaning.

The space between the panel and the caption in *The Family Circus* can likewise be viewed as the alley. Akin to its namesake from graphic design,

the empty space between the words and images in Keane's comic is anything but empty. On the contrary, the alley plays an important role in the way we read, experience, understand, interpret, and react to *The Family Circus*.

The alley functions in a way that is both similar to and far different from the gutter. The gutter asks readers to forge a connection between two separate panels: How are they linked, what is their relationship, and why are they in sequence with each other? In so doing, the gutter essentially requires the audience to construct a new feature of the comic—a thematic thread, a narrative detail, a mental image, and so on—that is taking place in this interstitial space and unites the two panels. As a result, the gutter is about filling in the blank part of this area in-between.

The alley likewise asks readers to narratively, cognitively, and aesthetically engage with blank space but in a very different way. The alley is the negative space not *between* two panels but between two elements—the words and the images—*within* the same panel. For this reason, the intellectual, emotional, and interpretive work that the alley requires also changes. Rather than engaging in a process of linking or connecting, the alley is concerned with the process of reuniting and unifying. Readers must contemplate how the words and the image work together in the alley to create the gag, generate the plot, or relay the message of the panel.

The *Family Circus* comic that appears in Fig. 6.2 forms an excellent example of this process in action (see Fig. 6.2). The image shows young Jeffy standing in front of his mother. She is lying down on a piece of furniture, presumably the couch, her head resting on a pillow, her eyes closed, and her mouth relaxed. Jeffy is looking directly at her, his face close to hers. The character's mouth is open so readers can immediately see that Jeffy is saying something. The scenario being depicted in the visual image of this panel is intriguing but also indeterminate. It is unclear what, exactly, is occurring: What is Jeffy saying to her? What is the significance of the mother lying down on the couch? Why are these two characters interacting? There are many possibilities for what might be taking place: Thel could be sick, she could be sleeping, or she could be taking a "time out." Likewise, Jeffy could be asking a question, making a statement, or singing a song. The image on its own gives no indication of the motivation for, or meaning of, this scenario. It likewise doesn't provide any clues about either the content or the impact of Jeffy's comments. His words could be doing his mother a welcome favor: waking her up at a designated time, informing her that it's time for dinner, telling her that he loves her, and so on. Or his remarks could be unwelcome or merely unrelated. He could be telling her about his favorite toy, asking her

why the sky is blue, or reciting his favorite poem. Again, based on the visual image alone, there's no way to know what is happening or why.

To understand the scenario being depicted in this comic, readers need to leave the panel's frame, travel into the alley, and examine the extrodiegetic narration printed in the caption. It reads, "Mommy, are you asleep or just pretendin'?" This comment sheds light on what is occurring in the image above: Jeffy's mother is taking a much-needed rest, and he is wondering if she is truly napping or just closing her eyes to give the impression that she is sleeping so she can have a break from the children. After all, if their mother is asleep, the kids are more likely to leave her alone. Not only will they give her some peace and quiet, but they are also more likely to be peaceful and quiet, so as to not wake her. Jeffy is calling her bluff—or at least, he is asking her if she is bluffing. The extrodiegetic narration contained in the alley clarifies the uncertainty of the image, relays the gag, and unifies the comic.

That said, the process of viewing, experiencing, and understanding this comic does not end with reading the caption in the alley. Instead, the audience's journey around the spatial geography of this installment of *The Family Circus* has one more step—or perhaps more accurately, one additional stop. After reading the extrodiegetic narration, the reader then returns to the image. They want to see how the caption relates to or engages with the scene depicted above it. In so doing, the alley serves as the jumping-off point for reentry into the visual imagery of the comic: it is the location to which the reader leaves the panel as well as from which they reenter it. Speakers of English have been trained to read both from top to bottom and also from left to right. Indeed, when initially viewing the comic's image, their gaze likely started at the top and then traveled downward. Or perhaps their eyes jumped into the middle of the circle. At the very least, given the way in which their reading habits have been habituated, it is unlikely that they began at the bottom of Keane's image. The second viewing of the visual portion of the comic, however, happens in this way: readers return to the image from the alley at the bottom of the image. When they reexamine the scene being depicted, they superimpose the words from the caption onto the figure speaking. The action of the comic is replayed, now with the line of missing dialogue. This same process recurs in every other *Family Circus* panel that includes a caption below the frame. The alley is more than merely a new spatial area generated, marshaled, and occupied during this process; it is the ground in which essential readerly understanding of the comic takes place.

Together with applying to other examples of Bil Keane's *The Family Circus*, the alley functions in the same way in other single-panel comics that use

extrodiegetic narration. In titles ranging from *Patty-Jo 'n' Ginger*, *The Far Side*, and *Dennis the Menace* to *Heathcliff*, *Marmaduke*, and many of the cartoons that appear in *The New Yorker*, readers follow this same process and traverse this same terrain: first, they view the image within the frame; then they move to the alley to see the caption; finally, they return to the image once again to replay the events in light of the extrodiegetic narration. The alley is the space where the narrative, cognitive, and thematic connections between the words and the image are made. It is a core area in the topography of a single-panel comic—and one whose naming, mapping, and examining is long overdue.

Alison Bechdel, in a lecture that she delivered in 2007, made the following observation about sequential art: "What I loved about cartooning was what I had learned from Charles Addams, that the space between the image and the words was a powerful thing if you could figure out how to work with it" (qtd. in Warhol 2). The story fissures, chronological lapses, and narrative elision that can exist between the written text and visual images in sequential art embody unique affordances of the medium. Akin to the much-discussed role of the gutter between panels, the gaps between the verbal and visual modes of narration constitute a rich site for meaning. For this reason, as Bechdel notes, this feature could and even should be harnessed to enhance the storytelling.

*The Family Circus* reaffirms the observation. While the gap in substantive meaning between the verbal and the visual in Keane's work is relatively small—indeed, most captions are a direct commentary on the events unfolding in the image above—the gap in their physical location is exceedingly significant. The placement of lines of direct dialogue as captions outside of the panel frame makes visible the further technical mechanics, the spatial geography, and the cognitive operations of comics. An old adage touts the benefits of being part of "the inner circle." Bil Keane's *The Family Circus* demonstrates the value of remaining outside of it.

# 7

## Ziggy Was Here

●●●●●●●●●●●●●●●●●●●●

Tom Wilson's Newspaper Series, World War II, and the Role of Graffiti in Comics

On June 27, 1971, a new comic made its debut in American newspapers, *Ziggy*. Created and drawn by cartoonist Tom Wilson Sr., the strip chronicled the experiences of the ill-fated title character. From the frustrations that he encounters at work and the disappointments that accompany his social life to the annoyances that emanate from modern technology and absurdities that arise from his menagerie of pets, Ziggy is "a hard-luck comics page hero" (Titus).

Although the subject matter for *Ziggy* was the mundane, its public reception was not. Wilson's comic quickly became a global sensation. Initially appearing in just fifteen newspapers, *Ziggy* would soon run in "more than 600 worldwide, with some 75 million readers looking for him each day" (Roberts). Additionally, over the decades, the comic was translated into over a dozen languages (Shaw). Finally, but far from insignificantly, the character's likeness has adorned numerous consumer items, including coffee cups, calendars, T-shirts, greeting cards, home decor, and Christmas decorations

(Shaw). Today, as Ziggy approaches his fiftieth birthday, "he remains one of the most beloved and lasting characters in American popular culture" (Roberts).

Despite the tremendous popularity of Tom Wilson's strip, it has been virtually ignored by the field of comics studies. *Ziggy* has been discussed briefly in newspaper articles, posts on fan websites, and entries in reference works. However, it has not been the subject of sustained scholarly interest. From the standpoint of both its single-panel format and its quotidian subject matter, *Ziggy* has been regarded as not requiring or even meriting much analysis.

This chapter challenges such long-standing assumptions. The discussion that follows demonstrates that *Ziggy* is not only worthy of critical study; it rewards such inquiry with new interpretive insight about Wilson's series and, just as importantly, U.S. comics as a whole. During this process, I engage with several of the factors fueling the scholarly neglect and even academic derision of Wilson's strip—namely, its mass appeal, its use of a simplistic cartooning style, and its widespread commercialization. Rather than minimizing or even apologizing for these features, I foreground them, arguing that they constitute important aspects of the creative origins, aesthetic qualities, and sociocultural significance of the strip. More specifically, I point out the ways in which Tom Wilson's well-known character from the closing decades of the twentieth century contains elements of overlap with an equally well-known figure from the middle portion of the century: Kilroy. A simple line drawing of a bald fellow whose nose and fingers peek over a wall as a caption reads "Kilroy Was Here," the persona was a popular form of graffiti that began during the Second World War (see Fig. 7.1).[1] Tom Wilson's Ziggy possesses a variety of aesthetic links to Kilroy. From their bald heads and bulbous features to their renderings as simple line drawings and association with a single-panel format, these two figures can be seen as possessing a kinship.

Placing Ziggy in dialogue with Kilroy brings together two iconic figures from the history of American cartooning, inviting us to reconsider them both. The way in which Ziggy echoes Kilroy calls attention to a possible, and long-overlooked, influence on Wilson's character. The aesthetic connections between Ziggy and Kilroy complicate common perceptions about Wilson's strip, giving it a historical dimension along with a sociopolitical component previously unknown. The possible points of correspondence between Ziggy and Kilroy add a new facet to the role that the Second World War played in U.S. comics. Previous discussions about this issue have largely focused on the

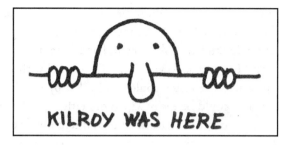

FIG. 7.1 "Kilroy Was Here," by unknown artist. Appears in *FUBAR: Soldier Slang of World War II*. By Gordon L. Rottman. Metro Books, 2007. Page 69.

influence of comic books. The suggestive echoes between Ziggy and Kilroy call attention to the way that individual characters who circulated outside of the floppies also fueled the rise of sequential art during this era. More specifically, given that the figure of Kilroy was scrawled on walls, tanks, and barracks by soldiers during World War II, it highlights the important but under-examined role of modern graffiti in contemporary comics.

## "Kilroy Was Here," There, and Everywhere: The Wartime Presence and Continued Postwar Existence of this GI Graffiti

The Second World War is associated with some of the most powerful iconography in American history. From photographs like the group of Marines raising the American flag at Iwo Jima to illustrations such as the ones on posters encouraging civilians to buy war bonds or plant a victory garden, the conflict gave rise to imagery that was exceedingly influential then and remains readily recognizable today. The figure of Kilroy ranks among these elements. This work of GI graffiti was a fixture in American culture both during the Second World War and in the years that followed.

The character of Kilroy started, quite appropriately, by an actual man named Kilroy. As Charles Osgood reported, "His name was James J. Kilroy and he was a civilian, a welding inspector at the Bethlehem Steel shipyard in Quincy, Massachusetts" (xv). Mr. Kilroy's job was to check the work done by riveters, marking areas that he had approved with chalk. Soon after the start of the war, however, Mr. Kilroy decided to forgo this practice for a mark

that was both more personal and more permanent. As he explained in an interview for the American Transit Authority in 1946, "I was getting sick of being accused of not looking the jobs over and one day as I came through the manhole of a tank I had just surveyed, I angrily marked with yellow crayon on the tank top, where the tester could see it, 'Kilroy was here'" (qtd. in Soniak). Chalk marks could be easily wiped off, either accidentally by metalworkers as they moved around a work zone or intentionally by the welders who were paid per rivet and thus trying to get areas counted twice (Wolf). The crayon drawing was far more visible for his supervisors to see as well as far more difficult for ship workers to erase. "Kilroy Was Here" was born.

Kilroy rapidly went from being found on ships to appearing on tanks, jeeps, planes, and barracks. World War II veteran Tony Hillerman recalled seeing the figure "scrawled on flat surfaces everywhere" (xi). Found in both the European and Pacific theaters, drawn on military equipment as well as on civilian structures, placed in highly visible spots as well as in obscure locations, the character "was a running gag throughout the war" (Osgood xiv). Charles Osgood, in fact, called Kilroy nothing less than "ubiquitous" (xiv). Josef Stalin even reportedly found the cartoon on the wall of his private bathroom during the talks in Potsdam, Germany, in July 1945. The Russian dictator "was clearly agitated and conferring urgently with his aides. A translator heard him ask 'Who is Kilroy?'" (Osgood xv). Kilroy formed such an essential part of the visual iconography of World War II that the National Memorial about the conflict in Washington, DC, includes him: he is carved next to the pillar honoring service members who hailed from the state of Pennsylvania (see Fig. 7.2).

Kilroy's popularity can be attributed to more than simply a popular in-joke within a specific community. Akin to most other forms of modern graffiti, the cartoon figure was a form of self-expression and, even more importantly, self-declaration ("History: Subway Writing"). By scrawling "Kilroy Was Here," service members were also, of course, saying that they were there too. Amid the vast operations of the war and the massive number of personnel mobilized for it, individual soldiers or sailors often felt insignificant: just another nameless, faceless GI. Indeed, as one of the millions of individuals involved, they were a tiny cog in a colossal war machine. By scrawling "Kilroy Was Here" on a wall, tank, or ship, they forged a connection, fostered camaraderie, and facilitated a bond with other service members. Just as importantly, they also made themselves visible, both literally and figuratively. Akin to the young people a generation later who would begin tagging walls, subways, and underpasses with spray paint, "Kilroy Was Here" allowed these men and women to leave their mark ("History: Subway Writing").

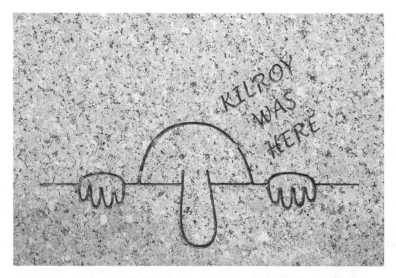

FIG. 7.2 Engraving of "Kilroy was Here" on the U.S. World War II Memorial in Washington, D.C. Image courtesy of Luis Rubio, September 4, 2006. Available here: https://en.m.wikipedia.org/wiki/File:Kilroy_Was_Here_-_Washington_DC_WWII_Memorial.jpg.

Kilroy's popularity continued well beyond V-E and V-J Days. "Once the war was won," Jacopo della Quercia reported, "an epic race broke out to stick Kilroy's name and face on whatever else existed anywhere." Osgood offered some specifics: "There he was on the torch of the Statue of Liberty. There he was on the girder of the George Washington Bridge. There he was on the Arc de Triomphe in Paris, on the Marco Polo Bridge in China" (xiv–xv). Kilroy even purportedly appeared on the surface of the moon, drawn in the dust by one of the Apollo astronauts (della Quercia). Additionally, references to the figure appeared in comic strips like Charles M. Schulz's *Peanuts*, Looney Tunes cartoons featuring Bugs Bunny, and popular television shows like *M\*A\*S\*H*.[2] Kilroy continues to play an important role in American visual culture. Discussions about the history of graffiti art commonly mention this figure (Johnson, "Bridges").

Given both the popularity of Kilroy during the Second World War and his ongoing significance in the years afterward, he constitutes an important development in American popular culture. The ubiquity of this figure lends new significance to his tagline. Since his origins in the 1940s, Kilroy was not only "here"; he was also there and everywhere.

## From Postwar Greeting Card to World War II Calling Card: Rethinking the Origins of *Ziggy*

For nearly fifty years, *Ziggy*'s creative and cultural lineage has been connected not with the realm of comics but with a far different print source: greeting cards. After graduating from the Art Institute of Pittsburgh in 1955, Tom Wilson Sr. took a job with American Greetings. As his son recalled, the future cartoonist was "Assigned to a new department in charge of creating a line of humorous studio cards" (Wilson, *Zig-Zagging* 11). For generations, greeting cards had been exceedingly formal both in their visual iconography and in their written text. Typically comprised "of scenic landscapes and bouquets of flowers partnered with saccharine prose," they embodied a mode of social exchange that was highly idealized and thus highly unrealistic (Wilson, *Zig-Zagging* 12). Whether marking a solemn event or a joyous occasion, greeting cards generally featured "a beautiful painting [that] senders could never paint" on the front and then "flowery lines of poetry [that] senders would never be able to compose themselves" as the message inside (Wilson, *Zig-Zagging* 12). As a result, the items were increasingly seen as contrived and thus disingenuous.

The American Greetings company sought to offer an alternative card that was more lighthearted and personal. To that end, Wilson and his fellow employees were asked to develop "a character, or characters, that both sender and receiver could readily identify with" (Wilson, *Zig-Zagging* 12). The appearance or style of these new personalities had few specifications beyond one: "to design characters that were generic enough to appeal to the largest segment of the card-sending public" (Wilson, *Zig-Zagging* 12). Wilson's son refers to them as "neuter characters, for lack of a better term" (*Zig-Zagging* 12). They could not possess too many physical details or personal traits that would make them too specialized. Again, the idea was to appeal to the broadest possible audience. Thus, the characters needed to be generic while also being likable.[3]

Changing the iconography on greeting cards was not the only feature that the new division for which Tom Wilson Sr. worked was implementing. They also changed the mode of verbal delivery. In the words of the cartoonist's son once again, "Another important strategy [in the new greeting card line] was to have these characters speak their humorous lines directly to the card's recipient" (Wilson, *Zig-Zagging* 13). Instead of featuring flowery formal verse, these greeting cards featured personal quips and casual comments. Both by depicting cute cartoon characters and having the figures

speak to the recipient one-on-one, these new cards would be more personal, more realistic, and more authentic.

When Tom Wilson created Ziggy over a decade later, he followed many of these same principles. First and foremost, Wilson's character is a bland figure who does not possess many specific traits. While Ziggy can be identified as Caucasian and male, he has few other personal traits or even physical qualities: Ziggy has no neck, no eyebrows, no eyelashes, no teeth, no fingernails, no eye color, and even no toes on his feet. In many ways, he is a humanoid blob. This quality places Ziggy in dialogue with Scott McCloud's argument about "amplification through simplification" in sequential art (30). In a well-known sequence from *Understanding Comics*, McCloud discusses how, "By stripping down an image to its essential 'meaning,' an artist can amplify that meaning in a way that realistic art can't" (30). When a drawing of a face becomes less detailed and more cartoonish, it also becomes less specific and more universal (McCloud 31–37). In short, it becomes easier for the reader to see themselves in—or even as—that character. McCloud dedicates an entire chapter in *Understanding Comics* to this concept, arguing that it forms a key aspect of the appeal of sequential art. Readers are first visually drawn *to* comics, and then they are psychologically drawn *in* by them because they can identify with the characters on the page. The aesthetic style employed by many cartoonists—using simplified line drawings for facial features—makes this identification possible.[4]

Ziggy does more than merely invite readers to identify with him because of his simplified visual rendering. Echoing another key facet of the new line of greeting cards on which Tom Wilson Sr. worked, Ziggy also appeals to readers via his frequent use of direct address. Not only does the character frequently break the fourth wall by looking out from the panel and making eye contact with the reader, but he also talks to them directly. One of Ziggy's most well-known taglines "See you in the funny papers!" exemplifies this phenomenon. Given these areas of both visual and verbal overlap, Ziggy is commonly seen as having his creative roots not in the realm of sequential art but in the greeting card industry.

While Tom Wilson's work at American Greetings undoubtedly influenced his creation of Ziggy, another life experience that predated this period may have also played a role: his time in the military. Wilson served in the U.S. Army from 1952 to 1954 (Wilson, "Re: ZIGGY").[5] The future cartoonist was assigned to the 440th Army Band stationed at Fort Bragg, where he played the tuba in USO parades, dances, and ceremonies (Wilson "Re: ZIGGY"). During this time, he also engaged in what would become his

future vocation. As Wilson's son recalled, "In the army, [Dad] drew caricatures of his military buddies" (11). After being discharged in the fall of 1954, Wilson enrolled at the Art Institute of Pittsburgh. Although his training was in the more highbrow mediums of painting, figure drawing, and sculpture, he once again retained a strong interest in comics. In the words of his son once again, "even in art school his paintings and drawings were a unique amalgam of both fine art and cartooning" (Wilson, *Zig-Zagging* 11).

At some point either during his time in the military or in civilian life, Wilson encountered images of Kilroy. As Jacopo della Quercia noted, "Quite a few Korean vets saw it and even some Vietnam vets went through the 'Kilroy Was Here' episode" ("Kilroy"). Kilroy remained equally prevalent in American popular culture: "The cartoon face with that phrase would appear spray-painted on walls, scrawled in lockers and written on the back of high school notebooks for decades" (della Quercia). Born in 1931, Tom Wilson Sr. was too young to serve in the Second World War, but he was certainly not too young to have seen and remembered images of Kilroy. To be sure, in a letter home to his parents that is postmarked July 21, 1954, Wilson included a Kilroy-themed doodle (see Fig. 7.3). On the back of the envelope, the future cartoonist depicted himself as the well-known GI persona. Instead of Kilroy's bald head, Wilson is wearing his garrison side cap. His hair is also showing on each side. In addition, rather than peering over a wall, the future cartoonist's fingers and nose peek over the V shape formed by the enclosure flap, which he has accentuated by tracing the line with pen. Finally, in place of the caption "Kilroy was here" or even "Wilson was here," he has written in a speech bubble above his head, "It won't be long untill [sic] I get out of here."[6] These changes notwithstanding, the doodle is clearly a variation on Kilroy, demonstrating Wilson's awareness of the visual and verbal tropes of the GI cartoon.

Interestingly, Tom Wilson's first foray into comics—as well as his earliest iteration of Ziggy—was in the realm of political cartoons. As his son recalled, during the early 1960s, Wilson "created a comical character that looked very much like Ziggy but was an elevator operator who commented on current events in much the same way an editorial cartoon would" (Wilson, *Zig-Zagging* 14). The cartoonist "shopped it around the syndicates, trying to sell it, but received little interest from them" (Wilson, *Zig-Zagging* 14). Consequently, he "put Ziggy on the back burner for several years" (Wilson, *Zig-Zagging* 14).

When Wilson finally reprised Ziggy, it was not for a comic strip but for "a series of small, humorous, card-like books, that were published under the

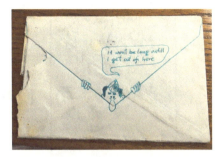

FIG. 7.3 Kilroy-themed self-portrait by Tom Wilson Sr. on the back side of an envelope containing a letter that he sent to his parents. The envelope is postmarked July 21, 1954. Image provided by Tom Wilson Jr.

name Sunbeam Library" (Wilson, *Zig-Zagging* 15). As his son recounted, the project was not planned. The future cartoonist's colleagues at American Greetings were overwhelmed with other deadlines, so Wilson "pitched in and illustrated one of these small books himself, and brought Ziggy out as a character" (Wilson, *Zig-Zagging* 15). Released in 1968, the text "sold an amazing half million copies" (Wilson, *Zig-Zagging* 15). Moreover, it bore a title that can be seen as a response to Kilroy's tagline. Whereas the popular World War II caricature always affirmed that he "was here," Wilson's book featuring the reboot of Ziggy was titled *When You're Not Around*.

One of the individuals who purchased a copy of *When You're Not Around* was Kathy Andrews. In the words of the cartoonist's son once again, "She bought it for her husband, Jim, who was busy traveling with his partner, John McNeel. They had a fledgling comic syndicate by the name of Universal Press Syndicate" (Wilson, *Zig-Zagging* 15). Jim Andrews loved both Ziggy and Wilson's drawings and recognized the potential for it to be a successful comic strip. At the time, Universal Press Syndicate "had acquired only one feature, a little-known comic strip by some college kid named Garry Trudeau" (Wilson, *Zig-Zagging* 15). Andrews contacted Wilson with the idea, who needed little convincing. *Ziggy* joined *Doonesbury* as the two inaugural titles in what would soon become "the largest comic strip syndicate in the world today" (Wilson, *Zig-Zagging* 15).

When *Ziggy* debuted on June 27, 1971, the comic was as simple as it was straightforward (see Fig. 7.4). The image featured the title character standing with his arms folded in front of his chest and his face looking directly out at the reader. Above his head, text printed in all caps read, "Hullo, my

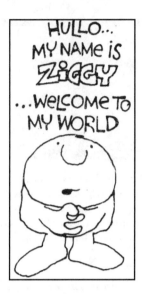

FIG. 7.4 Debut *Ziggy* comic from June 27, 1971. Reprinted in *The Ziggy Treasury*, by Tom Wilson. Universal Press Syndicate, 1977. Page 11.

name is Ziggy. . . . Welcome to my world." The baldness of Ziggy's head, the U-shape of his nose, the two black dots that form his eyes, and the simple loops that constitute his fingers are evocative of common renderings of Kilroy. Although Ziggy's head is rounder and Kilroy's face is more oblong, they possess many visual similarities.

The image of Ziggy that was used to mark the 45th anniversary of Wilson's comic strip makes this link even stronger. The design, which appeared prominently on the website that serves as the online repository of the strip, Go Comics, takes the image of Ziggy from the debut comic and crops his face just below his nose, akin to Kilroy. Additionally, the overall shape of this anniversary icon recalls the GI graffiti. Although the image does not feature Ziggy's fingers holding on to a wall, the rectangular dimensions echo drawings featuring Kilroy. This shape seems even more significant, given that the single-panel comics that form the daily *Ziggy* cartoons are almost perfectly square.

For more than forty years, Ziggy has been seen as having his creative roots and cultural origins in greeting cards. But this character may have also been consciously or unconsciously influenced by a World War II calling card. While Tom Wilson's work at American Greetings certainly shaped his cartooning, so too may have the figure of Kilroy.

The suggestive echoes between Ziggy and Kilroy do more than simply change our perception of Wilson's beloved character. They also add a new facet to the role that the Second World War played in shaping U.S. comics. As books by David Hajdu, Bradford C. Wright, and Will W. Savage Jr. have all documented, the conflict was a watershed moment for sequential art in the United States. The war years popularized comics for civilians and service members alike. From the creation of Wonder Woman to the debut of Captain America punching Hitler, the Second World War saw the release of some of the most commercially successful and critically influential titles, characters, and plotlines. Moreover, given their popularity among enlisted soldiers, sailors, and members of the Air Force as well as their equally strong circulation in civilian life, these stapled softbacks collectively gave rise to what Bradford W. Wright aptly called "Comic Book Nation."

While the centrality of comic books in the United States during the mid-twentieth century is indisputable, the figure of Kilroy adds a new facet to this phenomenon. Previous discussions about the growth of sequential art during the war years have focused on what David Hajdu termed "The Ten-Cent Plague." Whether examining the superhero genre, the detective category, or the horror set, views about influential comics from this era have largely been confined to these stapled softbacks. The cultural presence and creative power of this medium, however, include examples that existed outside of this format. Although Kilroy never appeared in a published comic book, he was seen by untold numbers of men and women. Given this situation, Kilroy's popularity rivaled that of other wartime works of cartooning. In the case of Tom Wilson Sr., his influence might have been even stronger than his counterparts in comic books. The visual, thematic, and cultural connections between Ziggy and Kilroy suggest that the time is long overdue for discussions about influential characters from the war era to broaden beyond the floppies.

## From Tagging to Braiding: The Unexplored Links between Modern Graffiti and Contemporary Comics

The areas of visual, thematic, and narrative overlap between Ziggy and Kilroy have implications that extend beyond simply identifying a formerly overlooking kinship between these two figures. They also invite us to see possible connections between modern graffiti and contemporary comics as a whole.[7]

Akin to all forms of artistic expression, comics did not emerge from a creative or cultural vacuum. Scott McCloud, in the opening chapter of his landmark *Understanding Comics: The Invisible Art* (1993), provides an overview of the origins and evolution of sequential art. As he notes, "Most books about comics begin shortly before the turn of the century" (9). R. F. Outcault's drawings featuring The Yellow Kid (1895–1898) are often identified as the first commercial newspaper comic and are thus seen as inaugurating the genre in the United States. However, as McCloud asserts, "I think we can venture back a bit farther than that" (9). Accordingly, he surveys an array of art forms that he sees as antecedents to comics. From Mesoamerican carvings and medieval French tapestries to ancient Egyptian hieroglyphs and eighteenth-century satiric caricatures, McCloud maps out a rich and vibrant prehistory (9–20). Possessing features like the use of sequencing and the interdependence of word and image, these earlier forms helped comics create "a language all its own" (McCloud 17).

McCloud's chapter may be one of the most well-known discussions of the global influences on comics, but it was certainly not the first one. Previous scholars had likewise explored the roots of sequential art, identifying additional sources. Will Eisner in *Comics and Sequential Art* (1985, 1990), for example, called attention to the links between Japanese calligraphy and the interplay of the verbal and visual in sequential art. Similarly, David Kunzle argued that European broadsheets from as early as the fifteenth century present "picture stories" and "narrative strips" that cause them to be seen—as the title of his 1973 book indicates—as *The Early Comic Strip*.

Of the myriad historical phenomena that have been viewed as shaping comics, however, one art form is consistently overlooked: graffiti. As Roger Gastman and Caleb Neelon's *The History of American Graffiti: From Subway to Gallery* (2011) documents, what began as young people writing or "tagging" their names on buildings, fences, and subway cars evolved into one of the most important and lucrative art forms. By the end of the twentieth century, graffiti exerted a "monumental influence" ("History of Graffiti") in American popular, visual, and material culture. From the presence of bubble lettering or "softies" to the rise of spray paint as an artistic medium, the aesthetics of graffiti can be seen in areas as diverse as fashion and advertising to music and graphic design. Indeed, two of the most popular and successful artists over the past ten years—Banksy and Shepard Fairey—do graffiti work. Moreover, this aesthetic style is no longer confined to the lowly realm of brick walls and bridge underpasses. It can be found among highbrow elements of society: Louis Vuitton scarves, couture gowns, and of course, art

galleries. Given this situation, by the second decade of the twenty-first century, graffiti had fittingly become as ubiquitous as the tags in which it had its modern origins.

Cartooning in general and comics in particular has long been seen as influencing graffiti. Jean-Michel Basquiat's now-legendary SAMO tag, for example, was not initially a graffiti moniker but "was actually developed along with high school friends Al Diaz and Shannon Dawson for a comic" (Gray). Additionally, what became known as the "wild style" of graffiti during the late 1970s was characterized by "utilizing bold color choices, involving highly stylized and abstract lettering . . . and/or including cartoon-like characters" ("Street Art"). Indeed, both Martha Cooper and Henry Chalfant's landmark book *Subway Art* (1984) and the equally groundbreaking film *Wild Style* (1983) present graffiti that contain characters from comic strips and cartoons: Popeye, Dick Tracy, Felix the Cat, and so on. Furthering these links, graffiti has also employed another signature facet of comics: the speech balloon. From curse words and jokes to sexual innuendo and political commentary, word bubbles have been a feature both of the aesthetic composition of graffiti and its sociocultural content. Moreover, the speech balloon itself has been utilized all on its own by graffiti artists. Ji Lee, for example, "pastes empty comic speech-bubbles onto advertisements, allowing passers-by to write in their own captions" ("Street Art").

In spite of the ways in which comics have played a role in the development of graffiti, the relationship is not widely seen as reciprocal. As discussions by Scott McCloud, Will Eisner, and others demonstrate, comics have their root in a wide array of cultural phenomena, but graffiti has not been viewed as one of them.[8]

The suggestive echoes between Ziggy and Kilroy call this long-standing belief into question and, in so doing, prompt us to reconsider the influence of modern graffiti on contemporary comics more broadly. While these two modes may seem separate and distinct—one circulating in the nation's print culture, the other in its material culture; one an illegal form of vandalism and the other a sanctioned commercial enterprise—they share a variety of areas of overlap. First and perhaps most prominently, both graffiti art and sequential art have a long history of being held in low cultural esteem. Whether appearing on a subway car, the side of a building, or a bathroom stall, graffiti has historically been seen as the criminal defacement of public (or private) property rather than an esteemed artistic form. Consequently, it has been ignored at best and removed at worst. It was not until the closing decades of the twentieth century that graffiti art and artists began to receive critical

recognition and cultural respect.[9] Books like Martha Cooper and Henry Chalfant's *Subway Art* (1984) made a case for the aesthetic value and cultural importance of graffiti. Indeed, the title that they chose for their collection of photographs positioned the tagging, murals, and messages on train cars as art rather than vandalism. In the coming years, graffiti would increase in cultural esteem. Several of the fine artists who rose to acclaim during the late 1980s and early 1990s—such as Keith Haring and the aforementioned Jean-Michel Basquiat—had their origins in, and remained heavily influenced by, graffiti.

Sequential art has a strikingly similar history. While comics have formed an important facet of American popular culture since the late nineteenth century, views of newspaper strips, comic books, and graphic novels as a serious and important art form did not emerge until the closing decades of the twentieth century. Books like Will Eisner's *Comics and Sequential Art* (1985) and Scott McCloud's *Understanding Comics* (1993) were among the first to make this then-radical assertion. Over the next decade, much of the work in comics studies served to support this view, with scholars demonstrating how sequential art was a complex form and thus a worthy area of study.

Together with sharing a history of critical neglect, both graffiti and sequential art share a history of ephemerality. Subway tags, wall writings, and street murals are not generally regarded—either by the artist who created them or by the passersby who see them—as permanent installations. Instead, they are considered temporary pieces that will likely be cleaned off or painted over. Several of the most influential forms of sequential art, such as newspaper strips and comic books, occupy a similar cultural status. Strips like *Ziggy* are enjoyed in the daily newspaper and then discarded, usually into the trash. A comic book might enjoy a longer circulation life—purchased by one child and then also read by their circle of friends—but the end result was the same. At some point, perhaps the following month when a new issue was released, the comic book ended up in the garbage. The poor quality of paper, subpar printing, and flimsy binding of these items supported this usage. Comic books were not intended to be volumes that would last for decades.

Graffiti and sequential art are likewise linked via their fundamental engagement with another element: typography. The earliest forms of modern graffiti were tags comprised of a solitary word, generally the artist's name or nickname. Twelve-year-old Darryl "Cornbread" McCray is commonly seen as inaugurating this phenomenon when, in 1965 in Philadelphia, he

began writing "Cornbread Loves Cynthia" on walls along the bus route in his neighborhood to catch the attention of a girl that he liked ("History of Graffiti"). As the website SprayPlanet has discussed, "The plan worked, and Cornbread's enigmatic tag soon inspired others, the city's walls growing dense with various names and numbers, each writer trying to snag their share of the glory" ("History of Graffiti"). Tagging spread from Philadelphia to other cities—namely, New York, where it exploded in the 1970s. Calling themselves graffiti writers—rather than graffiti artists—many combined their moniker with the number of the street where they lived. Tags like "Taki 183," "Tracy 168," and "Eva 62" could be seen on surfaces all over the five boroughs but especially in the subway system where trains transported the tags to every corner of the city.

As graffiti art grew, the emphasis on typography intensified. By the mid-1970s, "Writers began experimenting with new lettering styles and flourishes, embellishing their tags with stars, flowers, crowns, and eyeballs, simple tags evolving into what Raw Vision's John Maizels called 'hieroglyphical calligraphic abstraction'" ("History of Graffiti"). In marked contrast to the aim and intention of previous graffiti writers, legibility took "a backseat to style and artistic originality" ("History of Graffiti"). Dubbed the "wild style," this new aesthetic was typified by "interlocking type, arrow-tipped letters, and the use of icons like spikes, eyes, and stars" ("History of Graffiti"). Letters overlapped, interwove, and interlocked in such complex ways that the finished tag was often unreadable to the general public. In so doing, the letters themselves became images, and graffiti writers demonstrated how typography itself was an art form.

Lettering has long been regarded as a core aspect of comics as well. Whether written in all caps or mixed case, and whether hand-drawn or generated by a template, the size, style, and layout of the typeface in a comic can greatly shape its meaning. As Dan Greenfield has observed, "The best letterers are essentially graphic designers." Knowing where to place the words as well as how to arrange and render them can impact the readability of a comic and more importantly, its semiotics. For this reason, lettering is commonly seen as a key component of sequential art. The Eisner Awards, in fact, has long featured a category for Best Letterer/Lettering.

Finally, and far from insignificantly, graffiti and sequential art are also united through another strikingly similar signature practice. While the act of writing, drawing, or carving on surfaces in public spaces has been around for thousands of years, modern graffiti is commonly traced to the mid-twentieth century with the advent of tagging. As the still-anonymous

individual behind the moniker "Taki 183" commented in an interview, "You could walk 40 blocks and see my name on every pole" (qtd. in "History of Graffiti"). It was not enough to simply create a distinctive tag; the moniker also had to be replicated on as many surfaces as possible.

Sequential art also contains a feature that is akin to tagging. Thierry Groensteen, in his influential book *The System of Comics* (2010), explores the visual, technical, and aesthetic workings of comics that make them not only a distinct genre but a complex art form. One of the key elements of sequential art, he writes, is *"tressage"* or "braiding" (*System* 145). Broadly defined as a recurring visual feature of a comic, braiding takes the form of a specific image or distinctive shape that recurs over the course of a work of sequential art, forming a visual motif (Groensteen, *System* 145–149).[10] In so doing, the practice helps tie the work together and allows it to be seen as a unified whole. Braiding can be placed in dialogue with tagging in many ways. Akin to the practice among graffiti artists, the feature is repeated as a means to make the comic distinctive and recognizable.

Viewing comics through the lens of graffiti impacts more than simply our perception of broad aesthetic elements like braiding and typography; it also changes our view of specific titles. Depictions of graffiti as well as graffiti-inspired styles appear in many examples of sequential art, past and present. The work of underground cartoonist Vaughn Bodē, for instance, was just as popular among graffiti artists as it was among comics fans during the late 1960s and 1970s. From his use of bubble lettering throughout issues of his *Cheech Wizard* series (1967–1975) to his choice of solid bright colors embellished with flourishes like stars and dots, Bodē's comics were influenced by the era's graffiti style. Not coincidentally, Bodē's work had a strong fanbase among graffiti artists, with characters and compositions from his comics even appearing in street murals.

The following decade, the presence of graffiti in sequential art expanded with the release of Alan Moore's *V for Vendetta* (1982–1989). The title character has a signature graffiti mark or tag that he often scratches or sprays onto public places: a large *V* in a circle. This symbol is so central to the narrative that it appears on the covers of various editions of the series. As a result, while the central character's name is V for Vendetta, it could just as easily be V for graffiti-generated Vandalism.

Graffiti likewise plays a key role in Ariel Schrag's series of autobiographical comics. As Emma Maguire has commented, in titles like *Awkward* (1995), Schrag "engages with . . . markers of youth subculture such as graffiti art" (57). Episodes throughout the other volumes, *Definition* (1996), *Likewise*

(1998), and *Potential* (1997), show the cartoonist's avatar seeing graffiti as well as engaging in it herself. In so doing, the practice is positioned as both a pervasive cultural backdrop and a poignant artistic outlet.

Aaron McGruder's *The Boondocks* (1996–2006) evokes another facet of graffiti art. The coloring technique used in the strip has an airbrushed quality that makes it reminiscent of graffiti works made with spray paint. Moreover, the cartoon series based on the strip features an episode where the character Riley Freeman engages in graffiti. Bearing the Kilroy-esque title "Riley Wuz Here" and appearing during the first season, the episode opens with the figure tagging the side of a neighbor's house, much to the dismay of both the home's owner and an art critic, who offers him suggestion about both his color work and his lettering.

In 2011, Gene Mora took the connections between sequential art and street art one step further when he launched his single-panel comic, *Graffiti*. Each installment features a short statement that is scrawled on a brick wall, wood fence, or concrete barrier. The sayings offer "a clever, often ironic message" ("Overview"), such as "You Could Think of TV as a Form of Air Pollution" (January 25, 2013), "Compromise Is When Two People Get What Neither Want" (May 1, 2017), and "People Who Shoot off Their Mouths Never Run Out of Ammo" (November 16, 2014).

Finally, the interactions between graffiti and comics continue in Ed Piskor's *Hip Hop Family Tree* series (2012–2015). In a nod to the influence that street art had on this musical genre, the volumes are created in the "wild style." The title that appears on each of the covers, for example, uses bubble letters in bold colors with heavy black shading. Moreover, the letter *i* in "Hip" is dotted with a star, while a crown is used as an accent over the letter *o* in the word "Hop."[11]

As even this brief discussion demonstrates, modern graffiti and contemporary comics contain a variety of areas of overlap. Although these two modes of visual art are not commonly placed in conversation with each other, they could and even should be. Beginning with the way in which Tom Wilson's *Ziggy* recalls facets of Kilroy and extending through the "wild style" aesthetic that permeates Ed Piskor's *Hip Hop Family Tree* series, graffiti art and sequential art have a long, rich history. The past and present connections between these two visual forms deserve both current acknowledgment and further future examination.

More than two decades before Darryl McCray began writing "Cornbread" around his neighborhood in Philadelphia, "Kilroy Was Here" was being scrawled on surfaces by soldiers throughout the European and Pacific fronts. In many ways, the bald-headed caricature can be seen as the first modern graffiti tag. Although not the work of a solitary graffiti writer, Kilroy is nonetheless regarded as an important milestone in the development, popularization, and proliferation of the phenomenon. To be sure, discussions about the origins and evolution of modern graffiti commonly mention him.

One of the reasons why *Ziggy* has been denigrated over the years is because of its widespread commercialism. Tom Wilson created the comic strip character to be a marketable commodity, and market him is exactly what he did. At the height of Ziggy's popularity during the 1980s, his likeness appeared on seemingly every consumer product imaginable, from stationary and bedding to toys and home decor. Identifying the suggestive echoes between Ziggy and Kilroy introduces a new way of seeing this character's ubiquity. If Tom Wilson's figure has his roots in GI graffiti, he can be viewed as equal parts tag and trademark. More specifically, Ziggy can be seen as an early and prescient example of the way in which graffiti would become monetized as the twentieth century drew to a close. What began as individual tags—Jean-Michel Basquiat's SAMO, Keith Haring's dancing figures, and Shepard Fairey's Andre the Giant—became lucrative brands. Ziggy is an illuminating case study of this phenomenon. He can be seen as having his origins in a graffiti character; moreover, he quickly became a highly commercialized licensed property.

In a fitting homage to Kilroy, the motto or slogan from card shops, toy stores, and booksellers during the closing decades of the twentieth century could have been "Ziggy Was Here." The areas of visual, thematic, and aesthetic overlap between Wilson's comic character and Kilroy invite us to explore the ways in which graffiti has also left its mark—literally as well as figuratively—on U.S. comics as a whole.

# 8

## "His People Are Grotesque"

• • • • • • • • • • • • • • • • • • • • •

*The Far Side* and the Aesthetics of Ugliness

While there have been a multitude of single-panel comics released over the decades, perhaps none has been more acclaimed than Gary Larson's *The Far Side*. Making its debut in the *San Francisco Chronicle* on January 1, 1980, the daily series featured a quirky worldview that showcased everything from ludicrous daily events and ironic natural occurrences to satirical historical scenarios and comedic wordplay. Over the next fifteen years, *The Far Side* became one of the most successful strips of its era. At the height of its popularity, the comic appeared in nineteen hundred newspapers. During this period, *The Far Side* was reprinted in more than twenty books, all of which made *The New York Times* bestseller list (Soper 10). Additionally, Larson's comics adorned a plethora of consumer items, ranging from coffee cups and calendars to T-shirts and greeting cards.

*The Far Side* was as lauded by critics as it was loved by readers. Larson received the Newspaper Panel Cartoon Award from the National Cartoonist Society not once but twice: in 1985 and then again in 1988. Likewise, he was

also the recipient of their highest honor, the Reuben Award for Outstanding Cartoonist of the Year, on two occasions, in 1990 and 1994. Larson ended *The Far Side* on January 1, 1995, when he retired from cartooning to pursue other interests. By this point, as Kate Streit observed, his series had secured "a special place in pop culture history." In comments that have been echoed by many other critics, Kerry D. Soper noted that it is difficult "to overestimate how much Larson's success changed the geography of comedy and cartooning in the United States" (Soper 12). The single-panel series "help[ed] to clear the path for other 'alternatively mainstream' comics texts, such as *Bloom County*, *The Simpsons*, *South Park*, *Pearls before Swine*, *Boondocks*, *Get Fuzzy*, and *Rick and Morty*" (Soper 12). In light of these accomplishments, Joseph Collins declared, in an essay marking the twentieth anniversary of the end of the strip, "Gary Larson is, without a doubt, an American comic icon."

These accolades call attention to a powerful paradox in the field of comics studies. Whereas the work of cartoonists that do not include multiple images arranged in a deliberate sequence is often excluded from the realm of comics, few would argue that Larson's panels should be. On the contrary, *The Far Side* is often hailed as a masterpiece by critics. Additionally, while comics that use the single-panel format are often seen as lacking in complexity and thus are held in low esteem, *The Far Side* has consistently been viewed in the highest regard. Discussions about the problems with—or at least, limitations of—the one-panel format, in fact, routinely omit *The Far Side*. Conversely, commentaries about the brilliance of *The Far Side* do not engage with the fact that the series appears in this mode. These discussions may mention that the series is a single-panel one, but they do not see Larson's work as being in dialogue, or even possessing any kind of kinship, with other single-panel titles like *Little Lulu*, *Ziggy*, or *The Family Circus*. In sum, single-panel comics are typically derided unless they are *The Far Side*. From its initial release in 1980 through the present day, Larson's work is regarded as too good to be considered a single-panel series, even though it is one.

Much of the past success as well as ongoing acclaim for *The Far Side* stems from its nerdy subject matter. As David Leon Higdon observed, although the series did not have an official theme, it was "almost totally dominated by the discourses of science—especially anthropology, archaeology, botany, entomology, paleontology, and zoology, with occasional ventures into physics and mathematics" (Higdon 49). Over the course of its run, the comic's "cows, mad scientists, disgusting insects, amoebae, ducks, etc. became known to millions" (Markstein, "Far Side"). Given the frequency with which

*The Far Side* focused on such issues, *Natural History* magazine dubbed Larson "the unofficial cartoonist laureate of the scientific community" (Collins 2016).

While the nerdy subject matter certainly endeared *The Far Side* to audiences, this chapter explores another equally central, but less often discussed, aspect of the single-panel series: its aesthetic style. More specifically, my focus is on the way that Larson rendered his human characters. Whether man or woman, old or young, Neanderthal or contemporary, the cartoonist depicted these figures in a crude, unflattering, and even unattractive manner (see Fig. 8.1). Their heads are attached directly to their torsos, their bodies are out of proportion, and their faces are gawky and pimply. As Kerry Soper rightly noted about Larson's work, "his people are grotesque" (109).[1] Whereas most cartoonists strive to create characters who are appealing and attractive, *The Far Side* is populated by ones whose appearance is unusual, unsightly, and—when compared with conventional standards of beauty—even ugly.

The discussion that follows explores this signature aspect of Larson's single-panel series. As I argue, ugliness is more than simply an iconic feature of this equally iconic strip; it is both critically and culturally significant. The use of ugliness in *The Far Side* enriches the meaning, enhances the impact, and augments the resonance of these strips. Far from embodying an inconsequential detail, this detail is as central as it is powerful.

An examination of ugliness in Gary Larson's *The Far Side* has implications that extend beyond simply this cartoonist and his creation. It also calls attention to the important role that ugliness plays in comics. Much attention has been given over the decades to the visually stunning and artistically skillful imagery of sequential art. Past and present critics alike have called attention to elements such as the exquisite line work, finely crafted compositions, and magnificent drawings that permeate all modes of sequential art to demonstrate that it is a serious artistic form. Gary Larson's single-panel comics add a new and contradictory facet to this ongoing conversation. Ugliness in comics can be just as visually striking, narratologically effective, and culturally memorable as drawings that are beautiful. In so doing, *The Far Side* offers an instructive case study of what might be called the beauty of ugliness.

Exploring the role that ugliness plays in Gary Larson's work not only adds a new significance to the aesthetics of his series; it also invites us to explore an unexpected visual connection between this popular single-panel series from the closing decades of the twentieth century and some of the most

176 • Singular Sensations

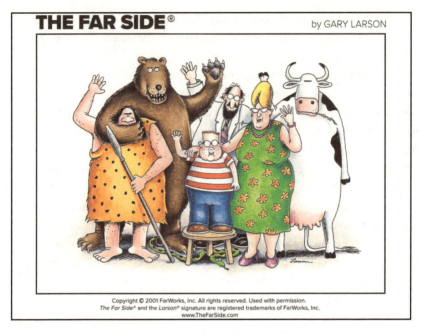

FIG. 8.1 *The Far Side* characters by Gary Larson. Image available at Go Comics, https://www.gocomics.com/blog/4827/the-far-side-launches-official-site.

successful digital comics released during the opening decades of the new millennium. Titles like *The Oatmeal*, *Natalie Dee*, and *Hyperbole and a Half* engage with vastly different subject matter than *The Far Side*, but they echo and even amplify Larson's aesthetic when it comes to presenting the human body: all three of these web comics present their characters in unflattering, unattractive, and unsightly ways. When *The Far Side* debuted in 1980, Larson's single-panel series was distinctive for its grotesque rendering of people. In a detail that can be regarded as another aspect of *The Far Side*'s already formidable legacy, this mode of representation likewise permeates some of the most well-known and widely circulated digital comics in the present day.

## "Bodies . . . like Giant, Lumpy Pears": Gary Larson's Geeks, Dorks, and Nerds

Gary Larson's *The Far Side* was one of the most beloved newspaper comics of its era. It was also one of the most recognizable. Regardless of the specific type of human figure being depicted—scientists, cowboys, cave people, youngsters, businessmen, suburban parents—the cartoonist rendered them in a

similar manner. Nearly every facet of the character's anatomy is misshapen, distorted, or even seemingly malformed. As Kerry Soper commented, human figures in *The Far Side* "are shaped like giant, lumpy pears" (109). This assessment is far from an exaggeration. In Larson's series, no child was cute, no man was handsome, and no woman was beautiful by conventional standards. The odd, unusual, and even unsightly appearance of *The Far Side*'s human characters did not distract readers from the content of the panel. On the contrary, such depictions echoed and even amplified the theme, topic, or message.

The way in which Gary Larson uses the peculiar appearance of his characters to accentuate the equally peculiar humor of his series appears in the very first installment of *The Far Side* (see Fig. 8.2). Published on January 1, 1980, the image depicts a baby and a toddler building a sandcastle at the seashore. Undoubtedly, the first detail that readers notice about Larson's drawing is the appearance of the two children. Far from adorable cherubs, Larson's youngsters look like villains from a silent-era film. The baby on the left side of the composition is anything but cute: the figure—who appears to be male—has beady eyes, a globular ear, pointy nose, and pursed lips that run together. Additionally, the youngster has an enormous forehead, compressing the facial features and making them even more unsightly. Even the infant's tufts of hair and little legs lack cuteness. The placement, length, and shape of the few strands of hair on his head look more like his hair is receding rather than coming in. The appearance of the baby's lower body is no better. His bulging kneecaps and lumpy ankles aren't adorably plump; they look misshapen. Finally, the baby's bottom is so bulbous that it is unclear whether he is sitting in a baby beach chair or just in his diaper.

The toddler-aged girl playing on the other side of the sandcastle is even more startling. Her face is pimply or pockmarked, her eyes are extremely close set, and her nose looks like a snout. Viewed collectively, her visage more closely resembles a frightening clown than a cute young child. Adding to her scary appearance, the youngster also has an exceedingly pointed chin. The rest of the toddler's body is equally strange. The little girl has no neck. Instead, her head is attached directly to her torso. Finally, while her face and body are plump, her arms, hands, and fingers are inexplicably thin and sharply pointed. Especially in relation to her puffy face and boxy torso, her hands have an insect-like quality.

Larson's two child figures occupy the background of his composition, but their unusual appearance causes them to stand out to his readers. Not only do these two youngsters not appear cute; they don't even look like youngsters. Instead, both more closely resemble grizzled miniature adults.

178 • Singular Sensations

FIG. 8.2 Inaugural panel of *The Far Side* by Gary Larson. Originally published on January 1, 1980. Reprinted in *The Complete Far Side*, vol. 1, by Gary Larson (Andrews and McMeel, 2014), 4.

In the foreground of this inaugural panel of *The Far Side* are two crabs. Whereas Larson has distorted the appearance of the two human babies in his drawing, it is noteworthy that he has not done so with either of these crustaceans. The legs, claws, and eyes of both creatures are proportional. Additionally, the surface of their shells is not marred or sullied in any way. If anything, all of the bumps, spikes, and prickles that typically appear on the bodies of crabs have been smoothed out. Similarly, the numerous leg joints, body plates, and claw segments have been minimized or even eliminated. None of the features on the crabs are presented in a manner that makes them scary or even strange. On the contrary, if anything, the two crustaceans are rendered in a manner that makes them more cartoonish and thus more friendly, adorable, and appealing.

The crab on the right side of Larson's drawing is saying something. The creature's mouth, which is both enlarged to be more visible and simplified to omit the sharp teeth and tiny pinchers that it possesses in real life, is

open in a conversational way. A line of dialogue that appears below Larson's drawing reveals what he is saying: "Yes. . . . They're quite strange during the larval stage" (Larson, *Complete Far Side* 1: 8). The humor of this comment, of course, arises from inversion: invertebrate animals like insects and echinoderms have a larval stage, not humans. However, the crab's comment is accurate in many ways. Infants and toddlers can be viewed as larval in many respects. Larvae are the immature form of an organism: grubs are larvae that develop into beetles, caterpillars are ones that become butterflies, and tadpoles are larvae that mature into frogs ("Metamorphosis"). While we generally consider infants and toddlers as their own distinct stages of development, they do embody the immature form of the mature human organism. In order to become adults, these youngsters undergo a massive, multifaceted metamorphosis, changing physically, intellectually, emotionally, and psychologically. Viewed from this perspective, the crab in Larson's comic is not entirely wrong: the baby and toddlers can be regarded as a type of human larva.

The aesthetic appearance of Larson's beach babies, of course, accentuates this connection—and by extension, the panel's humor. Most aquatic and terrestrial larvae are far from cute and adorable; on the contrary, they are often strange and even unsightly. Caterpillars are usually wormlike and either slimy or hairy. Meanwhile, grubs have thick, white, C-shaped bodies and often look like a zombie shrimp burrowed into the dirt. Even tadpoles are bizarre looking, with their oversized heads and translucent bodies.

While babies and toddlers are commonly regarded as cute, Larson's comic calls attention to how strange they can—and in reality, often do—look. The faces of infants are commonly puffy, their eyes are often tightly shut, and their skin is frequently red or blotchy. Additionally, the proportions of an infant and toddler's body are different from that of an adult: their limbs are significantly shorter, and their skulls are often boxy or flattened from lying on their backs for prolonged periods. Of course, these features change as they develop. However, they can make young children look unusual and even alien. Larson's rendering of the two youngsters on the beach enhances these qualities—and in the process, underscores the humorous but nonetheless insightful observation of how larval-like they are in many respects.

Larson's depiction of babies and toddlers as unattractive, odd, and even grotesque in this inaugural comic of *The Far Side* was not an anomaly. On the contrary, such representations can be found in numerous installments throughout *The Far Side*. The panel that appeared on January 11, 1986, forms an excellent example (see Fig. 8.3). The drawing depicts a hospital

FIG. 8.3 "Belly button slipknots," in *The Far Side* comic by Gary Larson, January 11, 1986. Reprinted in *The Complete Far Side*, vol. 2, by Gary Larson (Andrews and McMeel, 2014), 145.

nursery. Viewers can see multiple rows of newborns tucked into bassinets, save one. This infant has shot up into the air, zooming and spiraling toward the ceiling. The newborn's body looks floppy and deflated, like a punctured balloon. The caption, "Belly button slipknots," explains what has occurred (Larson, *Complete Far Side* 2: 145). Of course, the humor of Larson's panel arises from its impossibility: the area on a newborn's abdomen where the umbilical cord was snipped—and which becomes their belly button—is not keeping the youngster from deflating. Nonetheless, as anyone who has ever seen an umbilical cord stump can attest, this outcome seems plausible.

Of course, the newborn who is shooting through the air in Larson's comic is not depicted as cute or adorable. On the contrary, the deflating baby looks more like a rubbery sea creature—an octopus or a jellyfish—than a human newborn. Moreover, the infant appears to be losing both the air from their body and their skeletal structure: their skull has softened, their arms and legs are floppy, and their face has elongated as if all the cheek bones have melted. This rendering, of course, enhances the humor of the scene. It

also ensures that the panel is viewed in a comedic rather than macabre way. After all, few people would find a scenario where a newborn was realistically being depicted in distress amusing. So the cartoonist's decision to present the deflating newborn as more closely resembling a rubber octopus is not only significant; it is essential. If Larson had rendered the newborn cuter and more human, this scene would have shifted from being humorous to being horrifying.

Older children in Larson's series are not depicted in ways that are any more adorable or appealing. On the contrary, they are presented in the same unflattering, unattractive, and even grotesque manner. The *Far Side* panel that appeared on October 19, 1983, forms a representative case in point (see Fig. 8.4). The comic features a bespeckled boy having a snack; the box on the table in front of him reads in large lettering "Animal Cookies." This seemingly quintessential portrait of American childhood, however, has a *Far Side* twist. In typical Larson fashion, instead of the young boy munching on the animal crackers, they are munching on him. Playing with the premise "What if animal cookies were actual animals?" two cookie creatures have clamped onto the fingers of the boy's left hand. Larson's panel captures the aftermath of this event: the boy's arm is extended into the air, his eyebrows are raised, and sweat is emanating from his brow. The kid's dorkiness—his big glasses, freckled face, and neckless torso—accentuates the humor of this scene. If Larson had depicted the young boy in a cute and adorable way, this scene would seem pitiable rather than comical.

Larson's portrayal of young girls in his series is no different. In marked contrast to long-standing societal views that white, elementary-aged girls are cute, sweet, and adorable, *The Far Side* presents them as just as gawky and gangly as their male peers (see Fig. 8.5). The noses of these figures are commonly snout-like, their faces are routinely bulbous, and their arms, in sharp contrast to the bulkiness of their torsos, are pencil thin: they have no visible biceps, triceps, or deltoids. Additionally, Larson often depicts his elementary-aged female characters wearing cat-eye-shaped eyeglasses. While these types of frames are now fashionable among young people and considered stylish and artsy, when *The Far Side* ran during the 1980s, they were associated with the elderly. Grandmothers wore cat-eye-shaped eyeglasses, not children. Thus, putting them on an elementary-aged girl made her not only profoundly uncool but also prematurely old.

Admittedly, girls are more commonly background characters in *The Far Side* rather than the main protagonist. Nonetheless, their awkward, gawky, and even anachronistic appearance makes an important contribution to its

FIG. 8.4 "Animal Cookies," in *The Far Side* comic by Gary Larson, October 19, 1983. Reprinted in *The Complete Far Side*, vol. 1, by Gary Larson (Andrews and McMeel, 2014), 337.

humor. These odd and unusual figures populate a scene that is equally odd and usual, such as a child improbably choosing the bland soda cracker over the sweet graham for snack time. The presence of gangly, cat-eye-bespeckled girls as secondary figures confirms the bizarre nature of the scenario that is being presented in Larson's drawing.

While it might be tempting to argue that childhood is a challenging time when many youngsters are gangly and awkward, Larson's portrayal of adults follows this pattern. Whether depicting suburban parents, laboratory scientists, or corporate businessmen, the cartoonist presents these figures in the same unflattering way. As Kerry Soper has said about their typical appearance, their "backs are hunched, with heads attached directly to the front of chests" (Soper 109). In many cases, the skeletal structure of these men and women is off: long bones often seem too short, and short bones are routinely too long. Additionally, "the structure of the arms is all wrong, with bones bending at odd angles" (Soper 109). The limbs of some of Larson's adult characters are so lumpy that they appear to have healed poorly from a break—or alternatively, might even be broken right now. Not surprisingly,

"His People Are Grotesque" • 183

Nov. 12, 1957: Kevin Wakefield, during snack time, makes kindergarten history by selecting the soda cracker over the graham.

FIG. 8.5 "Nov. 12, 1957 . . ." in *The Far Side* comic by Gary Larson, March 16, 1987. Reprinted in *The Complete Far Side*, vol. 2, by Gary Larson (Andrews and McMeel, 2014), 271.

the hands of Larson's human characters are equally strange. Their "fingers look like broken sausages, dangling from hands in random directions" (Soper 109). The visages of Larson's adult characters are just as unconventional and even unattractive. From pimples, pockmarks, and beady eyes to bad haircuts, thick glasses, and pointy noses, their faces exist far outside conventional notions of beauty.

Akin to Larson's depiction of children, the unconventional appearance of these figures perfectly suits the equally unconventional topics, themes, and humor of the panel. The comics featuring scientists are among the most popular in *The Far Side*, and they also provide an excellent case study for how this phenomenon functions in the series. Scientists have long been regarded as awkward geeks and weird dorks by mainstream American culture. Thus, Larson's decision to accentuate their nerdy appearance enhances this perception and by extension the willingness of his readers to chuckle

at their actions. That said, the interplay between the visual appearance and the thematic content of Larson's comics featuring scientists is often much more complicated. Chemists, physicists, and astronomers in *The Far Side* may look ultranerdy, but the humor of the panel often arises from the fact that they are engaged in conduct that is goofy, silly, and even dumb. In sum, anything but genius caliber: gleefully running outside to catch the ice cream truck, taping a comedic mathematical equation to a colleague's back, or startling a laboratory coworker by popping a large paper bag behind their head (see Fig. 8.6). In so doing, the ultranerdy visual appearance of Larson's scientists stands in marked contrast to their behavior, a tension that forms the basis for the humor.

While *The Far Side* was one of the most popular and acclaimed newspaper comics of its era, it was not without its detractors. Over the years, various individuals and organizations voiced their objections to the comic. The human-rights advocacy group Amnesty International, for example, criticized a panel that depicted a group of men tied up in a gloomy dungeon. A sign hanging on the wall above their heads reads, "Congratulations Bob: Torturer of the Month" (Holmquist). Likewise, animal lovers in general and cat aficionados in particular were upset by a *Far Side* comic in which dogs play a game called "Tethercat": instead of having a ball tied to a rope on a pole, the canines are swatting around a feline (Holmquist). Some of the complaints lodged against *The Far Side* were more general or broad. As Larson recounts in the second volume of *The Complete Far Side*, a letter written to the editor of a newspaper complained that the comics page was supposed to be populated by cute cartoons. However, the characters in *The Far Side* were all so ugly (Larson, *Complete Far Side* 2: 137). Gary Larson's characters were indeed ugly. Moreover, they were intentionally, unmistakably, and unapologetically so. This feature was not a flaw in his series; the odd, weird, and unsightly appearance of Larson's human figures formed an important and all-too-often overlooked aspect of *The Far Side*'s success.

## The Beauty of Ugliness: When "Bad" Drawing Is Good

The synergy that exists between the aesthetic appearance and thematic content of *The Far Side* does more than simply affirm the long-standing axiom about how style can accentuate substance. These features also call attention to the important, but long-overlooked, role that "ugliness" plays in these strips—and by extension, comics as a whole.

FIG. 8.6 *The Far Side* comic by Gary Larson, June 4, 1983. Reprinted in *The Complete Far Side*, vol. 1, by Gary Larson (Andrews and McMeel, 2014), 306.

As Gretchen E. Henderson aptly observed, "from contemporary television to toys to literature to music, recent years have witnessed rising interest in ugliness" (9). Even a cursory examination of American print, visual, and material culture in the opening decades of the twenty-first century affirms the veracity of this claim. From the prevalence of the plush toys Ugly Dolls (debuted in 2001) and the popularity of the television show *Ugly Betty* (2006–2010) to the strong sales of Scott Westerfield's young adult novel *Uglies* (2005) and the growth of "ugly sweater" parties, the unpretty, unattractive, and unappealing has—ironically—had a strong appeal in millennium American culture. The ascendency of ugliness over the past few decades, in fact, prompted Sarah Kershaw to declare in an article from *The New York Times* in 2008, "Move over, My Pretty, Ugly Is Here."

While ugliness may have enjoyed unprecedented cultural traction in recent years, it has a long, rich, and complicated history. As long as there

have been notions of beauty, there have been ones of ugliness. For centuries, these two concepts have functioned as opposites. Sara Halprin, for example, has written about "the polarity of beauty and ugliness" (9). While notions of beauty change across cultures and time periods, one truism remains: to be beautiful is, by definition, not to be ugly—and vice versa. Whether referring to art or appearances, objects or individuals, these concepts are mutually exclusive. More than simply constituting a binary, these ideas are antipodal.

Notions of beauty and conceptions of ugliness might be oppositional, but they share a common set of determining factors: each is heavily connected to race, class, gender, age, sexuality, religion, ethnicity, and able-bodiedness. As Halprin explains, "White women are expected to follow a standard of white beauty that implies purity and chastity. Women of color are judged according to white standards of beauty" (7). Additionally, she goes on to elaborate, "Lesbians are judged according to white [heterosexual] standards of beauty. All women, as we age, must come to terms with a universal standard of youthful beauty, in a world that increasingly worships youth and denigrates age" (Halprin 7). Furthermore, while cultural conceptions of beauty change over time, one feature remains constant: they remain firmly rooted in able-bodiedness. Individuals whose bodies differ from what is regarded as "normal" are excluded from notions of beauty and often even denigrated as ugly. Lennard J. Davis, Kim E. Nielsen, and Gretchen Henderson have discussed the passage of what came to be known as "'Ugly Laws' (or 'unsightly beggar ordinances,' starting around the 1880s) that prohibited individuals with physical deformities from visiting public spaces, perpetuating historic conflations of deformity and ugliness" (Henderson 14). As Henderson reveals, "In some cities, this legislation remained on the books into the 1970s when challenged by the rise of the Disability Rights Movement" (14).

Of course, individuals who possess some type of impairment are not the only ones to have been viewed as "ugly" in the United States; so too have various races, ethnicities, nationalities, and religions over the centuries. From portrayals of African Americans with grotesquely big lips, bulging eyes, and exaggerated grins to depictions of Irish Catholics as pugnacious drunks, entire groups of people have been regarded as "unsavory" because of their identity. In these instances, beliefs that such figures are physically unattractive and socially unappealing arise from the fact that they are Other. In the words of Henderson once again, "Ugliness was not inherent to these groups but rather inscribed and imagined, arising when different cultures and ideologies collided, shifting curious and wondrous qualities to be feared as circumstances changed" (79). Their difference from—and thus, challenge

to—the status quo becomes the reason for their denigration. In so doing, ugliness shifts from being an aesthetic concept to being a cultural tool, political tactic, and even societal weapon.

Such phenomena notwithstanding, the etymology of the term "ugly" reveals a far different cultural origin of, along with sociopolitical function for, this concept. As the *Oxford English Dictionary* notes, "ugly" has its root in the Old Norse term *ugglig-r*, which means "to be feared or dreaded." Accordingly, when the term made its initial appearance in the English language in the mid-thirteenth century, the adjective connoted "Having an appearance or aspect which caused dread or horror" (*OED*, "ugly (adj.), sense 1"). It would be more than a century until this understanding shifted to its common usage today: denoting objects, individuals, or elements that are "Offensive or repulsive to the eye; unpleasing in appearance; of disagreeable or unsightly aspect" (*OED*, "ugly (adj.), sense 1").

The linguistic history of the term "ugly" is far from esoteric trivia. Instead, the etymology reveals a commonly overlooked or routinely forgotten aspect of this state: the power that it possesses. Discussions about ugliness commonly frame this condition as lamentable because it involves a loss of agency and autonomy. Ugly individuals, objects, or entities are not simply stigmatized and disparaged but shunned and even ostracized. They are regarded as losing societal power and sociopolitical influence. Being ugly means living on the margins or even hiding in the shadows. The etymological root of the term, from the Old Norse word meaning "to be feared or dreaded," upends or at least complicates this conception. It allows us to recoup the way in which ugliness can be an asset rather than a liability. Viewed from this perspective, ugliness connotes a state of personal empowerment rather than societal exclusion.

While the benefits of ugliness can be viewed in an array of sites and sources, the punk movement in the 1970s forms an excellent example. As J. Jack Halberstam has written, punk "allowed for a different trajectory of rebellion" ("Bondage" 154). With music that was cacophonous, lead singers who were not heartthrobs, and behavior that was rude and often even aggressive, the punk movement did not simply contain various forms of ugliness; it celebrated them. For many punk fans, this in-your-face commitment to the unconventional, iconoclastic, and unsightly was as politically subversive as it was personally freeing. Instead of trying to adhere to social conventions, they reveled in their refusal to do so. Moreover, this countercultural status gave them a distinct form of power. Echoing the etymological root of the word ugly, it caused them to be feared and dreaded by many members

of mainstream society who either did not understand punk's rebellion or did not approve of it.

The empowering impact of punk was especially poignant for white, middle-class, heterosexual young women. As I have written elsewhere on this topic, "With its interest in shock and emphasis on ugliness, [punk] represented a radical new way for young women to reject femininity" (Abate, *Tomboys* 198). Indeed, with an aesthetic that included black lipstick, torn stockings, and ears pierced with oversized safety pins, the punk look was about shock value. Their attire was a clear public rejection of the expectations for white, middle-class, heterosexual women regarding appearance. By being openly, brazenly, and even aggressively "unpretty," these young women tapped into a new kind of sociocultural power (Halberstam, "Bondage" 154). The rise of all-girl punk bands in the 1990s—such as Hole, Bikini Kill, and L7—offered a vivid demonstration of this phenomenon. As Kartina Eileaas has commented, "ugliness [was] a strategy of resistance among girl bands" (122). As the lyrics to Hole's song "Pretty on the Inside" (1991) asserted, "There's no power like my ugly" (qtd. in Eileaas 122).

The work of Gary Larson echoes while it extends the historical uses of ugliness. Much attention has been given over the decades to the beauty of comics. Citing aspects ranging from the skillful use of line and the creation of complex compositions to the adroit use of color and the synergistic relationship between word and image, a bevy of past and present books, essays, and articles demonstrate how comics are a skilled art form. Indeed, many of the most critically important and culturally influential discussions about the genre—including Scott McCloud's *Understanding Comics* (1993), Will Eisner's *Comics and Sequential Art* (2008), and Nick Sousanis's *Unflattening* (2015)—contain this argument at its core.

The work of Gary Larson adds a new facet to ongoing conversations about the aesthetics of comics. The cartoonist demonstrates how seemingly "bad" drawings can be good. Rather than embodying examples of the beauty of sequential art, *The Far Side* invites us to consider the important but neglected role of ugliness in it. In the same way that physically attractive figures and visually appealing compositions contribute to seeing comics as an important and influential form, so too do unattractive characters and unappealing drawings. As the work of Larson demonstrates, ugliness can be just as thematically rich and visually compelling. It can add to both the aesthetic complexity and the narrative content of a comic. Consequently, rather than embodying a feature to overlook or excuse, ugliness is an aspect to spotlight and value.

Umberto Eco, in his treatise *On Ugliness* (2007), reflected, "Beauty is, in some ways, boring. Even if its concept changes through the ages, nevertheless a beautiful object must always follow certain rules." By contrast, Eco continues, "Ugliness is unpredictable and offers an infinite range of possibilities. Beauty is finite. Ugliness is infinite, like God." While I wouldn't go so far as to claim that beautiful comics are dull, I would assert that the ugliness of Gary Larson's characters makes them exceedingly interesting. The awkward, unsightly, and even unattractive figures who populate *The Far Side* make the series more compelling and complex. Danish artist Asger Jorn once opined, "An era without ugliness would be an era without progress" (qtd. in O'Donnell 100). Whereas beauty pleases viewers, "ugliness provokes a shift beyond comfort and stasis" (Henderson 12). The unattractive and unsightly requires us to question, challenge, and reevaluate. In light of these qualities, ugliness is disruptive, dynamic, and often even transformative.

From the standpoint of both its aesthetic appearance and its thematic content, so too was *The Far Side*. At the heart of the subversive nature of the acclaimed newspaper series was ugliness. This trait—whether manifest in the visual look of the drawings or in the content that they depicted—fueled the way in which Larson's panels questioned, challenged, and disrupted the status quo. In the same way that comics studies have concerned itself with questions of aesthetic beauty, the time is long overdue for it to recognize the artistic value, symbolic importance, and sociopolitical power of ugliness.

## Bigger Than Life (and Twice as Ugly): Gary Larson's Unsightly Legacy

When critics and fans explain the reasons for *The Far Side*'s success, they usually focus on the comic's content. In comments that have been echoed in many other past and present analyses, Sarah Larson (no relation to the cartoonist) reflected in *The New Yorker*, "It was confidently modern and confidently weird" (Larson, "Far Side"). From sardonic cows to macabre mathematicians, *The Far Side* was unlike any other comic series in the newspaper. "We'd long been capable of laughing at praying-mantis jokes," Sarah Larson remarked, and "finally, someone was making them" (Larson, "Far Side").

While such content puzzled some and horrified others, untold millions loved Gary Larson's single-panel series precisely for these reasons. Both during its own time and in the decades since it ceased publication, *The Far Side*'s impact on both popular culture and the practice of cartooning in the United

States is undeniable. In the words of *The New Yorker* once again, "the culture flourished and changed, in part encouraged by the landscape that 'The Far Side' helped create" (Larson, "Far Side"). Larson's single-panel series was among the first to champion dorks and celebrate geeks. By the dawn of the twenty-first century—as television shows like *The Big Bang Theory* emerged as massive hits and Hollywood movie adaptations of comic book figures like Iron Man, Captain America, and Thor became staples in theaters—"Nerd culture, and nerds, took over" (Larson, "Far Side"). *The Far Side* has been credited as a catalyst for this trend.

While the role that the subject matter of *The Far Side* played in influencing American popular culture is undeniable, the aesthetic appearance of the strip is just as significant. The gangly, awkward, and even ugly manner in which Gary Larson depicted characters in *The Far Side* has become increasingly common in U.S. web comics over the past few decades.[2] Titles like *Natalie Dee* (2002–2013), *Hyperbole and a Half* (2009–present), and *The Oatmeal* (2009–present), for example, present both humans and animals in crude, gawky, and unflattering ways. Moreover, this aesthetic appearance embodies both a signature facet of the appearance of these titles and—akin to Larson's *The Far Side*—also enhances their subject matter.

Natalie Dee's self-titled single-panel series was one of the first digital comics to gain national popularity in the opening years of the new millennium. It was also a series whose odd, unusual, and often unflattering rendering of its characters was a hallmark of its visual style. Throughout the series, Dee renders human characters as little more than stylized stick figures. However, even with this simplified design, they are crudely drawn. Comic #861, which bears the sarcastic title "don't be late," embodies a representative example (see Fig. 8.7). The mouth of the figure extends inexplicably across the entire face, stretching from ear to ear. This feature makes the individual look more like a fish than a person. Additionally, the figure's left arm doesn't line up with the side of their body. Instead, this appendage attaches both below the shoulder and—in an even more bizarre detail—inside the torso. Moreover, Dee's protagonist has no neck whatsoever; the individual's large head sits directly atop their boxy body. The figure likewise has no nose or ears. Finally, but far from insignificantly, even the dots that the cartoonist uses for this figure's eyes are odd; not only are they spaced very far apart, but they are also different sizes, giving the character an ogre-ish look.

This crudely drawn and oddly proportioned figure echoes and even enhances the content of the panel. Several lines of text appear beside Dee's figure. "Well, look at the time. I need to run back inside so I can be

FIG. 8.7  Comic #861: "don't be late," in *Natalie Dee* comic by Natalie Dee. http://www.nataliedee.com/index.php?date=042006.

passive-aggressive and shitty on the internet!!" it says in remarks that can be attributed to the character. The unpleasant appearance of Dee's character perfectly suits these unpleasant remarks. Her stick figure is drawn in a rough, coarse, and unpolished way. It is only fitting that this person expresses sentiments that are equally rough, coarse, and unpolished.

A similar phenomenon permeates Allie Brosh's *Hyperbole and a Half*. The series, which sometimes appears in a single-panel format but more often uses multiple frames, has an aesthetic that echoes that of Natalie Dee: Brosh's characters are largely rendered as crudely drawn and awkwardly proportioned stick figures (see Fig. 8.8). Their limbs are distorted, their facial features are either exaggerated or omitted entirely, and their posture is odd and even bizarre. In some instances, in fact, her characters blur the line between human and animal, as a tuft of hair resembles a horn, bulging eyes are more indicative of a reptile or amphibian, and gaping mouths with rows of small sharp teeth look piscatorial. Echoing both *Natalie Dee* and *The Far Side*, the odd, strange, and even weird appearance of Brosh's figures does not distract readers from her content; these features enhance it. The humor of *Hyperbole and a Half* is as raw as the characters who populate it. In commentary that could easily be used to describe Gary Larson's series, the subtitle to one of Brosh's book-length collections characterizes this set of reprinted panels as "Unfortunate Situations, Flawed Coping Mechanisms, Mayhem, and Other Things That Happened." This overview is apt, both for the comics that appear in this volume and for other installments of the series. Brosh's work often addresses her struggles with bouts of devastating depression and crippling anxiety with unvarnished candor. Moreover, she illustrates these panels with "very precise crudeness" (qtd. in Gross). Brosh wants the rawness of her drawings to mirror the rawness of her disclosures. It is difficult to imagine anyone arguing that her work does not achieve this goal.

FIG. 8.8 "This Is Why I'll Never be an Adult," in *Hyperbole and a Half* by Allie Brosh. https://hyperboleandahalf.blogspot.com/2010/06/this-is-why-ill-never-be-adult.html?commentPage=5.

Matthew Inman's *The Oatmeal* functions in an analogous way from an aesthetic standpoint. Whereas both *Natalie Dee* and *Hyperbole and a Half* use slim stick figures as the basis for their characters, *The Oatmeal* does the opposite: whether animal or human, the characters who populate the series are exceedingly plump. Generally speaking, the pudgy nature of Inman's characters does not make them cute or adorable in an "I-want-to-pinch-those-chubby-cheeks" kind of way. Instead, Inman depicts the plumpness of his characters in a way that makes them grotesque (see Fig. 8.9). Their flesh is so ample that their skin can barely contain it. The corpulence of some figures causes them to look more like blobs than humans: they lack necks, wrists, and ankles; meanwhile, their eyes, ears, and mouths have been pushed out of place and are distorted. Akin to *Natalie Dee* and *Hyperbole and a Half*, however, the aesthetic appearance of Inman's characters suits his subject matter. Whether it is a comic depicting the unbridled joy that accompanies eating a bowl of cereal or one addressing the rage that artists feel when they're asked to do creative work "for the exposure," the rendering of figures as oversized accentuates the equally strong viewpoints or hefty themes.

*The Oatmeal*, *Hyperbole and a Half*, and *Natalie Dee* are not merely examples of twenty-first-century web comics; they are among the most commercially successful and critically acclaimed titles during the past two decades. Within one year of launching, Matthew Inman's web comic had four million monthly visitors (Snow). By 2012, *The Oatmeal* generated a half-million dollars in revenue (Snow). In 2014, Inman won the Eisner

Award for Best Digital/Web Comic. *Hyperbole and a Half* has rivaled this success. The web comic began as something that Brosh created just for her friends, but it quickly grew into an internet sensation. Panels like "Clean all the things!" have become globally circulated memes. Additionally, echoing the licensing deals made by many cartoonists before her, Brosh's work appears on an array of merchandise. Finally, two book-length collections of *Hyperbole and a Half* have been released, the first in 2013 and the second in 2015. Both made *The New York Times* bestsellers list in the category of Advice, How-To, and Miscellaneous.

The success of *Natalie Dee* has been more modest, but it is far from insignificant. At the peak of the site's popularity around 2009, her comics appeared on T-shirts, mugs, and tote bags. Additionally, her web comic has been mentioned in mainstream national publications like *Entertainment Weekly*. Although Dee ceased uploading new panels around 2018, her website is still available, and comics like "Anxiety Girl" and "The Masked Procrastinator" remain cultural touchstones.

*The Far Side* can be seen as an important, and long overlooked, influence on these well-known web comics. Although Larson's single-panel series addresses vastly different subject matter than *The Oatmeal, Natalie Dee*, and *Hyperbole and a Half*, its aesthetic of presenting human figures in odd, unusual, and unflattering ways permeates these titles. In many respects, in fact, *The Oatmeal, Natalie Dee*, and *Hyperbole and a Half* take Larson's ethos of ugliness and magnify it. At the very least, these web comics demonstrate how this visual style, which was odd and unusual when *The Far Side* appeared in newspapers, has become an increasingly common feature of comics in the twenty-first century. *The Far Side* has long been regarded as a hugely influential title in the history of U.S. comics from a thematic standpoint. As the visual appearance of web comics like *The Oatmeal, Natalie Dee*, and *Hyperbole and a Half* demonstrates, Larson's work was just as significant from an aesthetic one.

*The Far Side* is often lauded as the apex of American newspaper comics, single-panel or otherwise. Both when new installments of the series appeared in national publications and in the decades since it ceased regular print syndication, *The Far Side* has been discussed almost exclusively in superlatives.[3] The series has been deemed "amazing," "insightful," and even "perfect" (Epps). Meanwhile, Gary Larson has been repeatedly described as nothing short of a "genius" (Dorn). *The Far Side* has been praised for many reasons, ranging from its unique subject matter and clever humor to its unusual viewpoint and eclectic characters. To the list of elements that made

FIG. 8.9 "Eight Marvelous & Melancholy Things I've Learned about Creativity," in *The Oatmeal* by Matthew Inman. https://theoatmeal.com/comics/creativity_things.

Gary Larson's single-panel comic so memorable and effective, its use of ugliness needs to be added.

A jocular phrase characterizes some individuals as "bigger than life and twice as ugly." A variation on this sentiment applies to Gary Larson's single-panel comics. In the case of *The Far Side*, however, the series was bigger than life in large part because its human characters were twice as ugly. When we consider the twentieth-century impact and ongoing twenty-first-century legacy of Larson's work, we need to acknowledge both its single-panel format and the beauty of its ugliness.

# Epilogue

# Reimagine, Recombine, Recreate

●●●●●●●●●●●●●●●●●●●●●

Dan Piraro's *Bizarro*,
Mash-Ups, and the Comics
of Remix Culture

By the dawn of the twentieth century, sequential art had undergone an array of transformations. Computer technology had radically changed both the way that cartoonists created their work and how they distributed it to audiences. Additionally, comics had moved from the margins to the mainstream of American society. The annual Comic-Con was a red-carpet event, and superheroes from both Marvel and DC were the subjects of a panoply of blockbuster Hollywood movies. Finally, but far from insignificantly, long-form comics like graphic novels and memoirs moved to the forefront of the medium, enjoying critical acclaim as well as commercial success.

Within this environment where both book-length graphic narratives and superheroes ruled the day, one might expect that the single-panel form would fade—or at least, falter. After all, this mode had long been on the periphery of the genre, and at the start of the new millennium, it seemed even more out

of sync with the medium. However, single-panel comics remained a popular and pervasive mode of cartooning in the United States. From Mark Parisi's *Off the Mark*, Scott Hilburn's *The Argyle Sweater*, and Josh Alves's *Tastes like Chicken* to Lonnie Easterling's *Spud Comics*, Ged Backland's *Aunty Acid*, and Scott Metzger's cat cartoons, such titles abounded.[1] More than simply persisting into the twenty-first century, single-panel comics flourished. These titles enjoyed large fan bases: *Aunty Acid*, which features sassy one-liners uttered by an older white female character, counted more than eleven million followers on Facebook by 2022 (Aunty Acid). Single-panel comics were also the recipient of impressive critical accolades: Parisi's *Off the Mark* was named Best Newspaper Comic Panel by the National Cartoonists Society in 2008, 2011, and 2017.

Of all the many single-panel comics that rose to critical and commercial prominence by the twenty-first century, one stands out: Dan Piraro's *Bizarro*. Launched on January 22, 1985, the series offers a quirky, off-beat, and bizarre take on everyday life. *Bizarro* had a modest start—debuting in just eight newspapers (Heintjes, "Mondo")—but it steadily built a large following. By the second decade of the twenty-first century, in fact, Piraro's work appeared in more than 350 daily publications. While the bulk of these venues were in North America, *Bizarro* also appeared in newspapers throughout Asia, Europe, and South America (Santoni). Moreover, over the years, Piraro's panels have been collected and reprinted in more than a dozen books. In a telling index of the widespread popularity of *Bizarro*, the comic served as a clue on the popular game show Jeopardy in 2007: "'Weirdo' would be another name for this Dan Piraro comic," the prompt for contestants began (*Jeopardy!*).

*Bizarro* has been just as lauded by critics as it has been beloved by fans. The series was named Best Newspaper Cartoon Panel by the National Cartoonists Society three years in a row: 2000, 2001, and 2002. Additionally, in 2010, Piraro received the organization's top honor: the Reuben Award for Outstanding Cartoonist of the Year. In an equally impressive feat, prior to taking home this accolade, Piraro was nominated for the Reuben for eight consecutive years—a stretch that was unprecedented before and remains unparalleled to this day.

From its origins, Piraro's comic was likened to another single-panel series: *The Far Side*. Akin to Gary Larson's comic, *Bizarro* did not have a recurring cast of characters. Additionally, it didn't offer any ongoing storylines. Finally, and perhaps most importantly of all, *Bizarro* traffics in a similar type of odd, eccentric, and often even off-the-wall humor. The panel that

originally appeared on November 5, 2001, forms a representative example. The comic presents a snowman sitting atop a doctor's examining table. The body of the snowman, however, is hollowed out from his mouth down to his base. In a speech balloon at the top of the page, a human physician informs his frosty patient, "You've already lost all your teeth. If you don't give up hot chocolate soon, it could kill you." As the press department for Piraro's syndicate summarized about its focus, the series spotlights "the incredibly surreal things that happen to all of us in our so-called 'normal' lives" ("Dan Piraro Nominated"). Far from a comparison that was externally imposed, the similarity between *Bizarro* and *The Far Side* was one that Piraro openly acknowledged and even embraced. As he has recalled in various articles and interviews, seeing Larson's work inspired him to become a cartoonist: "Someone brought me a paper and said, 'Look at this thing called *The Far Side*!' I was like 'Wow, look at that! How strange is that! They're publishing things like that!' I couldn't believe it" (Heintjes, "Mondo"). Although Piraro was not trying to directly replicate *The Far Side*, *Bizarro* is often viewed as an imitation or, at least, a homage. As Tom Heintjes has commented, when the series first debuted, it was "relegated to the burgeoning category of *Far Side* clone" (Heintjes, "Mondo").[2]

This epilogue considers the state and status of single-panel comics in the United States in the early decades of the twenty-first century by reevaluating Dan Piraro's exceedingly popular series. More specifically, I make a case that although *Bizarro* owes an undeniable debt to *The Fire Side*, it is not a mere copycat. While the series does traffic in Larson's off-beat sense of humor, *The Far Side* is not its sole or even primary creative touchstone. Instead, *Bizarro* can more productively be seen as participating in a larger cultural phenomenon: the mash-up. As the name implies, mash-ups take two or more existing entities and combine—or mash—them together. DJ Danger Mouse's landmark *Grey Album* (2004), which remixed the music from the Beatles' *White Album* (1968) with the vocals from Jay-Z's *The Black Album* (2003) to create new tracks, embodies one of the most oft-cited examples. Drawing on previous practices like sampling, pastiche, and parody, mash-ups have become a defining feature of not simply music but literature, visual art, and film over the past few decades.

Mash-ups also form a core creative component of *Bizarro*. Piraro draws on a wide array of elements from print, visual, and popular culture in his panels. From well-known books, movies, and television shows to current events, public figures, and historical happenings, the series is far more of a collage than a homage. Locating Piraro's work within remix culture not only

offers a more accurate view of its logic of production; it also invites us to consider the important but overlooked role that mash-ups play in comics as a whole. For decades, this mode of production has embodied a defining aesthetic of music, literature, film, and visual art. *Bizarro* calls attention to the way that the mash-up has also been a driving force in U.S. comics, past and present.

## Mix and Mash: Art in the Age of Recombinant Reproduction

Peter Rojas, in an article that appeared in *Salon* in 2002, asserted, "We're at a point where it almost seems unnatural not to quote, reference, or sample the world around us" (Rojas). From internet memes and song remixes to doctored videos and works of fanfiction, twenty-first-century culture "is a tissue of citations, resulting from a thousand sources of culture and signs" (Cruger). For both amateurs and professionals, "creativity is a matter of drawing on, reconfiguring, and repurposing remade materials that are already at hand and in circulation" (Gunkel 85). Todd Gitlin, in *Inside Prime Time* (1983), was one of the first critics to discuss this phenomenon in the realm of television. A growing trend in broadcast programming, he observed, "does not create something out of nothing; it uncovers, selects, reshuffles, combines, synthesizes already existing facts, ideas, faculties, skills" (Gitlin 78). Rather than devising original ideas for television shows, programming is increasingly created by bringing together facets from existing ones that are already successful. For example, Gitlin explained, if the shows "*M\*A\*S\*H* and *Holiday on Ice* are both ratings winners," it is only a matter of time until a network executive somewhere makes the pitch, "why not an army of surgeons on skates?" (Gitlin 64). Through this act of combining and repackaging, "the new [is] a variant of the old" (Gitlin 63). Given these dynamics, Gitlin selected a word from science in general and genetics in particular to describe the phenomenon: "recombinant" (64). Echoing the process of mixing strands of DNA to create new genetic sequences, television producers recognized that "selected figures of recent hits can be spliced together to make a eugenic success" (Gitlin 64).

In the decades since the publication of Gitlin's work, recombinant culture has spread to every entertainment mode and artistic medium. These practices are known by different names in different arenas: sampling in music, pastiche in art, vidding in film, and so on. That said, one form of recombinant culture operates across multiple platforms: the mash-up. Paul J. Booth

offers one of the best explanations of this phenomenon: "the mash-up takes data from two or more different inputs and mixes them together in such a way as to create a unique, third form without loss to the meaning of the originals" (Booth). While there are no formal rules, official guidelines, or concretized expectations for the ingredients in a mash-up, the most successful yoke starkly incongruous elements to create what Kathleen Bartels calls "provocative juxtapositions" (16). The mash-up brings together vastly disparate elements that seemingly have no points of cultural, creative, or sociopolitical correspondence, but it recombines them in a way that is surprisingly effective. From merging the musical styles of glam rock and hip-hop on Run-DMC's recording of Aerosmith's "Walk This Way" (1986) to blending a highbrow piece of canonical literature with elements from lowbrow genre fiction in Seth Grahame-Smith's novel *Pride and Prejudice and Zombies* (2009), these combinations are delightfully unexpected and unexpectedly delightful. In many cases, in fact, the mash-up is so pleasing that its popularity exceeds that of the originals. The 1986 rap/rock version of "Walk This Way" peaked higher on the Billboard 100 chart than the initial recording from 1975 ("Walk This Way"). Likewise, while Jane Austen's *Pride and Prejudice* is a classic of British literature, Seth Grahame-Smith's vampiric reworking was a pop culture smash, debuting at #1 in contemporary literary on Amazon (Halford) and reaching the #3 spot on *The New York Times* Best Sellers List ("Paperback Trade Fiction").

Whether the mash-up takes place in music, literature, or the visual arts, the reasons fueling both its appeal and success remain the same. In the words of Booth once again, "the mashup works as an art form because the viewer must recognize each element as well as what happens when they are mixed" (Booth). First and foremost, audiences have to be familiar with the original source material: they need to understand the disparate nature of the elements being combined to appreciate why the act of blending them is so unexpected and thus remarkable. In so doing, mash-ups invite us to revisit, reconsider, and even rethink such phenomena. These creations "allow us to see old material afresh, defamiliarizing received knowledge and assumptions in order to reveal latent elements within, and connections between texts" (Salvati 98–99).

Mash-ups do more than simply alter our understanding of the source material; they also "open up the possibility of a third meaning," one that is generated from the merging of these elements (Harrison and Navas 188). When the ingredients of a mash-up are mixed together, something entirely new is created. The genre of rap-rock didn't exist until songs like "Walk This

Way" hit the airwaves. Now this category is a staple of the recording industry; entire performing groups—Linkin Park, Papa Roach, Limp Bizkit, Kid Rock—specialize in this type of music. A similar observation applies to the realm of literature. The success of *Pride and Prejudice and Zombies* inspired an array of texts using the same ethos: *Sense and Sensibility and Sea Monsters* (2010), *Wuthering Bites* (2010), *Jane Slayre* (2010), *Android Karenina* (2010), *Little Vampire Women* (2010), *Alice in Zombieland* (2011), and *Grave Expectations* (2011). As a result, the neo-Victorian novel-as-mash-up is now recognized as its own subgenre (de Bruin-Molé 249).[3]

Even though mash-ups are commercially successful, they are often critically derided. As Aram Sinnreich has noted, many "think of mashups as simply another example of paper-thin postmodernism" (Sinnreich). The art form does not adhere to "the old model of authorship that presupposes that the building blocks of creativity should spill forth from the mind of the artist" (Rojas). For this reason, they are often dismissed as "easy" and even "lazy." Macy Halford, in a review for *The New Yorker*, for example, asserted that *Pride and Prejudice and Zombies* blended 85 percent of Austen's original writing with 15 percent of new material to make a final product that was "one hundred per cent terrible" (Halford). If Grahame-Smith wanted to be a novelist, Halford asserted, he should write his own original book, not co-opt one published by someone else. Many hold similar views about mash-ups in any form. Items made in this way can never be important, they contend, because they are not original; instead, mash-ups are "plundered from others" (Gunkel 81). At best, they are artistic copies; at worst, they are creative thefts.

Those who defend and even celebrate mash-ups see this phenomenon in a markedly different way. This art form has risen to prominence not because it is so "simple" and "easy" but because it is so radical and even revolutionary. First and foremost, "By blurring the lines between artist and audience, original and copy, the mashup fundamentally rejects the atomistic assumptions that undergird our legal, economic, and political institutions" (Sinnreich). The often-unauthorized sampling and mixing is an act of rebellion against the social, cultural, political, and economic status quo. We live in a world that is saturated by images, many of which have been generated by corporations with the intent to sell products. As Eckart Voights has commented, "recombinant adaptations ... carry the potential to challenge, undermine, and transgress the semantic limits of corporate transmedia storytelling" (Voights).

When mash-ups are not pushing back against the forces of consumer capitalism, they are doing so against those of hegemonic culture. Whether taking the form of an internet meme, a redubbed video clip, or a work of

fanfiction, these phenomena are interested in "celebrating discontinuity and undermining textual authority and integrity by appropriating existing texts" (Voights). In the same way that a corporate mascot or company ad is not sacrosanct, neither is a novel by Jane Austen nor a painting by Van Gogh. These items can also be reimagined, reconfigured, and repurposed. In this way, "mash-up culture is in this sense a backlash against the cultural authority" (Shiga 104). The practice is at once a "dismissal of the old hierarchies" (Somerville, "Mash-Up" 133) and "a replenishment of the exhausted aesthetics of popular culture" (Voights). In short, it is a way of reclaiming control over what we see, how it is being presented to us, and the meaning that it possesses.

## "Achilles Appears in a Vision to a Young Dr. Scholl": Dan Piraro's Not-So-Bizarro Logic of Production

Dan Piraro's *Bizarro* grew in popularity during the same time as the mash-up. First appearing in 1985, his new single-panel comic rose to prominence as this new mode of artistic production became a dominant force in American popular culture. Far from distancing itself from the mash-up, *Bizarro* frequently drew on its logic of production. From the beginning of the series, Piraro combined elements from film, television, history, art, politics, music, and current events in his panels. Given this situation, Dan Piraro may have dubbed his new series "Bizarro," but its aesthetic coordinates were anything but bizarre or unusual. On the contrary, his single-panel comic participated in one of the era's most pervasive artistic modes. Identifying and exploring the ways in which mash-ups form a recurring and important component of *Bizarro* not only connects the series to developments taking place in the larger culture; it also complicates the comic's comedic operations. Piraro's work offers a perspective that is unquestionably similar to that of *The Far Side*. However, *Bizarro* generates its off-beat humor not by recreating Larson's talking cows or befuddled scientists but by reimaging, recombining, and recreating a wide array of disparate content. In so doing, Piraro's work does more than challenge our perception of an original comic; it also challenges our perception of hegemonic culture.

The way in which *Bizarro* recombines, reworks, and reimagines existing creative elements can be traced to its earliest installments. Many of the

panels that are reprinted in the first paperback collection—titled simply *Bizarro* (1985)—and which originally appeared during the comic's inaugural year of syndication, are mash-ups. One installment, for example, is labeled "Charlie on Merv" and brings together two well-known, but vastly different, personalities (see Fig. E.1). The panel imagines what would happen if talk show host Merv Griffin welcomed not fellow interviewer Charlie Rose to his program but comic strip protagonist Charlie Brown. "We have a marvelous show today folks," the speech balloon above Merv Griffin's head relays to his studio audience. "Our very special guest is loved and admired the world over as a fine performer and great humanitarian . . . please welcome one of America's oldest and most respected kids" (26). Sitting in the chair beside him is Charles M. Schulz's well-known character: the top of his bald head along with his trademark black shorts and saddle shoes are clearly visible. The humor of Piraro's panel arises from a combination of the widespread familiarity of these two figures, along with the absurdity of them ever crossing paths. First and foremost, of course, Charlie Brown is a fictional character, not an actual person. Even if Schulz's protagonist were a flesh-and-blood individual, he would be an unlikely guest on *The Merv Griffin Show*. The talk show was known for having detailed, in-depth conversations with its guests—something that is difficult to imagine Charlie Brown being interested in, or even able to, sustain.

Many other panels in Piraro's first book collection operate according to a similar ethos. A comic that appears near the middle of the volume, for example, brings together another pair of equally incongruous figures (see Fig. E.2). The drawing shows an adult man who is dressed in a Grecian robe sitting atop a bookcase in a darkened room. A glow emanates from his body as he speaks to a young white boy who is sitting up in bed. The grown man is pointing to his left foot. The speech balloon above his head reveals what he is saying to the boy: "I've had this problem with my heel for centuries and I was wondering if . . ." (72). The caption at the bottom provides further context for this scenario. "Achilles appears in a vision to a young Dr. Scholl," it reads (72). Echoing one of the foundational facets of the mash-up, Piraro's comic depends on the viewers being familiar with the two named figures: Achilles is a figure from Greek mythology who had an infamous vulnerability: the tendon in his heel. Meanwhile, "Dr. Scholl" is the brand name for a popular line of orthopedic products founded in the early twentieth century by podiatrist Dr. William Mathias Scholl. Piraro's panel brings together these two disparate figures and demonstrates how they can be productively placed in dialogue. Although Achilles is a fictional figure from ancient times

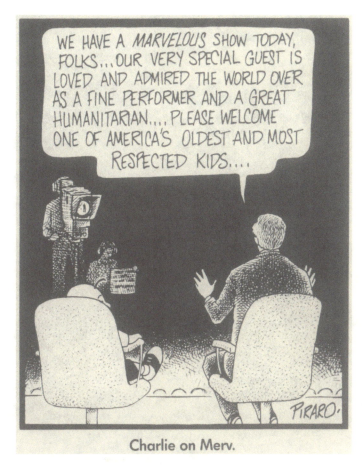

FIG. E.1 "Charlie on Merv," in *Bizarro* comic by Dan Piraro. Republished in *Bizarro* (Chronicle Books, 1985), 26.

and Dr. Scholl is a factual one from the current century, they have a shared interest in problems involving the feet.

One of the closing panels in Piraro's 1985 collection also forms one of its most memorable and provocative mash-ups. The image combines the title characters from two exceedingly dissonant movies: Bambi, the adorable baby deer from Disney's 1942 animated film by the same name, and Rambo, the macho action hero played by Sylvester Stallone in a franchise that began in 1982 (see Fig. E.3). Piraro's panel, which is drawn in the style of a movie poster, presents "Bambo," who looks like Bambi but behaves like Rambo. The deer is grimacing in a menacing manner, and he is also holding a long stick as if it were an assault rifle. Rather than facing off against the foes from Rambo, however, Bambo is staring down an adversary from his film: the

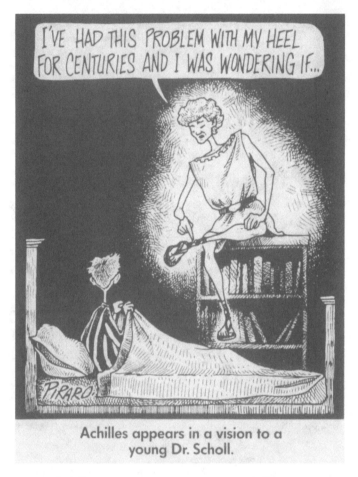

FIG. E.2 "Achilles appears in a vision to a young Dr. Scholl," in *Bizarro* comic by Dan Piraro. Republished in *Bizarro* (Chronicle Books, 1985), 72.

fire that rages through the forest. Even the tagline for Piraro's "Bambo" is a mash-up. Whereas the teaser for the sequel to *Rambo* was "First Blood Part II," the teaser that appears on his mock movie poster reads "First Fawn Part II" (83).

Far from an aesthetic approach that guided Piraro's early efforts, panels created by mashing together two or more existing elements within U.S. culture continued to be a common method for the cartoonist to create content. The opening pages of the volume *Glasnost Bizarro* (1989) contain a memorable example (see Fig. E.4). The panel depicts two prehistoric men painting on the wall of a cave. One of the animal-skin-clad figures has sketched a variety of typical images: a running antelope, a galloping deer, and a flying

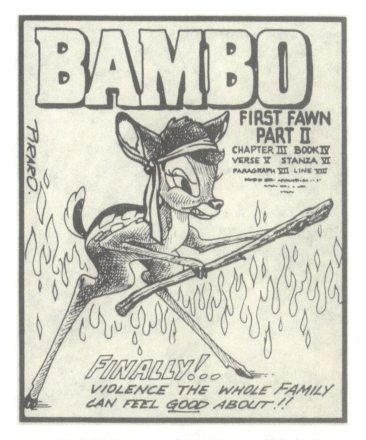

FIG. E.3 "Bambo," in *Bizarro* comic by Dan Piraro. Republished in *Bizarro* (Chronicle Books, 1985), 83.

arrow. Meanwhile, the caveman on the left has drawn something far different: a portrait of the animated television character Fred Flintstone. "I call it 'satire,'" he tells his fellow artist in a deadpan manner (22). The humor of this panel, of course, arises from the way that this image simultaneously defies and affirms chronology. *The Flintstones*, of course, aired during the late twentieth century, but the program purportedly took place in the prehistoric era. So Fred both is and isn't a contemporary of these cavemen.

Piraro's subsequent comics collection, *Bizarro Number 9* (1995), contains another even more clever recombinant comic: "Quentin Tarantino Directs an Episode of Barney" (94; see Fig. E.5). This caption is actually a bit of a misnomer. It would be more accurate to say that the panel takes an iconic scene from one of the director's most well-known films, *Pulp Fiction* (1994), and recasts the anthropomorphic dinosaur from the popular children's show

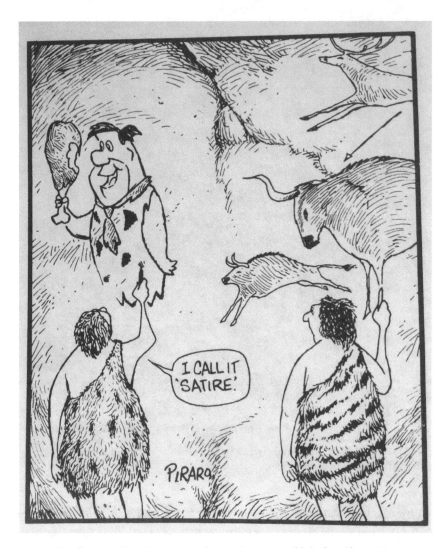

FIG. E.4 "I call it 'satire,'" in *Bizarro* comic by Dan Piraro. Republished in *Glasnost Bizarro* (Chronicle Books, 1989), 22.

into one of the main roles. To that end, the drawing depicts Samuel L. Jackson dressed as Jules Winnfield and driving his 1974 Chevy Nova. Beside him in the passenger seat, however, is not John Travolta but Barney the Dinosaur who is dressed to look like Travolta's character Vincent Vega. Not only is Barney wearing a dark suit, but he has on a wig with long black hair that is slicked back akin to Travolta's coif in the movie. Together with reimagining this iconic image from *Pulp Fiction*, Piraro's panel recreates one of the film's most well-known exchanges of dialogue: the one where Vincent

Reimagine, Recombine, Recreate • 207

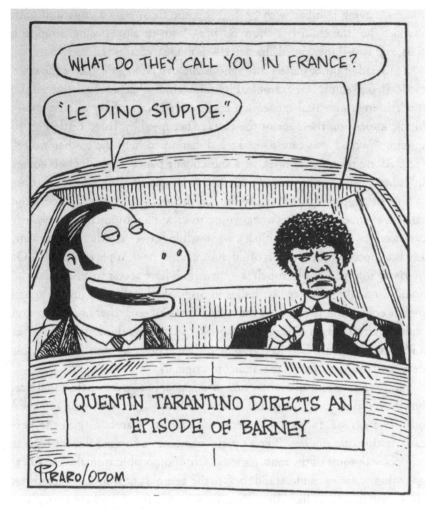

FIG. E.5 "Quentin Tarantino Directs an Episode of Barney," In *Bizarro* comic by Dan Piraro. Reprinted in *Bizarro Number 9* (Chronicle Books, 1995), 94.

discusses how McDonald's in Europe is different from the United States. Since France uses the metric system, he explains, the designation "Quarter Pounder with Cheese" has no meaning. After inviting Jules to guess what this menu item is called in France, Vincent reveals the surprising name: "A Royale with Cheese." Piraro's "Quentin Tarantino Directs an Episode of Barney" reimagines this exchange through the lens of its new combination of characters. In a speech balloon, Jules asks Barney "What do they call you in France?" to which Barney offers the following matter-of-fact answer: "Le Dino Stupide." Once again, the humor of this mash-up hinges on the

audience being familiar with both this scene from *Pulp Fiction* and with the fact that the children's show *Barney*—with its slow pacing, simplistic skits, and two-dimensional characters—is inane to adults.

A myriad of other panels throughout *Bizarro Number 9* utilize the same tactic. In one comic, for example, Piraro imagines what would happen if the modern environmental movement encountered classic fairy tales: a young hippie knocks on the door of the cottage occupied by Three Little Pigs to inquire, "Would you care to make a donation to help the timber wolf?" (20). Along those same lines, in a subsequent panel, Pablo Picasso comes in contact with some unlikely figures: members of the mafia. "Da Boss is *tired* of people with talent dominatin' the arts," they gruffly inform the famous abstract artist. "he wants youse to create a movement dat *anybody* can fake" (40; italics in original). Meanwhile, in yet another installment, Eve is tempted in the Garden of Eden by a fancy new Apple computer: "Of *course* he told you not to touch it—then *you'd* have access to all the data he does," the snake tells her (85; italics in original). Finally, but just as amusingly, a comic near the close of the collection brings together house pets and national efforts to get kids to "Just Say No to Drugs": a domestic feline gives a PSA for the "Anti-Catnip Campaign." "Remember kittens," the adult cat declares, "Just say '*Mew*'" (102; italics in original).

Piraro's Sunday installments of *Bizarro* appear in a larger single-panel size, but they also make frequent use of the mash-up. The comic that appeared on May 24, 1998, for example, bears the caption "Career Day in the Forest." As this title implies, Piraro's panel combines a common event held at schools with some of the most famous anthropomorphic animals. The Energizer Bunny, for example, stands before the assembly of woodland creatures, answering questions like "But what if you're not funny-looking enough to get into show business or advertising?" (46). The pink rabbit is not the only guest for the forest animal's career day. Sitting on a log behind him are Rudolph the Red-Nosed Reindeer, Donald Duck, and Mother Goose from Mike Peters's comic strip *Grimm and Mother Goose*.

A Sunday comic that appeared a few months later, on September 12, 1999, brings together different figures for a far different scenario but operates along similar lines. The panel imagines what would happen if two well-known artists from the twentieth century—Pablo Picasso and M. C. Escher—met for lunch. Although the two men were contemporaries—both were born during the fin de siècle and died in the early 1970s—their artistic styles as well as cultural legacies are so different that they are never viewed in tandem. Thus, the thought of Picasso and Escher dining together is simultaneously

odd and apropos. The room in which the duo meets is rendered in the style of an Escher drawing. Moreover, Picasso's face looks like one of his abstract portraits. The banter between the two figures is likewise in character. In one speech balloon, M. C. Escher tells Picasso, "Don't talk with your mouth full—or is that your ear?" (75). Similarly, the famed Spanish artist has his own pithy commentary. "I don't think you know which way is up," he sasses Escher at one point (75).

Lest any doubt remains about the centrality of mash-ups in *Bizarro*, the Sunday panel that appeared on December 5, 1999, has become an unofficial emblem or even symbol of Piraro's series. The drawing, which contains no speech balloons or captions, shows a group of individuals sitting in a subway car, reading. Although the figure in the foreground at the right is a "typical" commuter—a white man dressed in a business suit perusing the *Wall Street Journal*—his fellow passengers are a mélange of fictional and factual characters (15). From Father Time and the Grim Reaper to Christopher Columbus and a swashbuckling pirate, the scene mashes together individuals from history, folklore, and literature. The humor of Piraro's composition, however, arises not simply from the unexpected assembly of subway riders; it also emerges from the material that they are reading. Father Time, for example, is enjoying *Time* magazine. The pirate is engrossed by the latest issue of *Fortune*. Christopher Columbus has a copy of the publication *Discover*. Finally, and perhaps most amusingly of all, the Grim Reaper is perusing the latest issue of *Life* magazine. In a powerful index of both the success of this comic—and the cartoonist's fondness for it—this panel has been reprinted multiple times: it appears in *A Bizarro Sunday Treasury* (2001), *Bizarro and Other Strange Manifestations of The Art of Dan Piraro* (2006), and *Bizarro Buccaneers* (2008), as well as on his website.

As *Bizarro* entered the twenty-first century, Piraro made a number of changes to his work, such as using digital software to draw and color his panels as well as distributing his comics via the internet. That said, mashups remained a core feature of his series. The collection *Bizarro Buccaneers* (2008) is replete with examples. A comic near the middle of the collection, for instance, presents the unlikely combination of a fictional pirate from a famous nineteenth-century novel and a factual television game show that was popular from the closing decades of the twentieth century. More specifically, the comic imagines what would happen if Long John Silver from Robert Louis Stevenson's *Treasure Island* (1883) was a contestant on *Wheel of Fortune*. A speech balloon that emanates from a person out of the frame—presumably, *Wheel of Fortune* host Pat Sajak—says to Stevenson's

antagonist in an exasperated tone, "For the last time—'R' is *ALREADY ON THE BOARD!*" (56; italics and caps in original). Long John Silver's two fellow players look just as annoyed: the woman on the left is rolling her eyes while the figure on the right is giving him a grouchy glare. Meanwhile, Long John Silver himself appears equal parts confused and disappointed. The index finger on his right hand is raised, as if he was interrupted in the middle of speaking. Meanwhile, he has a puzzled look on his face, as if he can't think of a different way to begin speaking—or alternatively, he can't fathom why more "R's" don't appear in the puzzle.

A second collection of themed comics, *Bizarro Heroes* (2011), can be viewed in a similar way. Instead of bringing together Piraro's panels about pirates, it does so with ones focusing on superheroes. Many of the installments mash together figures like Superman, Batman, and Captain America with elements from American life and especially popular culture. A representative example of this phenomenon appears in a panel that combines Spider-Man, family therapy, and a well-known nursery rhyme. Peter Parker, dressed in his spidey suit, is sitting on the couch in a therapist's office beside an elderly white woman. Spider-Man's left hand is covering his face, signaling embarrassment. The speech balloon that appears at the top of the drawing and is uttered by the older white woman reveals the source of his chagrin. "I'll never forget when he was itsy bitsy and got stuck in the water spout," the woman says, who readers now realize is Peter's Aunt May (10).

Cory Doctorow, cultural critic and co-owner of the popular website *Boing Boing*, made the following observation about the current creative landscape: "If you're not making art with the intention of having it copied, you're not really making art for the 21$^{st}$ century" (qtd. in Murray). Whether "having it copied" comes in the form of being sampled, memed, parodied, or redubbed makes little difference. By the second decade of the twenty-first century, "appropriation remains a key tenet of creativity and innovation" (Murray).

For decades, Dan Piraro has largely been seen as having copied, in both form and content, the work of Gary Larson. His *Bizarro* series does contain the same eccentric sense of humor as *The Far Side*. When it comes to source material, however, the single-panel series draws on every side of extant culture. In so doing, Piraro's work both broadens and deepens Larson's message. Whereas *The Far Side* offered irreverent takes on isolated individuals, scenes, and situations, *Bizarro* does so with culture writ large. Larson's series largely poked fun at unnamed figures who already existed on the margins

of society: dorky children, befuddled aliens, frustrated cavemen, and so on. Piraro's panels offer the same perspective but with figures who are both real and readily recognizable: beloved superheroes, well-known literary characters, and figures from myth, history, and folklore. Through his mash-ups, Piraro does not simply invite us to question his creative kinship; he invites us to do something far more radical: question the status quo. In Piraro's comics, the only thing that would be truly "bizarro" would be to believe that culture is fixed and stable.

## The Amazing Spider-Man vs. Powdered Toast Man in The Ren and Stimpy Show: Mash-Ups in Comics, Comics as Mash-Ups

Recognizing that mash-ups embody a recurring and important feature in Dan Piraro's *Bizarro* does more than simply add a new facet to our understanding of his series. It also invites us to reconsider the role that this phenomenon plays in U.S. comics as a whole. The act of mixing, merging, and reimagining existing material has formed a consistent, but long-overlooked, facet in the work of many cartoonists. Tracing the presence of mash-ups in sequential art reveals an understudied source of creative influence, while it also provides a more accurate portrait of the genre's logic of production, past and present.

In the same way that Dan Piraro's *Bizarro* was not the only popular single-panel series in the opening decades of the twenty-first century, it was also not the only one that made use of the mash-up. Scott Hilburn's series *The Argyle Sweater* commonly draws on this feature. The comic that was originally published on October 27, 2014, offers a representative example. The panel is labeled "Advertising Mascot Pranks" and shows Mr. Clean taking a nap on the couch. His left hand has been placed in the vat of red liquid held by the Kool-Aid Man, who is sitting on the floor. A Keebler Elf stands on the arm of the couch on one side, giggling. Meanwhile, Tony the Tiger occupies the other end, declaring, "This will be grrrrreat!"

Mash-ups also permeate Mark Parisi's award-winning series, *Off the Mark*. A panel that forms a fan favorite appeared on September 3, 2020. The comic presents the characters of Beaker from The Muppets, the Road Runner from the Looney Tunes cartoons, and R2-D2 from Star Wars standing behind a large construction vehicle. Onomatopoetic words like "beep beep" and "meep meep" fill the air around them. Meanwhile, the commentary at the

bottom reads, "Tragically, no one could hear the truck backing up." Together with individual panels that remix existing cultural content, Parisi's series also has a recurring feature: "The Betty Rubble Center for Recovering Toons." Modeled after the Betty Ford Clinic, each installment brings together an array of well-known cartoon characters from print, film, and television. The figures are depicted in their room at the clinic accompanied by an exposition box that identifies why they have sought treatment. Thor, for example, checked in because he was "always hammered." Meanwhile, Eric Cartman from *South Park* has been struggling with an addiction to Cheesy Poofs. Finally, Marge from *The Simpsons* came to the Betty Rubble Center after she "OD'd on hairspray." To date, Parisi has created dozens of installments of "The Betty Rubble Center for Recovering Toons" that collectively mash together hundreds of past and present figures.

Mash-ups are not limited to single-panel comics; they also permeate their multipanel counterparts. Patrick McDonnell's series *Mutts* contains an array of strips that rework elements from *Peanuts*. Along those same lines, Stephan Pastis, in his popular multipanel comic *Pearls before Swine*, has incorporated facets from Bil Keane's *The Family Circus*. Meanwhile, other comics series have been founded entirely as a mash-up. *Garfeld*, for example, blends the television sitcom *Seinfeld* with the newspaper comic *Garfield*. Similarly, *Marfield* places Davis's feline character in the *Super Mario Bros* video game. *Garfield* has been the fodder for so many mash-ups over the past decade that they have led to a revival of Davis's often-maligned comic. As Neil Emmett noted in 2014, "the orange cat has been saved from cultural oblivion by a peculiar trend: the remixed Garfield strip" (Emmett). During the past few years, this situation has expanded to seemingly every comic series. In examples ranging from Randall Munroe's *xkcd*, Brian Gordon's *Fowl Language*, and Nate Pyle's *Strange Planet* to Matthew Inman's *The Oatmeal*, Kate Beaton's *Hark! A Vagrant*, and Tom Gauld's work in publications like *The Guardian* and *New Scientist*, it is difficult to find a strip that doesn't make use of the mash-up.

Mash-ups also appear in another important platform for sequential art: comic books. Some titles, such as *The Avengers on Late Night with David Letterman* (Marvel, 1984) and *The Batman and Scooby-Doo! Mysteries* (DC, 2021) explore the narrative possibilities that arise when different and even discordant figures come into contact. Meanwhile, other examples, such as *Archie vs Predator* (Dark Horse, 2015) and *The Amazing Spider-Man vs. Powdered Toast Man in The Ren and Stimpy Show* (Marvel, 1993), bring disparate figures together for antagonistic purposes: to pit them against each other in

battle. Still other comic book mash-ups—*Superman Meets the Quik Bunny* (DC, 1987) come to mind—have their roots in market forces: namely, cross promotion and product placement. Mash-ups have constituted such a consistent and powerful force in comic books, in fact, that some creators, such as Robert Sikoryak, have made entire careers out of them. In both standalone titles and compilations of collected strips, Sikoryak's comics have blended disparate people, events, and scenarios. One series, for example, unites superheroes with current political figures to create titles like *Black Voter* where Black Panther takes on President Donald Trump over access to the ballot box. Meanwhile, another series reimagines canonical works of literature with characters from classic comics in sequences like Dostoyevsky's *Crime and Punishment* starring legendary crime-fighter Batman. One of Sikoryak's most recent methods for mash-ups has been to explain the terms and conditions statements for major tech companies using characters from popular newspaper strips: a hipster-looking Snoopy, for example, walks us through the agreement with iTunes. Sikoryak's mash-ups have appeared in venues like *The New Yorker*, *The Village Voice*, and *Raw* magazine, and they have also been collected and published in omnibus editions, such as *Masterpiece Comics* (2009) and *Terms and Conditions* (2017); the covers of both volumes look like postwar comic books.[4]

When readers and critics contemplate the building blocks for comedic content in sequential art, elements like wordplay, puns, and slapstick routinely come to mind. Mash-ups need to be added to this list. As Marc Weidenbaum has commented, we live in a "brave new world of mash-up happy culture vultures" (Weidenbaum). Whether taking the form of an internet meme, a sampled song, or a work of fanfiction, entertainment in the twenty-first century is overwhelmingly "based on remixing existing content" (Booth).

Although comics are not commonly included in conversations about the proliferation of mash-ups, they could and even should be. From single-panel titles and multipanel strips to comic books and web-based cartooning, many forms of sequential art have participated in this mode of production. Moreover, there is no reason to believe that mash-ups will not merely survive but thrive in the medium for the foreseeable future.

The same observation, of course, applies to single-panel comics. This mode has been a foundational facet of sequential art for more than a century. In many respects, the single-panel comic formed an important landmark in the commercial origins of the medium during the nineteenth century. In the decades since, single-panel comics have remained among the most acclaimed

and successful titles. From the comics profiled in the previous chapters to the many dozens of additional examples, single-panel comics are part of the fabric of U.S. culture. They have delighted countless numbers of fans across multiple generations, becoming household names. At this point, in fact, it is difficult to imagine finding someone who has not seen, read, or even loved a single-panel series.

Single-panel comics not only are comics; they routinely represent the genre at its most interesting, important, and innovative. These titles have consistently and continuously pushed the genre forward, creatively, culturally, and commercially. Although single-panel comics have long been relegated to the margins of sequential art, they occupy its center in many ways. Including single-panel titles within discussions about comics provides a more accurate view of its operations, elements, and evolution. From the role of graffiti in *Ziggy*, extrodiegesis in *The Family Circus*, and everyday life in Peter Arno's *New Yorker* cartoons—to name just a few—single-panel comics call attention to new aesthetic features, narratological operations, and sociocultural implications. They are, to borrow a well-known lyric from a famous Broadway show tune, singular sensations. The time is long overdue for the field of comics studies to recognize this fact as well.

# Notes

### Introduction  All by Myself

1. One notable exception is Robert C. Harvey's chapter "How Comics Came to Be," in *A Comics Studies Reader* (UP of Mississippi, 2009). In it, Harvey examines gag comics and their role in the genre. As he asserts, "I realize that the gag cartoon falls outside McCloud's definition because it is not a sequence of pictures. In fact, gag cartoons fall outside most definitions of comics. But not mine" (Harvey, "How Comics" 26). For Harvey, the distinguishing feature of comics is not the presence of a sequence of images but the interplay of text and image. More specifically, he argues that "comics consist of pictorial narratives or expositions in which words (often lettered into the picture area within speech balloons) usually contribute to the meaning of the pictures and vice versa" (Harvey, "How Comics" 26). That said, even this more expansive conception of comics still excludes a major category of the single-form: the wordless panel. Marjorie Henderson Buell's hugely popular *Little Lulu* series—which I examine in chapter 4—routinely omitted text and thus would fall outside of Harvey's definition of comics.
2. Giving further credence to this viewpoint, one of the reasons that Thierry Smolderen identifies William Hogarth's caricatures as a "defining moment [in] the prehistory of comics" (3) is because they contain what he calls "*polygraphic* humor" (9). Hogarth's panels might be solitary, but they are enlivened by events that directly preceded the moment being depicted as well as are about to follow it. "To decipher Hogarth's images," Smolderen explains, "the reader had to navigate multilayered visual text saturated with allusions to conflicting systems of representation (ranging from the highly rhetorical language of history paintings to the rebellious insolence of graffiti drawings)" (9). In so doing, Hogarth's drawings didn't actually comprise a single image; they were palimpsestic and thus, in that regard, also sequential.
3. For more on these cartoonists, see the work of Maite Urcaregui and Jessica Rutherford.
4. That said, no award was given in 1960. Additionally, as an indicator of the shift that would take place in the years to come, the Pulitzer Prize for Editorial Cartooning

in 1964 was given to Paul Conrad "for his editorial cartooning during the past year" ("Paul Conrad").

## Chapter 1   "Those Damned Pictures"

1. I say "original" because broadsides bearing drawings that commented on current events had appeared in the American colonies before this date. However, these items had been both drawn and printed in England. Franklin's "Join, or Die" was the first political cartoon to originate in North America.

## Chapter 2   Freeze Frame

1. In the same way that Outcault's work reflected events taking place in American popular culture, it did so with elements from its visual iconography. Numerous installments of both *Hogan's Alley* and *McFadden's Row of Flats* are filled with racist caricatures of black, Indigenous, Asian, and Latinx peoples. Moreover, as I have written elsewhere, even The Yellow Kid himself can be seen as modeled after the era's xenophobic depictions of the Chinese. In this way, while Outcault's comic series can be seen as challenging and even upending some facets of the era's sociopolitical status quo, it unquestionably affirmed others.
2. Christina Meyer, in a nod to Blackbeard, also uses this term in her book *Producing Mass Entertainment: The Serial Life of the Yellow Kid* (2019). Mirroring her predecessor, she likewise refers to Outcault's work as "comics-tableaux" (9) as a means to signal the large size, eventful scenes, and grand scale of his drawings, not as a means to explore their possible kinship to the tableau vivant.

## Chapter 4   Not Jokester, but Prankster

1. For more on the history, evolution, and popularity of *Little Lulu* in American print and popular culture, see my book *Funny Girls: Guffaws, Guts, and Gender in Classic American Comics* (UP of Mississippi, 2019).
2. Although Henderson presented her young, white, female title character in ways that questioned, challenged, and even upended the status quo, she did not do so with nonwhite individuals. The cartoonist's depiction of figures who were black, Indigenous, Asian, and Latinx trafficked in many of the racist stereotypes that permeated the work of white cartoonists during this era. Thus, while Henderson's comics confronted and even defied some aspects of the nation's sociopolitical hegemony, they upheld others.
3. See chapter 3, "From Battling Adult Authority to Battling the Opposite Sex: *Little Lulu* as Gag Panel and Comic Book," in my book *Funny Girls: Guffaws, Guts, and Gender in Classic American Comics* (UP of Mississippi, 2019), pp. 63–89.

## Chapter 5   Civil/Rights

1. It should be noted that some early installments of this strip appeared as *Torchy in "Heartbeats."* For more on this issue, see chapter 7 of Nancy Goldstein's *Jackie Ormes*, pages 132–158. For the sake of clarity and concision, I refer to this series by its later, ultimate, more frequent name, *Torchy in "Heartbeats."*

2   Jackie Ormes took her interest in fashion even further in her next comic series, *Torchy in "Heartbeats"* (1950–1954). Akin to Ginger, the title character in the multipanel strip is always impeccably dressed in the latest styles. Moreover, below each installment is a section called "Torchy's Togs." The special feature contains a paper doll version of Ormes's character for readers to cut out, along with a variety of stylish outfits for her to wear.
3   For more on Emmett Till, see Timothy Tyson's *The Blood of Emmett Till* (Simon & Schuster, 2017), Devery S. Anderson's *Emmett Till: The Murder That Shocked the World and Propelled the Civil Rights Movement* (UP of Mississippi, 2017), and Elliott J. Gorn's *Let the People See: The Story of Emmett Till* (Oxford, 2018).

## Chapter 6   Outside the Circle of Influence

1   Warhol's work draws on the foundational concepts of narratology articulated by Gérard Genette. For more information on these concepts along with this overall method of literary analysis, see Genette's *Narrative Discourse: An Essay in Method* (1979).
2   For a helpful introduction to narratology in sequential art, see Pascal Lefèvre's "The Construction of Space in Comics," in *Image & Narrative*, vol. 16 (February 2006). Available here: http://www.imageandnarrative.be/inarchive/house_text_museum/lefevre.htm.
3   Bil Keane did occasionally include exposition boxes in *The Family Circus*. The larger format Sunday editions most often featured them to offer third-person commentary on the events depicted. Likewise, the daily comics that depicted the spectral scoundrel "Not Me"—the individual who is to blame for whatever calamity has just transpired: the broken lamp, the spilled milk, the dirty handprints on the wall, etc.—are often accompanied by an exposition box pointing to this figure and explaining that he is "the invisible gremlin who lives in everybody's house." For a variety of examples of this phenomenon, see the paperback collection *Not Me!* (1976).
4   Indeed, Kukkonen comments about her analysis: "There has been a lot of debate around narration, focalization and its overlaps, and many narratologists might disagree with my account. It is meant to be useful for a basic analysis, rather than a flawless system" (45).
5   For more on the central role of the gutter in sequential art, see also Barbara Postema's *Narrative Structure in Comics: Making Sense of Fragments* (RIT, 2016). As she observes, "The spaces between panels in comics are sites of elision and erasure. They are gaps that stand in for moments and events that go unrepresented in the comics sequence, moments that are not pictured but that are nevertheless evoked by the empty space" (Postema 50).

## Chapter 7   Ziggy Was Here

1   Since the image of Kilroy was hand-drawn by different individuals, it varied slightly in appearance. Sometimes, for example, Kilroy was depicted with a few small strands of hair atop his head; at other times, he was completely bald. Likewise, on occasion, his eyes were represented with pupils; other times, they were presented by two simple dots. Similarly, his fingers varied from round tips at the top of the wall to long fingers dangling over it. Finally, his tagline "Kilroy Was Here" appeared above,

below, or beside him, depending on the creator. These specific variations aside, the overall appearance of Kilroy remained the same—and thus, the figure remained highly recognizable. The newspaper article that contains the image of Fig. 7.1 includes additional renderings of Kilroy.

2. For a more comprehensive list of the many, and often unexpected, places in which Kilroy has appeared in U.S. culture, see Tom Kercher's catalog "Kilroy Sightings" on his website, KilroyWasHere.org.

3. Of course, seeing figures who were white, male, and cisgendered as "non-specialized," "generic," and "neutral" belies the systemic racism, sexism, and heteronormativity that permeated this era—and continues to typify the bulk of U.S. culture.

4. These points aside, I'd still call attention to the problematic nature of seeing a white, male, and cisgendered character as "non-specialized," "generic," and "neutral." Once again, such views belie the systemic racism, sexism, and heteronormativity that permeate U.S. culture.

5. The dates commonly given for Tom Wilson Sr.'s military service are 1953 to 1955. The dates that I am citing were established by his son and came from reviewing letters that the future cartoonist sent home to his parents. See the note below for more information along these lines.

6. I am greatly indebted to Tom Wilson Jr. both for sending me this image and for providing information about his father's military service. Through a series of phone calls and emails in November 2018, Mr. Wilson corresponded with me about his father's time in the U.S. Army. He then looked through letters that his father had written back home to his parents for additional details, which is when he saw the Kilroy doodle and sent me an image of it via text message. I would like to thank Tom Wilson Jr. for his kindness and generosity.

7. I say "modern graffiti" here and in other places throughout my discussion because the act of writing, drawing, or carving on surfaces in public places dates back thousands of years. "Historians have found graffiti depicting [everything from] sexual boasting to simple declarations that are similar to what you'd find on public bathroom stall walls" in cities throughout ancient Rome and Greece ("History of Graffiti"). That said, it was during the second half of the twentieth century when graffiti shifted from being isolated acts to being systematic works—and in so doing, took on its modern form, meaning, and function. See my discussion for more details about this phenomenon.

8. One possible exception to this trend appears in Thierry Smolderen's *The Origins of Comics: From William Hogarth to Winsor McCay* (English language ed., 2014). The second chapter of the book is titled "Graffiti and Little Doodle Men: Töpffer and the Romantic Preference for the Primitive." Smolderen discusses how the amateur drawings and crude carvings made by visitors to the ruins at Pompeii influenced Rodolphe Töpffer's artistic style. That said, the notion of "graffiti"—both to Töpffer and thus in Smolderen's chapter—signifies something different than what I am discussing here. For the nineteenth-century Swiss cartoonist, the graffiti around Pompeii embodied a new "primitive" aesthetic: it was untrained, unskilled, and unrefined (Smolderen 27–29). A similarly antiacademic form of drawing—one that privileged caricature over proportion, whimsy over realism, and exaggeration over verisimilitude—became a hallmark of Töpffer's style. Although the cartoonist had been educated at some of the finest schools in Paris, he chose to draw in a manner that mirrored (along with other sources of influence) the amateurish scribblings made by visitors to Pompeii (Smolderen 27–29).

9   For more on this issue, see not only Roger Gastman and Caleb Neelon's *The History of American Graffiti* (Harper, 2011), but also David Diallo's "From Street to Art Galleries: How Graffiti Became a Legitimate Art Form," in *Revue de recherche en civilisation américaine* [En ligne], mis en ligne le 23, décembre 2014, consulté le 29 juillet 2020, http://journals.openedition.org/rrca/601.

10  It should be noted that in 2016, Groensteen published a follow-up essay in which he revisited and even revised his views on braiding. As he explained, not all comics include this feature. Instead, "there are degrees of braiding: it can involve a small (a minimum of two) number of elements, or many more, and it can be more or less resonant for the reader" (Groensteen, "Art" 88). For this reason, Groensteen clarifies his conception of braiding as a recurring visual feature that serves "to deepen and enrich our reading of the comic" (88).

11  To the list of twenty-first-century cartoonists who have been influenced by graffiti art, Brandon Graham could be added. Given the multiple allegations of sexual harassment against him, however, I omitted him from my discussion. For more on this issue—including Graham's comments, tweets, and web comic about the accusations—see Rich Johnson's article "Brandon Graham on His 'Diss Track'" in *Bleeding Cool*. Available here: https://bleedingcool.com/comics/comics-brandon-graham-diss-track-abuse/.

## Chapter 8   "His People Are Grotesque"

1   To be fair, the animal characters in *The Far Side* are not depicted in any more flattering ways. As Soper observed, whether chickens, cows, horses, bears, or ducks, "the anatomy of the animals is equally awkward: stiff legs, joints in odd spots, poorly defined faces and torsos, and little sense of movement or energy on display" (Soper 109).

2   The aesthetic presentation of human figures in *The Far Side* also invites connections to the work of a contemporary cartoonist from Larson's own generation, Lynda Barry. For more on this issue, see my article "The Far Side of Comeeks: Gary Larson, Lynda Barry, and Ugliness," in vol. 11, no. 2 of *ImageTexT*. Available here: https://imagetextjournal.com/the-far-side-of-comeeks-gary-larson-lynda-barry-and-ugliness/.

3   I say "regular print syndication" here because, in late 2019, Larson began releasing occasional new installments of *The Far Side* online. These panels appear on the cartoonist's official website for the series, in a section titled simply "New Stuff." That said, as Larson makes clear in short prose commentary that prefaces these comics, he is not fully reprising the series. "I don't want to mislead anyone here," he states in his opening sentence (Larson, "New Stuff"). Instead, Larson is "exploring, experimenting, and trying stuff" at his own pace, in his own way, and with no deadlines (Larson, "New Stuff").

## Epilogue   Reimagine, Recombine, Recreate

1   Together with these new single-panel series, the opening decades of the twenty-first century also saw the reboot of at least one previous title. *Love Is*, originally created by Kim Casali in the 1960s and 1970s as notes to her husband, was collected and posted online beginning in 2007. The site became so popular that new comics in the style of the originals were created by Casali's son, Sefano, working in conjunction with

cartoonist Bill Asprey ("About," https://loveiscomics.com/about/). New versions of the comic can "be seen in newspapers worldwide" ("About").

2   The suggestive echoes between *Bizarro* and Larson's work had a direct impact on the comic's early syndication struggles along with its ultimate success. Initially, the similarity in content prevented *Bizarro* from being picked up, but then, this same feature ironically became the reason that the series was published. When Piraro first submitted samples of his work to Chronicle Features, the editor "said they wouldn't be able to do anything about syndication at that moment because they had a very small sales force and they already had *The Far Side*," and the company felt that one single-panel comic of this nature was sufficient (Piraro, qtd. in Heintjes). A few years later, however, when Larson's contract with Chronicle expired, the cartoonist unexpectedly left, moving his series to Universal Press Syndicate. Larson's departure from Chronicle Features opened the door for Piraro's work. His series was regarded, both within the company and outside of it, "as a replacement for Gary Larson's famous *The Far Side*" ("*Bizarro* Wins"). When Gary Larson retired *The Far Side* in 1995, Piraro followed in his footsteps once again: he took over his spot at Universal Press Syndicate, a move that, for many, forever solidified its status as a sequel or at least a spin-off of Larson's famed series. Don Markstein, in fact, begins his discussion of Bizarro with the assertion, "*The Far Side* . . . made it possible for *Bizarro* to exist" (Markstein, "Bizarro"). This situation is true both thematically and logistically.

3   Together with these mash-ups of well-known novels, an array of mock biographies of well-known figures written in this similar style also appeared. Titles included A. E. Moorat's *Queen Victoria: Demon Hunter* (2009) and *Henry VIII: Wolfman* (2010) along with Seth Grahame-Smith's *Abraham Lincoln: Vampire Hunter* (2010). In a telling index of the popularity of these titles, Grahame-Smith's book was made into a feature-length film in 2012.

4   Mash-ups were also endemic to another important platform for comics during the latter half of the twentieth century: *Mad* magazine. Although often viewed through the lens of parody or satire, many of the images that appeared on the cover as well as comics that populated the pages of the humor magazine remixed, recombined, and reimagined popular people, events, and phenomena.

# Works Cited

Abate, Michelle Ann. *Tomboys: A Literary and Cultural History*. Temple UP, 2008.
Adler, John, with Draper Hill. *Doomed by Cartoon: How Cartoonist Thomas Nast and "The New-York Times" Brought Down Boss Tweed and His Ring of Thieves*. Morgan James, 2008.
"Alley." *Creative Glossary*. http://www.creativeglossary.com/graphic-design/. Accessed 22 September 2020.
Alves, Josh. *Tastes like Chicken*. U.S. comic series. https://www.joshalves.com/. Accessed 27 September 2022.
Anderson, Brad. *Marmaduke*. U.S. comic series. 1945–present. https://www.gocomics.com/marmaduke.
*Archie vs Predator*. Written by Alex de Campi and drawn by Fernando Ruiz. Dark Horse, 2015.
Arno, Peter. *Ladies & Gentlemen*. Simon & Schuster, 1951.
Astor, Dave. "'Family Circus' Keane Wins Reuben." *Editor & Publisher*, vol. 116, no. 16, 23 April 1983, p. 112.
*Aunty Acid. Facebook*. https://www.facebook.com/auntyacid. Accessed 9 February 2022.
Backland, Ged. *Aunty Acid*. U.S. comic series. https://www.gocomics.com/aunty-acid. Accessed 27 September 2022.
Bakhtin, Mikhail. *Rabelais and His World*. 1965. Translated by Hélène Iswolsky, Indiana UP, 2009.
Bartels, Kathleen. "Director's Foreword." *MashUp: The Birth of Modern Culture*, edited by Bruce Grenville, Daina Augaitis, and Stephanie Rebick, Black Dog, 2016, pp. 16–17.
Bechdel, Alison. *Dykes to Watch Out For*. U.S. comic series. 1983–present.
Bernstein, Robin. *Racial Innocence: Performing American Childhood from Slavery to Civil Rights*. NYU, 2011.
"*Bizarro* Wins Genesis Award for Outstanding Cartoon." *King Features*, 25 March 2004, https://kingfeatures.com/2004/03/bizarro-wins-genesis-award-for-outstanding-cartoon/.
Blackbeard, Bill. *R. F. Outcault's "The Yellow Kid": A Centennial Celebration of the Kid Who Started Comics*. Kitchen Sink Press, 1995.
Bodē, Vaughn. *Cheech Wizard*. Rip-Off Press, 1986.

Boissoneault, Lorraine. "A Civil War Cartoonist Created the Modern Image of Santa Claus as Union Propaganda." *Smithsonian Magazine*, 19 Dec. 2018. https://www.smithsonianmag.com/history/civil-war-cartoonist-created-modern-image-santa-claus-union-propaganda-180971074/.

Bolton, Jonathan. "Richard Outcault's *Hogan's Alley* and the Irish of New York's Fourth Ward, 1895–96." *New Hiberia Review*, vol. 19, no. 1, Spring 2015, pp. 16–33.

Booth, Paul J. "Mashup as Temporal Amalgam: Time, Taste, and Textuality." *Transformative Works and Cultures*, vol. 9, 2012. https://journal.transformativeworks.org/index.php/twc/article/view/297.

Brown, Joshua. *Beyond the Lines: Pictorial Reporting, Everyday Life, and the Crisis of Gilded Age America*. U of California P, 2002.

Brown, Ruth Nicole. *Hear Our Truths: The Creative Potential of Black Girlhood*. U of Illinois P, 2013.

Bryant, Edward, and Patrick Coleman. "Thomas Nast." *The Grove Encyclopedia of American Art*, edited by Joan Marter, Oxford UP, 2011, pp. 404–406.

Buell, Marjorie Henderson. *Little Lulu*. U.S. comic series. *The Saturday Evening Post*, 1935–1944.

Butler, Judith. *Gender Trouble: Feminism and the Subversion of Identity*. Routledge, 1990.

Carmen, Eric. "All by Myself." *Eric Carmen*. Arista Records, 1975.

Cascone, Sarah. "Today's Google Doodle Celebrates Pioneering Artist Jackie Ormes, the First Professional Black Woman Cartoonist in the US." 1 September 2020. https://news.artnet.com/art-world/jackie-ormes-google-doodle-1905378.

Caté, Ricardo. *Without Reservations: The Cartoons of Ricardo Caté*. Gibbs Smith, 2012.

"Celebrating Jackie Ormes." *Google*, 1 September 2020. https://www.google.com/doodles/celebrating-jackie-ormes.

Chapman, Mary. "'Living Pictures': Women and Tableaux Vivants in Nineteenth Century American Fiction and Culture." *Wide Angle*, vol. 18, no. 3, July 1996, pp. 22–52.

Chatelain, Marcia. *South Side Girls: Growing Up in the Great Migration*. Duke UP, 2015.

Chung, Evan. "Guilty Pleasures: Lynda Barry Steps into 'The Family Circus.'" *The World*, 21 November 2019, https://www.pri.org/stories/2019-11-21/guilty-pleasure-lynda-barry-steps-family-circus.

Clopton, Kay, and Jenny E. Robb. *Dark Laughter Reconsidered: The Life and Times of Ollie Harrington*. Billy Ireland Cartoon Library and Museum, 13 Nov. 2021–8 May 2022.

Clowes, Daniel. *Ghost World*. Fantagraphics, 1997.

Cole, Jean Lee. *How the Other Half Laughs: The Comic Sensibility in American Culture, 1895–1920*. UP of Mississippi, 2020.

Cooley, Will. *Moving Up, Moving Out: The Rise of the Black Middle Class in Chicago*. Northern Illinois U, 2018.

Cooper, Martha, and Henry Chalfant. *Subway Art*. 1984. Thames & Hudson, 2016.

Crapol, Edward P. *James G. Blaine: Architect of Empire*. Scholarly Resources Books, 2000.

Cruger, Roberta. "Death of the Author 2.0." *Wired*, 26 September 2007. https://www.wired.com/2007/09/death-of-the-au/.

Davis, Jim. *Garfield*. Newspaper comic strip. 1978–present.

Davis, Lennard J. *Enabling Acts: The Hidden Story of How the Americans with Disabilities Act Gave the Largest U.S. Minority Its Rights*. Beacon, 2015.

de Bruin-Molé, Megen. "'Now with Ultraviolent Zombie Mayhem!': The Neo-Victorian Novel-as-Mashup and the Limits of Postmodern Irony." *Neo-Victorian Humor: Comic Subversions and Unlaughter in Contemporary Historical Re-vision*, edited by Marie-Luise Kohlke and Christian Gutleben, Brill, 2017, pp. 249–276.

della Quercia, Jacopo. "7 Memes That Went Viral before the Internet Existed." *Cracked*, 11 April 2011. http://www.cracked.com/article_19119_7-memes-that-went-viral-before-internet-existed.html.

Dewey, Donald. *The Art of Ill Will: The Story of American Political Cartoons*. NYU, 2007.

Dirks, Rudolph. *The Katzenjammer Kids*. Newspaper comic strip. 1897–1913.

Dorn, Lori. "The Insightful Single Panel Genius of 'The Far Side.'" *Laughing Squid*, 3 July 2023. https://laughingsquid.com/far-side-single-panel/.

Drake, St. Clair, and Horace R. Cayton. *Black Metropolis: A Study of Negro Life in a Northern City*. 1945. U of Chicago P, 2015.

Easterling, Lonnie. "Movie Shoot on Mars." *Super Spud*. http://www.superspud.com/. Accessed 9 February 2022.

Eco, Umberto. "On the History of Ugliness." *VideoLectures.Net*, 14 Dec. 2007. http://videolectures.net/cd07_eco_thu/.

Edeh, Uchenna. "Jackie Ormes: The First Professional African American Woman Cartoonist." *Kentake Page*, 1 August 2017. https://kentakepage.com/jackie-ormes-the-first-professional-african-american-woman-cartoonist/.

The Editors. "Introduction: It Was a Dark and Stormy Night . . . Narration in Comics." *European Comic Studies*, vol. 3, no. 1, March 2010, pp. v–viii.

Eichberger, D. H. "The *Tableau Vivant*—an Ephemeral Art Form in Burgundian Civic Festivities." *Parergon*, vol. 6, 1988, pp. 37–64.

Eileaas, Katrina. "Witches, Bitches & Fluids: Girl Bands Performing Ugliness as Resistance." *Drama Review*, vol. 41, no. 3, Fall 1997, pp. 122–139.

Eisner, Will. *Comics and Sequential Art: Principles and Practices from the Legendary Cartoonist*. 1985. New York: W. W. Norton, 2008.

Emmett, Neil. "How Garfield Got His Groove Back: The 'Garfield' Remix Phenomenon." *Cartoon Brew*, 11 June 2014, https://www.cartoonbrew.com/cartoon-culture/how-garfield-got-his-groove-back-the-garfield-remix-phenomenon-100343.html.

Epps, Justin. "'National Geographic on Prozac': Robin Williams Perfectly Explained *The Far Side*'s Genius." *Screen Rant*, 11 June 2023, https://screenrant.com/robin-williams-far-side-genius/.

Eschner, Kat. "Why 'The Family Circus' Was Always So Sentimental." *Smithsonian Magazine*, 5 October 2017. https://www.smithsonianmag.com/smart-news/why-family-circus-was-always-so-sentimental-180965114/.

"extra-, prefix." *OED Online*. Oxford UP, September 2020, http://www.oed.com/view/Entry/67077.

"extro-, prefix." *OED Online*. Oxford UP, September 2020, http://www.oed.com/view/Entry/67188.

Fallianda, Rani Atiti, and Zulvy Alivia Hanim. "Analyzing Humor in Newspaper Comic Strips Using Verbal-Visual Analysis." *Lingua Cultura*, vol. 12, no. 4, 2018, pp. 383–388.

Faulk, Barry J. *Music Hall Modernity: The Late-Victorian Discovery of Popular Culture*. Ohio UP, 2004.

Fischer, Roger A. *Them Damned Pictures: Explorations in American Political Cartoon Art*. Archon Books, 1996.

Floyd, Tom. *Black Man Comics. Jet Magazine*, 1972.

———. *Integration Is a . . . Bitch!* 1969. Vantage Books, 1995.

Franklin, Benjamin. "Join, or Die." *Broadside*, 1754. https://www.loc.gov/pictures/item/2002695523/.

———. "The Speech of Polly Baker." *Benjamin Franklin: Biographical Overview and Bibliography*, edited by Christopher J Murrey, Nova Science Publishers, 2002, p. 18.

Frazier, E. Franklin. *Black Bourgeoisie*. 1957. Free Press, 1990.

Gabilliet, Jean-Paul. *Of Comics and Men: A Cultural History of American Comics Books*. Translated by Bart Beaty and Nick Nguyen, UP of Mississippi, 2010.

Gardner, Jared, and Ian Gordon. Introduction. *The Comics of Charles Schulz: The Good Grief of Modern Life*. UP of Mississippi, 2017, pp. 3–12.

Gastman, Roger, and Caleb Neelon. *The History of American Graffiti*. Harper, 2011.

Gately, George. *Heathcliff*. U.S. comic series. 1973–present. http://heathcliff.com/.

Genette, Gérard. *Narrative Discourse: An Essay in Method*. 1979. Translated by Jane E. Lewin, Cornell UP, 1983.

Gitlin, Todd. *Inside Prime Time*. Pantheon Books, 1983.

Goldstein, Nancy. "Fashion in the Funny Papers: Cartoonists's Jackie Ormes's American Look." *The Blacker the Ink: Constructions of Black Identity in Comics and Sequential Art*, edited by Frances Gateward and John Jennings, Rutgers UP, 2015, pp. 95–116.

———. *Jackie Ormes: The First African American Woman Cartoonist*. U of Michigan P, 2008.

———. "Jackie Ormes: The First African American Woman Cartoonist." U of Michigan P. https://www.jackieormes.com/pattyjo.php.

———. "The Trouble with Romance in Jackie Ormes's Comics." *Black Comics: Politics of Race and Representation*, edited by Sheena C. Howard and Ronald L. Jackson II, Bloomsbury, 2013, pp. 23–43.

Gray, Steve. "Graffiti History—10 Important Moments." *Widewalls*, 27 March 2015, https://www.widewalls.ch/magazine/graffiti-history-10-important-moments.

Greenberg, Jonathan Daniel. Review of *The Comic Worlds of Peter Arno, William Steig, Charles Addams, and Saul Steinberg*. *Modernism/modernity*, vol. 13, no. 2, April 2006, pp. 401–403.

Greenfield, Dan. "13 Things You Didn't Know about Comics Lettering." *13th Dimension: Comics, Creators, Culture*, 1 Sept. 2019, https://13thdimension.com/13-things-you-didnt-know-about-comics-lettering/.

Gregory, James. "The Great Migration (African American)." *America's Great Migrations Project*, https://depts.washington.edu/moving1/black_migration.shtml. Accessed 22 December 2021.

Groensteen, Thierry. "The Art of Braiding: A Clarification." *European Comic Art*, vol. 9, no. 1, 2016, pp. 88–98.

———. *The System of Comics*. Translated by Bart Beaty and Nick Nguyan, UP of Mississippi, 2007.

Gunkel, David J. "What Does It Matter Who Is Speaking? Authorship, Authority, and the Mashup." *Popular Music and Society*, vol. 35, no. 1, 2012, pp. 71–91.

Hague, Ian. *Comics and the Senses: A Multisensory Approach to Comics and Graphic Novels*. Routledge, 2014.

Hajdu, David. *The Ten-Cent Plague: The Great Comic-Book Scare and How It Changed America*. Picador, 2008.

Halberstam, J. Jack. "Oh Bondage! Up Yours! Female Masculinity and the Tomboy." *Sissies and Tomboys: Gender Nonconformity and Homosexual Childhood*, edited by Matthew Rottnek, NYU Press, 1999, pp. 153–179.

Hale-Stern, Kalia. "Remember When the 'Barbie Liberation Organization' Switched Barbie and G. I. Joe's Voice Boxes?" *The Mary Sue*, 31 May 2017, https://www.themarysue.com/barbie-liberation-organization/.

Halford, Mary. "Jane Austen Does the Monster Mash." *The New Yorker*, 4 April 2009. https://www.newyorker.com/books/page-turner/jane-austen-does-the-monster-mash.

Halloran, Fiona Deans. *Thomas Nast: The Father of Modern Political Cartoons*. UNC Press, 2012.

Halprin, Sara. *"Look at My Face!": Myths and Musings on Beauty and Other Perilous Obsessions with Women's Appearance*. Viking, 1995.

Harrington, Oliver. *Dark Laughter: The Satiric Art of Oliver W. Harrington*, UP of Mississippi, 2009.
Harris, Karen. "Meet the Katzies." *History Daily*, 18 July 2019. https://historydaily.org/meet-the-katzies-the-katzenjammer-kids-one-of-the-earliest-ethnic-comic-strips.
Harrison, Nate, and Eduardo Navas. "Mashup." *Keywords to Remix Studies*, edited by Eduardo Navas, Owen Gallagher, and xtine burrough, Routledge, 2017, pp. 188–201.
Harvey, Robert C. "How Comics Came to Be: Through the Juncture of Word and Image from Magazine Gag Cartoons to Newspaper Strips, Tools for Critical Appreciation plus Rare Seldom Witnessed Historical Facts." *A Comics Studies Reader*, edited by Jeet Herr and Kent Worcester, UP of Mississippi, 2009, pp. 25–45.
———. "Outcault, Goddard, the Comics, and the Yellow Kid." *Comics Journal*, 9 Jan. 2016. http://www.tcj.com/outcault-goddard-the-comics-and-the-yellow-kid/.
Hatfield, Charles. *Alternative Comics: An Emerging Literature*. UP of Mississippi, 2005.
———. "Thoughts on Understanding Comics." *Comics Journal*, April 1999, pp. 87–91.
Heintjes, Tom. "Marge and Lulu: The Art of the Deal." *Hogan's Alley*, 22 May 2012.
———. "Mondo Bizarro: The Dan Piraro Interview." *Hogan's Alley: The Magazine of the Cartoon Arts*. 25 December 2017.
Henderson, Gretchen E. *Ugliness: A Cultural History*. London, Reaktion, 2015.
Herriman, George. *Krazy Kat*. Newspaper comic strip. 1913–1944.
Hess, Stephen, and Milton Kaplan. *The Ungentlemanly Art: A History of American Political Cartoons*. Macmillan, 1975.
Hess, Stephen, and Sandy Northrop. *American Political Cartoons: The Evolution of a National Identity, 1754–2010*. Transaction Publishers, 2013.
Higdon, David Leon. "Frankenstein as Founding Myth in *The Far Side*." *Journal of Popular Culture*, vol. 28, no. 1, Summer 1994, 49–60.
Highmore, Ben. *Everyday Life and Cultural Theory: An Introduction*. Routledge, 2001.
Hilburn, Scott. *The Argyle Sweater*. Comic series. https://www.pinterest.com/pin/327073991662262096/. Accessed 27 September 2022.
Hillerman, Tony. *Kilroy Was There: A GI's War in Photographs*. Kent State UP, 2004.
"The History of Graffiti." Canvasdesign. https://www.canvasdesign.co.uk/blog/the-history-of-graffiti/. Accessed 22 July 2020.
"A History of Graffiti—the 60's and 70's." *SprayPlanet*, 16 Aug. 2018, https://www.sprayplanet.com/blogs/news/a-history-of-graffiti-the-60s-and-70s.
"History: Subway Writing, 1969–1989." *Subway Outlaws*, http://subwayoutlaws.com/History/History.htm. Accessed 22 July 2020.
Holmquist, Annie. "The Far Side Is Returning. . . . But Can the PC Crowd Handle It?" *Intellectual Takeout*, 18 December 2019, https://intellectualtakeout.org/2019/12/the-far-side-is-returning-but-can-the-pc-crowd-handle-it/.
Huggins, Nathan Irvin. *Harlem Renaissance*. 1971. Oxford UP, 2007.
Inge, M. Thomas. Introduction. *Dark Laughter: The Satiric Art of Oliver W. Harrington*, edited by M. Thomas Inge, UP of Mississippi, 1993, pp. vii–xliii.
Jackson, Tim. *Pioneering Black Cartoonists of Color*. UP of Mississippi, 2016.
Jacob, Kathryn Allamong. "Little Lulu Lives Here." *Radcliffe Quarterly*, 2006.
Jamieson, Teddy. "Graphic Content: On Peter Arno, the Ultimate *New Yorker* Cartoonist." *Herald*, 11 Aug. 2016. https://www.heraldscotland.com/arts_ents/14677296.graphic-content-on-peter-arno-the-ultimate-new-yorker-cartoonist/.
*Jeopardy!* Archive. Show #5337. Originally aired November 20, 2007. https://www.j-archive.com/showgame.php?game_id=2192&highlight=.

Johnson, E. Patrick. Foreword. *From Bourgeois to Boojie: Black Middle-Class Performances*, edited by Vershawn Ashanti Young and Bridget Harris Tsemo, Wayne State UP, 2011, pp. xii–xxii.

Johnson, Sam. "The Bridges of Graffiti: A Story in Street Art." *AnOther Magazine*, 10 June 2015. http://www.anothermag.com/art-photography/7498/the-bridges-of-graffiti-a-story-in-street-art.

*Judge*. U.S. weekly magazine. Judge Publishing Company, 1881–1947. https://catalog.hathitrust.org/Record/000056566/Home. Accessed 19 April 2022.

Justice, Benjamin. "Thomas Nast and the Public School of the 1870s." *History of Education Quarterly*, vol. 45, no. 2, 2005, pp. 171–206.

"The Katzenjammer Kids." *Guinness World Records*, 12 December 2014, https://www.guinnessworldrecords.com/world-records/longest-running-comic-strip-still-syndicated.

Keane, Bil. *Can I Have a Cookie?* Fawcett Gold Medal, 1970.

———. *The Family Circus*. U.S. comic series. 1960–present.

———. *The Family Circus*. Fawcett Gold Medal, 1964.

———. *"The Family Circus" by Request*. Guidepost Books, 1998.

———. *Jeffy's Look' at Me!* Fawcett Gold Medal, 1976.

———. *Not Me!* 1976. Fawcett Gold Medal, 1980.

———. *Quiet, Mommy's Asleep!* Fawcett Gold Medal, 1974.

———. *Where's PJ?* Fawcett Gold Medal, 1974.

Keane, Jeff. "Re: Follow-up Question." Received by Michelle Ann Abate, 19 Sept. 2020. Email.

Kershaw, Sarah. "Move over, My Pretty, Ugly Is Here." *The New York Times*, 29 Oct. 2008.

Ketcham, Hank. *Dennis the Menace*. U.S. comic series. 1951–present.

Key, Ted. *Hazel*. U.S. comic series. 1943–2008. http://www.tedkey.com/.

Kiger, Patrick J. "How Ben Franklin's Viral Political Cartoon United the 13 Colonies." *History.com*, 28 Sept. 2021, https://www.history.com/news/ben-franklin-join-or-die-cartoon-french-indian-war.

"Kilroy Was Here." *Skylighters*. Accessed 21 October 2018.

Kopf, Dan. "The Great Migration: The African American Exodus from the South." *Priceonomics*, 28 January 2016, https://priceonomics.com/the-great-migration-the-african-american-exodus/.

Kukkonen, Karin. *Studying Comics and Graphic Novels*. Wiley-Blackwell, 2013.

Kunzle, David. *The Early Comic Strip: Narrative Strips and Picture Stories in the European Broadsheet from c.1450 to 1825*. UC California, 1973.

Kunzle, Peter. *Rodolphe Töpffer: Father of the Comic Strip*. UP of Mississippi, 2007.

Landry, Bart. *The New Black Middle Class*. U of California P, 1987.

———. "A Reinterpretation of the Writings of Frazier on the Black Middle Class." *Social Problems*, vol. 26, no. 2, 1978, pp. 211–222.

Larson, Gary. *The Complete Far Side*. Vol. 1. Andrews McMeel, 2014.

———. *The Complete Far Side*. Vol. 2. Andrews McMeel, 2014.

———. *The Far Side*. U.S. comic series. 1980–1995. https://www.thefarside.com/.

———. "New Stuff." *The Far Side*, 2020, https://www.thefarside.com/new-stuff.

Larson, Sarah. "'The Far Side' Returns to a Weird World." *The New Yorker*, 25 July 2020. https://www.newyorker.com/culture/culture-desk/the-far-side-returns-to-a-weird-world. Accessed 21 January 2024.

Lee, Judith Yaross. *Defining "New Yorker" Humor*. UP of Mississippi, 2000.

Lefèvre, Pascal. "The Construction of Space in Comics." *Image & Narrative*, 16 February 2006. http://www.imageandnarrative.be/inarchive/house_text_museum/lefevre.htm.

Leigh, Danny. "Is It Cos I Is Wack? The Rise and Fall of Sacha Baron Cohen." *Guardian*, 5 Apr. 2016. https://www.theguardian.com/film/2016/apr/05/sacha-baron-cohen-career-grimsby-borat-ali-g.

Letizia, Anthony. "Jackie Ormes and African American Comic Strips." *Geek Frontiers*, 22 Jan. 2014, https://geekfrontiers.com/pittsburgh-history/jackie-ormes-and-african-american-comic-strips/.
Levins, Sandy. "Jackie Ormes—First African American Female Cartoonist." *Wednesday's Women*, 2 Dec. 2020, https://wednesdayswomen.com/jackie-ormes-first-african-american-female-cartoonist/.
Lukovich, Mike, and Mike Peters. Interview by Renee Montagne. "Political Cartoons Cast an Eye Back on 2005." *Morning Edition*, 28 Dec. 2005.
Maguire, Emma. "*Potential*: Ariel Shrag Contests (Hetero)Normative Girlhood." *Prose Studies*, vol. 35, no. 1, 2013, pp. 54–66.
Marcus, Jerry. *Trudy*. U.S. comic series. 1963–2005.
Marge. *Laughs with Little Lulu*. David McKay Company, 1942.
———. *Little Lulu*. David McKay Company, 1936.
———. *Little Lulu and Her Pals*. David McKay Company, 1939.
———. *Little Lulu on Parade*. David McKay Company, 1941.
———. *Oh, Little Lulu!* David McKay Company, 1943.
Markstein, Don. "The Family Circus." *Don Markstein's Toonopedia*, 2007, http://www.toonopedia.com/fam_circ.htm.
———. "The Far Side." *Don Markstein's Toonopedia*, http://www.toonopedia.com/farside.htm. Accessed 7 May 2018.
———. "The Katzenjammer Kids." *Don Markstein's Toonopedia*, http://www.toonopedia.com/katzen.htm. Accessed 14 Dec. 2020.
———. "Little Lulu." *Don Markstein's Toonopedia*, http://www.toonopedia.com/lulu.htm. Accessed 8 Dec. 2020.
———. "Ziggy." *Don Markstein's Toonopedia*, http://www.toonopedia.com/ziggy.htm. Accessed 7 May 2018.
Martell, Nevin. *Looking for Calvin and Hobbes: The Unconventional Story of Bill Watterson and His Revolutionary Comic Strip*. New York: Bloomsbury, 2009.
Marulli, Larissa. "Jackie Ormes: From Cartoons to Dolls, Portraying the Real American Black Girl." Accessed 3 September 2020.
Maslin, Michael. *Peter Arno: The Mad, Mad World of "The New Yorker's" Greatest Cartoonist*. Regan Arts, 2016.
McCay, Winsor. *Little Nemo in Slumberland*. Newspaper comic, 1905–1911; 1924–1927.
McCloud, Scott. *Understanding Comics: The Invisible Art*. New York: HarperPerennial, 1993.
McCullough, Jack W. *Living Pictures on the New York Stage*. 1981. UMI Research Press, 1983.
McDonnell, Patrick. *Mutts*. Comic series. https://mutts.com.
McEnroe, Colin. "Here's Looking at You, Kid." *Hartford Courant*, 10 May 1995.
McGruder, Aaron. *The Boondocks*. Newspaper comic strip. 1996–2006.
McIsaac, Peter M. "Rethinking Tableaux Vivants and Triviality in the Writings of Johann Wolfgang von Goethe, Johanna Schopenhauer, and Fanny Lewald." *Monatshefte*, vol. 99, no. 2, Summer 2007, pp. 152–176.
McLeod, Kembrew. *Pranksters: Making Mischief in the Modern World*. NYU, 2014.
Meier, Matthew R. Review of *No Billionaire Left Behind* and *Pranksters*. *Studies in American Humor*, vol. 1, no. 2, 2015, pp. 299–303.
Merish, Lori. "Laboring to Play: Home Entertainment and the Spectacle of Middle-Class Cultural Life." *Legacy*, vol. 23, no. 2, 2006, pp. 210–212.
"Metamorphosis in Arthropods." *American Museum of Natural History*, https://www.amnh.org/learn-teach/curriculum-collections/biodiversity-counts/arthropod-identification/arthropod-morphology/metamorphosis-in-arthropods. Accessed 30 July 2023.

Metzger, Scott. *MetzgerCartoons.com*. https://www.metzgercartoons.com/.
Meyer, Christina. *Producing Mass Entertainment: The Serial Life of the Yellow Kid*. Ohio State UP, 2019.
Miller, Stephen. "Wry Cartoonist Created 'Family Circus.'" *Wall Street Journal*, 10 Nov. 2011.
Minix, Dean. "Political Cartoons: A Research Note." *Southwestern Journal of International Studies*, vol. 1, March 2004, pp. 75–81.
Moore, Alan. *V for Vendetta*. Illustrated by David Lloyd. 1988. Vertigo, 2018.
Mora, Gene. *Graffiti*. Syndicated comic. Andrews McMeel, 2011–present.
Murphy, Shannon. "Tableaux Vivant: History and Practice." *Art Museum Teaching*, 6 Dec. 2012, https://artmuseumteaching.com/2012/12/06/tableaux-vivant-history-and-practice/.
Murray, Ben. "Remixing Culture and Why the Art of the Mash-Up Matters." *Tech Crunch*, 23 Mar. 2015, https://techcrunch.com/2015/03/22/from-artistic-to-technological-mash-up/?guccounter=1&guce_referrer=aHR0cHM6Ly93d3cuZ29vZ2xlLmNvbS8&guce_referrer_sig=AQAAAAavPhiaMQPuUgs2T7a07oHtjg29MGZ9SoNUY_wR-2NGWjAqEomkAHKKIHgSK9gO4sgoabxCslKm2nbfvtD0lKPWZcORMpygt8XKT0T7TFJocP0Bv_OpkFoyERTq-s6X0neN1ft7HZ_0So4nn-0oy91Bz0lG6IV9zX36cCwu83mh.
Nast, Thomas. "Illustrations and Political Cartoons by Thomas Nast." *Library of Congress*, 1861–1886. https://www.loc.gov/pictures/item/2010651579/.
Navasky, Victor S. *The Art of Controversy: Political Cartoons and Their Enduring Power*. Knopf, 2013.
Nead, Lynda. *The Haunted Gallery: Painting, Photography, Film c. 1900*. Yale UP, 2007.
Nelson, Valerie J. "Cartoonist Chronicled the Lighter Moments of Family Life for More Than 50 Years through Gentle, Heartfelt Humor." *The Los Angeles Times*, 10 Nov. 2011. https://www.latimes.com/local/obituaries/la-xpm-2011-nov-10-la-me-bil-keane-20111110-story.html.
Newton, Leslie. "Picturing Smartness: Cartoons in the New Yorker, Vanity Fair, and Esquire in the Age of Cultural Celebrities." *Journal of Modern Periodical Studies*, vol. 3, no. 1, 2012, pp. 64–92.
*The New Yorker*. U.S. weekly magazine. 1925–present. http://www.newyorker.com.
Nielsen, Kim E. *A Disability History of the United States*. Beacon, 2012.
O'Donnell, Caroline. "Fugly." *Log*, no. 22, 2011, pp. 90–101.
Olson, Richard D. "R. F. Outcault, the Father of the American Comics, and the Truth about the Creation of the Yellow Kid." http://www.neponset.com/yellowkid/history.htm. Accessed 11 June 2021.
On, Carol. "The Amazing Jackie Ormes." *Cultural Gutter*, 24 Feb. 2016, https://culturalgutter.com/2016/02/24/the-amazing-jackie-ormes/.
Ormes, Jackie. *Patty-Jo 'n' Ginger*. U.S. comic series. *The Pittsburgh Courier*, 1945–1957.
Osgood, Charles, ed. Introduction. *Kilroy Was Here: The Best American Humor Writing from World War II*. New York, Hyperion, 2001, pp. ix–xviii.
Outcault, R. F. *Hogan's Alley*. U.S. comic series. *New York World*, 1895–1896.
———. *McFadden's Row of Flats*. U.S. comic series. *The New York Journal*, 1896–1898.
"Overview." *Graffiti*. By Gene Mora, Andrews McMeel Syndication, http://syndication.andrewsmcmeel.com/comics/graffiti. Accessed 27 July 2020.
Paige, Simon. *The Very Best of Winston Churchill: The Very Best from a British Legend*. CreateSpace, 2014.
"Paperback Trade Fiction." *The New York Times*, 19 Apr. 2004.
Parisi, Mark. *Off the Mark*. Comic series. https://www.offthemark.com/.
Parmal, Pamela A. "Hemlines." *Encyclopedia of Clothing and Fashion*, https://www.encyclopedia.com/fashion/encyclopedias-almanacs-transcripts-and-maps/hemlines-0. Accessed 30 Nov. 2021.

Partch, Virgil. *Big George*. U.S. comic series. 1960–1990.
"Paul Conrad of *The Denver Post*." *The Pulitzer Prizes*, https://www.pulitzer.org/winners/paul-conrad. Accessed 24 Sept. 2022.
Pekar, Harvey. *American Splendor* series. U.S. comics series. 1976–2008.
Pflueger, Lynda. *Thomas Nast: Political Cartoonist*. Enslow Publishers, 2000.
Pintar, Judith, and Steven Jay Lynn. *Hypnosis: A Brief History*. Blackwell, 2008.
Piraro, Dan. *Bizarro*. Comic series. https://bizarro.com.
———. *Bizarro*. Chronicle Books, 1985.
———. *Bizarro Buccaneers*. Andrews McMeel, 2008.
———. *Bizarro Heroes*. Last Gasp, 2011.
———. *Bizarro Number 9*. Chronicle Books, 1995.
———. *Glasnost Bizarro*. Chronicle Books, 1989.
———. *Life Is Strange and So Are You: A "Bizarro" Sunday Treasury*. Andrews McMeel, 2001.
Piskor, Ed. *Hip Hop Family Tree*. Book 1: 1970s–1981. Fantagraphics, 2014.
Postema, Barbara. *Narrative Structure in Comics: Making Sense of Fragments*. RIT, 2013.
"Presidents, Politics, and the Pen: The Influential Art of Thomas Nast." *Norman Rockwell Museum*, 2016, https://www.nrm.org/2016/07/thomas-nast/.
*Puck*. U.S. weekly magazine. Puck Publishing Company, 1876–1918. https://catalog.hathitrust.org/Record/008886840.
Raiteri, Steve. "Graphic Novels [Book Reviews]." *Library Journal*, 15 May 2005, pp. 98–103.
Reed, Patrick A. "No Girls Allowed: Celebrating the Impact of Little Lulu." *Comics Alliance*, 23 February 2016, https://comicsalliance.com/tribute-little-lulu/.
"Riley Wuz Here." *The Boondocks*, animated series, season 1, episode 12, Cartoon Network, 19 Feb. 2006.
Roberts, M. B. "Celebrating Ziggy." *American Profile*, 16 June 2011, https://americanprofile.com/articles/ziggy-comic-strip-video/.
Rojas, Pete. "Bootleg Culture." *Salon*, 1 Aug. 2002, https://www.salon.com/2002/08/01/bootlegs/.
Rossen, Jake. "11 Fun Facts about *The Family Circus*." *Mental Floss*, 29 May 2018, https://www.mentalfloss.com/article/543723/facts-about-the-family-circus-comic-strip.
Rutherford, Jessica. "Latinx Political Cartooning during the COVID-19 Global Pandemic: Coping and Processing via Lalo Alcaraz's and Eric J. García's Social Activism." *Prose Studies*, vol. 41, no. 2, 2020, pp. 228–252.
Saguisag, Lara. *Incorrigibles and Innocents: Constructing Childhood and Citizenship in Progressive Era Comics*. Rutgers UP, 2019.
Salvati, Andrew J. "History Bites: Mashing Up History and Gothic Fiction in *Abraham Lincoln: Vampire Hunter*." *Rethinking History*, vol. 20, no. 1, 2016, pp. 97–115.
Sanders, Joe Sutliff. "Good and Funny, Old and New." *Teacher Librarian*, vol. 38, no. 1, October 2010, p. 69.
Santoni, Matthew. "Pittsburgh Artist Wayno to Take over Nationally Syndicated 'Bizarro' Comic." *The Pittsburgh Tribune-Review*, 3 Jan. 2018. https://archive.triblive.com/aande/more-a-and-e/pittsburgh-artist-wayno-to-take-over-nationally-syndicated-bizarro-comic/.
Savage, William W., Jr. *Comic Book and America, 1945–1954*. U of Oklahoma Press, 1990.
Schneider, Greice. *What Happens When Nothing Happens: Boredom and Everyday Life in Contemporary Comics*. Leuven UP, 2016.
Schrag, Ariel. *Awkward*. 1995. Touchstone, 2008.
———. *Definition*. 1996. Touchstone, 2008.
———. *Likewise*. 1998. Touchtone, 2008.
———. *Potential*. 1997. Touchstone, 2008.

Schudel, Matt. "'Family Circus' Artist Was Norman Rockwell of Cartoons." *The Washington Post*, 10 Nov. 2011.
Schulz, Charles M. *Peanuts*. Newspaper comic strip. 1950–2000.
Schutt, Craig. "Little Lulu, Big Media Star." *Hogan's Alley*, vol. 15, 2007, pp. 32–43.
Schwartz, Ben. "The Double Life of Peter Arno, *The New Yorker*'s Most Influential Cartoonist." *Vanity Fair*, 5 April 2016. https://www.vanityfair.com/culture/2016/04/peter-arno-the-new-yorker-cartoonist.
Shaw, Kurt. "Ziggy: Celebrating the 'Hug Life.'" *TribLive*, 13 Apr. 2012, https://triblive.com/aande/1012189-74/ziggy-wilson-art-institute.
Sheringham, Michael. *Everyday Life: Theories and Practices from Surrealism to the Present*. Oxford UP, 2006.
Shiga, John. "Copy-and-Persist: The Logic of Mash-Up Culture." *Critical Studies in Media Communication*, vol. 24, no. 2, 2007, pp. 93–114.
Sikoryak, R. *Masterpiece Comics*. Drawn and Quarterly, 2009.
———. *Terms and Conditions*. Drawn and Quarterly, 2017.
"single, adj." *OED Online*. Oxford UP, Sept. 2022, http://www.oed.com/view/Entry/180129.
Sinnreich, Aram. "Remixing Girl Talk: The Poetics and Aesthetic of Mashups." *Sound Studies Blog*, 2 May 2011, https://soundstudiesblog.com/2011/05/02/remixing-girl-talk-the-poetics-and-aesthetics-of-mashups/.
Slott, Dan. *The Amazing Spider-Man vs. Powdered Toast Man in The Ren and Stimpy Show*. Marvel, 1993.
Smolderen, Thierry. *The Origins of Comics: From William Hogarth to Winsor McCay*. 2000. Translated by Bart Beaty and Nick Nguyen. UP of Mississippi, 2014.
Snow, Shane. "How Two of the Internet's Top Comics Names Turn Creativity into Cash." *Fast Company*, 24 January 2012, https://www.fastcompany.com/1679437/how-two-of-the-internets-top-comics-names-turn-creativity-to-cash.
Somerville, Kristine. "Living Pictures: The Art of Staging in Contemporary Photography." *The Missouri Review*, vol. 40, no. 2, 2017, pp. 33–49.
———. "Mash-Up: The Enduring Fusion of High Art & Mass Culture." *Missouri Review*, vol. 43, no. 3, 2020, pp. 121–139.
Soniak, Matt. "What's the Origin of 'Kilroy Was Here'?" *Mental Floss*, 19 June 2013, http://mentalfloss.com/article/51249/whats-origin-kilroy-was-here.
Soper, Kerry D. *Gary Larson and "The Far Side."* Jackson, UP of Mississippi, 2018.
Sousanis, Nick. *Unflattening*. Harvard UP, 2015.
Spiegelman, Art. "The Sky Is Falling!" *In the Shadow of No Towers*. Pantheon, 2004.
Stern, Roger. *The Avengers on Late Night with David Letterman*. Marvel, 1984.
Straus, Neil. "Sacha Baron Cohen: The Man behind the Mustache." *Rolling Stone*, 30 Nov. 2006. https://www.rollingstone.com/movies/movie-news/sacha-baron-cohen-the-man-behind-the-mustache-249539/.
Streit, Kate. "7 Fun Facts about 'The Far Side.'" *SimpleMost*, 21 December 2017, https://www.simplemost.com/fun-facts-about-the-far-side/.
Swift, Jonathan. *A Modest Proposal and Other Prose*. Barnes & Noble, 2004.
Teutsch, Matthew. "Are We Protecting Our Children When We Don't Answer Their Questions?" *Medium*, 10 December 2023. https://interminablerambling.medium.com/are-we-protecting-our-children-when-we-dont-answer-their-questions-d60693b5d658.
"They Shoot Single People, Don't They?" *Sex and the City*, season 2, episode 4. HBO, 27 June 1999.
Titus, Gillian. "Ziggy at 45." *Go Comics*, 27 June 2016, https://www.gocomics.com/blog/338/ziggy-at-45.

Tomine, Adrian. *Shortcomings*. Drawn & Quarterly, 2007.
Topliss, Ian. *The Comic Worlds of Peter Arno, William Steig, Charles Addams, and Saul Steinberg*. Johns Hopkins UP, 2005.
Travis, Trysh. "What We Talk about When We Talk about *The New Yorker*." *Book History*, vol. 3, 2000, pp. 252–285.
Trester, Anna Marie. "Telling and Retelling Prankster Stories: Evaluating Cleverness to Perform Identity." *Discourse Studies*, vol. 15, no. 1, Feb. 2013, vol. 91–109.
Turner, Morrie. *Wee Pals*. Newspaper comic strip. 1965–2014.
Unger, Jim. *Herman*. U.S. comic series, 1975–1992. https://www.gocomics.com/herman.
Urcaregui, Maite. "(Un)documenting Single-Panel Methodologies and Epistemologies in the Non-fictional Cartoons of Eric J. García and Alberto Ledesma." *Prose Studies: History, Theory, Criticism*, vol. 41, no. 2, 2020, pp. 207–227.
Vinson, John Chalmers. *Thomas Nast: Political Cartoonist*. U of Georgia P, 1967.
Voights, Eckart. "Memes as Recombinant Appropriation: Remix, Mashup, Parody." *The Oxford Handbook of Adaptation Studies*, edited by Thomas Leitch, Oxford, 2017, pp. 285–304.
Wagwan. "Ghosts and Angels in *Family Circus*." *No Signal*, 25 April 2018. https://loveotg.wordpress.com/2018/04/25/family-circus-is-bonkers/.
"Walk This Way." Pop Culture Wiki. https://chnm.gmu.edu/aq/comics/index.html. Accessed 9 February 2022.
Ware, Chris. *Jimmy Corrigan: The Smartest Kid on Earth*. Pantheon, 2001.
Warhol, Robyn. "The Space Between: A Narrative Approach to Alison Bechdel's *Fun Home*." *College Literature*, vol. 38, no. 3, Summer 2011, pp. 1–20.
Watterson, Bill. *Calvin and Hobbes*. Newspaper comic strip. 1985–1995.
Weidenbaum, Marc. "Mix and Mash-Up." *Nature*, 20 Apr. 2008, https://www.nature.com/articles/453033a.
Westbrook, David. "From Hogan's Alley to Coconino County: Four Narratives of the Early Comic Strip." *Roy Rosenzweig Center for History and New Media*, 2009, https://chnm.gmu.edu/aq/comics/.
Whipps, Heather. "How 'Kilroy Was Here' Changed the World." *Live Science*, 15 Sept. 2008, https://www.livescience.com/7577-kilroy-changed-world.html.
Wiener, Jon. "It Was 50 Years Ago Today: Abbie Hoffman Threw Money at the New York Stock Exchange." *Nation*, 24 Aug. 2017. https://jonwiener.com/50-years-ago-today-abbie-hoffman-threw-money-new-york-stock-exchange/.
Williams, Maren. "Profiles in Black Cartooning: Jackie Ormes." *Comic Book Legal Defense Fund*, 1 Feb. 2016, http://cbldf.org/2016/02/profiles-in-black-cartooning-jackie-ormes/.
Wilson, Tom. *Ziggy*. U.S. comic series. 1971–present. https://www.gocomics.com/ziggy.
Wilson, Tom, Jr. "Re: ZIGGY." Received by Michelle Ann Abate, 16 Nov. 2018. Email.
———. *Zig-Zagging: A Memoir*. Deerfield Beach, FL, Health Communications, 2009.
Wolf, Jeanine Wiley. "'Kilroy Was Here': Latest Campaign Brings Long-Nosed World War II-Era Cartoon to Ball-Produced Cans." *Courier*, 5 June 2017.
Wottowsky, George. "Swift's Modest Proposal: The Biography of an Early Georgian Pamphlet." *Journal of the History of Ideas*, vol. 4, no. 1, January 1943, pp. 75–104.
Wright, Bradford W. *Comic Book Nation: The Transformation of Youth Culture in America*. Johns Hopkins UP, 2001.
Wright, Nazera Sadiq. *Black Girlhood in the Nineteenth Century*. U of Illinois P, 2016.
Yaszek, Lisa. "'Them Damn Pictures': Americanization and the Comic Strip in the Progressive Era." *Journal of American Studies*, vol. 28, no. 1, Apr. 1994, pp. 23–38.

Young, Vershawn Ashanti. "Introduction: Performing Citizenship." *From Bourgeois to Boojie: Black Middle-Class Performances*, edited by Vershawn Ashanti Young and Bridget Harris Tsemo, Wayne State UP, 2011, pp. 1–38.

Zelizer, Julian E. "Confronting the Road Block: Congress, Civil Rights, and World War II." *Fog of War: The Second World War and the Civil Rights Movement*, edited by Kevin M. Kruse and Stephen Tuck, Oxford UP, 2012, pp. 32–50.

# Index

Page numbers in *italics* refer to figures.

Abate, Michelle Ann, 188, 216n1 (chap. 4)
Achilles, 202, 204
*Acme Novelty Library #18* (Ware), 84
Addams, Charles, 68, 154
Adler, John, 24, 25, 34
Ahern, Gene, 20
Alcaraz, Lalo, 20
*Alice in Zombieland*, 200
alleys (in comics), 151–154
alleys vs. gutters, 151–154
alternative comics / underground comix, 70, 147
Alves, Josh, 2, 196
*American Splendor* (Pekar), 83
*Android Karenina*, 200
Anderson, Brad, 20
*Argyle Sweater, The* (Hilburn), 2, 196, 211
Arnaz, Desi, 72
Arno, Peter, v, 15–16, 68–82, 84, 214
   biographical information, 71–72
   "Boo! You pretty creature!," *75*, 76
   "Cette ... and cette ... and cette," 76, *77*
   debut spot in *The New Yorker*, 73, *74*
   "Feelthy pictures?," 77, *77*, 79
   "Man in the Shower, The," 79, *80*, 84
   professional career, 69–70, 72

Astor, Dave, 2
*Aunty Acid* (Backland), 2, 196
Austen, Jane, 199, 200, 201

Backland, Ged, 2, 196
Bambi, 203
Banksy, 166
Barbie Liberation Organization (BLO), 91
*Barney* (television show), 205, 206, 207–208
Baron Cohen, Sacha, 88, 91–92, 104
Barry, Lynda, 219
Basquiat, Jean-Michel, 167, 168
Batman, 210
Bayard, Thomas (U.S. senator), 36
Beatles, the, 197
Bechdel, Alison, 154
Bell, Darrin, 28
Bernstein, Robin, 108, 110, 111
Berryman, Clifford, 20
*Big Bang Theory, The*, 190
*Big George* (Partch), 20
*Bizarro* (Piraro), 2, 19, 195–198, 201–211, 214
   awards and honors, 196
   book collections, 196, 202, 204, 205, 209
   and *Far Side, The*, 196, 197, 201, 210, 220n2
   and mash-ups, 197–198, 201–211, 213

*Black Album, The* (Jay-Z), 197
Black bourgeoisie, v, 106, 117–119, 120, 121, 128, 131, 132, 134
Black female sexuality, 17, 109–117
Black girlhood, v, 17, 106, 109–117, 131–132, 134
Black middle class, 2, 17, 108, 118
Black newspapers, 2, 14, 17, 106, 109
Black upper class, 108, 117, 118, 120, 121, 131, 133
Black working class, 118, 132, 133, 134, 135
Blackbeard, Bill, 46, 47, 51, 52, 216n2 (chap. 2)
blackface minstrelsy, 66
Block, Herbert, 21, 28
*Blondie* (Young), 82
*Bloom County* (Breathed), 104, 174
Bodē, Vaughn, 170
Bolton, Jonathan, 65
*Boondocks* (McGruder), 67, 171, 174
Booth, Paul J., 198, 199, 213
Bradshaw, Carrie, 12
Brady, Mathew, 39
braiding, 151, 165, 170, 219
Breathed, Berkeley, 104
Briggs, Claire A., 20
Brosh, Allie, 177, 191–194
Brown, Charlie, 83, 202
Brown, Joshua, 40
Buell, Marjorie Henderson, 2, 9, 10, 16, 85–88, 92–101, 104, 215n1, 216n1 (chap. 4)
Bulwer-Lytton, Edward George Earle, 93, 94, 95, 100
burlesque, 46, 51
*Buster Brown* (Outcault), 47
Butler, Judith, 96–97

*Calvin and Hobbes* (Watterson), 20, 66, 67, 103–104
*Candy* (Ormes), 106, 132–133
Caniff, Milton, 82
Captain America, 165, 190, 210
caricature, 15, 25–26, 30, 32, 33, 39, 43, 44
Carmen, Eric, 4
Caté, Ricardo, 20
Cayton, Horace R., 108, 110, 118
Chalfant, Henry, 167, 168

Chapman, Mary, 49, 50, 51, 59, 60
Chast, Roz, 68
Chatelain, Marcia, 108, 110
*Cheech Wizard* (Bodē), 170
Chicago, 110, 118, 119, 120, 121, 125, 126
*Chicago Defender, The*, 106, 107, 119, 132
Churchill, Winston, 104, 105
civil rights movement, 2, 17, 106, 109, 118, 126, 127, 129, 130–131
Civil War (United States), 39, 40, 41, 43, 103, 108
Clopton, Kay, 132
Clowes, Daniel, 84
Cole, Jean Lee, 54, 101
Comic-Con, 195
Connolly, Richard B., 32, 33
Conrad, Paul, 28, 215n4
Cooper, Martha, 167, 168
Crewdson, Gregory, 51
Crumb, R., 83

*Dark Laughter* (Harrington), 2, 17, 20, 109, 131–134, 135
Davis, Lennard J., 186
DC Comics, 195
della Quercia, Jacopo, 159, 162
*Dennis the Menace* (Ketcham), 20, 154
depth of field, 14, 25, 32, 43, 146
*Dick Tracy* (Gould), 67
Dickens, Charles, 40
digital comics, 13, 14, 19
Dirks, Rudolph, 82, 102
Disney, 203
DJ Danger Mouse, 197
Doctorow, Cory, 210
*Doonesbury* (Trudeau), 67, 104, 163
Dorgan, Tad, 20
Drake, St. Clair, 108, 110, 118
Duffy, Edmund, 20

Easterling, Lonnie, 196
Eco, Umberto, 189
Eisner, Will, 5, 6, 7, 107, 166, 167, 168, 169, 188, 192
  *Comics and Sequential Art*, 6, 166, 168, 188
Energizer Bunny, 208
Escher, M. C., 208–209

everyday life, v, 16, 68, 70, 73, 74–81, 82–84
everyday life theory, 79–81
extradiegetic narration, 17, 139, 148, 149, 150
extradiegetic space, 17
extrodiegetic narration, 147, 150

Fairey, Shepard, 166, 172
*Family Circus, The* (Keane), 2, 3, 4, 5, 6, 10, 17–18, 137–154, 174, 212, 214, 217n3 (chap. 6)
  animated specials, 138
  awards and honors, 138
  captions as dialogue, 142, 143, 144, 145, 146, 147, 149–157
  captions as extrodiegetic narration, 150, 153
  commercial success, 137–138
  critical reception, 137, 138–139
  legacy, 138
  and speech balloons, 139, 140, 141, 142, 143, 144, 145, 146, 147
  storyworld vs. storyspace, 147, 148–150
  subject matter, 137–138
fanfiction, 198, 211, 213
*Far Side, The* (Larson), vi, 2, 10, 18–19, 154, 173–184, 188–194, 196, 197, 201, 210, 219nn1–3 (chap. 8), 220n2
  adult characters, 175, 176, 177, 183–184
  and *Bizarro*, 196, 197, 201, 210–211, 220n2
  child characters, 175, 176, 177–183
  commercial success, 173–174
  critical reception, 173–174, 193–194
  and *Hyperbole and a Half*, 176, 190–193
  and *Natalie Dee*, 176, 190–193
  nerdy subject matter, 18, 174, 175, 176, 183–184, 190
  and *Oatmeal, The*, 176, 190–193
  science/scientists, 174–175, 176, 182, 183–184, *185*, 201
  and ugliness, vi, 18–19, 173, 175–186, 219
Faulk, Barry, 49, 54, 59, 64
Fisher, Roger, 26
Fitzgerald, F. Scott, 71
flappers (1920s), 15, 70, *75*, 75–76, 84
Flintstone, Fred, 205

Floyd, Tom, 20
  *Black Man Comics*, 20
  *Integration Is a . . . Bitch!*, 20
*Fowl Language* (Gordon), 212
Franklin, Benjamin, 1, 22, 23, 24, 26, 27, 90–91, 104, 216n1 (chap. 1)
  "Join, or Die" (political cartoon), 1, 22, *23*, 24, 26–28, 216n1 (chap. 1)
  "Speech of Polly Baker, The," 90–91
Frazier, E. Franklin, 118, 119, 131
Freud, Sigmund, 104
Frueh, Alfred, 74–75

Gabilliet, Jean-Paul, 6
gag panels, 1, 3, 5, 8–10, 13, 14, 16, 17, 20, 74, 88, 89, 93, 99, 102, 107, 109, 120, 131, 133, 134, 136, 139, 140, 143, 146, 152, 153, 158, 215n1, 216n3 (chap. 4)
García, Eric. J., 20
Gardner, Jared, 5
*Garfield* (Davis), 102–103, 104, 212
*Gasoline Alley* (King), 82
Gately, George, 20
Genette, Gérard, 148, 217n1 (chap. 6)
*Get Fuzzy* (Conley), 174
*Ghost World* (Clowes), 84
Gitlin, Todd, 198
Goldstein, Nancy, vii, 107, 108, 111, 112, 113, 114, 115, 116, 119, 120, 121, 122, 123, 124, 125, 126, 127, 128, 130, 133, 134, 135, 136, 216n1 (chap. 5)
Gordon, Ian, 5
graffiti, v, 18, 155, 156, 157, 158, 159, 164, 165–172, 214, 215n2, 218nn7–8, 219n9, 219n10
  as art vs. vandalism, 168, 170
  and comics, 165–172
  tagging, 158, 165–170
  "wild style," 167, 169, 171
*Graffiti* (Mora), 171
graphic narratives, 3, 5, 13, 70, 84, 142, 148, 168, 195
*Grave Expectations*, 200
*Greek Slave, The* (Powers), 61, 64
Greenberg, Jonathan Daniel, 68
*Grey Album* (Danger Mouse), 197
Griffin, Merv, 202
*Grimm and Mother Goose* (Peters), 208

Groensteen, Thierry, 151, 170, 219n10
Guerrilla Girls, 95
Gunkel, David, 198, 200
gutters vs. alleys (in comics), 151–154

Hague, Ian, 142, 143
Hajdu, David, 165
Halberstam, J. Jack, 187, 188
Halford, Mary, 199
Hall, A. Oakley, 32, 33, 35, 36
Halliday, Aria S., 108
Halloran, Fiona Deans, 24, 26, 36, 41
Halprin, Sara, 186
Hardin, Nelson, 20
Haring, Keith, 168, 172
*Hark! A Vagrant* (Beaton), 212
Harlem Renaissance, 110
*Harper's Weekly*, 14, 23, 24, 29, 31, 32, 33, 34, 36, 37, 39, 40, 41, 42, 43, 44
Harrington, Ollie, 2, 17, 20, 109, 131–134, 135–136
Harvey, Robert C., 46, 63, 142, 215n1
Hatfield, Charles, 6, 70, 83, 147
Hays, Ethel, 20
*Hazel* (Key), 5, 20
Hearst, William Randolph, 46
*Heathcliff* (Gateley), 4, 20, 154
Heintjes, Tom, 87, 88, 196, 197, 220n2
Held, John, Jr., 20
Henderson, Gretchen, 186, 189
*Herman* (Unger), 20
Herriman, George, 82, 102, 104
Hess, Stephen, 13, 22, 25, 26, 27
Higdon, David Leon, 174
Highmore, Ben, 81, 84
Hilburn, Scott, 2, 196, 211
*Hip Hop Family Tree* (Piskor), 171
Hoffman, Abbie, 91, 104
*Hogan's Alley* (Outcault), 1, 15, 44–48, 51–59, 62–66, 216n1 (chap. 2)
Hogarth, William, 215n2, 218n8
*Holiday on Ice*, 198
homophobia, 92, 118
*How the Other Half Lives* (Riis), 59
Hughes, Langston, 107, 132
Hwang, Amy, 20
*Hyperbole and a Half* (Brosh), 176, 190–193

illustration, 15
Inge, M. Thomas, 67
Inman, Matthew, 176, 190–194, 212
intradiegetic narration, 17, 139, 148, 149, 150
intradiegetic space, 17
intrapanel sequentiality, 12
Iron Man, 190

Jackson, Andrew, 23
Jackson, Samuel L., 206, 207
Jackson, Zelda Mavin, 106, 119
Jacksonian era, 24, 27
Jacobs, Harriet, 117
*Jane Slayre*, 199
Jay-Z, 197
*Jet* (magazine), 20
*Jimmy Corrigan* (Ware), 84
Johnston, Gerald W., 26
*Judge* (magazine), 1

Kaplan, Milton, 22, 27
*Katzenjammer Kids* (Dirks), 82, 102, 104
Keane, Bil, 2, 6, 10, 17, 18, 137, 138–147, 149, 150, 152, 153, 154, 212, 217n3 (chap. 6)
  animated specials, 138
  and Arno, Peter, 142
  awards and honors, 138
  *Channel Chuckles*, 140
  commercial success, 137–138
  critical reception, 137, 138–139
  death, obituaries, and legacy, 138
  and *Family Circus, The*, 2, 3, 4, 5, 6, 10, 17–18, 137–154, 174, 212, 214, 217n3 (chap. 6)
  and National Cartoonists Society, 138
  Rueben Award for Cartoonist of the Year, 138
  *Silent Set*, 140
  *Silly Philly*, 141
Keane, Jeff, 138
Kemp, Jack, vii
Ketcham, Hank, 20
Key, Ted, 20
Kid Rock, 200
Kiger, Patrick J., 27
Kilroy, James J., 157–158
Kilroy / Kilroy Was Here, 18, 156, *157*, 158–159, *159*, 160–165, 167, 171–172, 217–218nn1–2 (chap. 7), 218n6

Kilyani, Edward, 61
King, Frank, 82
Kirby, Rollin, 28
*Krazy Kat* (Herriman), 82, 102, 104
Kukkonen, Karin, 148–149, 217n4 (chap. 6)
Kunzle, Peter, 7, 166

Landry, Bart, 118, 130–131
Larson, Gary, 2, 10, 18–19, 173–184, 188–190, 193–194, 219nn2–3 (chap. 8), 220n2
  award and honors, 173–174
  commercial success, 173–174
  critical reception, 173–174, 193–194
  and *Far Side, The*, vi, 2, 10, 18–19, 154, 173–184, 188–194, 196, 197, 201, 210, 219nn2–3 (chap. 8), 220n2
  legacy, 176, 189–190, 193–194
Lebovitz, Annie, 51
Ledesma, Alberto, 20
Lee, Judith Yaross, 74
Lefebvre, Henri, 79–80, 81
Lefévre, Pascal, 151, 217
Limp Bizkit, 200
Lincoln, Abraham, 40
Linkin Park, 200
lithography, 1, 23, 27
*Little Lulu* (Buell), 2, 8–9, *9*, 10, 16, 85–89, 92–101, 104, 174, 215n1, 216n1 (chap. 4)
  and adults/adulthood, 93–98
  and boys, 99–100
  as comic book series (Stanley and Tripp), 87–88, 99
  as gag panel, 85–87, 88–89
  and gender roles, 95–100
  licensing and merchandising, 87
  and pranks/pranking, 16, 89, 92–101, 104
  as syndicated newspaper strip, 87
*Little Nemo in Slumberland* (McCay), 66, 67, 82
*Little Vampire Women*, 200
*Love Is* (Casali), 219
Luks, George B., 46–47

*M*A*S*H* (television show), 159, 198
*Mad* (magazine), 220
Mankoff, Robert, vii, 68
Marcus, Jerry, 20

*Marge's Little Lulu* (Stanley and Tripp), 87–88, 99
Markstein, Don, 10, 87, 102, 138, 174, 220n2
*Marmaduke* (Anderson), 4, 5, 20, 154
Marvel Comics, 195
mash-ups, 19, 195–213, 219n1 (epilogue), 220nn3–4
  in *Bizarro*, 2, 19, 195–198, 201–211, 213, 219n1 (epilogue), 220n2
  in comics, 211–213
  origins and history, 198–199
  in popular culture, 197, 199–201, 219n1 (epilogue), 220nn3–4
Maslin, Michael, 68, 69, 70, 71, 72, 73
Mauldin, Bill, 21, 28
McCay, Winsor, 66, 67, 218n8
McCloud, Scott, 5, 6, 7, 151, 161, 166, 167, 168, 188, 215n1
  *Understanding Comics*, 5, 6, 7, 151, 161, 166, 168, 188, 215n1
McCray, Darryl "Cornbread," 168–169, 172
McCullough, Jack, 49, 50, 52, 61
McCutcheon, John T., 20
McDonald's (restaurants), 207
*McFadden's Row of Flats* (Outcault), 46–47, 52, 57–59, 62, 65, 216n1 (chap. 2)
McLeod, Kembrew, 89, 90, 91, 99–100, 101, 105
Meier, Matthew R., 89
memes (internet), 193, 198, 200, 210, 213
*Merv Griffin Show, The*, 202
Metzger, Scott, 2, 196
Meyer, Christina, 46, 51, 55, 64, 65, 216n2 (chap. 2)
misogynoir, 110, 111
*Modest Proposal, A* (Swift), 90
Montgomery bus boycott, 118, 127, 128
Mora, Gene, 171
Murray, Janet Horowitz, 99
*Mutts* (McDonnel), 212

*Nancy* (Bushmiller), 103, 104
narratology, v, 18, 137, 139, 147–150, 217nn1–2 (chap. 6), 217n4 (chap. 6)
  extradiegetic narration, 18, 139, 148, 149, 150
  extrodiegetic narration, 147, 150
  Genette, Gérard, 148
  heterodiegetic narration, 148–149, 150
  homodiegetic narration, 148–149

narratology (*continued*)
  intradiegetic narration, 18, 139, 148, 149, 150
Nast, Thomas, v, 14, 15, 22–26, 28–44
  "After the Battle—Rebels in Possession of a Field" (illustration), 40–41, *42*
  "American River Ganges, The" (cartoon), 33, *34*, 34–35, 36, 43–44
  and background space, 14, 25, 28, 29, 30–36, 38, 39, 43–44
  as caricaturist, 25–26, 30, 32, 33, 39, 43, 44
  and Catholicism, 33–36
  and Christmas, 40–41, 43
  "Christmas Eve" (illustration), *43*
  and Civil War, 39, 40, 41, 43
  and Democrat donkey, 24, 36–37
  "Emancipation" (illustration), *42*, 43
  as Father of the American Political Cartoon, 29
  as illustration, 15, 23, 36, 39–44
  as political cartoonist, 23–26, 28–38
  and Republican elephant, 24, 36–37
  "Stranger Things Have Happened" (cartoon), 36, *37*, 37–38
  "Tammany Tiger on the Loose, The" (cartoon), 38, *40*
  "Too Heavy to Carry" (cartoon), 38, *41*
  and Tweed, William "Boss" / Tammany Hall, 14, 23–24, 25, 30, 31, 32, 33, 36, 38, *39*
  "Under the Thumb" (cartoon), 29, 30–32, *31*, 34, 43
  "We Propose (When Things Blow Over)" (cartoon), 38, *39*
  "Who Stole the People's Money?" (cartoon), 32, *33*, 34, 36
*Natalie Dee*, 176, 190–193
National Cartoonists Society, 3, 20, 138, 196
Navasky, Victor S., 23, 24
Nead, Lynda, 55, 56
New Jersey, 30–31
New York City (also Manhattan), 14, 23, 29–32, 35, 45, 50, 51, 52, 54, 61, 62, 63, 65, 71, 72, 73, 74
*New York Journal, The*, 15, 46–47, 54, 56–58, 65
*New York Times, The*, 23, 138, 173, 185, 193, 199

*New York World, The*, 15, 44–47, 52–55
*New Yorker, The*, v, 1–2, 13, 14, 15, 16, 20, 68–81, 84, 154, 189, 190, 200, 213, 214
Newton, Leslie, 71
Nielsen, Kim E., 186
Northrop, Sandy, 25, 26, 27
nuclear war / nuclear weapons, 115, 116

*Oatmeal, The* (Inman), 176, 190–193, 212
*Off the Mark* (Parisi), 2, 3, 196, 211
Ormes, Jackie, 2, 16, 17, 106–109, 111–117, 119, 135–136, 216–217nn1–2 (chap. 5)
  and Black bourgeoisie, v, 106, 117–119, 120, 121, 128, 131–132, 134
  *Candy*, 106, 132–133
  and Chicago, 119, 120, 126
  and civil rights movement, 2, 17, 106, 109, 118, 126–127, 129, 130–131
  and *Dark Laughter*, 2, 17, 20, 109, 131–134, 135
  as Google doodle, 107, 108
  and Hughes, Langston, 107
  and Montgomery bus boycott, 118, 127, 128
  and nuclear war / nuclear weapons, 115, 116
  Patty-Jo doll, 107, 108
  *Patty-Jo 'n' Ginger*, v, 2, 16–17, 106–109, 111–117, 120–136, 150, 154
  and *Pittsburgh Courier, The*, 2, 16, 106, 107, 109, 114, 123, 124, 128, 129, 130, 132, 133, 136
  and rheumatoid arthritis, 129
  and segregation, 2, 110, 122, 125, 132, 135
  *Torchy Brown in "Dixie to Harlem,"* 106
  *Torchy in "Heartbeats,"* 106, 129, 216-217nn1–2 (chap. 5)
  and Will Eisner Comics Arts Hall of Fame, 107
  as Zelda J. Ormes, 119
  as Zelda Mavin Jackson, 106
Osgood, Charles, 157, 158, 159
Outcault, R. F., v, 1, 15, 44, 45–48, 51–59, 62–66, 82, 216nn1–2 (chap. 2)
  "Amateur Circus: The Smallest Show on Earth," 54, *55*
  *Around the World with the Yellow Kid*, 65

"At the Circus in Hogan's Alley," 52–54, *53*, 56, 62, 63
*Buster Brown*, 47
"Golf—the Great Society Sport as Played in Hogan's Alley," 54–57, *56*, 63–64, 65
*Hogan's Alley*, 1, 44–47, 52–56, 59, 62–65
*McFadden's Row of Flats*, 46–47, 52, 57–59, 62, 65, 216n1 (chap. 2)
and New York City / Lower East Side, 44, 45, 50, 51, 54, 61, 63, 65
and *New York Journal, The*, 15, 46–47, 54, 56–58, 65
and *New York World, The*, 15, 44–47, 52–55
"Studio Party in McFadden's Flats, The," 57, *58*, 59
Yellow Kid, The, v, 1, 15, 45–48, 51–52, 54–59, 62–66, 82, 166, 216n2 (chap. 2)

Papa Roach, 200
Paris (France), 77, 79
Parisi, Mark, 2, 3, 196, 211–212
Partch, Virgil, 20
Patty-Jo doll, 107, 108
*Patty-Jo 'n' Ginger* (Ormes), v, 2, 16–17, 106–109, 111–117, 120–136, 150, 154
*Peanuts* (Schulz), 83, 159, 212
*Pearls before Swine* (Pastis), 174, 212
Pekar, Harvey, 83
performance art, 15
Peters, Mike, 21, 28
Pflueger, Lynda, 23, 39, 40
*Philadelphia Gazette, The*, 23, 26
Picasso, Pablo, 208, 209
Piraro, Dan, 2, 19, 195–198, 201–211, 214, 220n2
 awards and honors, 196
 *Bizarro*, 2, 19, 195–198, 201–211, 214, 220n2
 book collections, 196, 202, 204, 205, 209
 and *Far Side, The*, 196, 197, 201, 210, 220n2
 and mash-ups, 197–198, 210–211, 214, 220n2
 Reuben Award for Outstanding Cartoonist of the Year, 196
Piskor, Ed, 171

*Pittsburgh Courier, The*, 2, 16, 106, 107, 109, 114, 123, 124, 128, 129, 130, 132, 133, 136
political cartoons / cartooning, 1, 3, 13–15, 20–21, 22–32, 36, 38, 40–41, 43–44, 82, 83
Postema, Barbara, 217n5 (chap. 6)
pranking/pranksters/pranks, 16, 89–92
*Pride and Prejudice and Zombies* (Grahame-Smith), 199, 200
*Prince Valiant* (Foster), 67
public education, 125, 134
*Puck* (magazine), 1
Pulitzer Prize for Editorial Cartooning, 21, 28, 215n4
*Pulp Fiction* (Tarantino), 210, 211, 212
punk movement, 187–188

racism, 92, 110, 118, 122, 135, 216n1 (chap. 2), 216n2 (chap. 4), 218nn3–4
*Rambo*, 207, 208
Ramirez, Michael, 28
rap-rock (as mash-up), 199–200
Reed, Patrick A., 99
remix culture, 19
respectability politics, 17, 108, 109, 110, 112, 113, 116, 122
*Rick and Morty*, 174
Riis, Jacob, 59, 63
Robb, Jenny E., 132
Rojas, Peter, 198, 200
Rose, Charlie, 202
Ross, Harold, 1, 68, 71

Saguisag, Lara, viii, 46, 47
Salvati, Andrew, J., 199
*San Francisco Chronicle, The*, 173
Sanders, Joe Sutliff, 88
*Saturday Evening Post, The*, 2, 9, 13, 85, 86, 87
Schneider, Greice, 70, 82, 83, 84
Scholl, Dr., 202, 203
Schrag, Ariel, 170
Schulz, Charles, 83, 159, 202
Schutt, Craig, 87
Schwartz, Ben, 69, 70, 71, 72
segregation, 2, 24, 110, 122, 125, 132, 135
*Seinfeld* (television show), 212

*Sense and Sensibility and Sea Monsters*, 200
sequential art (concept), 5–8, 10–12, 15, 18
  intrapanel sequentiality, 12
*Sex and the City*, 12–13
sexism, 92, 110, 218nn3–4
Sheringham, Michael, 81
Sherman, John (U.S. treasury secretary), 36
*Shortcomings* (Tomine), 84
*Simpsons, The*, 174
Sinnreich, Aram, 200
Smolderen, Thierry, 215n2, 218n8
Snoopy, 83, 213
Somerville, Kristine, 51
Soper, Kerry, 173, 174, 175, 177, 182, 183, 219n1 (chap. 8)
Sousanis, Nick, 38, 188
*South Park*, 174
speech balloons (in narratology), 148–149
Spider-Man, 210
Spiegelman, Art, 83
*Spud Comics* (Easterling), 196
Stallone, Sylvester, 203
Stanley, John, 88, 99
Steig, William, 68
Steinberg, Saul, 68
storyworld vs. storyspace in comics, 147, 148–150
*Strange Planet* (Pyle), 212
Streit, Kate, 174
*Super Mario Bros*, 212
*Superman* (comic), 82, 210
Sweeny, Peter B., 32, 33, 35, 36
Swift, Jonathan, 88, 90, 91

tableau vivant, v, 15, 45, 48–52, 54–67, 216n2 (chap. 2)
Tammany Hall, 23, 29, 32, 33, 36–37, 38, 40
Tarantino, Quentin, 205, 207
*Tastes like Chicken* (Alves), 2, 196
Telnaes, Ann, 21, 28
*Terry and the Pirates* (Caniff), 82
Thurber, James, 68
Till, Emmett, 125–127, 217n3 (chap. 5)
Toles, Tom, 21, 28
Tomine, Adriane, 84
Töpffer, Rodolphe, 7, 218n8

Topliss, Ian, 71, 72
Travolta, John, 206, 207
Trester, Anna Marie, 88
Tripp, Irving, 88, 99
Trudeau, Garry, 67, 104, 163
*Trudy* (Marcus), 20
Turner, Morrie, 103
Tweed, William "Boss," 14, 23–24, 25, *30*, *31*, *33*, *34*, 34, 35, 36, 38, *39*, *40*
Tweed Ring / Tammany Ring, 29, 34, 35, 38, *40*

*Uglies* (Westerfield), 185
ugliness, 184–189, 219n2
  as aesthetic, 184–185, 188–189
  as cultural phenomenon, 184–185
  etymology, 187
  and *Far Side, The*, vi, 18–19, 173, 175–184
  and *Hyperbole and a Half*, 176, 190–193
  and *Natalie Dee*, 176, 190–193
  and *Oatmeal, The*, 176, 190–193
  and power, 187
  and punk movement, 187–188
  and race, class, gender, sexuality, ethnicity, age, able-bodiedness, 186
*Ugly Betty*, 185
Ugly Dolls, 185
ugly sweater parties, 185
underground comix. *See* alternative comics / underground comix
*Understanding Comics. See* McCloud, Scott
Unger, Jim, 20

*V for Vendetta* (Moore), 170
vaudeville, 51, 66
Vega, Vincent, 206, 207
*Venus Rising from the Sea* (Titian), 61, 64

"Walk This Way" (Aerosmith), 199
"Walk This Way" (Run DMC), 199
Warhol, Robyn, 147–148, 154, 217n1 (chap. 6)
Watterson, Bill, 20, 66, 103–104
web comics. *See* digital comics
Webster, Harold T, 20
*Wee Pals* (Turner), 103, 104
*White Album, The* (Beatles), 197
Williams, J. R., 20

Wilson, Tom, Jr., 160, 161, 162, 163–165, 218n6
Wilson, Tom, Sr., v, 10, 11, 18, 155, 156, 160, 161, 162, 163, 164, 165, 171, 172, 218n5
   and American Greetings card company, 160, 161, 163, 164
   military service, 161–162, 218n5
   *Ziggy*, v, 4, 5, 10, *11*, 12, 18, 155, 156, 160, 161, 162, 163–164, *164*, 167, 168, 171, 172, 174, 214
*Without Reservations* (Caté), 20
Wonder Woman, 165
World War II, 2, 18, 85, 110, 156–159, 162, 164, 165
Wright, Bradford C., 165
Wright, Nazera Sadiq, 108, 110, 111, 117
*Wuthering Bites*, 200

xenophobia, 216n2 (chap. 2)
*xkcd* (Munroe), 212

Yaszek, Lisa, 47, 63
Yellow Kid, The (Outcault), v, 1, 15–16, 45–48, 51–52, 54–59, 62–66, 82, 166, 216n2
Young, Chic, 82

*Ziggy* (Wilson), v, 4, 5, 10, *11*, 12, 18, 155, 156, 160, 161, 162, 163–164, *164*, 167, 168, 171, 172, 174, 214
   commercial success, 155–156, 160, 161, 162, 163–164, 172
   critical reception, 156
   and Kilroy, 156, 157, 164–165, 167, 171, 172, 217n1 (chap. 7), 218n2
   and Universal Press Syndicate / John McNeel, 163–164
Zyglis, Adam, 21

## About the Author

MICHELLE ANN ABATE is a professor of literature for children and young adults at The Ohio State University. She is the author of seven previous books of literary criticism, including *Blockheads, Beagles, and Sweet Babboos: New Perspectives on Charles M. Schulz's Peanuts*. Dr. Abate has published peer-reviewed journal articles about a wide array of comics and graphic novels, ranging from *Calvin and Hobbes*, *Garfield*, and *Peanuts* to *Little Lulu*, *In the Shadow of No Towers*, and *Terry and the Pirates*. She is also the coeditor (with Gwen Athene Tarbox) of *Graphic Novels for Children and Young Adults: A Collection of Critical Essays*. Her first book, *Tomboys: A Literary and Cultural History*, was nominated for a Lambda Literary Award.